# London 2014

# FRIEZE ART FAIR

Skylark

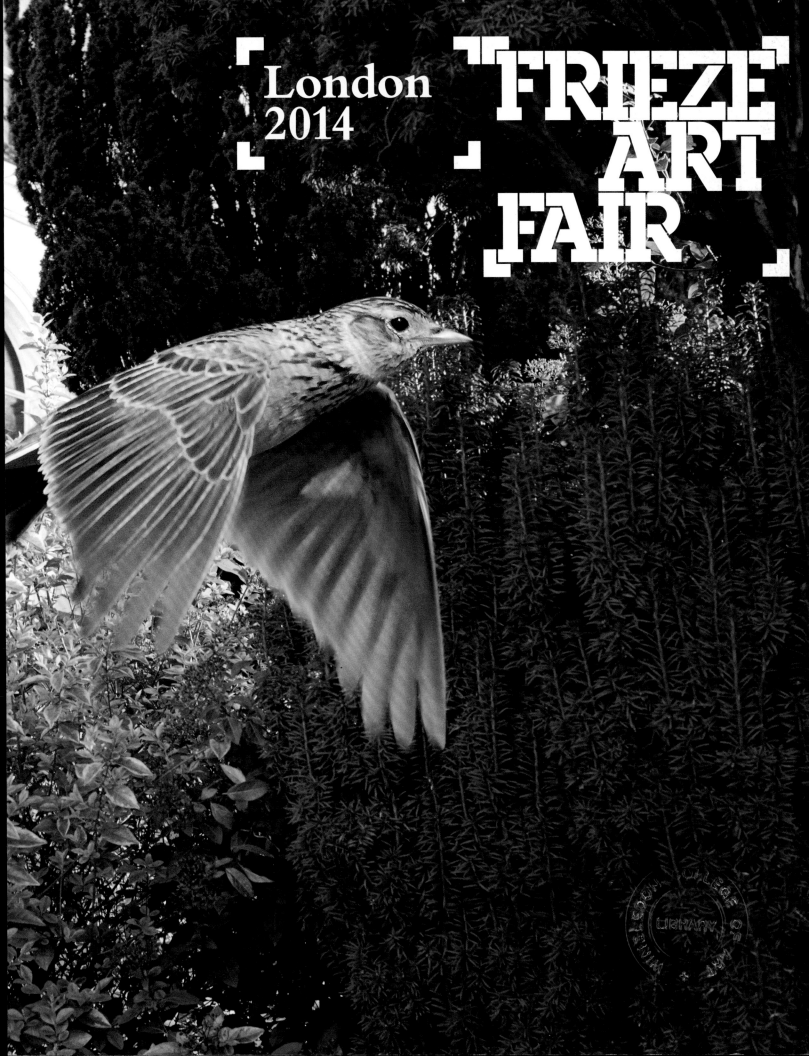

London
2014

# FRIEZE
# ART
# FAIR

Frieze Art Fair wishes to acknowledge the generous support
of the following companies and organizations:

**Main Sponsor
Deutsche Bank**

**Associate Sponsor**

ALEXANDER
MᶜQUEEN

**Media Partner**

FINANCIAL
TIMES

**Sponsors and Partners**

# Contents

# Participating Galleries

303 Gallery
Galería Juana de Aizpuru
Allied Editions
Galería Helga de Alvear
Ancient & Modern
The Approach
Laura Bartlett Gallery
Galerie Catherine Bastide
Galería Elba Benítez
Blum & Poe
Marianne Boesky Gallery
Tanya Bonakdar Gallery
The Box
BQ
Gavin Brown's enterprise
Galerie Buchholz
Cabinet
Campoli Presti
Canada
Galerie Gisela Capitain
Casas Riegner
Sadie Coles HQ
Contemporary Fine Arts
Pilar Corrias
Corvi-Mora
Galerie Chantal Crousel
Thomas Dane Gallery
Massimo De Carlo

Galerie Eigen + Art
Konrad Fischer Galerie
Foksal Gallery Foundation
Galeria Fortes Vilaça
Marc Foxx Gallery
Carl Freedman Gallery
Stephen Friedman Gallery
Frith Street Gallery
Gagosian Gallery
Annet Gelink Gallery
A Gentil Carioca
Goodman Gallery
Marian Goodman Gallery
Greene Naftali
greengrassi
Galerie Karin Guenther
Hauser & Wirth
Herald St
Galerie Max Hetzler
Hollybush Gardens
Taka Ishii Gallery
Alison Jacques Gallery
Galerie Martin Janda
Casey Kaplan
Georg Kargl Fine Arts
Anton Kern Gallery
Galerie Peter Kilchmann
Tina Kim Gallery
David Kordansky Gallery
Andrew Kreps Gallery
Galerie Krinzinger
Kukje Gallery
kurimanzutto
Lehmann Maupin
Lisson Gallery
Kate MacGarry
Mai 36 Galerie
Gió Marconi
Mary Mary
Galerie Greta Meert
Mendes Wood DM

Galerie Meyer Kainer
Meyer Riegger
Victoria Miro
Stuart Shave/Modern Art
The Modern Institute
MOT International
mother's tankstation
Taro Nasu
Galleria Franco Noero
Galerie Nordenhake
Office Baroque
Overduin & Co.
Pace
Maureen Paley
Peres Projects
Galerie Perrotin
Galerie Francesca Pia
Galeria Plan B
Galerija Gregor Podnar

Galerie Eva Presenhuber
Project 88
Rampa
Raucci/Santamaria
Almine Rech Gallery
Anthony Reynolds Gallery
Galerie Thaddaeus Ropac
Salon 94
Esther Schipper
Galerie Rüdiger Schöttle
Sfeir-Semler
Shanghart Gallery
Sommer Contemporary Art
Sprüth Magers
Standard (Oslo)
Stevenson
Galeria Luisa Strina
T293
Take Ninagawa
Timothy Taylor Gallery
The Third Line
Vermelho
Vilma Gold
Vitamin Creative Space
Wallspace
Michael Werner
White Cube
Wien Lukatsch
Wilkinson
Workplace Gallery
Zeno X Gallery
David Zwirner

## Focus

Christian Andersen
Arcade
Bureau
Callicoon Fine Arts
Carlos/Ishikawa
Clifton Benevento
Croy Nielsen
dépendance
Essex Street
Experimenter
Fluxia
Fonti
Freedman Fitzpatrick
Freymond-Guth Fine Arts
Frutta
François Ghebaly Gallery
Dan Gunn
Kendall Koppe
Galerie Emanuel Layr
Galerie Antoine Levi
Limoncello
Galeria Jaqueline Martins
Mathew Gallery
Misako & Rosen
P!
Raster
Real Fine Arts
Galerie Micky Schubert
Barbara Seiler
Société
Gregor Staiger
Galeria Stereo
Simone Subal Gallery
Sultana
Supportico Lopez
Tempo Rubato
Leo Xu Projects

## Live

gb agency
Green Tea Gallery
Project Native Informant
Rodeo
Silberkuppe
Galerie Jocelyn Wolff

# Foreword

We are delighted to welcome you to the 12th edition of Frieze London.

The fair's location in Regent's Park has been a defining feature since its launch in 2003. One of the many benefits of the temporary structure has been the ability to use architecture to enhance the environment of the fair, for galleries, visitors and artists alike, and following a distinguished line of collaborators, we are excited this year to work with Universal Design Studio. The founders of UDS, Ed Barber and Jay Ogersby, have worked across disciplines on projects as diverse as the Science Museum, the Olympic torch, retail interiors and domestic furniture, and we are excited to see the results.

Frieze London is an exciting and ambitious context for the commissioning of works that engage with the live dynamics of the fair. Launching this year is the Live section, which will give galleries the opportunity to realize performative works creating moments of interruption or immersion within the fair's environment. The programme includes the restaging of important historical installations as well as those conceived specially for the fair. This year Focus merges with Frame to become a significant destination for younger galleries presenting either solo or curated group stands.

Frieze Projects, the fair's series of site-specific artist commissions, is curated for the second year by Nicola Lees, and this year has a focus on artists whose practices intersect with other disciplines, including dance, film and music. The participating artists are: Cerith Wyn Evans with ZSL London Zoo; Isabel Lewis with the ICA, London, National Trust and Liverpool Biennial; Nick Mauss with Northern Ballet; Sophia Al Maria; Jonathan Berger; Tobias Madison; Jérôme Bel with Dance Umbrella (Frieze Dance); and Cally Spooner (Frieze Film). Works are presented around the fair and off-site, taking Frieze visitors around London and introducing the projects to new and diverse audiences.

The winner of this year's Frieze Artist Award, which gives a young artist the opportunity to create a new project for the fair, is Mélanie Matranga. Mélanie is creating a series of online videos, filmed during the construction of the fair, which follow the emotional and professional lives of an artistic couple. Frieze Talks— a series of lectures, discussions and interviews—is again curated by editors of *frieze* magazine, this year Jörg Heiser, Christy Lange and Amy Sherlock.

We are extremely proud of the Outset/ Frieze Art Fair Fund to Benefit the Tate Collection, which is now in its 12th year and continues to make an impressive contribution to the national collection. Our gratitude goes to the supporters of the fund, including sponsor Leviev Extraordinary Diamonds.

We are very grateful to receive the generous support of Deutsche Bank, now entering a second decade as the main sponsor of Frieze London (and the main sponsor of Frieze New York and Frieze Masters since their inception in 2012). Alexander McQueen is associate sponsor for the second year, this year supporting the Live section. We are also very happy to continue our relationships with our media partner the *Financial Times*, and automotive partner BMW. New this year, Gap will host 'Gap Lounge'—a public lounge serving complimentary beverages. In addition we welcome Selfridges as a new retail partner of the fair for 2014.

We hope you enjoy Frieze London.

Matthew Slotover
Director

Amanda Sharp
Director

Jo Stella-Sawicka
Director Frame/Focus
Deputy Director

Frieze Art Fair

Ken Okiishi
*Frieze Project*
2013
Installation view at
Frieze London 2013

# Sponsor's Foreword

Welcome to Frieze London 2014.

At Deutsche Bank we believe long-term success comes from partnership. That value defines our relationships with our clients, and it underpins our long-standing involvement with contemporary art too.

Deutsche Bank has championed contemporary art for 35 years. Through the Deutsche Bank Collection we promote young international talent such as Indian artists Raqs Media Collective, whose fascinating piece *The Arc of a Day* (2014) we are pleased to bring to Frieze this year. The work is also installed at our new Birmingham office, where it offers a daily reminder of our interconnected world.

The Bank's support for contemporary artists continues to grow and is reflected in a wide programme of activities. The Deutsche Bank Awards for Creative Enterprise have helped arts graduates to pursue their ambitions for over 20 years, and the Awards are now open to more students than ever before. Deutsche Bank KunstHalle in Berlin has also recently launched an exhibition series in cooperation with Tate Modern, London, which will run until 2017 and presents work by pioneering artists from Africa, Asia and the Middle East.

Our partnership with Frieze is now in its 11th year, and this year's programme underlines Frieze's talent for showcasing the work of today's artists in ever more imaginative ways. Frieze Live promises to be intriguing, unpredictable, provocative and memorable: everything that makes Frieze an event unlike any other.

We hope you enjoy the fair.

Sincerely,

Michele Faissola

Head of Deutsche Asset & Wealth Management, Member of the Group Executive Committee, Deutsche Bank

Robert Rankin

Co-Head of Corporate Banking & Securities and Head of Corporate Finance, Member of the Group Executive Committee, Deutsche Bank

Main Sponsor
Deutsche Bank

# Outset/Frieze Art Fair Fund to Benefit the Tate Collection

We are very proud to announce the 12th successive year of the collaboration between Outset, Frieze Art Fair and Tate.

Outset Contemporary Art Fund was founded in 2003 as a philanthropic organization dedicated to supporting new art. The annual fund at Frieze London allows Tate to buy important works at the fair for the national collection.

The fund has made an impressive contribution to the Tate collection. Over £1 million has been spent and 94 works by 64 artists have been collected, including major pieces by significant international practitioners such as Hideo Fukushima, Thomas Hirschhorn and Anri Sala. Acquisitions in 2013 included works by Terry Adkins, Christina Mackie, James Richards and Sturtevant.

This year the fund is set at £150,000 and the selection panel will include Agustín Pérez Rubio (Artistic Director, MALBA, Buenos Aires) and Laurence Rassel (Director, Fundació Antoni Tàpies, Barcelona) as well as Frances Morris (Head of Collections, International Art, Tate), Ann Gallagher (Head of Collections, British Art, Tate), Tanya Barson (Curator, International Art, Tate) and Clarrie Wallis (Curator, Contemporary British Art, Tate).

The fund is organized and financed by Outset and in 2014 enjoys continued support from Leviev Extraordinary Diamonds. We are very grateful to all the participants for their generosity and vision.

Sir Nicholas Serota, Director, Tate
Amanda Sharp and Matthew Slotover, Directors, Frieze Art Fair
Candida Gertler, Director, Outset Contemporary Art Fund

1
Christina Mackie
*The Dies*
2008
Plywood, steel, chalk, plaster, watercolour, plastic
140 × 500 × 25 cm
4' 7⅛" × 16' 4⅞" × 9⅞"
Shown by Supportico Lopez in 2013
Courtesy of Tate Photography

2
James Richards
*Not Blacking Out, Just Turning the Lights Off*
2011
Double-channel video installation
16 min. 16 sec.
Commissioned by Chisenhale Gallery
Shown by Rodeo in 2013
Courtesy of Rodeo

3
Sturtevant
*Trilogy of Transgression*
2004
3-channel video on 3 monitors, colour
1 min. 45 sec., 30-min. loop
Shown by Anthony Reynolds Gallery in 2013
Courtesy of Tate Photography

4
Terry Adkins
*Muffled Drums (from Darkwater)*
2003
Bass drums, mufflers
Dimensions variable
Shown by Salon 94 in 2013
Courtesy of Tate Photography

All works OFT acquisitions 2013

1

Supported by

LEVIEV
EXTRAORDINARY DIAMONDS

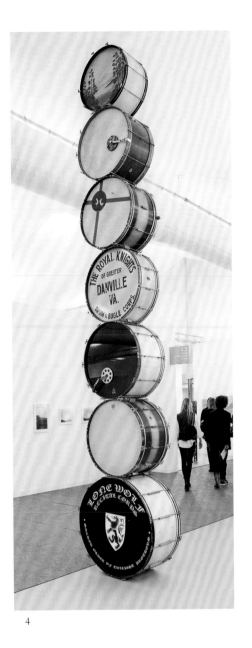

4

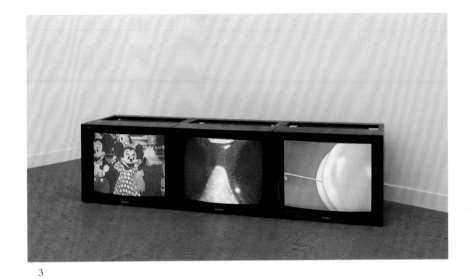

3

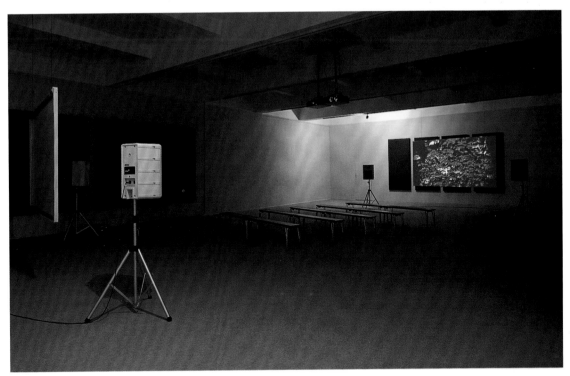

2

Introduction

**Frieze Projects**
Sophia Al Maria
Jonathan Berger
Isabel Lewis
Tobias Madison
Nick Mauss
Cerith Wyn Evans

Frieze Artist Award:
Mélanie Matranga

**Frieze Dance**
Jérôme Bel

**Frieze Film**
Cally Spooner

# Introduction

Frieze Projects at Frieze London 2014 brings together nine new commissions, realized both at the fair and in a number of off-site locations around the city. This year the programme has a focus on artists whose practices intersect with other disciplines. More than ever before, collaboration with institutions across London and the UK—from the National Trust to the Northern Ballet—draw attention to the ways in which art criss-crosses the fabric of the UK's cultural ecology.

Frieze London is an exciting and ambitious context for the commissioning of works that engage with the live dynamics of the fair. Dance, choreography and theatre have emerged as significant threads running though this year's Frieze Projects, reflecting current interest in the dynamics of staging and theatricality, which increasingly impact on human interactions, especially at public events such as Frieze London. It is perhaps significant that several artists have responded to this environment by presenting elements of their rehearsal processes, or revealing backstage environments or the mechanics of their making.

I have been struck by the way the artists bring to light the nature of the fair itself, and the structures that govern the way we look at artworks today, both through their conversations and through their projects at Frieze London. Variously, they have concentrated on the implicit etiquettes, coded knowledge systems and behavioural tics that include and exclude; the tendency that we have to iron out posthumously the difficult elements in artists' characters; the way in which a sense of occasion delimits the behaviour of audiences; the privileging of finished, rehearsed work over live improvisation; and the will to smooth out interactions with art and people into seamless transactions, rather than complex negotiations that offer increased potential for disappointment as well as enlightenment. All of these projects in one way or another aim to deepen engagements with art at this moment in the 21st century, and each one is made with an active form of respect for its audience.

New to the fair in 2014 is the inaugural Frieze Artist Award, established to enable an emerging artist to present a site-specific work at Frieze London. The winner of this year's award is Mélanie Matranga, who is creating a series of short online videos, co-directed by Valentin Bouré, that follow a young artistic couple as they negotiate 'freedom, success and the proper functioning of a couple'. The episodes will be filmed during the construction of the fair itself, within a purpose-built café that Matranga has designed for use by Frieze visitors, occasionally distributing 'under the counter' items. The narrative structure of the videos focuses on the simultaneous construction of both the couple's relationship and the set of the café, looking at the confluence of emotional and monetary trade economies.

Within the fair, Nick Mauss has constructed a 'living stage', on which a new ballet is performed each day. These durational performances will take place in a space that has a stage and backstage, both visible, responding to the fair environment as a place of constant movement and social dance. The ballet is accompanied and interrupted by newly commissioned texts and music, performed live by Kim Gordon and Juliana Huxtable. Mauss has worked closely with choreographer Kenneth Tindall and five dancers from Northern Ballet to develop this piece, with acclaimed choreographer Lorena Randi acting as mentor and dramaturge. This will be the first major performance piece by Mauss, who is known mainly for his paintings and sculptures.

Jonathan Berger's project for Frieze London is inspired by Andy Kaufman's 1979 performance *Andy Kaufman Plays Carnegie Hall*. Best known as an actor and comedian, Kaufman appeared regularly in 1970s and '80s American television shows including *Saturday Night Live* and *Taxi*. At the same time he had an alternative career as a stand-up innovator and live performer. Berger's proposal is to bring the musical overture that was performed at Carnegie Hall back to life at Frieze London. This piece of music was co-conceived by conductor Gregg Sutton, featuring references to Kaufman's best-known acts, and was only ever played on that occasion, with no recording. Berger has collaborated with Sutton to develop the project, which culminates in a daily performance at the fair by a full orchestra. The site for these performances also features ephemera from Kaufman's life and work; his friends, family and collaborators will be present within the space to engage with visitors. Berger's project seeks to act as an investigative portrait of an unclassifiable figure in American cultural history. Berger's projects often engage with the creation and presentation of an exhibition; this project is a continuation of 'On Creating Reality, by Andy Kaufman' and 'Andy Kaufman's 99cent Tour' (both 2013).

Tobias Madison has created two adjacent rooms at Frieze London that are interwoven with sensory and microbic technology. These rooms, based on Madison's previous *Frankenstein* installation (2013), become both the stage for and the monster itself, as an automated network of pipes pumps liquid and emits vapours at certain moments in a form of theatrical drama. However, the majority of the action will take place in an empty room: a sharp defence mechanism, activated by movement, will cause a mist to be released into the space and switch off the system when anyone enters the demarcated area. The work is therefore designed to present only a glimpse of the 'monster'.

Inspired by the subliminal messages in John Carpenter's high-concept/low-budget film *They Live* (1988), Sophia Al Maria has devised a project that deals head-on with the oft-voiced complaint that contemporary art is a conspiracy of the emperor's new clothes variety. In the same way that Carpenter's film proposes that commercial advertising is an occult mode of mind control, Al Maria's project questions what an art fair is really saying to its visitors. Using a combination of amusing and poignant statements and icons inspired by petroglyphs to mark the walls of the fair, she looks to expose its unspoken messages.

Presenting a project off-site, Cerith Wyn Evans has installed a work in the heart of ZSL London Zoo in Regent's Park. By creating an exhibition with an audience of both humans and animals, Wyn Evans twists the relationship between the subject and object involved in the viewing process. Important historical references for this work include Gino de Dominicis's five-day exhibition 'Zodiaco' (1970) and Braco Dimitrijević's 1998 installations with living animals in the Paris Zoo. The Snowdon Aviary, co-designed by Cedric Price, was one of the first places that Wyn Evans visited when he moved to London in the 1970s and the site for his project. We are very grateful to ZSL London Zoo; their continued engagement has been essential to the work's conception, production and presentation. Special thanks to Susan Stenger for her performance.

Isabel Lewis hosts a series of 'occasions' —at the Old Selfridges Hotel in collaboration with the ICA, London, the National Trust's Fenton House, and Liverpool Biennial—that conjure the ancient Greek symposium, where philosophizing, drinking and the erotic were inseparable. Occurring over the five days of the fair, they are a celebratory meeting of things, people, plants, music, smells and dance. Lewis is the host, and also an orator, impostor, DJ and dancer. She is collaborating with Norwegian chemist and smell researcher Sissel Tolaas, who will create scents for the Frieze occasions.

In partnership with Dance Umbrella, Frieze Projects brings Jérôme Bel's critically acclaimed *Disabled Theatre* (2012) to London. This is the UK première of this work, which was originally presented at Kunstenfestivaldesarts in Brussels and later in Documenta 13. A collaboration with Theater HORA, a Zurich-based theatre company of professional actors with learning disabilities, the performance offers a rare insight into lives laid bare on the stage in a way that is both compassionate and vulnerable. During the performance 11 actors between the ages of 18 and 44 react freely, subjectively and often with humour to a series of tasks proposed by Bel. The artist discussed this project in London at Frieze Talks in 2013, in conversation with Catherine Wood.

Frieze Film 2014 will be a series of trailers for Cally Spooner's forthcoming film. The section will consist of a number of commercial interruptions based on the transcript of the off-camera dialogue from her 2013 performance musical *And You Were Wonderful, On Stage.* The trailers will alternate between hyper-performing backing dancers, large-scale, hastily edited texts and coloured screens. This follows on from Spooner's Frieze Sounds commission at Frieze New York 2014, and will be produced in partnership with High Line Art, New York. These travelling, changeable commercial interruptions become the public face/advert for the pending film of the musical, and also are independent works in themselves, exploring ideas around automated speech and behaviour. The main film will be co-produced by the Stedelijk Museum, Amsterdam, and is made possible by a 2015 production residency at EMPAC (Experimental Media and Performing Arts Center) at Rensselaer Polytechnic Institute in Troy, NY.

We are grateful to Arts Council England for their contribution to Frieze Projects 2014. New partners also deserve our sincere thanks as they have provided additional support to particular projects this year. Mélanie Matranga was supported by Fluxus Art Projects.

I would like to thank the individuals who have contributed to the curatorial process, specifically: my colleagues on the Frieze Artist Award selection committee, Fredi Fischli and Niels Olsen, Hilary Lloyd and Stella Bottai; at Liverpool Biennial, Sally Tallant and Vanessa Boni; at the National Trust, Tom Freshwater; at the ICA, Gregor Muir and Katherine Stout, Juliette Desorgues and Sam Martin; at ZSL, David Field, James Wren, Sarah Thomas, Robin Fitzgerald and Steve Marriott; at Dance Umbrella, Emma Gladstone; everyone at Northern Ballet, Andrew Bonacina and Kate Coyne; Laura McLean Ferris; Frieze staff Lauren Wetmore, Justin O'Shaughnessy and trainee Greta Hewison; and all the many others who have contributed their time and energy to the Frieze Projects programme in 2014.

Nicola Lees
Curator, Frieze Projects

# Sophia Al Maria

Presenting an alternative tour of the Frieze Art Fair, Sophia Al Maria carves out subliminal routes and points to potential conspiracies

**Nicola Lees** You are possibly best known for your memoir *The Girl Who Fell to Earth* (2012), in which you describe growing up in Qatar, Saudi Arabia and Seattle, and which, by the title alone, introduces your interest in science fiction. How does writing inform your art?

**Sophia Al Maria** I am a writer. I guess that is the foremost element of most of my work. Writing is the opening for all my projects, especially these days, when it's all about statements and treatments. Everything begins with the word.

**Lees** You have many different modes of working, ranging from art projects and art films to writing novels, as well as writing and directing feature-length films. What connects all these elements of your practice?

**Al Maria** Story, I suppose. I get really frustrated without it. For example, I sometimes find theory really difficult to deal with when it is narrative-less. And I guess I resent the fact that there is often such a high entry fee to understanding. I do think that having a good story in every project is central.

**Lees** Tell me about *Beretta*, the film you are working on now.

**Al Maria** I always wanted to make a revenge film in Cairo. I was a very angry person there. I was wound up by the violence of everyday life, of being a woman walking on the street. It's a global problem, but it's particularly intense in places where there is overpopulation and unemployment. In Cairo it all culminated in being pulled out of a moving vehicle by a mob of football fans—by my breasts and neck and hair—that experience will always be with me. And so I wrote this rape revenge film set in the city I spent my youth in as a cathartic fantasy for anyone beset by these feelings of being powerless.

**Lees** And how have you transformed the material that informs *Beretta,* and your struggle to make it, into an exhibition at Cornerhouse?

**Al Maria** The title of the show in Manchester is 'Virgin with a Memory', which is a reference to a song by Destroyer. The first line of that song is 'Was it the movie or the making of *Fitzcarraldo* where someone learned to love again?' So there are three reference points for this in the exhibition: *Money into Light* (1985), which is John Boorman's diary of trying to make *Emerald Forest* (1985); Eleanor Coppola's *Hearts of Darkness* (1991), on the filming of *Apocalypse Now* (1979); and Les Blank's *Burden of Dreams* (1982), on Werner Herzog's struggle to make *Fitzcarraldo* (1982). They all cover the struggle of making films in the jungle; it's as though there is this jungle curse. This provides the idea of the cursed concrete jungle and attempting the impossible—to shoot that. It's maybe presumptuous of me to be thinking about my film in the context of these, but they have influenced me, for sure.

**Lees** *Beretta* is a revenge film, but in this expanded form revenge is an undercurrent of the entire project, isn't it?

**Al Maria** In a meta way, yes. The exhibition at Cornerhouse has become the revenge that I'm taking on the forces stopping me from making this movie,

Sophia Al Maria (b. 1983, USA) is an artist, writer and filmmaker based in London. She studied comparative literature at the American University in Cairo, and aural and visual cultures at Goldsmiths, University of London. Al Maria's work has been exhibited at: Frieze, London (2013); the 9th Gwangju Biennale (2012); and the Architectural Association School of Architecture, London (2011). Her memoir *The Girl Who Fell to Earth* was published in 2012, and her writing has appeared in *Harper's Magazine*, *Triple Canopy* and *Bidoun*. In 2014 Cornerhouse, Manchester, presents Al Maria's exhibition 'Virgin with a Memory', focusing on the stalled production of her début feature film (to November).

*The Watchers No. 1–6*
2014
5-channel digital video
with audio
3 min. 40 sec.
Courtesy of Cornerhouse

but that's a subtext really. It became clear that the only way to get a director's cut of anything would be to create the story as a property, and to write *Beretta* as a novel, because that's one of the purer ways to have control over an idea or over a story that you want to tell. The moment that money and politics and lawyers get involved, which happened with this project, you lose a little bit of control with every dollar that is spent. The camera is a sort of 'evil eye' in the exhibition. I certainly believe in it, and we joke that the evil eye has been given to this project, basically. Some of the videos are woven in the edit like protective amulets to ward off the bad juju.

**Lees** The constraints placed on making a film about current affairs contrast greatly with creating a science fiction work, another area of interest for you.

**Al Maria** Yes, the realm of SF has always been a place where we're able to move and create and work without constraints. I'm much more interested in other worlds, other inner spaces, in the words of J.G. Ballard.

**Lees** Could you explain your conception of 'Gulf Futurism'?

**Al Maria** Contrary to the obvious link of our starchitect-driven skylines, Gulf Futurism is about what's happening to people: what's happening to society. It's about time travel. And ultimately I see this decade in the region as a sort of preview of a dystopian world that's coming: an inhospitable environment where we all live indoors, segregated from nature and each other. Plus there is the *Metropolis*-like situation of workers and overlords. I think in so many different ways the Gulf is a herald of what is coming in the world. And because of the oil and the fact that this is a main point of extraction, it becomes a very symbolic place to think about a future where our addiction to fossil fuels is not curbed.

'I'm sure that many people, even people who collect art, often feel that there's some kind of joke being played on them.'

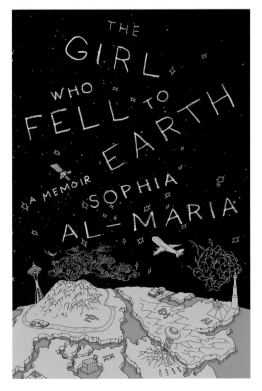

**Lees** Maybe we can talk about the gesture that you will be using in the Frieze Project and the cinematic references behind that gesture?

**Al Maria** Yes! *They Live*, directed by John Carpenter (1988). I went to a talk given by Simon Sellars, who runs the Ballardian blog, and he was saying that although *They Live* is based on a short story written in the 1970s, he believes that the actual antecedent for the film is Ballard's short story 'The Subliminal Man' (1963). In both, the idea is that all advertising, and everything in our visual sphere, is constantly ordering us to obey and buy and consume all the things that we know and accept. The project that I'm doing for Frieze is inspired by that film, by the awakening that happens when the protagonist puts on a pair of sunglasses for the first time and sees that the people who run the world are actually aliens—skull-faced aliens—and that their orders are written everywhere. It's really wonderful and terrifying.

**Lees** The project will be dispersed around the fair, in a way that is similar to the distribution of messages around the urban space in the film. So the fair becomes almost a miniature city environment in which to replay a certain moment of haze clearing from the eyes.

**Al Maria** I'm sure that many people, even people who collect art, often feel that there's some kind of joke being played on them. When you go to look at art, there's that cloying feeling that it might be the emperor's new clothes, or that you just don't get the joke.

**Lees** There will be symbols embedded in the fabric of the fair, which can only be seen in ultraviolet light. What are your visual references for the symbols?

**Al Maria** The symbols are inspired by petroglyphs and cave paintings. There's a place called Jassasiyah, outside Doha, where there are these strange rock petroglyphs that I've been obsessed with for years. When I was working at Mathaf (the Arab Museum of Modern Art in Doha), I made some petroglyphs for the museum—made a map of Doha,

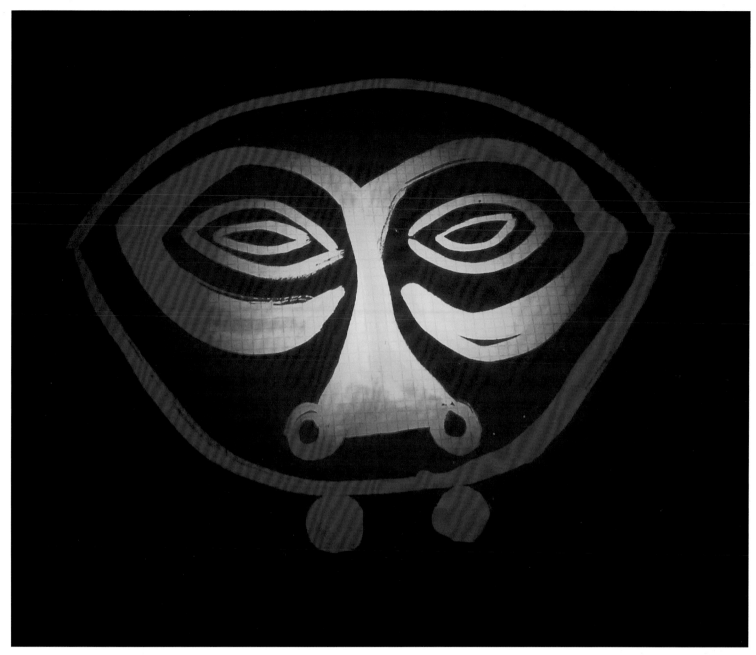

Above:
*Tsaglalal (She Who Watches)*
2014
Theft-detection ink
Dimensions variable

in fact—that was inspired by these carvings. Symbols are perhaps the things that will last longer than anything else on this earth, so this project is hoping to use them to illuminate myths about the world the visitor is walking around in. Plus, I think holding an ultraviolet torch to invisible ink on a white wall is an amusing play on holding fire to a cave wall to look at a Palaeolithic painting.

**Lees** There's also a theatrical element—tours that will be given so that visitors can be shown the symbols.

**Al Maria** The tours will be made up in direct response to what the galleries bring. It's very theatrical, which is hilarious because I have a very difficult time with theatre. I find interaction a bit terrifying, which is maybe why I write. Having a proxy or an avatar in the form of an actor playing a character giving a tour is an extremely pleasing possibility.

**Lees** And to return to the revenge genre, is the Frieze Project, in a humorous way, a bit of revenge on the art world?

**Al Maria** Yes, not that I have any right to wreak revenge, because I've been very kindly treated. Perhaps it is not my revenge to take, but I hope that it might enact some kind of vengeance for the public.

**Lees** Reclaiming the tradition of that science fiction genre of consumer critique?

**Al Maria** Exactly.

# Jonathan Berger

Jonathan Berger reassembles fragments from Andy Kaufman's personal life and career, and restages a forgotten overture from Kaufman's 1979 variety show at Carnegie Hall

Below:
*On Creating Reality,
by Andy Kaufman
(vitrine #16)*
2013
Found ephemera
4' × 4'
1.22 × 1.22 m
Courtesy of Jonathan Berger, the Estate of Andy Kaufman, Maccarone and Bob Zmuda

Opposite, below:
*On Creating Reality,
by Andy Kaufman
(vitrine #10)*
2013
Found ephemera
4' × 4'
1.22 × 1.22 m
Courtesy of Jonathan Berger, the Estate of Andy Kaufman, Maccarone and Bob Zmuda

**Jonathan Berger** (b. 1980, USA) lives in New York and works across a number of disciplines. His projects often engage with the creation and presentation of exhibitions. A recent recipient of a Pollock-Krasner Foundation Grant, he is an Assistant Professor at New York University as well as Director of their 80WSE Gallery. Recent exhibition projects include 'On Creating Reality, by Andy Kaufman' at Maccarone, New York (2013), in conjunction with 'Andy Kaufman's 99cent Tour' at Participant Inc., and 'Stuart Sherman: Nothing Up My Sleeve' at Participant, Inc., New York (2009), which was included in the 2009 Performa Biennial.

**Nicola Lees** You were involved with some important projects growing up. Can we start there, because they were central to shaping your thinking as an artist?

**Jonathan Berger** I grew up in NYC in the 1990s; my dad was involved in a very active non-profit arts organization during the 'culture wars' period, so that definitely influenced my interest in art and alternative processes. In high school I joined the youth committee of ACT UP (AIDS Coalition To Unleash Power), a diverse, non-violent, direct action organization devoted to ending the AIDS crisis. ACT UP's membership was full of incredible contemporary artists, including Zoe Leonard and Felix Gonzalez-Torres; my exposure to their work really informed my understanding of the role of art in society and also the non-literal ways an artist's aesthetic sensibility could support those ideologies.

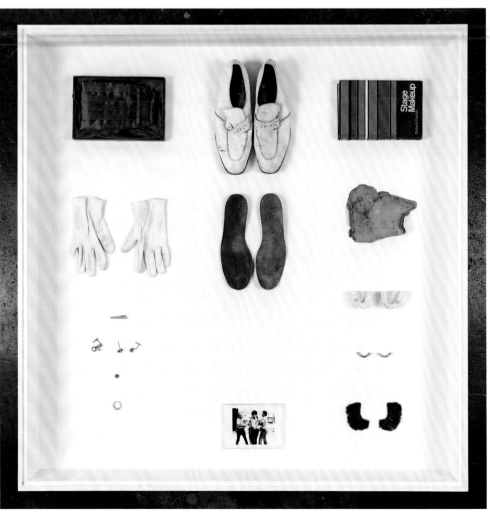

The art made during that time remains unique in that it is hyper-political but uses visual languages that are not apparently political.

When David Wojnarowicz's manifesto ignited the Political Funeral movement in the early 1990s, certain ACT UP members close to dying requested their bodies be used in public protests. I remember meetings where people were figuring out how to perform with a dead body or a person's ashes in public. So much of what the group was trying to do remains conceptually and logistically unprecedented; these remarkable creative minds were applying themselves to these efforts. Ultimately, much of the way I think now is rooted in that time—not

accepting what is, but, rather, rigorously and sincerely pushing into uncharted territory. I think a lot about how to work with people and how to make sure that a process is ethically calibrated.

**Lees** Your interests tend to focus on artists and groups working slightly outside of the white cube, the institution, the establishment?

**Berger** Yes. Generally, contemporary art exists within a limited set of conventions. I don't want those limitations to affect my thinking or what I do, so I keep a good deal of distance. I'm always drawn to people who pursue their work in the purest and most direct way possible; often that means that they can't really operate within the established systems—artists like Jack Smith or Eileen Gray. Charles and Ray Eames are the artists that I think about most in relation to my practice these days. They had this brilliant structure of setting up the Eames Office. The office encompassed everything they did; it comfortably brokered their relationship to the outside world, while allowing them to maintain total creative

freedom and control. It was the manifestation of their shared brain. Their office made everything from experimental movies to fabric, furniture, and IBM ad campaigns—all things most people wouldn't think go together.

**Lees** Can you tell me about the Stuart Sherman exhibition you made? I think there's a clear lineage between that project and what you are planning for Frieze Projects.

**Berger** In 2009 I organized a show at Participant, Inc. (NYC), including different artists, but based on the work of Stuart Sherman (1945–2001), whose work began with writing and later included drawing and performance. The show focused on his *Spectacles*—small tabletop performances in which he moved objects around in very brisk sequences he called 'routines'. Sherman said those performances evidenced his true self and he wished he could act like that all the time. For him those performances were his reality, but the rest of the time he had to live in everybody else's version of reality. These performances opened a space for him to be the way that he wanted to be in the world.

**Lees** So this led you to articulate individuals who have treated reality as a flexible concept, adapting it through the making of their work.

**Berger** Yes. From the beginning I wanted to include Andy Kaufman, but I didn't know anybody who knew him. Eventually, the assistant to Bob Zmuda, Kaufman's collaborator, connected me with Andy's girlfriend, Lynne Margulies. When I visited her in LA, she showed me boxes in her garage of things that she'd held on to—the possessions Andy had at the end of his life: his whole childhood record collection, his transcendental meditation materials, hate mail women sent him when he played a bad-guy sexist wrestler character. But what was immediately very striking—and started the trajectory of my Kaufman projects— is that it really felt like an embodied biography: a story told through objects.

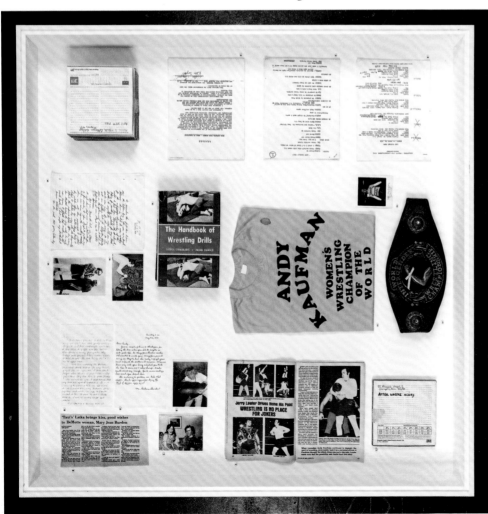

doing *Taxi*; he didn't consider it to be his own work; he did it only because it leveraged the ability to do his projects.

**Lees** And your work is in repositioning that kind of false perception and giving these lesser-known works a more viable space in the history of his kind of practice, is that correct?

**Berger** Yes. I'm trying to make a sort of experimental biography whose format makes space for experiencing Kaufman's life and work, on its own terms; a lot of that means making sure that things don't get resolved in the ways people want to resolve them. It's important to me to create a situation that presents first-hand primary source information, which creates more contradiction and intrigue than resolution.

**Lees** You've been very careful about how to present these objects. Can you describe the way you've transformed their presentation?

**Berger** I wanted to make aggressive juxtapositions. What I ultimately found most fascinating about Kaufman was the combination of seemingly disparate or opposing types of personalities or energies in his life and work. He practised transcendental meditation twice a day for his whole adult life, and was regularly sleeping with prostitutes at a brothel. He sincerely and naively believed that the Howdy Doody puppet on television was real and alive, and then was creating masterfully conceived hoaxes. He was naive and manipulative and spiritual and hypersexual. Many people don't want to accept that you can be all those different personalities wrapped into one, but he really was all of that and was outwardly performing it in his work—jacking up the volume on that kind of complexity of the human experience.

**Lees** Can you also explain who he was to a general audience, and then go into the details that you found through your excavation of these objects?

**Berger** Most people know him as a guest on *Saturday Night Live* or as the character Latka on the show *Taxi*. But Andy hated

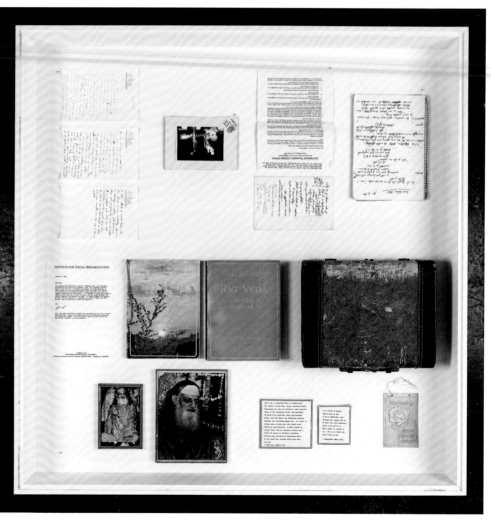

'What I ultimately found most facinating about Kaufman was the combination of seemingly disparate or opposing types of personalities or energies.'

**Lees** Can you also explain how you worked with the guests you invited each day to take part in 'On Creating Reality, by Andy Kaufman', the exhibition that you organized at Maccarone, New York, in 2013?

**Berger** During my research, people I talked to who knew Andy had different stories, different versions of the truth. They were all interesting and all 'true', but also conflicting. So for the exhibition I invited people who'd known Kaufman to sit in the gallery and have conversations with visitors alongside my arrangements of objects from his life. I tried to get as wide a range of people as possible: for example, there were family

members; Prudence Farrow, his transcendental meditation teacher (and Mia Farrow's sister); Dennis Hof, with whom he frequented the brothel that Dennis now owns; Bob Zmuda, his primary collaborator; his girlfriend Lynne; and Little Wendy, his 'little sister' in many of his acts. I liked the idea that the only way you could see the whole show was if you came all day every day. The show was the accumulation of every question, every answer, every conversation, every day.

**Lees** Your work is really embedded in the correspondence you have with these

individuals, so it almost becomes a live enactment of the relationships and correspondence.

**Berger** Yeah. That's a great way of putting it. I save voicemails and text messages, and the way I feel about those messages and what they represent is the way that I feel about the work. So when I want to remind myself about how I want the work to feel, I go back to the nature of the relationship I have with the people I'm working with. Those private messages, which I would never share, hold the emotions that I would want the work to provide for a viewer.

**Lees** How have you introduced the idea of the musical overture into the project for Frieze London?

**Berger** Gregg Sutton, who was the musical director for all of Andy's big performances and the orchestra conductor for *Andy Kaufman Plays Carnegie Hall* (1979), assembled an overture with Andy for the show. Gregg brought me a copy of the score as a present and I was totally fascinated by it. For reasons unknown, the overture was not recorded when the original performance was filmed, so there's no visual or audio documentation of it. As I looked at the sheet music, it became more and more profound. Because an overture is a preview of all the things in a show, and because it's Kaufman, Andy wanted his overture to be a *tour de force* of all his different acts, routines and interests. So it's a combination that includes Mighty Mouse, Elvis and Oklahoma—all things you'd never expect to hear in an overture. This is so quintessentially Andy—a 'greatest hits' of all the things he loved and performed. It's a total document of who he was, what he did, and what he believed in and cared about. It's really the only work you can restage without Kaufman himself— because he just made it up and didn't perform in it. It's stuck in a special space. That's what's so exciting about the Frieze Project—finally we will experience the overture through its restaging.

# Isabel Lewis

Isabel Lewis and Frieze collaborate with ICA, London, Liverpool Biennial and the National Trust to host a series of 'occasions' that play with hosting and composition within the space of social encounters

**Isabel Lewis** (b. 1981, Dominican Republic) is an artist of Dominican and American origin who grew up on a suburban island off the coast of southwestern Florida. She has danced for many choreographers in New York and from 2004 presented commissioned works at The Kitchen, Dance Theater Workshop, New Museum and Movement Research at Judson Church, among others. In 2009, Lewis moved to Berlin, where she spent the next two years working as an editor and DJ, before creating her solo show *STRANGE ACTION* (2010). She draws from her training in literary criticism, dance and choreography, as well as from party and popular culture.

**Nicola Lees** I'd like to start by talking about your time in New York City. You worked with dancer Erika Hand and cellist Chris Lancaster, and made choreographic works for the stage under the name the Labor Union. You also worked as a dancer for several choreographers, including Miguel Gutierrez and Ann Liv Young, as a dance programmer for Dixon Place and the Movement Research Festival, and as an editor and writer for the *Movement Research Performance Journal*.

**Isabel Lewis** Yes, I enjoyed working in the field of dance from many different angles. What's interesting for me about any dance scene is that it generates a community of people invested in bodily research who often come into contact in distinct, tactile ways. At university I studied literary criticism and philosophy alongside dance, so I guess I've always been interested in making experiences for myself that didn't end up on either side of this played-out mind/body divide.

**Lees** Out of all this production you cite *Body Map* (2001) as an important moment for you. Can you explain how this work, which you developed at the age of 20, relates to your current practice?

**Lewis** *Body Map* is a duet I created for a blindfolded dancer (me) and a lighting technician—it's a game of visibility and invisibility. The lighting rig was lowered and suspended just arm's length above my head so that the audience could see it. The lighting technician enacted a score for the dance of the light and I enacted a different score for the dance of the body. The lighting technician was not responsible for lighting me and I was not responsible for making sure I was lit.

I guess I am uneasy with the capture of a stable image on the stage. I was and still am dealing with the 'stage effect', not dissimilar to the 'museum effect', that posits the subject or image as a central point of focus that becomes a discrete object of observation. In *Body Map* I wanted to generate a certain marginality for the dancing body, a body that can be the centre of focus but must not always be

Isabel Lewis
photographed by
Joanna Seitz

‘occasion’, ‘performance’, ‘event’, ‘workshop’, etc.—to be important in terms of informing people's expectations of the piece?

**Lewis** I spend a lot of time thinking about language. For instance, for a month-long residency programme at the New Museum called RE:NEW RE:PLAY, in 2009, I initiated a collaborative project with my sisters and brother (George Lewis Jr, pop musician Twin Shadow), under the name Lewis Forever. When we opened the doors to the public, we consciously employed the term ‘workshop’ so that people would know they were expected to take part in some way. My issue with participatory theatre is that as a viewer you have no idea what's going to happen and you are first put into a state of anxiety and then coerced or pressured into doing something. I think there's also a rather desperate and anxious-sounding aspect to the word ‘workshop’, which begs for your participation. That was one of the reasons I decided to develop the more relaxed notion of the ‘occasion’.

**Lees** Your project for Frieze London will take the form of an occasion. While some of your older pieces can be re-performed, these occasion works can't be, since they are specific not only to a location but to a precise moment in time.

**Lewis** Using the word ‘occasion’ points to the fact that these projects are connected more strongly to the setting, to those present and to their energies than a fixed ‘piece’ would be. A ‘piece’ for me evokes the discreteness of an object, a self-contained and self-sufficient entity that aspires to retain its integrity no matter how or where it is situated. An ‘occasion’ has a temporal and social element in its connotation, it's an entity formed by contingencies that are gathered or arranged for a while. I'm fascinated by how perceptive we are to the behaviours that are expected of us in certain social settings; how the word ‘occasion’ calls for a particular attitude, an openness to interaction and to conversation. So, yes, my work is not only specific to its place and time but also to the guests, to the public that gathers for that particular occasion. I have no fixed idea of how long such an occasion should last either. I am

Isabel Lewis
photographed by
Joanna Seitz

and can also disappear or blend into a situation, like in a social occasion or club.

**Lees** You've mentioned that *STRANGE ACTION* (2010) was also an important moment for you.

**Lewis** Yes. It was the last work I made for a theatre space and the first in which I took up ‘hosting’. It's also the first I made after moving to Berlin. Before the audience entered the theatre, I was already in the space, moving around, greeting people as they came in. In this work I opened up the space by engaging the public socially first, then I moved through a range of performative presences, from addressing the public in a very direct and casual way to playing a character. Since then I've continued to work with this range of presences, working on how to activate the body in different ways and at varying intensities—but inside a social setting, not from the distance of the stage.

**Lees** Do you consider the language used to define a live work—words such as

**Lees** Your occasions conjure the ancient Greek symposium, where philosophizing, drinking and the erotic were inseparable. Each occasion includes a wealth of researched material—you have already mentioned that you will be drawing upon Bennett's notion of 'thing-power'. Perhaps you can elaborate on a detail— 'The Lover's Understanding and Alcibiades' Snake-Bitten Soul'—to give an example of the content that is interwoven between music and dancing?

**Lewis** I refer to a character from Plato's *Symposium* (385–380 BCE), Alcibiades. He arrives at a symposium (basically a drinking party) late in the night and he's drunk and with a band of other drunk people, and on the occasion of this symposium they've been giving lectures on love. They've been making these general and large statements about the true nature of love. And Alcibiades barges in and says, 'I'm going to tell you the truth about love if you will allow me to, but I'm going to tell it from a personal and specific point of view.' Alcibiades tells them about his love for Socrates. In getting to know his love he is developing a type of practical knowledge. It's a specific, particular understanding, what classicist Martha Nussbaum calls 'the lover's understanding'. I really relate to this notion, it seems to be less about 'knowing' in an abstract or general sense, and more about 'knowing how' (or at least making the attempts to learn how) to be responsive and attentive to your lover, or to the particulars of a situation.

**Lees** Over the past few years we have talked at length about how a certain type of movement makes sense in a particular age and is warped each time it is transferred. If you could cite one historical example from this correspondence that relates to the forthcoming project in London, what would it be?

**Lewis** I am interested in social dances, especially contemporary club dancing of all kinds: booty-shaking, jump-step, grinding, raving, etc. I am prone to thinking about our Western *habitus* as a kind of cultural choreography that is learned, habituated, and continues our culture. I wonder, to what degree can we become aware of these sets of intricate and nuanced choreographies that we're performing daily? To what degree can we shape and change them, and what can be learned or gained by doing so? *Habitus* plays a role in the social dances of any era. These dances have a strong relationship to music and are enmeshed and embedded in the everyday.

Dance has existed throughout history as celebration, as ritual, as connected to all of the senses, and it doesn't seem relevant any more to separate movement and music and make them into Modernist forms of their own. I am much more attracted to seeking out experiences that bring the human sensorium back together in all of its sensuality.

**Lees** This autumn you begin a new collaboration with Sissel Tolaas, who you met after you both participated in the Serpentine Gallery Memory Marathon 2012. Can you explain how this relationship has evolved and what it will add to our London occasions?

**Lewis** Sissel's work as a smell researcher is fascinating. She's been doing this work for more than 20 years and her lab in Berlin is stocked from floor to ceiling with small bottles of smell molecules that she's collected and chemically reproduced, from all over the world. I see her project as a political one: she points out that as a culture we are obsessed with sterilization and do everything to suppress and cover up a diversity of smells. We even have a limited vocabulary for smells, in contrast to the visual sense, for example. What will it add to the occasions? Well, smells.

composing it live, so its length and how it unfolds really respond to where it is, who's there, what their energies are.

**Lees** Your first occasions were hosted as part of the Manchester International Festival, and in London this year the idea is to host a series of occasions as the week unfolds, in various locations across London. Can you expand a little more on how this notion has developed over the last year?

**Lewis** For a while now I've been thinking about how to compose in a non-linear way. So, while I might work through certain ideas in a studio beforehand, I only decide how to actually set them in motion during the occasion itself. In order to do this I develop the material into 'content islands' that can link to one another. In general they reflect on how, as humans, we might respond to the situations—environmental, political, ethical—that we will have to face as we move further into the 21st century. I am less interested in the human subjectivity that dominated 20th-century thought than in exploring the human sensibility that can be responsive to other kinds of presences, such as those of objects and animals. I draw on political theorist Jane Bennett's notion of 'thing-power' amongst others, which questions the belief in the importance of our own subjectivity and proposes taking up a more humble relation to all presences, human and otherwise.

# Tobias Madison

For his first solo project in the UK Tobias Madison constructs an experimental environment that interacts with the visitors' presence

**Tobias Madison** (b. 1985, Switzerland) lives and works in Zurich, Switzerland. He uses video, text and installation as tools for continuous recording, distribution and thinking. So far, his career has been defined by a collaborative practice, in projects for the Hepworth Wakefield, Leeds, and The Power Station, Dallas, with artists Emanuel Rossetti and Stefan Tcherepnin. Madison has had solo showings at Kunsthalle Zurich (2013) and in the 2013 Carnegie International.

**Nicola Lees** Collaborative practice has such an influence on the way that artists think and produce work, but it's quite rare for the nature of the collaborations themselves to continue to evolve. Could you talk about your work with Emanuel Rossetti and Stefan Tcherepnin?

**Tobias Madison** Personally, I am interested in forms of collaborative practice that deny a certain market logic—in which things are shifting around and moving smoothly from one context to another. I was interested in a situation where artists physically occupy space, so that the artistry is revealed by the way that you develop the project there. This becomes quite self-contradictory just because of the multitude of tongues that speak within the space. *Drip Event* (2013) at The Power Station in Dallas is a really good example of that. If you talk to Emanuel or to Stefan or to me about this project it means something completely different to each one of us, but it was united under this catastrophe that took place in the space.

*Drip Event*
2013
Installation view at
The Power Station,
Dallas
Courtesy of Galerie
Francesca Pia

**Lees** As with several of your collaborations, there was a musical element to the concept of *Drip Event*?

**Madison** Stefan, who is a composer, unified the project under the approach of music rather than art: the project attempted to create a kind of spatial music piece, based on an orchestrated score. There were automated parts of the installation that would move with a certain frequency. For example, the second storey of the building was flooded with water once a week, which would then drip down to the lower part of the installation, becoming a sound piece as it fell into the metal pans that were laid out to catch the drips, as well as falling into the water-based works, off which it then evaporated. But it was also unified by the movements of visitors and workers' hours in the institution.

**Lees** For Frieze you are creating a form of backstage zone within the context of the art fair. Can you expand a bit on how it will be constructed within the fair and how you will develop its staging?

**Madison** From my experience of fairs they are already spaces of sensory overload. It's a paralyzing, alienating kind of experience to see so many artists and people you know and so on. The project that I want to show is a form of theatre, essentially. The booth will be built closed, as something that is not accessible, but we will remove a section of wall. I want it to seem like you've entered something from the wrong side: a place that you could see from the wrong angle. Like Michael Asher's *Project* (1970) at Pomona College, where the front door to the exhibition space was left open to the elements and the architecture was narrowed inside the space. Wind and leaves, just nature, could be left in the gallery: creating a sense of peace, I guess.

**Lees** So this is a kind of curative space that you want to create for Frieze London?

**Madison** I think of the fair as a kind of mesh of different economic vectors that come together; all these different kinds of transactions. I want to make a counter-vector that breaks with that. An art fair is

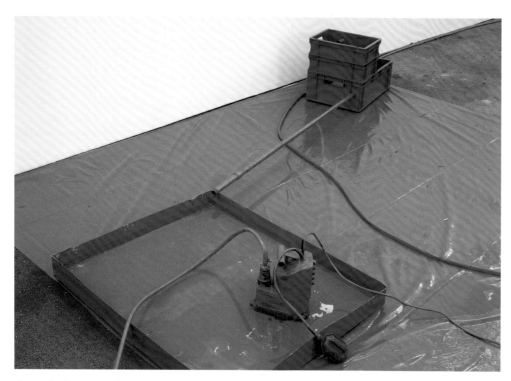

the culmination of a certain continuity: content turned into value, turned into transaction. It's a very smooth social sphere, and I want to create some kind of discontinuity within that. I'm planning to stage a play that runs on its own, using a system of pumps and air humidifiers that distribute iodine within the space. It's essentially going to be a remake of *Frankenstein*, as it was performed by the Living Theatre in the 1960s. *Frankenstein* only has one main character: the monster. There's the doctor, various helpers, the bodies that are being harvested—but essentially it's about the sensation of something coming to life. You could think of the room itself as being the monster and you will get a glimpse of the organs that run this monster. But when you enter, your part will be one of certain anti-bodies in the system of that monster, which will have an effect on how this monster functions.

**Lees** How does the visitor have an effect?

**Madison** The play happens when no one is in the space; at the moment when someone enters the space, a defence mechanism triggered by a sensor starts to produce a fog. This communicates to the visitor that they will have to leave before it becomes too toxic. But for that short amount of time that you're in there, you can observe the running of the pumps, the score that explains how the play works. It creates a stage in which mechanical and biological systems coexist, but it also tells you to leave at that time. It's a disappointment zone.

**Lees** You have used the term 'disappointment' on a number of occasions. In this case, does the disappointment refer to the relationship between technology and the body?

**Madison** I have a strong belief in art that is a continuous declaration of autonomy from all oppressing forces. Now we are exposed to such high degrees of visuality that everything becomes spectacular, including our smooth-running social lives. But I think that in this context disappointment starts to become a very interesting choice; it becomes something that breaks with that continuity. And I think that visual disappointment, all of a sudden, especially in an art fair, becomes a very autonomous position, and also one that opens possibilities for a different way of looking at things.

**Lees** I'm particularly interested in your relationship with iodine as a material. For me it's a pharmakon because in one sense it's a remedy but it's also quite well known as a poisonous substance. Can you explain more about why you're currently using iodine as a prominent material in your work and your ideas about its healing qualities?

**Madison** If the art exhibition space has become the physical extension of a variety of networks, then I want to create

Above:
*The Living Theatre of Death*
2013
with Flavio Merlo
Mixed media
Installation view at
Supportico Lopez, Berlin
Courtesy of Galerie
Francesca Pia

Opposite:
*NO; NO; NO; NO; NO; NO; NO; NO; NO; NO*
2013
with Emanuel Rossetti
Cardboard, light bulbs
Installation view at
Kunsthalle Zurich
Courtesy of Galerie
Francesca Pia

Below:
*The Lurking Fear*
2014
Digital collage

# 'The play that I'm inventing for Frieze is something to heal the visitor from this condition of the art fair.'

something that is devoid of those networks and devoid of all the humans that operate them. Iodine is a way of cleansing and at the same time killing everything that exists in a space. I'm thinking about creating an experience that heals: the space, the visitors, art in general. I also wanted to invent a healing process that actually is, on a theoretical and a practical level, able to heal the visitors' minds. For an artist, art fairs are systemically sickening. So the play that I'm inventing for Frieze is something to heal the visitor from this condition of the art fair.

**Lees** I'm reminded of *Safe* (1995), the thriller starring Julianne Moore, directed by Todd Haynes. It's about a character who starts to react to chemicals and everyday household products due to her psychological state, and has to go and live in a retreat community. It seems to have an interesting relationship with the culture of the time—a very paranoid obsession with cleanliness that's almost destroying our immune systems.

**Madison** It's an amazing film. Very clinical, with low-velocity shots. I watched it a year ago, so I guess it was really influential then.

**Lees** The cancellation or break in events also relates to *Relâche* [the 1924 ballet directed by Francis Picabia with music by Erik Satie, notoriously and confusingly cancelled on the night of its première], which you have also been thinking about.

**Madison** *Relâche* exists in two different versions. The first evening in 1924 was cancelled, triggering uproar from the disappointed visitors, of whom some then came to see the play a week later. Sturtevant's *Relâche* in 1967 triggered a play of social interactions between people: there, the play was whatever resulted from that cancellation, exposing a way more specific crowd, a certain élite of art-world professionals—Duchamp just stopped in a cab, smiled and left again. The art fair as a type of theatre is one of professionals meeting, where it doesn't matter if the play happens or not. I think of the piece I'm going to make in

London as being a cancellation of all social activity within the space. I've been thinking a lot about Raymond Roussel's *Locus Solus* (1914), which is important because of its description of marvels. Roussel famously found a gap within the system of language—

a technique that would turn language almost into a machine that would continuously invent marvellous fairy tales. His logic of the mechanical in language is as important to me as what he describes. What you will see in the *Frankenstein* installation will be a series of mechanical operations, but it's actually the reverse of *Locus Solus*. You will see mechanical devices that are supposed to trigger the wonder in you.

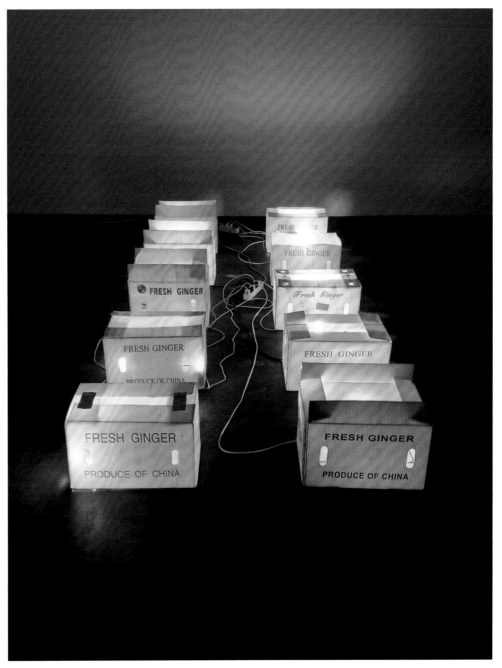

# Nick Mauss

Nick Mauss constructs a 'living stage' on which a ballet is presented each day by dancers and a choreographer from Northern Ballet, intertwining with performances by Kim Gordon and Juliana Huxtable

**Nick Mauss** (b. 1980, USA) lives in New York and works at the interstices of different media. He is a graduate of Cooper Union and teaches in the MFA programme at Bard College, New York. Mauss has had recent solo exhibitions at: Indipendenza Studio, Rome; Midway Contemporary Art, Minneapolis; 303 Gallery, New York; and MD72, Berlin. His work has been exhibited at institutions including: MoMA, New York; Walker Art Center, Minneapolis; and Artists Space, New York. He was included in the 2012 Whitney Biennial and his writing has been published in *Artforum*, *MAY*, *Peep Hole* and *MAP*.

**Nicola Lees** In its theatricalization of the viewer's experience of the exhibition space, your work for the 2012 Whitney Biennial, *Concern, Crush, Desire*— an installation based on the velvet and appliqué antechamber to the French perfumer Guerlain's first Institut de Beauté, which opened in Paris in 1939— has much in common with the project you are planning for Frieze London. Can you tell me what the genesis of that piece was?

**Nick Mauss** It emerged from two sides: on the one hand, from the impulse to articulate different, often collaborative and transhistorical, exhibition formats; and on the other, through a circuitous process of encounter with the traces left by Christian Bérard, an artist now best remembered—if at all—for his covers and illustrations for *Vogue* and his scenography for Jean Cocteau's *Beauty and the Beast* (1946).

In trying to trace particular modes of painting I was interested in, I kept on finding Bérard in the proximity of artists and events to which I was drawn. Suddenly, his lyrically neurotic signature seemed to connect all these disciplines and I a sensed a widespread, somehow submerged, influence emanating from his dispersed touch. After visiting the antechamber Bérard designed, this enlarged, penetrable 'sketch' (*étude*) kept playing in my mind and became something of a filter through which I could work and see differently. I installed my reiteration of this space in the Whitney as an architectural counter-memory, a space that literalized this threshold experience I described, and that functioned as many things at once: an interruption, a drawing, a theatrical set, a frame for other works and sensations, or even a maquette into which visitors felt themselves suddenly collaged.

**Lees** In *By, With, To & From* (2014), a new commission for the Fiorucci Art Trust in London, you introduced slow-moving, automated curtains to reconfigure the space, instantly evoking an on-stage/off-stage dynamic. Are you planning to employ curtains in a similar way for your project for Frieze?

**Mauss** The first presentation of these serpentine curtains reacted directly to the domestic situation they were designed to intercept and also inflate with a sense of overblown drama—someone described their movements as indifferent to, or 'despite', the viewer. Curtains, drapes and folds have a strangely evocative presence, the way they self-describe. Sonia Delaunay lived with a curtain hanging over her window that had been 'autographed' by her friend the poet

close, they suggest other ways of moving in the space, and they flip the point of view: which side of the curtain are we on?

**Lees** In terms of the choreography for your project, I know you have an interest in the Ballets Russes—particularly Bronislava Nijinska's *Les Biches* (1924).

**Mauss** The Ballets Russes is a very opulent precedent, almost impossible to follow, full of examples of a kind of self-reflexive ballet, in which the dancers themselves might move and alter the scenography while dancing, or where the audience is practically blinded —Throbbing Gristle-style— by a décor made of hundreds of light bulbs and reflectors.

*Les Biches* revolves around a group of women gossiping and flirting at a salon. While they don't actually speak, their movements are animated and conversational: dancing together in small groups before dispersing again, suggesting all kinds of interpersonal dynamics and implications. I love the casual, almost banal gestures encoded in the highly mannered language of ballet, which summons for me, as if in a holographic overlay, the kind of attention to movement and gesture you see in minimalist dance.

Philippe Soupault with a poem about the curtain and the wind that moves it. In Jean Genet's novel *Our Lady of the Flowers* (1943), curtains reappear throughout, and the folds of their fabric are made to absorb and project varying echoes, memories, fears, even a type of violence. The first instance that struck me refers to them as devices that absorb death and the barking of dogs.

**Lees** The curtains in *Our Lady of the Flowers* are also strangely self-possessed. Will the curtains in your project for Frieze London take an active role in terms of fragmenting the space?

**Mauss** In the exploded ballet head-space I have in mind for Frieze, I want them to function as performers, because they do have their own timing and their own relationship to choreography. I thought initially of a sculpture whose relationship to an audience is constantly shifting, an experience that indirectly triggers spontaneous gestures, or the possibility of role reversal … to think of an experience as recto/verso. The moving curtain walls delineate new volumes as they open and

**Lees** Can you tell me about the costumes you've designed for the dancers?

**Mauss** In many stagings of *Les Biches*, the ballerinas all wear strings of pearls and gloves, and hold cigarettes, and there is a subversive, almost caricatured depiction of gender roles. I'm thinking of props that double as leisurely actions, like gloves made by brushing latex directly onto the dancers' hands, which they can peel off and leave in shreds on stage at the end of each performance; various headgear, e-cigarettes. In some way each element of this piece, everything that constitutes a ballet, including the hidden preparations, is on the same plane as the dance itself. I would love it if this ballet, including the various moments 'before' and 'after' it, could be seen in a constant state of 'becoming'. I will paint directly on the dancers' bodies, and appliqué onto jersey bodysuits, a new design, a new scheme, for each performance, so that the costuming and maquillage are also 'live'.

**Lees** One of the triggers for your integrated approach to mixing dance, props and costumes was inspired, I believe, by a visit to the archives of the Walker Art Center to view the Merce Cunningham Dance Company Collection.

**Mauss** Abigail Sebaly, the collection's archivist, invited me to look at some of the objects in the collection just at the beginning of the cataloguing process. They were in the Walker's storage, surrounded by painting racks and flat files—it was very much 'backstage'—we looked at rollerskates, an umbrella lined with Christmas lights, stubs of face paint in Ziploc bags, masses of parachute silk, a knitted turtleneck sweater with five arms; and carefully folded costumes, painted and printed by Rauschenberg, laid between sheets of tissue paper in baby-blue archival boxes. The sense of each object flickering between its former fantastical function and artefact or reliquary status was very moving.

**Lees** Taking from Cunningham the collaborative approach with Johns and Rauschenberg, you are going to be working on this project with artist–musicians Kim Gordon and Juliana Huxtable, as well as with the choreographer Kenneth Tindall from Northern Ballet.

**Mauss** My approach to such a complex collaboration is to interleave my various interests, and to play off certain traces and blind spots to create an inter-textual experience. So yes, there is the idea of indeterminacy, and an open-ended process in which each protagonist contributes while also reacting to the others. I just realized that none of the collaborators I've invited to work on this ballet have ever met, or ever worked together before. Kim and Juliana are each writing new texts to perform, with musical improvisation, over the movements of the dancers, while Ken will be choreographing a classical ballet. What I'm really hoping is that, out of the contrast between the formal language of the ballet and the direct speech of Kim and Juliana, an unexpected third element will emerge. I often begin somewhere— with a text, for example—and become consumed in the process of spinning away from it, where the text dissolves and the margins remain.

*Simultaneous 1*
2014
Coloured pencil and marker on paper

**Lees** You seem to be fascinated by these transitional moments. In the films Charles Atlas made about Cunningham's works, on-stage performance coexists alongside off-stage documentary, creating a tension between fiction and reality. Is that something you've been thinking about in relation to your project?

**Mauss** Kim said something I really liked, about her collaborative performances with Jutta Koether: she said they treat each performance as if it's a rehearsal for the next performance. There's an element of that in this project: states of rehearsal, performance, repose, even boredom, are stretched out into a continuity, every day. So there will be constant movement, even if very slow, or slight, and not 'spectacular': dancers in make-up, Kim speaking, or improvising, Juliana passing the time on a chaise-longue. I see this project, too, as a penetrable sketch, where many elements are held in suspension. But the slightest gesture can shatter everything. I'm hoping this work will illuminate those moments when the performance unravels; and that, even when the music, text and dance are all perfectly in sync, there will be something else happening outside of the frame of the stage that is still visible to the audience. That's what I'd really love to see: every element of the performance and everything on the periphery all acting at the same time.

'I see this project as a penetrable sketch, where many elements are held in suspension.'

# Cerith Wyn Evans

Off-site from the fair, Cerith Wyn Evans locates a new work and performance in the heart of ZSL London Zoo

**Cerith Wyn Evans** (b. 1958, UK) was born in Wales. His conceptual practice incorporates a range of media, including sculpture, film, photography and text. He has participated in numerous exhibitions internationally, including the Venice Biennale (2013, 2003 and 1995) and Documenta 11 (2002). He began his career as a filmmaker, making his own short experimental films throughout the 1980s. Since the 1990s his work has focused on language and perception in relation to the context of the exhibition site or its history.

**Nicola Lees** When we first met to discuss the possibility of a Frieze Project, we ended up focusing on your interest in artists, and particularly your interest in artists who work with animals. You referenced a number of examples, some of which we will discuss later on, and it was this initial correspondence about the zoo as a certain taxonomy or museum that sparked a desire to install a piece of your work in one of the animal houses at London Zoo. Can you expand a bit more on what it is about the zoo that particularly interests you?

**Cerith Wyn Evans** I've been to London Zoo so many times over the years but, no matter how often I visit, I'm always taken by surprise. Much as when I go to the British Museum or Kew Gardens, I usually have no particular aim in mind because invariably I come across something new and surprising. The zoo also affords you the opportunity to watch other people watching, to observe at a remove. In this sense, I'm interested in the correlations between zoos and museums as well as in how those mutualities might negate each other or facilitate dialogue.

I suppose there's a rather maudlin aspect to zoos, as well: the fact that these poor creatures are locked in there purportedly for their own preservation and safety—which have largely been endangered as a direct consequence of the selfish actions of humans—but, ultimately, for our future diversion. Zoos are rich territory on all sorts of levels: think of the stories that abound around the idea of animals escaping from zoos, fantasies of lions running amok in Selfridges department store in London—a familiar trope from children's books.

**Lees** When Pascale Berthier and I visited London Zoo to begin this process, you were unable to join us, as you were in Japan at the time. You managed to be with us in spirit by mirroring our movements in visiting the zoo in Tokyo. Have you visited other zoos?

**Wyn Evans** Well, London Zoo is undoubtedly the most familiar, but Chapultepec Zoo in Mexico City is exciting, they've been very successful with breeding giant pandas. As you mention, I recently went to the Ueno Park Zoo in Tokyo during cherry blossom time, when the park becomes a magnet for visitors wanting to participate in this gorgeous and culturally significant spectacle. Despite it being a busy bank holiday weekend, the exhibit of native Japanese birds was practically deserted—since none of the visitors wanted to spend time looking at creatures they could see on the balconies of their own apartments—so I had it almost entirely to myself. Most of the photographs I took on that trip were of these rather quiet, lowly species ('Species of Spaces' by Georges Perec, 1974). It was rather an odd experience to see the same kinds of birds flying freely around the park as were caged in the zoo.

**Lees** We also discussed Chris Dercon's 'Theatergarden Bestiarium' (Institute for Contemporary Art, P.S.1, 1989) as an example of a previous exhibition that

Snowdon Aviary at
ZSL London Zoo
Constructed 1962–4
Architects: Antony
Armstrong-Jones (Lord
Snowdon), Cedric Price
and Frank Newby

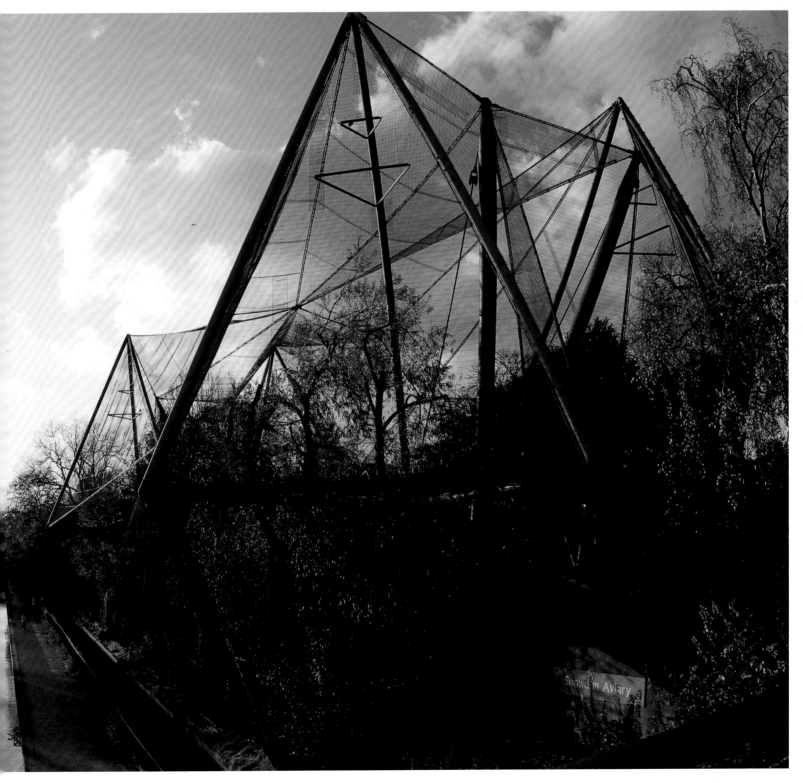

# 'I'd like the animals from London Zoo to get at least as much out of my intervention as human visitors hopefully will.'

pointed to the way that artists have always been attracted to the theatrical, and if we move from the garden to the zoo this at times goes even further towards a 'Disneyfication'.

**Wyn Evans** 'Disneyfication' the word just always makes me think of cryogenic suspension, Walt on ice…. In connection to 'Theatergarden', yes I think there's a high level of artifice and staging in zoos. Despite the attempts made in recent years to promote a more three-dimensional visitor experience—aquariums with walk-through tunnels, for example—for the most part, the cages or architectural elements that frame the animals face the visitor head-on, while behind them are 'backstage' areas where the creatures can sleep. My father, Sulwyn Evans, a keen amateur photographer, was alive to the theatre of the zoo. He took a number of

photographs at zoos, some of which I return to from time to time. The works of his that I find most affecting are those in which the main action takes place beyond the frame. For instance, he did a series of photographs of people watching animals being fed. You don't get to see the animals, just the reactions on the people's faces.

**Lees** London Zoo is not only the oldest scientific zoo in the world, it is also the site of many of the UK's earliest Modernist buildings. Some of these stunning examples are the beautiful Hugh Casson-designed Elephant and Rhino House (1962–5), whose building exterior was hand chiselled to create a texture similar to the animal skin, while its aerial view presents a group of elephants drinking from a watering hole. In addition to the Elephant and Rhino House, there's the Snowdon Aviary. Designed by Antony Armstrong-Jones, 1st Earl of Snowdon, Frank Newby and Cedric Price, this 1964 structure was Price's first commission as an independent architect and due to it

being sited on the only protected view/sight-line in the city—it can still be seen all the way from Primrose Hill as well as Regents Canal and Regents Park—it is the most public location in the zoo.

**Wyn Evans** I find the whole concept of zoo architecture fascinating: the challenge not only of re-creating the diverse range of natural habitats of the various genera, but subsequently naturalizing them in these staged environments. London Zoo is fantastic in terms of architecture. Price's masterpiece is a series of interconnecting chambers that change shape according to various environmental factors, such as wind force and direction, thereby allowing the aviary to more closely articulate interior and exterior space.

**Lees** Since many of the enclosures at London Zoo are buildings of architectural significance, they can't be demolished—even when they are no longer considered suitable for housing animals. Two of the first Modernist buildings in London were the Berthold Lubetkin-designed Round House (1933) and Penguin Pool (1934): the former, intended to home gorillas, now plays host to bats; while the latter lies empty, the penguins having demonstrated a preference for the duck pond to which they had been temporarily relocated ten years ago during the pool's refurbishment—before they were all rehoused on Penguin Beach. I remember reading that the main reason the penguins didn't like the original enclosure was because the height of the walls meant they couldn't see the horizon.

**Wyn Evans** Maybe it wasn't particularly good or liked by the penguins, but it was a fine piece of architecture! Elegant and playful, with its intertwining helical slides, now it's little more than a ghost ship, a white elephant! I wonder, what will happen to it? It's an interesting question.

**Lees** For an exhibition at Galerie Neu in Berlin ('Cerith Wyn Evans', 2000) you worked with a local circus, and one of their camels made a brief appearance at the gallery the day before the opening. This nodded to a famous story of Marcel Broodthaers entering the Palais des Beaux-Arts in 1974 with a camel from the Antwerp Zoo…

**Wyn Evans** Yes, animals and art. The work of Braco Dimitrijević—one of the pioneers of Conceptualism and an artist I've long admired—interrogates cultural, social and political hierarchies in relation to the elements of chance that determine who or what become famous or influential. I have a book that documents an exhibition Dimitrijević held in a zoo in which he installed artworks he'd made growing up alongside the caged animals. So, a painting he'd done as a child would be hung on the wall of a lion's den, the creature seemingly unaware of the intervention. It made me think of Barnett Newman's potentially inflammatory declaration: 'Aesthetics is for the artist as ornithology is for the birds.' It's a statement I certainly don't disagree with: it's just a succinct way of making the point that there are multiple levels of taxonomies.

**Lees** You mentioned that the work of Italian artist Gino De Dominicis, likewise informed your project.

**Wyn Evans** In 1975, De Dominicis installed a show called 'Exhibition for Animals Only' at the Lucrezia De Domizio Gallery in Pescara. In an absurdist inversion of the societal mores that hold culture as pre-eminent and symbolic of high worth, the artist decreed that only animals would be allowed to view it. The artist appears to have requested that the exhibition should not be documented, so the only archival image of the show depicts the hindquarters of a cow and a chicken as they enter the gallery to attend the private view. The piece conjures all sorts of creative possibilities as to what the exhibition might have comprised, or whether there perhaps weren't any art works on display at all. Zoos seem to act as the key to us unlocking doors to the imagination: it's a very fertile space.

**Lees** I know that you also love Andreas Slominski's *Anfeuchten der Briefmarke* (Moistening the Stamp, 1997), shown at the Skulptur Projekte Münster, in which the artist coaxed a giraffe to lick a postage stamp, which was then put on a letter and sent to someone.

**Wyn Evans** I remember being really jealous of that piece when I heard about it. There is an almost baroque, Raymond Roussel-like quality to the fact that Slominski went to such extraordinary lengths to make such a simple gesture. It was not merely absurd; it was also somehow loving and tender. There's something very admirable about that piece and, at times, I use it as a benchmark in relation to my own work. How did Marcel Duchamp describe Roussel? As 'he who pointed the way'.

**Lees** And finally, what would you like the animals at London Zoo to get out of your project?

**Wyn Evans** I keep a couple of pet budgerigars and, when the weather's nice, I hang their cage in the garden so that they can talk to the wild birds in call and response. Staging a correspondence between inside and outside, both variously captive. The birds are stimulated by novelty, and I'd like the animals from London Zoo to get at least as much out of my intervention as the human visitors hopefully will.

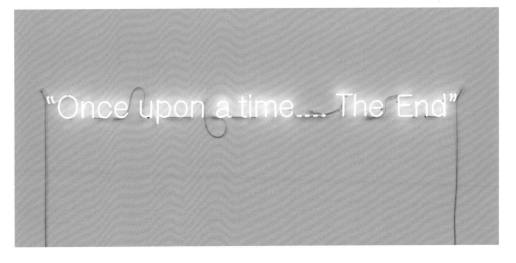

# Frieze Artist Award: Mélanie Matranga

Mélanie Matranga explores the confluence of emotional and monetary trade economies through a series of online videos shot in a café designed for the use of visitors to the fair

Opposite:
*Europe, Europe*
2014
Ink on paper
29.7 × 42 cm
11¾" × 16½"

Right:
*Overreacted*
2014
Knoll chair frame,
silicone, polyester resin
Dimensions variable

**Nicola Lees** Let me begin by asking about how you see your own work—holistically, as a practice?

**Mélanie Matranga** I always try to find a way to speak as a person, and I always think about the representation of the self in art. But you can represent yourself as an artist through the relationships you have or through the statements you make, your feelings, your understanding of economies and the way things are. So I'm interested in mixing all these values, and representing them somehow.

**Lees** How does this come through in your contributions, say, to 'The Issues of Our Time', the exhibition arranged by Paris project space castillo/corrales in 2013?

**Matranga** 'The Issues of Our Time' is very close to my practice, because of its focus on post-Romantic value in art. It was not really an exhibition; it was more like a set for a couple of events. I made two chairs with fake coffee and coffee cups on their surface, using silicone, and they were kind of waiting-room chairs, because this material is very wet and not solid. I was thinking Benjamin Thorel and Thomas Boutoux, part of the collective who run castillo/corrales, could sit on them during the talks. I also made a carpet with cables under it (which gave the floor a sculptural quality), for people to sit on to watch the film.

**Lees** I'm really interested in your use of cables, because cables are such a familiar sight at exhibitions—you can almost read an exhibition by the way the cables have been handled. In museums they're always immaculately installed—all the cables are in straight lines or are made invisible—whereas in your work they're almost like creatures. They affect the carpet in a sculptural way, and don't necessarily even connect to anything.

**Matranga** All the materials we use hold feelings. Like all the tension before an exhibition. These elements are more important than an object to me. In the film and café I'm making for Frieze Projects everything, even the café itself, becomes a character. Our way of life is becoming like a real image: with the Internet and social networks people are performing their own lives, making their usual environment the set of their own show.

**Lees** You also work with clay sometimes, in quite an instinctive fashion.

**Matranga** I like this method of self-representation with the hands. With clay, they are always wet, never dry … the works are so very fragile and very breakable, and if you touch them, you transform them. And that's why I also do animation, because it's never a fixed form, it's more a gesture.

**Lees** I was particularly interested in the sofas that you made for those exhibitions.

**Mélanie Matranga** (b. 1985, France) is based in Paris. She has previously employed animation, sculpture and installation to create environments that communicate the emotional value of their production and economy. She graduated from the École nationale supérieure des Beaux-Arts in 2011 and has exhibited internationally at: Bodega, Philadelphia (2011); BETC, Nuit Blanche, Paris (2012); and Tripod, Nantes (2014). Recently, Matranga was included in castillo/corrales's group exhibition 'The Issues of Our Time', Paris (2013), which travelled to Artists Space, New York (2014). She is nominated for the Prize Fondation d'entreprise Ricard/Art Contemporain 2014.

**Matranga** The sofa that I made for Artists Space was placed outside, and the fabric was fixed with resin and glue, so it was very solid. It became a social sculpture, where people could sit or have a cigarette. I like it when the work needs people. If nobody sits on the sofa, it's not really interesting.

**Lees** It's kind of a living economy, and the work has to be alive to create the right atmosphere for it to work.

**Matranga** Yes. Now we really have economic behaviour. Capitalism now is not only a concept, it's a lifestyle. In a way I like that, as I am interested in making a concept that is close to a way of life.

**Lees** At Frieze Projects your idea is that the construction of an environment, a functioning café at the fair, will also be the set for the film. And the film will also be a drama, scenarios involving two main actors who are in a relationship. Is this the first time your films and installations have come together?

**Matranga** Yes, I've been looking for a way to combine making film and installation, and here I can include the process and the feeling, the construction and the tension.

**Lees** Building the set becomes part of the film, and then the film somehow generates another language that also alters the space.

**Matranga** It's a really simple analogy—that creating a relationship is the same thing as building a house or painting a room—but it's more like extracts from a relationship between two people who are trying to think about how they can represent themselves in a particular society. They're trying to build more than a relationship, they're trying to build themselves, they're trying to exist.

**Lees** So let's start at the beginning, the first episode.

**Matranga** It will be shot at the real beginning of the building of the fair, when there is just a tent. It starts in the morning. They are in bed, and the

Above:
*White Noise*
2014
Couch, fabric, polyester resin
Dimensions variable
Courtesy of New York City

Opposite:
*Handmade Situation*
2014
Non-drying paste
Dimensions variable

# 'Creating a relationship is the same thing as building a house or painting a room.'

character Jeanne is kind of stressed and depressed. She is thinking about a dinner that will take place in the second episode, and her partner isn't taking it seriously.

To me it was interesting to mix fiction and reality, and so the fiction becomes more realistic, and the reality becomes more fictional.

**Lees** You're also using the language of coffee in the film.

**Matranga** Yes, because you know in New York or here we always get asked: 'Do you want milk, sugar, to stay, to go?' This sentence is amusing, because between this couple it's used as a lovers' language, but it's also a very commercial, formal, impersonal language. So for me it was humorous to take this formula and use it as a secret language between them throughout the three episodes.

**Lees** The film will be going out in an email newsletter—quite short, three- to five-minute episodes—which will be sent out during the fair. So there is a relationship with real time in your editing process.

How do you imagine the space will change when it becomes less of a set and more of a social space, which can be used by people at the fair, the galleries, the general public and the professional public?

**Matranga** I think it will be obvious that it's a set, because it's going to feel really handmade and temporary. I really want to create an intimate space, because a lot of my friends are going to come, and we are all going to run the café.

**Lees** It's very interesting when artists and writers make their own lives part of the subject of their work. Perhaps you could talk a bit about your influences?

**Matranga** Joan Didion always talks about herself, but through others. In her essay 'On Keeping a Notebook' (1966) she realizes that in her notebook there are only notes about other people, because she is a journalist. The subject is always other people's situations, but she writes about how we describe ourselves through others.

In *The Year of Magical Thinking* (2005) she talks about the death of her husband, and her mourning—but through all the conversations with nurses at the hospital, through the letters that arrive for him after he has died. She never talks about all those feelings which occur in such a dramatic context. She talks about the bureaucracy, and through that you can feel a lot of love and sadness.

I also admire Frederick Wiseman, and his documentaries about American institutions. The subject is always the function of the institution, but he shows the human ambiguities, distresses and joys.

**Lees** You watch a lot of films, and your partner is a filmmaker, so talking about film is part of your everyday life. You've mentioned the importance of John Cassavetes to your thinking.

**Matranga** For me, Cassavetes is most important because he keeps his attention on his characters with a long lens. I'm really interested in the way he mixes in his own life, too. *Opening Night* (1977) is basically his own life, as he was directing his wife, Gena Rowlands. There's this scene where she turns up drunk, and he helps her get through her lines. It's really beautiful.

**Lees** You've also mentioned Marguerite Yourcenar's novel *L'Œuvre au noir* (The Abyss, 1968).

**Matranga** I love the way she writes. She suggests that time and historical period don't matter, finally, because her subject is the way humans interact. You always have jealousy, possessiveness. *L'Œuvre au noir* is about an alchemist who attempts to solve the problems of his society in the 16th century. At the end he is imprisoned and he realizes his task is impossible. Even if you look for a better life, you always have to deal with yourself in relation to others.

**Lees** It almost comes back to what you were saying earlier, that you're always trying to think about how to speak 'as a person'.

**Matranga** Yes. We all say 'I', but 'I' is just a language system we use. Every generation thinks it will be more authentic and singular, and new and creative, but finally we all use systems to exist, and ultimately it is just a system.

# Frieze Dance: Jérôme Bel

In partnership with Dance Umbrella,
Jérôme Bel presents his acclaimed
*Disabled Theatre* for the first time to
UK audiences

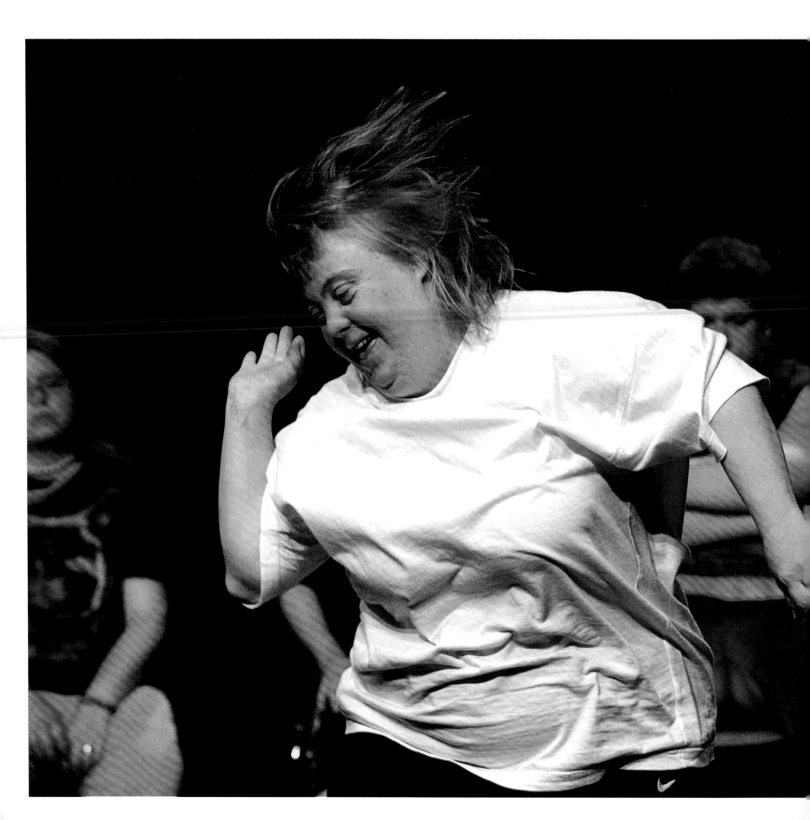

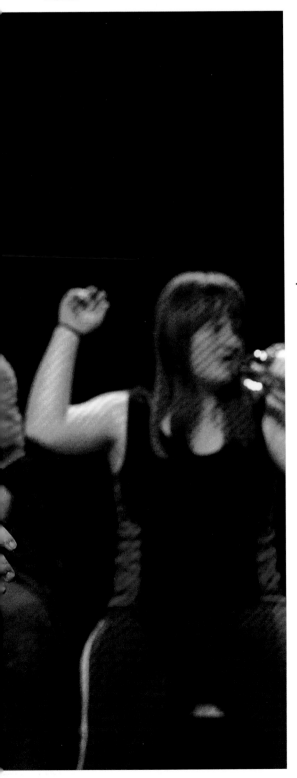

*Disabled Theatre*
2012
Performance by Theater
HORA

acknowledging these individual moments of exclusion can dismantle larger forces of institutionalized marginalization, by creating a national community of shared vulnerability rather than one that perceives difference as threat.

Kristeva's letter served as a catalyst in moving France's political approach to disability away from a medical basis towards a social and civic model rooted in individual experiences of equality and inclusiveness. The resultant legislation—Act No. 2005–102, of 11 February 2005, *Equal Rights and Opportunities, Participation and Citizenship of People With Disabilities*—meant major advances in access to education, training and employment. However, as Kristeva made clear from the start, a holistic transformation of attitudes must be continually carried out at a personal, individual level, difficult to access through legal processes. Débuting nearly a decade after Kristeva's letter, French choreographer Jérôme Bel's *Disabled Theatre* (2012) disarmingly enacts exactly the kinds of live encounter between disabled and non-disabled individuals that Kristeva suggests are key to the negotiation of a mutually responsible society.

As a choreographer, Bel often understands everyday behaviours and social interactions as important forms of performance, given that his overarching project is to interrogate and often puncture the established framework of performance as artifice.

In collaborating with Theater HORA (a Swiss theatre company committed to the artistic expression of professional actors with disabilities, including Down's Syndrome), Bel sees the opportunity to work with actors whose practices present alternatives to theatrical conventions based on the construction of character and the suspension of disbelief. He has remarked that, more than other professional performers he has worked with, the actors of Theater HORA are willing to appear on stage as themselves, an important tenet of Bel's practice.

**Jérôme Bel** (b. 1964, France) lives in Paris and works worldwide. His projects include: *Nom donné par l'auteur* (1994), a choreography of objects; *Jérôme Bel* (1995), a project based on the total nudity of the performers; *The Show Must Go On* (2001), bringing together 20 performers, 19 pop songs and one DJ; *Véronique Doisneau* (2004), a solo inspired by the dancer from the Paris Opéra, and its Brazilian version, *Isabel Torres* (2005), for the ballet of the Teatro Municipal of Rio de Janeiro; and *Cour d'Honneur,* presented at the Festival d'Avignon 2013.

Following her appointment by Jacques Chirac as head of the French National Council on Disability in 2002, the writer and philosopher Julia Kristeva was asked to produce a report on the current situation for people with disabilities in France. Kristeva responded with a public document entitled *Letter to the President of the Republic on Citizens With Disabilities: For the Use of Those With Disabilities and Those Without* (2003), which describes the problem of the 'excluding meeting' between a disabled person and non-disabled person, in which feelings of anxiety and shame produce experiences of alienation and dehumanization for both. Kristeva suggests that

*Disabled Theatre*
2012
Performance by Theater
HORA

'The performer is the heart of my theatre,' he noted in an interview with Marcel Bugiel last year. 'He or she must appear on the stage as an artist, worker, citizen, subject and individual in his or her most absolute uniqueness.'

Bel has explored the laying bare of individual experience through the use of direct-address monologue before, specifically in *Véronique Doisneau* (2004), where a *sujet* of the Ballet de l'Opéra de Paris intimately describes an inner life necessarily concealed by her profession. In *Disabled Theatre*, however, the individuality of each performer is employed to facilitate an encounter rather than an exposure. It is in this encounter that we see the alignment between Bel's choreography and Kristeva's proposal.

Through a simple series of presentations by the disabled performers to the implicitly 'able' audience, Bel facilitates a mutually vulnerable meeting in a context usually characterized by explicitly delineated roles of action and reaction. *Disabled Theatre* is performed on a stage furnished with only a row of chairs for the members of Theater HORA to use when they are not responding to Bel's prompts, the first of which is for each performer to stand alone in the middle of the stage, facing the audience, in silence, for one full minute. While subjecting the singular performer to the audience's united gaze might suggest placing them in a position of vulnerability, the performers' mirroring of the audience's

role immediately dismantles the authority gained through their anonymity and distance, forcing each audience member to acknowledge his or her bodily presence, and the susceptibility inherent in their reactions.

The meeting becomes more intimate as the actors introduce themselves, giving their names, ages and occupations, before going on to perform self-choreographed

# 'You don't know how to react … the theatrical device is a way of provoking this encounter.'

complicated because these days it's highly unthinkable,' he has explained. 'You don't know how to react when you encounter [disabled people] because they are not represented in the public domain. And for as long as that is the case there will continue to be embarrassment and uneasiness. The only method is confrontation […] The theatrical device is a way of provoking this encounter.'

By employing the empathetic choreography of encounter rather than enacting the violence of representational theatre, *Disabled Theatre* does not seek to repair the individual (whether disabled or non-disabled) in a participatory theatre 'therapeutic in orientation', to quote Claire Bishop. Instead, it proposes a critical stance on what Kristeva calls the 'cult of performance—excellent—enjoyment' enforced by conventional values and behaviours that seek to obfuscate the shared reality of human vulnerability. 'To be an individual in this context', Kristeva observes, 'is a fundamental liberty, but requires extraordinary psychological strength.'

dances. Their ages range as widely as their performances: individuals aged from 18 to 44 variously slam-dance or soft-shoe shuffle to anything from ABBA's *Dancing Queen* to a 1990s techno anthem. The performance culminates in an arresting lack of guardedness on the part of both the performers and the choreographer, as the actors describe their personal experiences of disability and share their thoughts on Jérôme Bel and *Disabled Theatre*. Here Bel consciously allows himself to be implicated in the encounter, taking responsibility for his role in its facilitation and thus its outcome.

Bel describes his collaboration with Theater HORA as based on a desire to facilitate more visibility for disabled people: 'The question of performances by people with learning disabilities is

*Disabled Theatre* is performed at the Shaw Theatre in London by Remo Beuggert, Gianni Blumer, Demian Bright, Matthias Brücker, Nikolai Gralak, Matthias Grandjean, Julia Häusermann, Sara Hess, Tiziana Pagliaro, Fabienne Villiger and Remo Zarantonello.

Lauren Wetmore
Assistant Curator, Frieze Projects

# Frieze Film: Cally Spooner

For Frieze Film 2014 Cally Spooner screens a series of commercial interruptions in-between the main activities of the fair, exploring the short-circuiting of language in today's attention economies

Right:
*Damning Evidence
Illicit Behaviour
Seemingly Insurmountable
Great Sadness Terminated
In Any Manner*
2014
Opera singers and
surtitles
Installation view at
'La Voix humaine',
Kunstverein München,
Munich

Left and right:
*Frieze Film Edit*
(rough cut sketch/stills)
2014
90 sec.
Courtesy of the Friends
of the High Line and
Frieze Film

**Cally Spooner** (b. 1983, UK) is a London-based artist and writer. Following her large-scale touring musical *And You Were Wonderful, On Stage* (2013)—commissioned and presented by Stedelijk Museum, Amsterdam; Performa 13, New York; and Tate Modern, London—Spooner is currently producing a film based on the musical that will be made at EMPAC, New York, in 2015. This work follows on from her Frieze Sounds commission at Frieze New York, and will be produced in partnership with High Line Art, New York. Also in 2014 her projects include a solo exhibition at gb agency, Paris, and a presentation for the Future Generation Art Prize (until January 2015).

Drawing from pop music, current affairs, corporate rhetoric and philosophical writing, Spooner's projects address automated behaviour, outsourced subjectivity, mutated human resources and the short-circuiting of language in today's attention economies. Appropriating different performance genres such as the musical, the television commercial and the radio play as both forms and a reference, Spooner considers how dematerialized, indeterminate and unmediated performance, and the movement and behaviour of speech, can sit alongside the extreme visibility of entertainment.

For Frieze Film 2014, Spooner has created a series of commercial interruptions, strange promises and 'extorted content', which also function as advertisements for her upcoming film. Based on a transcript of an off-camera dialogue from *And You Were Wonderful, On Stage*, each interruption explores linguistic apparatuses through agitated swarms of hyper-performing hired backing dancers. The dancers perform the corrections to a worker's speech as a score, generating a choreographed dance that builds itself into algorithmic repetition. Part problem-solving procedure, part vacuous gesture, each step is spliced with fast edits and large instructional text. Here, Spooner presents a public-facing strategy, extracting material from the musical and repackaging it into clips that will later comprise components of a larger film. Within the Frieze Film programme this new work is an interlude during its own acceleration into completion.

Sophie Oxenbridge
Production Assistant to Cally Spooner /
Frieze Film

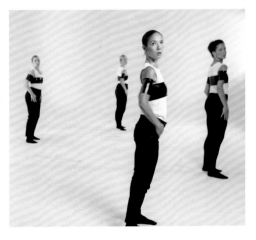

# Ignasi Aballí

Art as practised by Ignasi Aballí involves an alertness to barely detectable quotidian wonders, a relishing of the foibles of serial production and a serious delight in the systems that purport to classify the world. With a mischievous sense of Conceptual art's fondness for futility, Aballí has often deployed seriality and indexing in his work— his celebrated 'Lists' series (1997–2005) comprises tallies of newspaper headlines that enumerate numbers of refugees, amounts of money and so on. His text-based works, photographs, installations, paintings, films and sculptures of the last 20 years have wrested meaning from everything from dust to shredded banknotes, images of the sky and clouds, scuffed museum walls and thin air. MA

**Selected by**
Galería Elba Benítez H6

**Biography**
Born 1958
Lives in Barcelona

The work of Barcelona native Aballí has been shown in solo exhibitions held at: Meessen de Clercq, Brussels (2014 and 2010); Galería Elba Benítez, Madrid (2013 and 2009); Artium Centro Museo Vasco de Arte Contemporáneo, Vitoria, Spain (2012); Fundación Rosón Arte Contemporáneo, Pontevedra, Spain (2011); Pinacoteca do Estado de São Paolo (2010); Fundació Joan Miró, Barcelona (2008); Zentrum für Kunst und Medientechnologie Karlsruhe, Germany (2006); and MACBA, Barcelona (2005). His works are held in public collections of institutions that include: Museo Nacional Centro de Arte Reina Sofía, Madrid; MACBA, Barcelona; and Centro Andaluz de Arte Contemporáneo, Seville.

'Lists'
1997–2005
Installation view at the 52nd Venice Biennale, 2007
Courtesy of Galería Elba Benítez

1

2

**Selected by**
Mai 36 Galerie C4

**Also shown by**
Gavin Brown's enterprise
F9
Galeria Fortes Vilaça D5
Gió Marconi B2
Meyer Riegger B2
White Cube D4

**Biography**
Born 1963
Lives in Berlin

Ackermann has been the subject of solo exhibitions held at: Mai 36 Galerie, Zurich (2014 and 2008); Staatliche Kunsthalle, Karlsruhe, Germany (2014); Faena Arts Center, Buenos Aires (2012); Kunstmuseum St Gallen, Switzerland (2009); Kunstmuseum Bonn (2009); Witte de With Center for Contemporary Art, Rotterdam (2006); and Museo Nacional Centro de Arte Reina Sofía, Madrid (2003). His work has been included in recent group shows at venues that include: Kunstmuseum St Gallen, Switzerland (2013); Temporäre Kunsthalle, Berlin (2010); and Camden Arts Centre, London (2006).

1
*The Fall of the Wall*
2014
Mixed media, watercolour, oil on canvas, photography
1.53 × 1.73 m
5' ⅜" × 5' 8¼"
Courtesy of Mai 36 Galerie

2
*Atlantic*
2014
Mixed media, watercolour and photography
1.84 × 3 m
6' 5⅝" × 9' 10⅛"
Courtesy of Mai 36 Galerie

# Franz Ackermann

Shards of traffic-cone yellow, billboard blue and grass-verge green explode across Franz Ackermann's densely populated cityscapes. The artist has honed this graphic fusion for over three decades: collage-like built elements (towering blocks of flats with Brutalist balconies) captured in painterly tendrils and jagged diamonds of colour. His installations, murals and paintings on canvas suggest a dizzying sensorial overload of the contemporary globalized city undergoing rapid change. *The Fall of the Wall* (2014), with its graffiti-swatches, conjures up the Berlin Wall and the collapse of the Soviet system in 1989. Ackermann's work presents a vision that all but overwhelms the viewer, seeking to expose its ambivalent pleasures: the overcrowding and relentless pace mitigated by sheer, visceral enjoyment at sights passing with such gleeful rapidity. CP

**Selected by**
Wien Lukatsch G7

**Biography**
Born 1942
Lives in Cotonou and
Hamburg

Adéagbo, who originally
studied law before a
curator discovered his
art in 1993, has since
presented his work in
exhibitions held at:
Wien Lukatsch, Berlin
(2014); Moderna Museet,
Stockholm (2014); Museo
de Arte Contemporáneo
de Castilla y Léon, Spain
(2011); daadgalerie,
Berlin (2007); Museum
Ludwig, Cologne (2004);
Documenta 11, Kassel
(2002); Toyota Municipal
Museum of Art, Toyota,
Japan (2000); and the
48th Venice Biennale
(1999), where he was
awarded the Prize of
Honour.

*'Les Artistes et l'écriture'..!*
('Artists and Writing'..!)
2014
Mixed media
2.9 × 4.4 × 0.4 m
9' 6¼" × 14' 5¼" × 1' 3¾"
Courtesy of Wien
Lukatsch

# Georges Adéagbo

Georges Adéagbo made elaborate installations in his yard in Benin for years before he began exhibiting. He transfers the same aesthetic to the gallery space, creating multi-part installations including paintings and sculptures commissioned from local artisans, books, photographs and photocopies. Books are a key component of Adéagbo's spaces, providing the iconic images and textual directives that shape his highly personalized interpretations of themes ranging from African socialism to religious missionaries to 'The Explorer and Explorers before the History of Exploration', as he titled one exhibition. After providing these initial reading prompts, Adéagbo leaves the viewer on their own to knit together his transnational and transhistorical vision, spanning points as far-flung as Berlin, Cotonou, Porto Novo and Rome. SNS

1

2

3

**Selected by**
David Zwirner B7

**Also shown by**
Galerie Peter Kilchmann
A17

**Biography**
Born 1959
Lives in Mexico City

Alÿs has exhibited solo
presentations at: Museo
d'Arte Contemporanea
Donna Regina, Naples
(2014, travels to Centre
for Contemporary Art,
Warsaw, in October
2014); David Zwirner,
New York (2013 and
2007); Museum of
Contemporary Art Tokyo
(2013); and Hiroshima
City Museum of
Contemporary Art (2013).
His work was presented in
the career survey 'A Story
of Deception', on view
from 2010 to 2011 at: Tate
Modern, London; WIELS
Contemporary Art
Centre, Brussels; MoMA,
New York; and MoMA
PS1, New York.

1
*Untitled (Study for Don't
Cross the Bridge Before You
Get to the River)*
2006–8
Oil and encaustic on
canvas on wood
24.4 × 19.4 cm
9⅝ × 7⅝"
Courtesy of David
Zwirner

2
*Untitled*
2011–12
Oil and collage on canvas
on wood
13 × 17.8 cm
5⅛ × 7"
Courtesy of David
Zwirner

3
*Untitled*
2011–12
Oil on canvas on wood
12.7 × 17.8 cm
5 × 7"
Courtesy of David
Zwirner

# Francis Alÿs

Francis Alÿs has staged actions that are
at once absurdist, political and poetic.
They have ranged from moving a giant
sand dune 10 centimetres (*When Faith
Moves Mountains,* 2002) to walking
through the city of Jerusalem, dribbling
a fine line of paint along the armistice
borders of the state of Israel (*The Green
Line,* 2004). These charged and effortful
works often take place within an urban
landscape, a backdrop also present in
Alÿs's small-scale paintings; *Untitled*
(2011–12) imagines an intervention on
the rooftops of Kabul. The paintings
often loosely act as studies for proposed
actions, such as the figurative canvas
*Untitled (Study for Don't Cross the Bridge
Before You Get to the River)* (2006–8). KK

**Selected by**
Kukje Gallery B6

**Also shown by**
Goodman Gallery H1
Tina Kim Gallery B6

**Biography**
Born 1963
Lives in New York

Egyptian artist Amer has
presented solo exhibitions
at venues that include:
Kukje Gallery, Seoul
(2013 and 2007); Musée
d'art contemporain
de Montréal (2012);
Cheim & Read, New
York (2011 and 2010);
Tina Kim Gallery, New
York (2008); Singapore
Tyler Print Institute,
Singapore (2008);
Brooklyn Museum, New
York (2008); Museo
d'Arte Contemporanea
Roma, Rome (2007); and
the Tel Aviv Museum of
Art (2000). Select group
shows in which her work
has been seen include the
4th Thessaloniki Biennial,
Greece (2013); and the 3rd
Moscow Biennial (2009).

*Baisers 2*
(Kisses 2)
2011
Nickel-plated bronze and
black patina
44.5 × 63.5 × 45.5 cm
17½ × 25 × 18"
Courtesy of Kukje
Gallery

# Ghada Amer

At first glance, Ghada Amer's canvases
appear to be abstract paintings. In fact,
they are neither abstract nor painted:
what she calls her 'occupation' of the
canvas involves an irreverent use of
traditional 'women's materials'—
needle and thread—to depict erotic
images of women pleasuring themselves.
Amer's work thus intervenes in the
material hierarchies that structure a
Western history of art, while portraying
a multilayered view of women's
place within it: stereotyped, even
interchangeable, but also monumental
and self-sufficient. Her wide variety
of practices includes garden projects
and sculptures, which similarly play on
hierarchies of materiality, gender and
language. The lyrical *Baisers 2* (2011),
translates as 'kisses' (as well as having
more vulgar meanings). SNS

1

2

**Selected by**
Take Ninagawa H8

**Biography**
Born 1974
Lives in Kyoto

Aoki has presented
solo and two-person
exhibitions at galleries
and institutions that
include: Take Ninagawa,
Tokyo (2011); Konrad
Fischer Galerie,
Dusseldorf (2009);
Kodama Gallery,
Osaka (2007 and 2005);
Hammer Museum, Los
Angeles (2005); and
Marc Foxx Gallery, Los
Angeles (2004). Select
group shows include:
'Tsubaki-Kai - Shoshin',
Shiseido Gallery, Tokyo
(2013); 'Re-Quest:
Japanese Contemporary
Art since the 1970s',
SOMA Museum of Art,
Seoul (2013); the 5th
International Biennial
of Media Art, RMIT
Gallery, Melbourne
(2012); and Documenta
12, Kassel (2007).

1
*Leopard Pink*
2010
Ink and felt-tip pen on
paper
30 × 21 cm
11¾ × 8¼"
Courtesy of Take
Ninagawa

2
*Rain Drops*
2009
Pencil, watercolour and
ballpoint pen on paper
37 × 45 cm
14⅝ × 17¾"
Courtesy of Take
Ninagawa

# Ryoko Aoki

Ryoko Aoki's delicate drawings range
from the figurative—often of girls and
young women—to the more purely
abstract, but are throughout lit with
a luminous quality, as in the pastel
forms of *Collection* (2013). Her interest
in patterns is evident in vibrant works
such as *Leopard Pink* (2010). Using felt-
tip pen on graph paper, Aoki references
the world of classroom doodling and
a dreamy adolescence, even as the
work indicates a darker and more
obsessive mood. Meanwhile, the delicate
*Rain Drops* (2009) presents a wash of
images that are at once bucolic and in
a state of decay. Working in a territory
traditionally designated as 'feminine',
Aoki undermines its stereotypes,
creating images that are subtly
unnerving, that combine grace with
humour and disquiet. KK

**CAFÉ ROYAL**
68 REGENT STREET, LONDON W1B 4DY, TELEPHONE +44 (0)20 7406 3333, FAX +44 (0)20 7406 3366, HOTELCAFEROYAL.COM
REG NO. 7792054; REG OFFICE ADDRESS: 11 ST CHRISTOPHER'S PLACE, LONDON W1B 1NG, VAT REG. GB 129 7107 10

A HOTEL OF THE SET

**Selected by**
Sadie Coles HQ D2

**Also shown by**
Gavin Brown's enterprise
F9
mother's tankstation H7

**Biography**
Born 1977
Lives in New York

Aran has been the focus of solo exhibitions presented at: Peep-Hole, Milan (2014); Disjecta Contemporary Art Center, Portland, OR (2014); South London Gallery (2013); Kunsthalle Zürich (2013); and the High Line, New York (2012). His work has been shown in recent group shows at venues that include: Garage Centre for Contemporary Culture, Moscow (2014); Dallas Museum of Art (2014); and the American Academy in Rome (2013). He participated in the 2014 Whitney Biennial, Whitney Museum of American Art, New York, and the 55th Venice Biennale (2013). Aran currently has work exhibited in the 8th Liverpool Biennial (2014).

*Cafe Royal*
2014
Acrylic, polyurethane, monotype and spray paint on letterhead
29 × 21 cm
11½ × 8¼"
Courtesy of Sadie Coles HQ

# Uri Aran

At once mournful and playful, Uri Aran's work explores the limits of language and suggests oblique, fragmented narratives. Laid out on work tables or pedestals like mysterious specimens or inscrutable craft projects, stale biscuits, beads, rusted key chains, cut-up latex gloves, ID photographs and trails of dried glue evoke unsettling psychic terrains. Despite apparent randomness, a subtly keyed palette heightens the sense of ruined poetry and meaning that is just out of reach. Aran also creates palimpsestic two-dimensional works, such as *Café Royal* (2014), in which he layered various materials on letterhead. His videos sometimes incorporate futile attempts to categorize knowledge, as in *A to Z (that stops at Q)* (2011), which shows Aran presenting an absurd, incomplete alphabet using random objects. KMJ

1

2

**Selected by**
Canada J6

**Biography**
Born 1940
Died 2008

The work of Canadian
artist Askevold has
been the subject of
posthumous exhibitions
held at: Armory Center
for the Arts, Pasadena,
CA (2012); Camden Arts
Centre, London (2012);
National Gallery of
Canada, Ottawa (2011);
and Le Consortium,
Dijon, France (2010).
His work is held in
the public collections
of institutions that
include: Art Gallery
of Nova Scotia,
Yarmouth, Canada;
Canadian Museum
of Contemporary
Photography, Ottawa;
Long Beach Museum
of Art, CA; National
Gallery of Canada,
Ottawa; and Van
Abbemuseum, Eindhoven.

1
*Rock Art Saga with Tourists*
2000
Inkjet photograph on
canvas
122 × 184 cm
48 × 72½"
Courtesy of Canada

2
*Pilescape with Two Tourists*
1999
Inkjet photograph on
canvas
122 × 167.5 cm
48 × 66"
Courtesy of Canada

# David Askevold

In the cosmology of David Askevold,
Pokemon and Niagara Falls were
both equivalent artefacts. Working
for over five decades, his multimedia
installations, videos and photographs
reflected his anthropological
background to ask how we define
and shape the landscapes around us.
*Pilescape with Two Tourists* (1999) is a
digital collage in which two curious
visitors examine the museum display
of a rocky terrain punctuated by a
colourful mash of churches, temples,
angels and demons from around the
globe. Providing the link between the
Conceptualists and the 'clusterfuck'
installations of later artists such as
Mike Kelley, Askevold found in his
everyday surroundings, in waterfront
cliffs or magazine ads, the material for
kaleidoscopic reflections on what we
tell ourselves is culture. CFW

1

2

**Selected by**
Workplace Gallery H10

**Biography**
Born 1955
Lives in London

Bainbridge has been the
subject of solo exhibitions
at: Workplace Gallery,
Gateshead, UK (2014
and 2008); The New
Art Gallery Walsall, UK
(2012); Camden Arts
Centre, London (2012);
Middlesbrough Institute
of Modern Art, UK
(2008); Cornerhouse,
Manchester, UK (1997);
Stedelijk Museum,
Amsterdam (1989); and
the ICA, Boston (1987).
He has participated in
select group shows at
venues that include:
Workplace London
(2013); Drawing Room,
London (2013); and Royal
Academy of Arts, London
(2011).

1
*Occurrence on an Endless
Column*
1987
Mixed fur fabric, plaster,
timber and steel
2.82 × 2.26 × 1.39 m
9' 3" × 7' 4" × 4' 7"
Courtesy of Workplace
Gallery

2
*Bobble / Bubble*
2011
Steel and cotton
2.38 × 1.81 × 1.52 m
7' 9¾" × 5' 11¼" × 4' 11⅞"
Courtesy of Workplace
Gallery

# Eric Bainbridge

The post-Minimalist sculpture of
Eric Bainbridge is suffused with
humour, implied corporeality and
a preoccupation with the absurd.
Accordingly, the twin legacies of
modern British sculpture and American
Minimalism, though present, are treated
with fluid irreverence. *Bobble / Bubble*
(2011), an arrangement of steel
rods and panels, presents a study in
equilibrium and balance reminiscent
of Anthony Caro's work—minus
the po-faced academicism. *The Ghost of
Jimmy the Nail* (2012), two long white
sheets clothes-pegged to a washing line,
draws the viewer towards a lyrical
consideration of physical absence (the
missing body suggested by its bed linen),
while simultaneously referencing the
television actor Jimmy Nail, best
known for his role in the classic UK
comedy *Auf Wiedersehen, Pet.* MQ

1

... AND MATISSE

2

3

**Selected by**
Marian Goodman
Gallery C8

**Also shown by**
Mai 36 Galerie C4
Galerie Greta Meert B16
Sprüth Magers C5

**Biography**
Born 1931
Lives in Santa Monica,
CA

Awarded a Golden Lion
Award for Lifetime
Achievement at the
53rd Venice Biennale
in 2009, Baldessari has
exhibited solo shows
internationally, at venues
that include: Garage
Center for Contemporary
Culture, Moscow (2013);
Marian Goodman
Gallery, New York (2013,
2012, 2008, 2006, 2002
and 1999), and Paris
(2012, 2009, 2006 and
2005); Van Abbemuseum,
Eindhoven (2012);
MACBA, Barcelona
(2010); The Metropolitan
Museum of Art, New
York (2010); Tate
Modern, London (2009);
Deutsche Guggenheim,
Berlin (2009); Serpentine
Gallery, London (1995);
MoMA, New York (1994);
and the Whitney Museum
of American Art, New
York (1990).

1
*Beethoven's Trumpet (with Ear), Opus 127*
2007
Resin, fibreglass,
bronze, aluminium and
electronics
1.85 × 1.83 × 2.66 m
6' 1" × 6' × 8' 9"

2
*Double Bill:…and Matisse*
2012
Varnished inkjet print on
canvas with acrylic and
oil paint
2.10 × 1.45 m
6' 10¾" × 4' 9"

3
*Raised Eyebrows/Furrowed Foreheads: (with Pain and Insouciance)*
2008
3D archival print
laminated with lexan and
mounted on sintra with
acrylic paint
2 × 1.45 × 0.1 m
6' 6¾" × 4' 9¼" × 3⅞"
All images courtesy
of Marian Goodman
Gallery

# John Baldessari

It is apt that one of John Baldessari's former students at CalArts has compared his work to Jean-Luc Godard's films, given Baldessari's nimble, cerebral exploration of the relationship between word and image, part and whole, and found and new material. His work, he has said, is about 'seeing the world askance'. Sometimes that has involved focusing on body parts, as in *Raised Eyebrows/Furrowed Foreheads: (with Pain and Insouciance)* (2008), or creating enigmatic storyboards, as in *Storyboard (In Four Parts): Four Women at Fashion Show Staring at a Model* (2013). Baldessari's sculptural works include the uncanny and poignant *Beethoven's Trumpet (with Ear), Opus 127* (2007), which invites viewers to speak into a giant ear trumpet and hear music from one of the composer's late string quartets. KMJ

1

2

**Selected by**
Galerie Nordenhake B11

**Also shown by**
Galería Juana de Aizpuru
B15
White Cube D4

**Biography**
Born 1958
Lives in Warsaw

Bałka has presented solo
exhibitions worldwide,
at venues that include:
National Centre for
Contemporary Arts,
Moscow (2013); WRO Art
Center, Wrocław, Poland
(2013); FRAC Centre,
Orléans, France (2012);
Centre for Contemporary
Art, Warsaw (2011);
Museo Nacional Centro
de Arte Reina Sofía,
Madrid (2010); Staatliche
Kunsthalle Karlsruhe,
Germany (2010); Tate
Modern, London (2009);
National Galleries of
Scotland, Edinburgh
(2008); Museo de Arte
Moderna, Rio de Janeiro
(2007); and National
Museum of Art, Osaka
(2000). In 2013 he
participated in the 55th
Venice Biennale.

1
*Sch*
2000
Glue, paper and steel
0.06 × 51 × 0.06 m
2⅜" × 167' 3⅞" × 2⅜"
Courtesy of Galerie
Nordenhake

2
*268 × 142 × 54, 84 ×
40 × 22*
2008
Wood and glass
Part 1: 268 × 142 ×
54 cm
105½ × 56 × 21¼"
Part 2: 84 × 40 ×
22 cm
33 × 15¾ × 8⅝"
Courtesy of Galerie
Nordenhake

3
*268 × 142 × 54, 84 ×
40 × 22*
(detail)
2008
Wood and glass
Part 1: 268 × 142 ×
54 cm
105½ × 56 × 21¼"
Part 2: 84 × 40 × 22 cm
33 × 15¾ × 8⅝"
Courtesy of Galerie
Nordenhake

3

# Mirosław Bałka

Minimal form, maximal emotional resonance: such is Mirosław Bałka's preferred ratio. The work *268 x 142 x 54, 84 x 40 x 22* (2008), for example, crowns a column of wood with a glass of water: the height (specific, as often, to his own body) positions the vessel out of reach, the water as liquid metaphor for something inaccessible. That something might be the fullness of historical memory—the Polish artist's deeply melancholic proposals and deployment of raw, history-laden materials often seem connectable to the Holocaust—but this work, as always, accommodates private experience. Larger catastrophes and local ones collapse, here, together: see the articulation of death's endless continuity in *Sch* (2000), paper chains made from newspaper obituaries. MH

1

2

3

**Selected by**
Gió Marconi B2
Meyer Riegger B2

**Biography**
Born 1972
Lives in Berlin

Sicilian-born Barba
has recently completed
residencies at Artpace
San Antonio, TX
(2014), and The Chinati
Foundation, Marfa, TX
(2013). She has had solo
exhibitions at venues that
include: MAXXI, Rome
(2014); Contemporary
Art Centre, Vilnius
(2014); Museo de
Arte Contemporáneo
de Castilla y León,
Spain (2013); Turner
Contemporary, Margate,
UK (2013); Kunsthaus
Zürich (2012); Tate
Modern, London
(2010); and Center for
Contemporary Art, Tel
Aviv (2010). In 2010 she
was the recipient of the
Nam June Paik Award.

1
*Color Studies*
2013
Two-channel 16 mm film
projection, screen
2 min.
Courtesy of Gió Marconi
and Meyer Riegger

2
*Definition Landfill*
2014
35 mm film
5 min.
Courtesy of Gió Marconi
and Meyer Riegger

3
*Perceptual Response to
Sound and Light*
2014
Site-specific installation
at the Locker Plant, The
Chinati Foundation,
Marfa, TX
Courtesy of Gió Marconi
and Meyer Riegger

# Rosa Barba

Rosa Barba's work seeks to contest
and recast truth and fiction, myth and
reality, metaphor and material, as part
of an expanded Conceptual practice.
Invoking cinema's evolving, century-
long investigation of mechanical and
narrative affects, she re-articulates
its industrial heritage in spatial and
sculptural terms, highlighting the
contingency and fragility of cinematic
illusion. *Color Studies* (2013), which
was installed in Barba's solo show at the
contemporary art museum (MUSAC)
in León, Spain, features two 16 mm films
projecting abstract blocks of colour
on to either side of a free-standing
screen. The work creates a dialogue
that is mysterious and beguiling,
reawakening cinematic forces in a
mute but potent conversation. CP

**Selected by**
Casey Kaplan C16

**Biography**
Born 1985
Lives in New York

Beasley is artist in residence at the Studio Museum in Harlem, New York, for their 2013–14 programme. He has presented work in exhibitions that include: 'When the Stars Begin to Fall: Imagination and the American South', Studio Museum in Harlem, New York (2014); 77th Whitney Biennial, Whitney Museum of American Art, New York (2014); 'Realization is Better Than Anticipation', Museum of Contemporary Art, Cleveland (2013); and 'Some Sweet Day', MoMA, New York (2012).

1
*Untitled (spoon)*
2014
Urethane foam, resin, artist's apparel
106.5 × 12.5 × 16.5 cm
42 × 5 × 6½"
Courtesy of Casey Kaplan

2
*Untitled (chest pack)*
2014
Urethane foam, resin, long-sleeved shirt, battery charger
34.5 × 76 × 30.5 cm
13½ × 30 × 12"
Courtesy of Casey Kaplan

2

# Kevin Beasley

Kevin Beasley's work resonates with the body. Many of his sculptural objects feature items of his clothing, the touch of his flesh solidified by urethane foam and resin. 'Artist's apparel' is listed in the materials for *Untitled (spoon)* (2014), the specific items easily decipherable up close to this bulging black form. These sculptures often sit directly on the floor, their abject state confronting the viewer at foot-level. Beasley's soundworks similarly intend to shake the spectator: from *I Want My Spot Back* (2012) at MoMA, a remix of a cappella tracks by deceased rappers played at a blood-curdling volume, to the subtle pre-recorded sounds of The Studio Museum presented on noise-cancelling headphones in an installation there earlier this year. EN

Composition for Hearing an Architectural Space, 2013

The score is to be sung in a reverberant space by between two and six singers. The aim is to sing as little as possible; allowing the space to sing for you.

You are to underline the two audible elements of the acoustic which can be heard independently of the direct sound produced by your voice:
1. the resonant frequencies (modes) of the space and 2. the reverberation of the space.

1. Sing pianissimo glissandi with a round timbre and the mouth closed to identify any resonant frequencies which you can exploit during the performance. Descend slowly through your tessitura and when you pass a resonant frequency your voice will be suddenly amplified by the space. Focus precisely on these frequencies and your voice will be amplified, and its timbre eclipsed by that of the room. Crescendo and diminuendo as indicated. Crescendos may be accompanied by briefly opening the mouth to the vowel 'Or'.

2. Starting on the principle resonant frequency of your position, sing the following cyclic harmonic progression according to the notation below. The goal is to stimulate the maximum reverberation with the minimum amount of singing. The staccato indicates your sung note, whilst the tie shows its extension by the reverberation of the space. You should feel like you are trying to play the echos of the space with your voice. Each singer should take turns at this sequence, in which a single voice is able to harmonise with itself. You are free to improvise and experiment with different articulations within the arpeggios of the sequence, the goal being to listen not to your voice, but to its movement within the architecture.

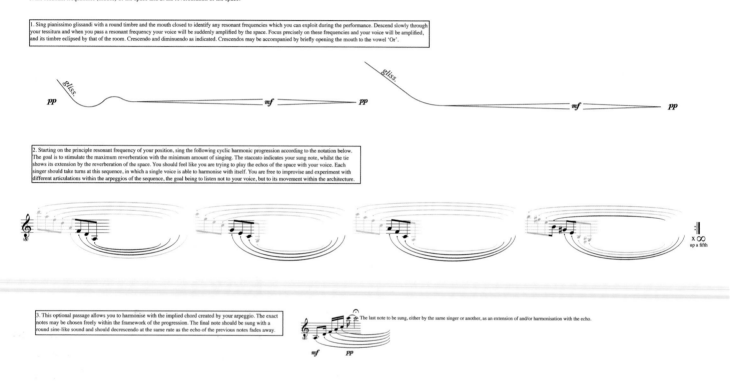

3. This optional passage allows you to harmonise with the implied chord created by your arpeggio. The exact notes may be chosen freely within the framework of the progression. The final note should be sung with a round sine-like sound and should decrescendo at the same rate as the echo of the previous notes fades away.

The last note to be sung, either by the same singer or another, as an extension of and/or harmonisation with the echo.

Oliver Beer, 2013

1

2

**Selected by**
Galerie Thaddaeus
Ropac A5

**Biography**
Born 1985
Lives in Paris

British artist Beer, who
in 2013 was artist in
residence at Villa Arson,
Nice, has presented solo
exhibitions at: Musée
d'art contemporain de
Lyon, France (2014);
Galerie Thaddeus
Ropac, Pantin (2014);
and Ikon Gallery,
Birmingham, UK (2013
and 2010). Select group
shows include: 'Sunday
Sessions', MoMA PS1,
New York (2014); 12th
Biennale de Lyon (2013);
'The Resonance Project
Performance', WIELS
Centre for Contemporary
Art, Brussels (2013); and
'Nouvelles Vagues', Palais
de Tokyo, Paris (2013).

1
*Composition for Hearing an
Architectural Space*
2013
Score for a performance
2 scores, performance
Dimensions variable
Courtesy of Galerie
Thaddaeus Ropac

2
*Composition for Tuning an
Architectural Space (Palais
de Tokyo / Biennale de Lyon)*
2012
2 scores, performance
Dimensions variable
Courtesy of Galerie
Thaddaeus Ropac

# Oliver Beer

Oliver Beer's recent work has focused on
sonic techniques of amplification and
sustain, from *Mum's Continuous Note*
(2012), a video of the artist's mother
demonstrating singing via circular
breathing, to acoustic sculptures such
as *Outside-In* (2013), glass windowpane
inserts that funnel outdoor noises into an
architectural space. Since 2007 Beer has
made several site-specific choral pieces
for buildings as part of 'The Resonance
Project', an ongoing series which has
taken place in churches, stairwells,
car parks and museums. Singers are
instructed to 'tune' buildings by finding
the notes that resonate in a given
space, often using corners and walls
as amplification devices, and then
follow a score that harmonizes with the
space's natural notes, creating sounds
that bounce around the space to
palpable, tectonic degrees. LMcLF

1

2

3

**Selected by**
Overduin & Co. B20

**Also shown by**
dépendance G17
Gió Marconi B2
Galerie Meyer Kainer F12

**Biography**
Born 1978
Lives in Paris

Los Angeles native
Benedict has been the
focus of solo and two-
person exhibitions held
at: Balice Hertling, Paris
(2014); dépendance,
Brussels (2014); Halle
für Kunst, Lüneburg,
Germany (2013); Galerie
Meyer Kainer, Vienna
(2013, 2012 and 2009);
Neue Alte Brücke,
Frankfurt (2012 and
2010); and Gió Marconi,
Milan (2012). Recent
group shows in which
Benedict has participated
include: 'Chat Jet:
Painting <Beyond>
The Medium', KM –
Künstlerhaus Graz,
Austria (2013); 'Vertical
Club', Bortolami, New
York (2013); and 'Flaca',
Portikus, Frankfurt (2011).

1
*The Heir*
2014
Gouache on board and
canvas, aluminium frame
with glass
70 × 95.5 cm
27⅝ × 37½"
Courtesy of Overduin
& Co.

2
*Untitled*
2014
Gouache on foamcore
and canvas, aluminium
frame with glass
155 × 108 cm
61 × 42½"
Courtesy of Balice
Hertling

3
*Korean War Bride Head
Injury*
2013
Gouache on foamcore
and canvas and archival
inkjet print, aluminium
frame with glass
89 × 70 cm
35 × 27½"
Courtesy of dépendance

# Will Benedict

One recurring formal motif in Will
Benedict's paintings and installations
is the picture-within-a-picture. For the
series 'Bonjour Tourist' (2012) Benedict
cut and glued photographs—of friends
chatting face to face, or a man reading
the *International Herald Tribune*—onto
foamcore panels, and paired them with
a floating, hypertextual image: a real
postcard (*Lucie, See You When I See You*,
2012), an abstract painting, a stamp,
a cocktail or a scribbled outline of a
country. These passepartout paintings
seem like the weather screens of a
television presenter, playfully yet
assertively caricaturing national
representation, the news and tourism:
in *Korean War Bride Head Injury* (2013)
a drawing of Japan is superimposed over
a photographic cut-out of a disgruntled
woman wearing a bandana painted
with a blood-red Rising Sun. PL

1

2

**Selected by**
A Gentil Carioca G6

**Biography**
Born 1962
Lives in Belo Horizonte

The work of Brazilian artist Bento has been the focus of solo presentations held at: A Gentil Carioca, Rio de Janeiro (2012); Galeria Bergamin, São Paulo (2006); Museu de Arte da Pampulha, Belo Horizonte (2004); Galeria Marília Razuk, São Paulo (2003 and 2001); and Galeria Celma Albuquerque, Belo Horizonte (2003). He has participated in select group shows held at Mendes Wood DM, São Paulo (2013), and Museu de Arte Contemporânea de São Paulo (2009). His work is held in the public collections of: Pinacoteca do Estado de São Paulo; Itaú Cultural, São Paulo; and Museu Nacional de Belas Artes, Rio de Janeiro.

3

1
*Untitled*
2012
Various woods native to Brazil: roxinho, pau pereira, jequitibá rosa, garapa, braun, oak, balsam, carvalho and pau Brazil
120 × 90 × 2 cm
47¼ × 35⅜ × ¾"
Courtesy of A Gentil Carioca

2
*Chão*
2011
Various woods native to Brazil, springs and iron cables
Dimensions variable
Courtesy of A Gentil Carioca

3
*Untitled*
2010
Braun wood
60 × 30 × 30 cm
23⅝ × 11¾ × 11¾"
Courtesy of A Gentil Carioca

# José Bento

José Bento has been exhibiting his sculptures, drawings, videos and photographs since the 1980s, as well as working under the framework of his company Woodpecker Industry and Commerce Ltd. Focused most intensely on one material—wood—Bento's work appears to branch off from a strictly formalist tradition, growing instead in a seductively organic and narrative direction. An untitled work from 2010, for example, comprises open and solid forms of dark, monochrome woodiness, whose smooth-tooled exterior seems barely able to contain the knotty splits of their raw tree-trunk-ness. MA

1

2

**Selected by**
Alison Jacques Gallery C9

**Also shown by**
Galerija Gregor Podnar
A14

**Biography**
Born 1934
Lives in Milan

German artist Blank
has presented solo
shows at galleries
and institutions that
include: Alison Jacques
Gallery, London (2014);
Mostyn, Llandudno,
UK (2014); P420 Arte
Contemporanea,
Bologna (2013); Galleria
Spaziotemporaneo,
Milan (2009); Museum
Folkwang, Essen,
Germany (1992); and
Bonner Kunstverein,
Bonn (1989). Her work
has been included in
recent group shows
at: Alison Jacques
Gallery, London (2014);
Fondazione Sandretto
Re Rebaudengo, Turin
(2014); and Centre
Pompidou, Paris (2013).

1
*Eigenschriften, Pagina 52*
1972
Pastel on paper
70 × 50 cm
27½ × 19⅝"
Courtesy of Alison
Jacques Gallery

2
*Radical Writing, Exercitium
9*
1988
Oil on canvas
24 × 36 cm
9⅛ × 14⅛"
Courtesy of Alison
Jacques Gallery

3
*Ur-schrift ovvero Avant-
testo, 15-3-02, 2002*
2002
Ballpoint pen on polyester
on wooden stretcher
25 × 25 cm
9⅞ × 9⅞"
Courtesy of Alison
Jacques Gallery

3

# Irma Blank

Irma Blank's painting, she has written,
'denudes writing of sense to charge it
with other values', saving it from 'its
enslavement to sense' and returning it
to an existentialist silence. This zero
degree of writing has been her *modus
operandi* since the late 1960s, and the
results can be austere—the pastel
*Eigenschriften Pagina 52* (1972) resembles
both a Minimalist grid and an out-of-
focus page of text; up close, what might
have been words are mute blue lines.
They can also be sumptuous. Blank
skews to blue hues, and a work like
*Radical Writing Exercitium 9* (1988),
with its narrow horizontal bands of
rich navy oil paint, looks like an open,
empty, blue notebook: emptied of
words, but full of pointed withholding
and reductive beauty. MH

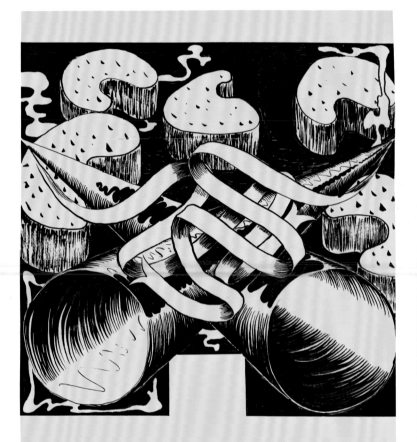

1

2

3

**Selected by**
Galerie Karin Guenther
J2

**Also shown by**
Casey Kaplan C16
Galerie Meyer Kainer F12

**Biography**
Born 1975
Lives in Hamburg

The work of German artist Bohl has been presented in solo exhibitions held at: Rob Tufnell, London (2014); Kunsthalle Nürnberg, Nuremberg (2013), and Kunstverein in Hamburg (2011), Germany; Cubitt, London (2010); Casey Kaplan, New York (2009 and 2007); Oldenburger Kunstverein, Oldenburg (2008), and Frankfurter Kunstverein, Frankfurt (2003), Germany. Select group shows in which Bohl has participated include: Carnegie International, Carnegie Museum of Art, Pittsburgh (2013); 'about painting', abc art berlin contemporary (2011); and 'Looking Back: The 4th White Columns Annual', White Columns, New York (2009).

1
*Untitled*
2014
Marker, ink and gouache on paper
42 × 43 cm
16½ × 16⅞"
Courtesy of Galerie Karin Guenther

2
*Untitled*
2014
Marker, ink and gouache on paper
43 × 42 cm
16⅞ × 16½"
Courtesy of Galerie Karin Guenther

3
*Untitled*
2014
Marker, ink and gouache on paper
42 × 30 cm
16½ × 11¾"
Courtesy of Galerie Karin Guenther

# Henning Bohl

Like broken or wrongly assembled theatre sets, Henning Bohl's sculptures, installations and paintings often pit art against the decorative fields of interior design or furniture. In works such as *Cornet of Horse* (2011) Bohl created unstable-looking, table-like sculptures by balancing industrial wood panels on upturned cones printed festively with abstract designs. At other times Bohl hangs abstract canvases at eye-level throughout an exhibition space and peels the layered canvas edges up, nodding to upturned wallpaper or old posters. Poster design recurs in recent works, such as the phantasmagorical untitled drawings (2014) made by Bohl using marker, ink and gouache against a yellow background; they allude as much to Aubrey Beardsley prints and book illustrations as to zine culture and 1990s television cartoons. PL

**Selected by**
Peres Projects G2

**Also shown by**
The Box G3

**Biography**
Born 1970
Lives in Frankfurt

Californian artist Bouchet has been the focus of solo exhibitions shown at: Peres Projects, Berlin (2014); Portikus, Frankfurt (2014); Hotel, London (2012); The Box, Los Angeles (2010 and 2007); Centre Pompidou, Paris (2008); and MoCA, Los Angeles (2007). His work has been exhibited in group shows at select venues that include: Haubrok Projects, Berlin (2013); Kunstverein Hannover (2012); Garage Center for Contemporary Culture, Moscow (2011); Fundacíon Jumex, Mexico City (2010); Astrup Fearnley Museet, Oslo (2009); and the 53rd Venice Biennale (2009).

1
*David Kissinger Jacuzzi*
2012
Fibreglass resin, cardboard, enamel paint
1.22 × 1.85 × 2.97 m
4' × 6' ⅞" × 9' 9"
Courtesy of Peres Projects

2
*Smoky Mountain*
2008
Oil on canvas
2 × 2 m
6' 6¾" × 6' 6¾"
Courtesy of Peres Projects

# Mike Bouchet

'I don't want people to feel like they are stupid or didn't do their homework ... I don't like that kind of attitude in art', Mike Bouchet has commented. Accordingly, since emerging on the Los Angeles scene in the mid-1990s, his art has taken American popular culture as its Classicism. Whether making his own customized denims (*Carpe Denim*, 2004) or canning a burger product with a shelf-life of two years (*Canburger*, 2008), Bouchet approaches the production and consumption of culture as a disquietingly jocular construction. His series of fibreglass 'Jacuzzi' sculptures (1998– ongoing) are uninvited commissions, customized hot tubs intended for celebrity individuals, which pique art's history of patronage. MA

# Kerstin Brätsch

**Selected by**
Gavin Brown's enterprise
F9

**Also shown by**
Gió Marconi B2

**Biography**
Born 1969
Lives in New York

Hamburg-born
Brätsch has presented
solo shows at: Gavin
Brown's enterprise, New
York (2014 and 2012);
The Green Gallery,
Milwaukee, WI (2014);
Various Small Fires,
Los Angeles (2012);
Kölnischer Kunstverein,
Cologne (2011); and
Kunsthalle Zürich (2011).
In collaboration with
Adele Röder, she has
presented exhibitions
under the moniker of
DAS INSTITUT at
venues that include:
Staatliche Kunsthalle
Baden-Baden, Germany
(2014); Swiss Institute,
New York (2009); and
Sculpture Center, New
York (2009).

*Unstable Talismanic
Rendering 15*
2014
Ink and solvent on paper
2.78 × 1.83 m
9' 1½" × 6'
Courtesy of Gavin
Brown's enterprise

Kerstin Brätsch frustrates questions about what her authentic artistic voice might be through promiscuous dalliances with established techniques and media. She welcomes the limitations associated with certain traditional craft processes, but nevertheless coerces them into eccentric and outlandish new forms. She titled a recent series of large marbled ink paintings 'Unstable Talismanic Renderings' (2014), concentric coloured rings, starbursts and globular patterns sometimes suggesting malevolent faces and microscopic slides of mutant cells. They call to mind Sigmar Polke's sliced agate windows for the Grossmünster church in Zurich, and connect to earlier glass paintings by Brätsch made with assistance from the craftsman who worked on those windows. Brätsch's less traditional variations on the theme of translucency have included abstract paintings on Mylar and Perspex. JG

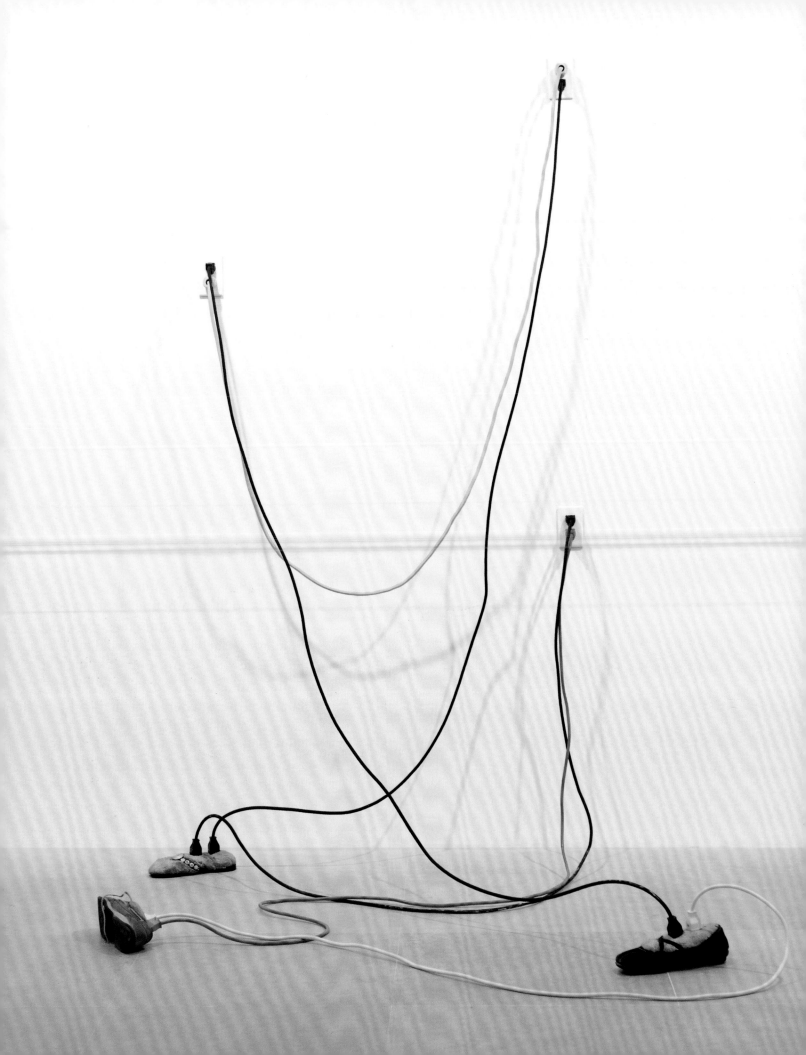

**Selected by**
Greene Naftali C14

**Biography**
Born 1973
Lives in New York

Chan has been the focus of solo presentations at: Schaulager, Basel (2014); Greene Naftali, New York (2009); The Renaissance Society, University of Chicago (2009); Carpenter Center for the Visual Arts, Harvard University, Cambridge, MA (2008); Serpentine Gallery, London (2007); New Museum, New York (2007); Stedelijk Museum, Amsterdam (2007); Magasin 3 Stockholm Konsthall (2006); and Hammer Museum, Los Angeles (2005). He has participated in group shows that include: Documenta 13, Kassel (2012); 'Found in Translation', Solomon R. Guggenheim Museum, New York (2011); and the 16th Sydney Biennial (2008).

*Michael Bloomberg and Jonathan Franzen*
2013
Shoes, cords, outlets
2.17 × 1.83 × 1.54 m
7' 1½" × 6' × 5' ½"
Courtesy of Greene Naftali

# Paul Chan

Paul Chan's artworks wear their literary, political and philosophical hearts on their sleeves. In 2007, in post-Katrina New Orleans, Chan presented *Waiting for Godot in New Orleans*, a performance of Samuel Beckett's play by local actors. *The 7 Lights* (2005–7) and *Sade for Sade's Sake* (2009) are projected animations that recall, respectively, the tragedy of 9/11 and the debaucheries described by the Marquis de Sade. Chan's dual interests in art and publishing are reflected in his current practice, which combines artistic production with ongoing work for his publishing imprint Badlands Unlimited. *Michael Bloomberg and Jonathan Franzen* (2013) is one of a series of recent sculptures made from electrical cables that plug disparate objects into the wall. JG

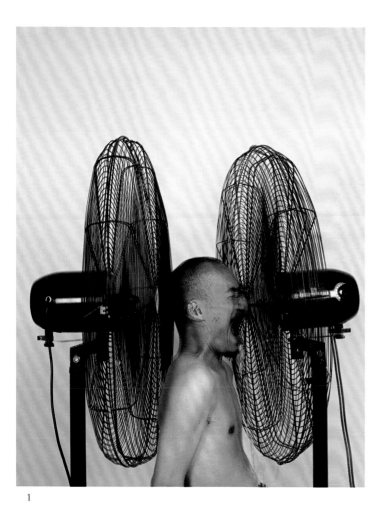

1

2

**Selected by**
Shanghart Gallery A15

**Biography**
Born 1971
Lives in Beijing

Chen has been the focus
of solo exhibitions
presented at: Shanghart
Gallery, Shanghai
(2014), and Beijing
(2013 and 2012); A4
Contemporary Arts
Centre, Chengdu (2013);
and The Project Gallery,
New York (2008).
He has contributed
work to various group
shows internationally,
including: 'Moving on
Asia: Towards a New
Art Network', City
Gallery Wellington,
New Zealand (2013–14);
'Perspectives 180 –
Unfinished Country,
New Video from China',
Contemporary Arts
Museum, Houston (2012);
the 16th Sydney Biennial
(2008); and the 5th
Shanghai Biennial (2004).

1
*Contacting with Self-Chaos
02*
2013
Photograph, inkjet print
150 × 120 cm
59 × 47¼"
Courtesy of Shanghart
Gallery

2
*Right-Angle Turn*
2009
Photograph, inkjet print
144 × 180 cm
56¾ × 70⅞"
Courtesy of Shanghart
Gallery

3
*The Thorny Road of Food
Digestion*
2014
Bronze
62.5 × 181.5 × 80 cm
24½ × 71½ × 31½"
Courtesy of Shanghart
Gallery

3

# Chen Xiaoyun

In Chen Xiaoyun's videos and
photographs, bodies are made to do
unsettling and sometimes violent things.
They swim among carp in an aquarium,
get prodded by anonymous hands from
off-screen, are immersed in water
while hugging a triangular ruler, find
themselves squashed between two
whirring fans. Four men stuff food into
a woman's mouth until she cries with
pain. Chen's titles can also suggest
extremity, as in *Making the Model
Depressive, Giving Him the Tool of Misery,
Turning the Truth of Despair Itself into a
Dubious Image* (2013). But Chen is aiming
for a critical and poetic distance:
'I have no interest in SM, but I am very
interested in the image effect of SM, this
relation between desire and love.' BD

1

2

**Selected by**
The Modern Institute F7

**Also shown by**
Corvi-Mora C13
Marc Foxx Gallery B10
Anton Kern Gallery E3

**Biography**
Born 1970
Lives in New York

Collier has shown
solo exhibitions
internationally, at venues
including: The Modern
Institute, Glasgow
(2014); Nottingham
Contemporary,
UK (2011); Bonner
Kunsverein, Bonn (2008);
and Marc Foxx Gallery,
Los Angeles (2013, 2008,
2004, 2002 and 2001).
She has contributed work
to such group shows as
'New Photography 2012',
MoMA, New York (2012);
'Haunted: Contemporary
Photography/Video/
Performance',
Guggenheim Museum
Bilbao (2011); and
'How Soon Is Now',
Garage Center for
Contemporary Culture,
Moscow (2010). A solo
exhibition at the Museum
of Contemporary Art,
Chicago, is forthcoming
(November 2014).

1
*Eye #1*
2014
C-type print
126.5 × 165.5 cm
49¾ × 65¼"
Courtesy of Anton Kern
Gallery, Corvi-Mora,
Marc Foxx Gallery and
The Modern Institute

2
*Open Book #11 (Sea)*
2014
C-type print
126.5 × 155.5 cm
49¾ × 61¼"
Courtesy of Anton Kern
Gallery, Corvi-Mora,
Marc Foxx Gallery and
The Modern Institute

# Anne Collier

Some things are too unstable, too overloaded with emotional or interpretive cargo, to be photographed without the image veering off into mawkish sentimentality. When Anne Collier pictures the ocean—a scene heavy with personal significance for the California-born artist—she does it through found images, as with *Open Book #11 (Sea)* (2014), in which hands hold a book open at a photograph of ocean waves. In *Eye #1* (2014) a hand proffers a printed photograph of the artist's own eye, gazing implacably back at the viewer. Collier has described her technique, which approximates the studio photography of instructional manuals and advertising imagery, as 'forensic': the term acknowledges the mysterious poignancy of her images' content. JG

1

2

**Selected by**
Pace A2

**Also shown by**
Blum & Poe A3

**Biography**
Born 1973
Lives in London and Kent

Cooke has been the
focus of solo exhibitions
presented at: Douglas
Hyde Gallery, Dublin
(2013); Moderna Museet,
Stockholm (2007);
Modern Art Museum
of Fort Worth, TX
(2006); South London
Gallery (2006); and Tate
Britain, London (2004).
He has participated in
group shows at select
venues that include:
Stellenbosch Modern and
Contemporary Gallery,
Cape Town (2014);
Herzliya Museum for
Contemporary Art, Israel
(2013); New Museum,
New York (2010); and
Minsheng Art Museum,
Shanghai (2010). His
works are held in major
international collections,
including: Tate collection,
UK; British Council,
London; Solomon R.
Guggenheim Museum,
New York; MoMA,
New York; MoCA, Los
Angeles; and the Hammer
Museum, Los Angeles.

3

1
*Prospectors*
2013
Oil on linen backed with
sailcloth
2.3 × 3.2 m
7' 6½" × 10' 6"
Courtesy of Pace

2
*Silva Morosa*
2002–3
Oil on canvas
1.83 × 2.44 m
6' × 8' ⅛"
Courtesy of Pace

3
*Experience*
2009
Oil on linen
2.2 × 1.95 m
7' 2⅝" × 6' 4¾"
Courtesy of Pace

# Nigel Cooke

Nigel Cooke's critical yet entranced attitude to figurative painting has, in recent years, played out via narratives set in a radioactive wasteland that might be the studio or the mind. Semi-ridiculous figures, anxious proxies for the artist (one wears a cook's hat) appear: in *Experience* (2009) a hirsute figure with a creepy, smiling mask waits with a colourful daub he's pinned to a tree. *Prospectors* (2013), meanwhile, finds the decapitated heads and stranded eyeballs of Cooke's early paintings returning amid silvery nudes and giant closed books. As we try to parse this stuttering storyline and ponder how and why artists get caught up in their own iconographies, Cooke is way ahead of us, making work that's wildly reflexive and knowing, yet laced with unanswerable questions. MH

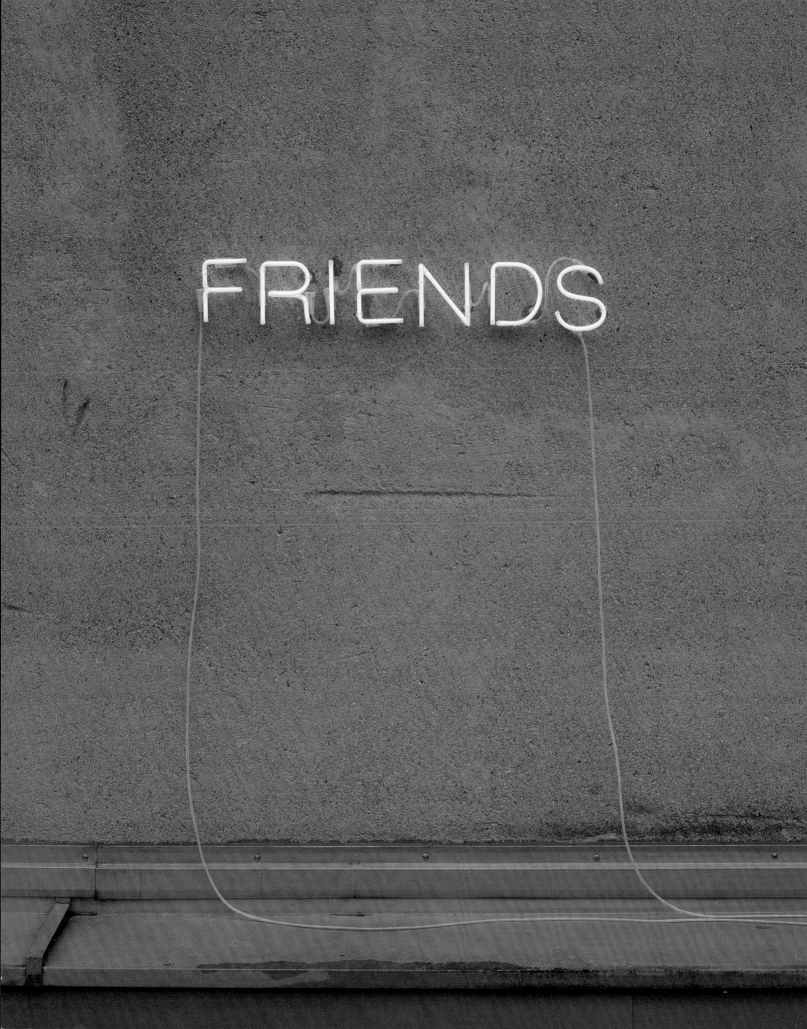

**Selected by**
Galerie Rüdiger Schöttle
B21

**Also shown by**
Gavin Brown's enterprise
F9
Hauser & Wirth D6

**Biography**
Born 1968
Lives in London

British artist Creed, recently the subject of a mid-career retrospective presented at the Hayward Gallery, London (2014), has held solo exhibitions internationally, at venues that include: Tate Britain, London (2013); Cleveland Museum of Art, OH (2012); Museum of Contemporary Art, Chicago (2012); Musée d'art moderne et d'art contemporain, Nice, France (2011); Moscow Museum of Modern Art (2010); MoMA, New York (2009); Artsonje Center, Seoul (2009); Centre Pompidou, Paris (2009); and Van Abbemuseum, Eindhoven (2004). In 2001 Creed was awarded the Turner Prize.

*Friends*
2013
Green neon
15 × 97 × 6 cm
5⅞ × 38¼ × 2⅜"
Courtesy of Galerie Rüdiger Schöttle

# Martin Creed

Why do anything? Martin Creed's sculptures, paintings, actions, videos and installations are momentary impulses, fleeting ideas that are then simply given a number and produced. Whether it's his Turner Prize-winning *Work No. 227: The Lights Going On and Off* (2000) or *Work No. 503* (2006), a video of a girl vomiting copiously on a white floor, Creed's work is as much about our own scattered thoughts and what we choose to do with them as about any finished object. *Friends* (2013) is simply the word in green neon on a wall—at once a statement, an invitation and an offered theme for thought. Creed collects these moments of whimsy with a no-nonsense directness, leaving them for us to provide our own answers why. CFW

2

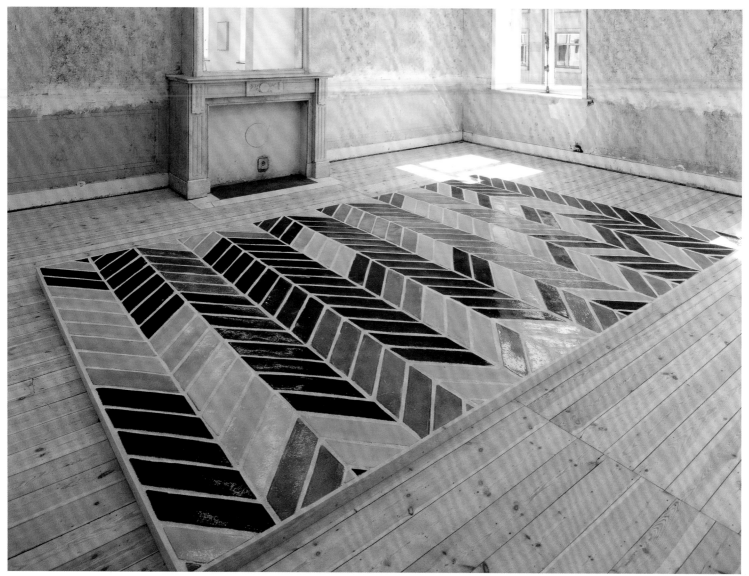

1

**Selected by**
Galerie Catherine
Bastide C15

**Also shown by**
Galerie Nordenhake B11

**Biography**
Born 1974
Lives in New York

Crowner has been the
subject of solo and two-
person exhibitions held
at: Galerie Catherine
Bastide, Berlin (2014
and 2011); Kunstverein
Amsterdam (2013);
Galerie Nordenhake,
Stockholm (2012); Helena
Papadopoulos, Athens
(2011); and daadgalerie,
Berlin (2008). She has
participated in select
group shows at venues
that include: WIELS
Contemporary Art
Centre, Brussels (2013);
ICA, Philadelphia (2013);
MoMA, New York (2013);
Whitney Museum of
American Art, New York
(2010); White Columns,
New York (2009 and
2006); and The Kitchen,
New York (2008).

1
*Motifs*
2013
Glazed terracotta
tiles handmade in
Guadalajara, Mexico
Dimensions variable
Courtesy of Galerie
Catherine Bastide

2
*Flying Painting*
2013
Two panels: oil on canvas,
gouache and raw canvas,
sewn
Each 1.52 × 1.98 m
5' × 6' 6"
Courtesy of Galerie
Catherine Bastide

# Sarah Crowner

Sarah Crowner makes her exuberantly composed abstract paintings by sewing together pieces of canvas—raw, or painted or dyed in vivid colours—giving painting the energy of collage. Her inclusion of ceramics and wooden objects reflects her emphasis on materiality. She also creates viewing platforms that cast viewers as protagonists: in *The Wave (Flame)* (2014), a raised floor with glazed turquoise terracotta tiles offers a charged perspective on flame-like abstractions that engage in a dialogue with the herring-bone tiled floor. Approaching art history as another medium, Crowner invokes the work of Sophie Taeuber-Arp, Lygia Clark and Bridget Riley. She also resurrects the cross-pollination between theatre and the visual arts of the early 20th-century avant-garde, as in *Curtain (Vidas Perfectas)* (2011), a dynamic stage backdrop. KMJ

**Selected by**
kurimanzutto D7

**Also shown by**
Mendes Wood DM H2
Wien Lukatsch G7

**Biography**
Born 1975
Lives in Berlin

Winner of the Zurich
Art Prize in 2012 and the
Prix de Rome in 2004,
Mexico-born artist
Deball has presented solo
exhibitions and projects
at venues that include:
Centre for Contemporary
Arts, Glasgow (2013);
Chisenhale Gallery,
London (2013); Museo
Experimental El Eco,
Mexico City (2011);
Museum of Latin
American Art, Long
Beach, CA (2010); Kunst
Halle Sankt Gallen,
Switzerland (2009);
and Stedelijk Museum,
Amsterdam (2004). She
was a participant in
Documenta 13, Kassel
(2012).

1–3
*Umriss*
2014
Wooden masks from
Guatemala kept in
the Studiensammlung
(Study Collection),
Ethnologisches Museum,
Berlin
Laser chrome mounted on
Dibond
Dimensions variable
Courtesy of
kurimanzutto

# Mariana Castillo Deball

Mariana Castillo Deball's colourful sculptural installations playfully twist through a space where mathematical, philosophical and aesthetic considerations are indistinguishable. Her '*Umriss*' (Contour, 2014) series of photographs captures the inside of a set of wooden Guatemalan masks kept in Berlin's Ethnologisches Museum. Shot against bright red, yellow and blue reflective backgrounds, it's as if she invites us to don the masks and step into an awaiting carnival. Blending different disciplines like an exuberant Western 17th-century polymath, she merges colonial trajectories and craft methodologies in her work to suggest a quietly pensive angle on both past and future potential forms of knowledge, arrived at through paradoxical, shape-shifting, narrative sedimentation. CFW

1

2

3

4

**Selected by**
Marianne Boesky Gallery
B14

**Biography**
Born 1974
Lives in Vienna

Austrian artist
Deininger has shown
solo exhibitions at such
galleries as: Marianne
Boesky Gallery, New
York (2013); Galerie
Martin Janda, Vienna
(2013 and 2010); Factory,
Kunsthalle Krems,
Austria (2012); and Bank
Austria Kunstforum,
Vienna (2011). She
participated in the 5th
Beijing International Art
Biennial (2012) and, as the
recipient of the Strabag
Art Award in 2012,
was the subject of an
exhibition at Strabag Art
Lounge, Vienna, in 2013.

1
*Untitled*
2013
Oil on canvas
30.5 × 33 cm
12 × 13"
Courtesy of Marianne
Boesky Gallery

2
*Untitled*
2013
Oil on canvas
28 × 20.5 cm
11 × 8"
Courtesy of Marianne
Boesky Gallery

3
*Untitled*
2013
Oil on canvas
28 × 20.5 cm
11 × 8"
Courtesy of Marianne
Boesky Gallery

4
*Untitled*
2013
Oil on canvas
28 × 20.5 cm
11 × 8"
Courtesy of Marianne
Boesky Gallery

# Svenja Deininiger

A painting, for Svenja Deininger, is the concrete realization of a set of medium-specific questions. As a result, the colourful yet muted abstraction explored in works presented here—all titled as *Untitled,* and all completed in 2013—can be seen as the resolution of inquiries into problems of formal composition, harmony and the presentation of space. 'It is important to me that painting can be seen as process,' says Deininger. That such a potentially austere and academic undertaking has resulted in the uncluttered and inviting surfaces of her works is not only a testament to her abilities as a painter, but also evidence of the medium's enduring relevance and singular potential to affect. MQ

**Selected by**
Campoli Presti B9

**Also shown by**
Galerie Buchholz C10

**Biography**
Born 1966
Lives in New York

Boston-born Deschenes,
who from November
2014 will exhibit a solo
show at Walker Art
Center, Minneapolis, has
previously presented solo
exhibitions at: Campoli
Presti, Paris (2013 and
2009), London (2013,
2009 and 2007), and
Brussels (2010); Miguel
Abreu, New York (2014,
2009 and 2007); and
Secession, Vienna (2012).
Her work has been seen
in group shows exhibited
at venues that include:
MoMA, New York (2014);
Fotomuseum Winterthur,
Switzerland (2013);
Whitney Museum of
American Art, New York
(2012); Art Institute of
Chicago (2012); Jewish
Museum of Belgium,
Brussels (2011); New
Museum, New York
(2011); Tate Liverpool,
UK (2009); and The
Photographers' Gallery,
London (2002).

*Bracket (London)*
2013
Installation view at
Campoli Presti, London
2013
Dimensions variable
Courtesy of Campoli
Presti

# Liz Deschenes

According to the long-standing orthodoxy of Roland Barthes, the photograph is a trace of what 'has been'. Liz Deschenes, however, combines photography's most elemental components to produce work that is emphatically present. In concurrent exhibitions held at Campoli Presti, London and Paris, in 2013, the artist presented geometric panels of deep viridian and silvery photogram whose surfaces seemed tarnished, as if by the touch of gloveless fingers, collectively titled 'Bracket'. These works continue to oxidize, producing a faint, constant reflection of atmospheric conditions. A bracket is not a frame: it encloses but does not seal off. This porous kind of division is consistent with a practice in which the spaces between and around works—and the only ever partial vision that this suggests—are as significant as the objects themselves. AS

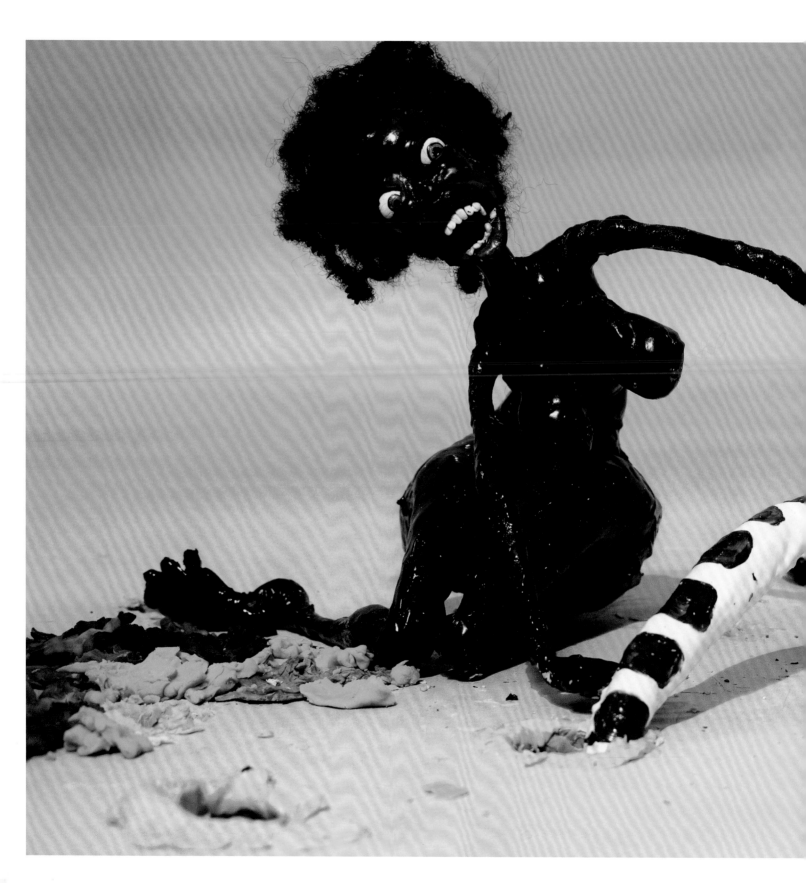

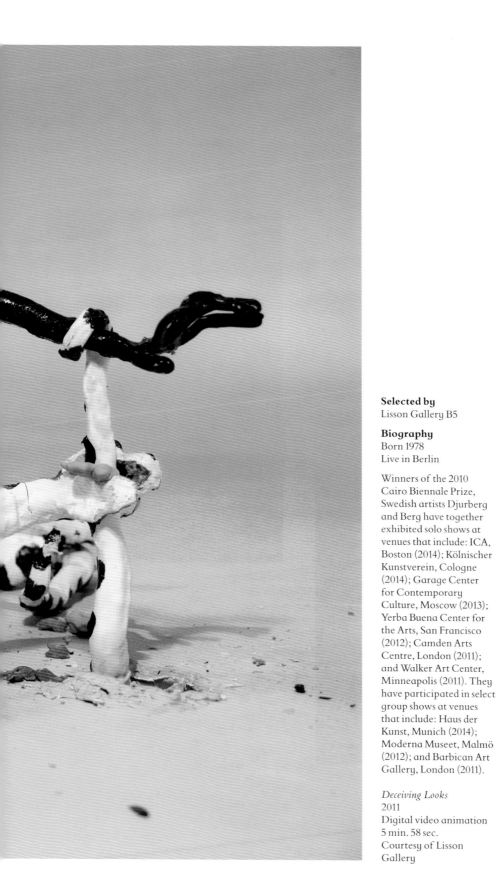

# Nathalie Djurberg & Hans Berg

**Selected by**
Lisson Gallery B5

**Biography**
Born 1978
Live in Berlin

Winners of the 2010
Cairo Biennale Prize,
Swedish artists Djurberg
and Berg have together
exhibited solo shows at
venues that include: ICA,
Boston (2014); Kölnischer
Kunstverein, Cologne
(2014); Garage Center
for Contemporary
Culture, Moscow (2013);
Yerba Buena Center for
the Arts, San Francisco
(2012); Camden Arts
Centre, London (2011);
and Walker Art Center,
Minneapolis (2011). They
have participated in select
group shows at venues
that include: Haus der
Kunst, Munich (2014);
Moderna Museet, Malmö
(2012); and Barbican Art
Gallery, London (2011).

*Deceiving Looks*
2011
Digital video animation
5 min. 58 sec.
Courtesy of Lisson
Gallery

The recurrent fate of Nathalie
Djurberg's hyper-sexualized Claymation
characters includes self-dismembering,
castration, lobotomy, cannibalism
and other unnameable desecrations
of the human body. Like distinctly
*outré* fairy tales mined from the Freudian
unconscious, Djurberg's videos are both
difficult to watch and utterly compelling.
With eerie music by composer and
collaborator Hans Berg, *Deceiving Looks*
(2011) features a naked female figure in
a Sahara-yellow desert entangled in
mortal battle with snakes that emerge
from the sand. The artist duo frequently
exhibit their videos alongside monstrous
sculptures (of plants, humans or birds)
by Djurberg, creating disquieting
immersive environments. Her work
differs from significant predecessors
(such as Jan Švankmajer or the Brothers
Quay) in her feminist stance in favour
of female fantasies rooted in both fear
and desire. CP

What in life could

be more extatic

an occupation than

putting orchids in

an ice-box & then

taking them out again?

1

2

3

**Selected by**
Ancient & Modern G4

**Biography**
Born 1973
Lives in London

Hamburg-born Eichelmann has presented solo and two-person exhibitions at venues that include: Ancient & Modern, London (2013 and 2010); Silverman Gallery, San Francisco (2011); Galerie Andreas Huber, Vienna (2008 and 2005); ArtHouse, Dublin (2000); and Cubitt Gallery, London (1998). He has participated widely in group shows, at venues that include: Mostyn, Llandudno, UK (2013); Galerie für Zeitgenössische Kunst, Leipzig (2012); Cornerhouse, Manchester, UK (2010); Zentrum für Kunst und Medientechnologie Karlsruhe, Germany (2006); and MAK, Vienna (2004).

1
*Untitled (Stephen Tennant IV)*
2011
Mixed media on paper
114 × 84 cm
44⅞ × 33⅛"
Courtesy of Ancient & Modern

2
*Veronika 'Willie' Vontberg-Foss*
2013
Collage on card
65 × 50 cm
25⅝ × 19⅝"
Courtesy of Ancient & Modern

3
*Nora St John Smith*
2012
Collage on card
70 × 50 cm
27½ × 19⅝"
Courtesy of Ancient & Modern

4
*Zelah and Mulfra, The Indian Queens*
2013
Collage on card
65 × 50 cm
25⅝ × 19⅝"
Courtesy of Ancient & Modern

# Volker Eichelmann

The hazy, bucolic summer indolence of the bourgeoisie permeates London-based Volker Eichelmann's painting *Untitled (Stephen Tennant IV)* (2011). It is a bright mix of abstraction and bold black text, which quotes from the eponymous poet: 'What in life could be more extatic [*sic*] an occupation than putting orchids in an ice-box & then taking them out again?' In many ways *Untitled* is the perfect metaphysical distillation of Eichelmann's concerns. Here his interests in genteel country-house pursuits, in their architecture and landscapes during the 18th and 19th centuries, and the curious mid-20th-century practice of composing treatises on manners, comportment and taste come together in a painting that captures the essence of ennui born of affluence. MQ

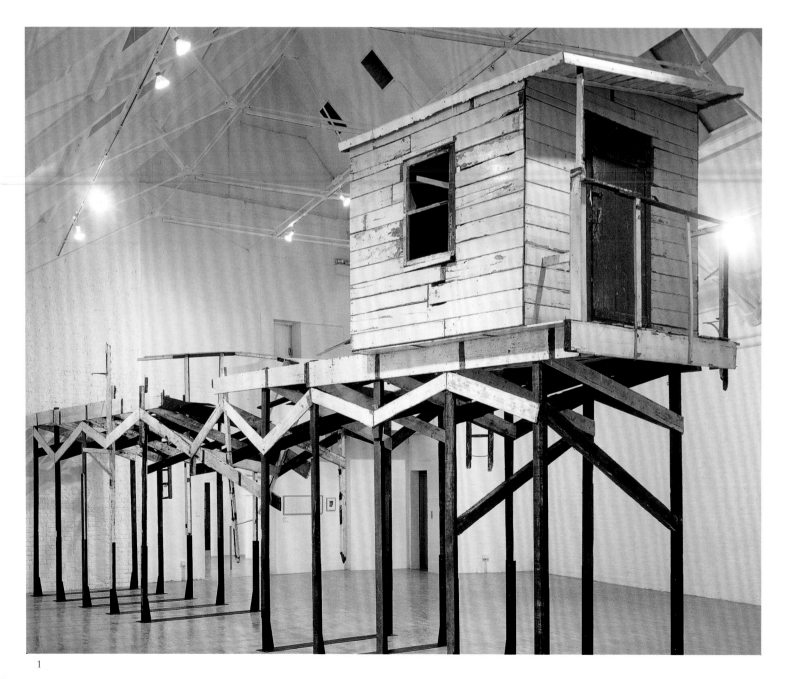

2

# Tracey Emin

From the outset of her career Tracey Emin has made the vicissitudes of her existence into artistic material, from her tumultuous upbringing in an English seaside town—see the ominous Margate beach hut on a rickety pier, *Knowing My Enemy* (2002)—to her adult personal life. The mode, only partly disguised by stylistic flexibility, is expressionist, whether Emin is making confessional texts in neon (for example, *My Heart Is With You Always*, 2014) and embroidery, autobiographical videos or her infamously dissolute *My Bed* (1998). Increasingly her art appears to have forecast the garrulous over-sharing of today's youth, but it uses the prism of the personal to approach large-scale concerns such as violence against women, love and loneliness, demonstrating that Emin's tribulations are, to some degree, everyone's. MH

1

2

3

**Selected by**
Stephen Friedman
Gallery C7

**Biography**
Born 1912
Died 2006

The work of Argentinian artist Espinosa has been presented in posthumous exhibitions at: Stephen Friedman Gallery (2014); Museo de Arte Contemporaneo de Buenos Aires (2013); Sicardi Gallery, Houston, TX (2013 and 2010); and Museo Nacional de Bellas Artes, Neuquén, Argentina (2009). His work is held in the public collections of: Fondo Nacional de las Artes, Buenos Aires; Museo de Arte Moderno de Buenos Aires; Blanton Museum of Art, The University of Austin, TX; Museo Nacional de Bellas Artes, Buenos Aires; and RISD Museum, Rhode Island School of Design, Providence, RI.

1
*Emina*
1968
Acrylic on canvas
1.5 × 1.5 m
4' 11" × 4' 11"
Courtesy of Stephen
Friedman Gallery and
Sicardi Gallery

2
*Agarnixg*
1966
Oil on canvas
1.5 × 1 m
4' 11" × 3' 3⅜"
Courtesy of Stephen
Friedman Gallery and
Sicardi Gallery

3
*Untitled*
c.1970
Oil on canvas
1.5 × 1 m
4' 11" × 3' 3⅜"
Courtesy of Stephen
Friedman Gallery and
Sicardi Gallery

# Manuel Espinosa

Like the phases of the moon, or the path of the sun across the sky, Manuel Espinosa's abstract paintings summon both time and light through their elegant, geometric cadences and sensual adherence to grid and structure. The late artist was a co-founder of the Asociación de Arte Concreto-Invención, a Concrete Art movement formed shortly after World War II by a group of Buenos Aires artists disillusioned with representational painting and inspired by the world of material innovations to be found in Geometric Abstraction. Espinosa's paintings of the 1960s and '70s often feature repetitions of a single shape, such as a circle or square, layered in degrees of intensity and contrast so that pale colours create haloes around units of more intense pigment. LMcLF

**Selected by**
Standard (Oslo) D1

**Also shown by**
Galerie Eva Presenhuber
F3

**Biography**
Born 1973
Lives in Oslo

Faldbakken has been
the focus of solo
presentations held at
venues that include:
Standard (Oslo) (2014,
2012, 2010, 2007 and
2005); Le Consortium,
Dijon, France (2013);
WIELS Contemporary
Art Centre, Brussels
(2012); Museum
Boijmans van Beuningen,
Rotterdam (2012); The
Power Station, Dallas
(2011); Ikon Gallery,
Birmingham, UK (2009);
and Kunst Halle Sankt
Gallen, Switzerland
(2009). Public collections
that hold his works
include: Astrup Fearnley
Museet, Oslo; National
Museum of Art, Design
and Architecture, Oslo;
Jumex Collection, Mexico
City; and MoCA, Los
Angeles.

*Untitled (Canvas #51
Poster Man)*
2012
Marker pen on Belgian
linen
1.52 × 1.52 m
5 × 5'
Courtesy of Standard
(Oslo)

# Matias Faldbakken

Fittingly for an artist whose 2008 novel *Unfun* takes Ad Reinhardt's phrase 'Stay with the negative' for its epigraph, Matias Faldbakken's work frequently combines the visual language of Minimalism and abstraction with a nihilistic punk Conceptualism. A gestural row of crosses marks the erasure of identity in *The Name of a Person That I Want Dead, Written in Xs* (2006); he scrawls across a wall of brick tiles in *Untitled (Remainder #XV)* (2011) and renders brutal grids in white marker on plastic bags, cardboard or canvas, as in *Untitled (Canvas #51 Poster Man)* (2012). Giving material form to defacement, negation and excision, Faldbakken shows how art can not only stay with the negative but stay true to it. MMcL

1

2

3

**Selected by**
Galerie Peter Kilchmann
A17

**Biography**
Born 1953
Lives in Burgundy

Zurich-born artist
Fehr has presented solo
exhibitions at galleries
and institutions that
include: Galerie Peter
Kilchmann, Zurich
(2014); Helmhaus, Zurich
(2011); and Thomas
Amman Fine Art AG,
Zurich (2006). His work
is held in the public
collections of institutions
that include: Aargauer
Kunsthaus, Aarau,
Switzerland; National
Art Collection, Bern;
Kunsthaus Zürich; and
Kunstmuseum Olten,
Switzerland.

1
*Midas*
2009
Oil on canvas
2 × 2.9 m
6' 6¾" × 9' 6⅛"
Courtesy of Galerie Peter
Kilchmann

2
*Pierrot et Colombine*
(Pierrot and Colombine)
2009
Oil on canvas
2.8 × 5.8 m
9' 2¼" × 19' ⅜"
Courtesy of Galerie Peter
Kilchmann

3
*Nature morte de chasse*
(Hunting Still Life)
2014
Oil on canvas
1 × 1.31 m
3' 3⅜ × 4' 3⅝"
Courtesy of Galerie Peter
Kilchmann

# Marc-Antoine Fehr

Marc–Antoine Fehr's paintings draw on the world of the travelling funfair, but their import is deadly serious. Puppets bruised by years of service attain sentience; others are put on trial. See *Midas* (2009), the titular gold-obsessed figure held out by the artist's hand like a miniature war criminal, or the chipped, pondering Pierrot used in a game where balls were thrown at him and capped with a hat like a traffic cone. Fehr's *oeuvre*, elsewhere gravitating to skulls and deserted beer-garden tables, accordingly creates a liminal world between Punch & Judy and protest sites. His classical technique might suggest the timelessness of strife between dominators and dominated; unquestionably, though, he's speaking— at a sly remove—about right now. MH

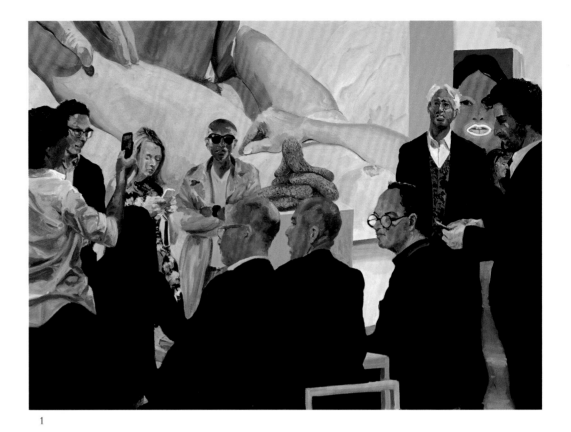

1

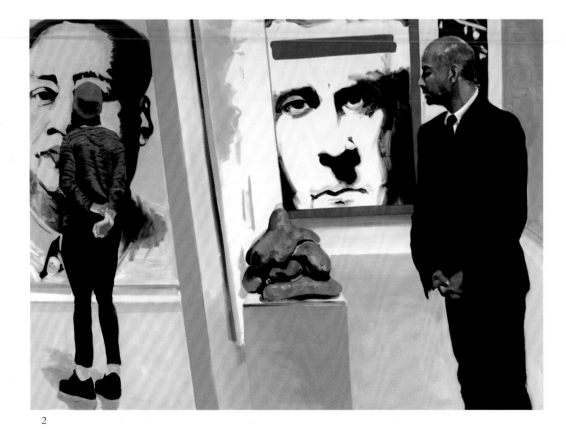

2

**Selected by**
Victoria Miro B3

**Biography**
Born 1948
Lives in New York

Fischl has been the subject
of solo presentations held
at: Albertina, Vienna
(2014); San Jose Museum
of Art, CA (2012); Centro
de Arte Contemporáneo
de Málaga, Spain
(2010); Kunstmuseum
Wolfsburg, Germany
(2003); Gagosian Gallery,
London (2000); Walker
Art Center, Minneapolis
(1990); and Saint Louis
Art Museum, St Louis,
MO (1986). His works
are held in the public
collections of institutions
internationally. These
include: the Art Institute
of Chicago; Solomon R.
Guggenheim Musuem,
New York; ICA, London;
Centre Pompidou, Paris;
MoMA, New York;
MoCA, Los Angeles;
National Gallery of
Canada, Ottawa; and
the Whitney Museum of
American Art, New York.

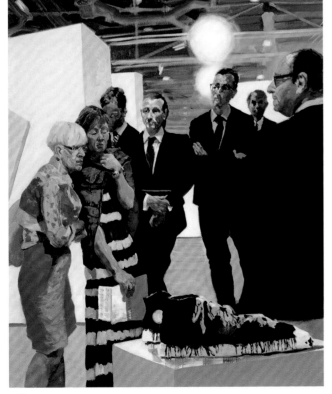

1
*Art Fair: Booth #4 The
Price*
2013
Oil on linen
2.08 × 2.84 m
6' 10" × 9' 4"
Courtesy of Victoria
Miro and Mary Boone
Gallery

2
*Art Fair: Booth #16 Sexual
Politics*
2014
Oil on linen
2.08 × 2.84 m
6' 10" × 9' 4"
Courtesy of Victoria
Miro and Mary Boone
Gallery

3
*Art Fair: Booth #1
Oldenburg's Sneakers*
2013
Oil on linen
2.08 × 1.72 m
6' 10" × 5' 8"
Courtesy of Victoria
Miro and Mary Boone
Gallery

# Eric Fischl

Eric Fischl's paintings have long involved
looking at looking—see an indelible
early work such as the voyeuristic youth/
older woman scenario *Bad Boy* (1981),
after which he recently titled his memoir.
But he's long diversified and nuanced
uneasy spectatorship, whether in later
paintings of bullfights or, most recently,
scenes at art fairs. Here, as collectors
coolly assess a pricey piece of Pop
(*Art Fair: Booth #1 Oldenburg's Sneakers*,
2013), or as a gallerist sizes up a visitor's
rear while she, in turn, sizes up a Warhol
Mao (*Art Fair: Booth #16 Sexual Politics,*
2014), Fischl presents an environment
overflowing with discomfiting
acquisitive observation—and, through
expert limning of expression, gesture
and the excitable cool of the booths,
he enlists our gaze too. MH

1

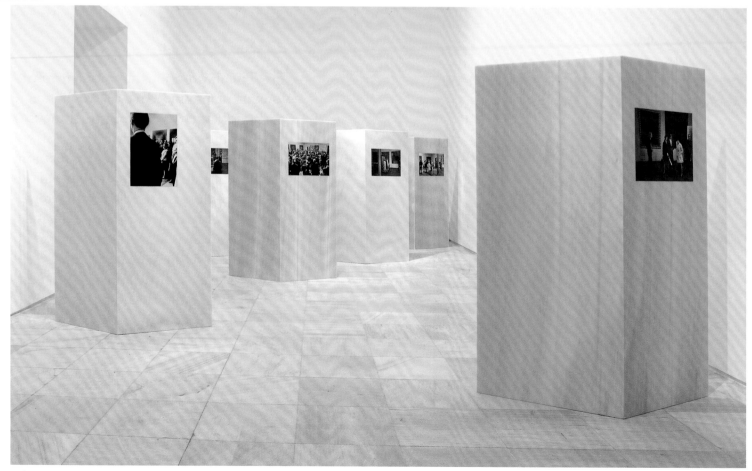

2

3

**Selected by**
Georg Kargl Fine Arts B18

**Biography**
Born 1977
Lives in Vienna

Vienna native Fogarasi
has exhibited solo
shows at: Galerie für
Zeitgenössische Kunst,
Leipzig (2014); Museum
Haus Konstruktiv, Zurich
(2014); Prefix Institute
of Contemporary Art,
Toronto (2013); Museo
Nacional Centro de
Arte Reina Sofía,
Madrid (2011); Grazer
Kunstverein, Graz,
Austria (2008); and also
at the Hungarian Pavilion
at the 52nd Venice
Biennale (2007). His
work is held in the public
collections of institutions
that include: FRAC
des Pays de la Loire,
France; Ludwig Museum
of Contemporary Art,
Budapest; and MAK,
Vienna. Fogarasi has a
forthcoming exhibition
with Oscar Tuazon at
MAK Center for Art and
Architecture, Los Angeles,
from November 2014.

1
*LED China*
2012
Digital C-type print
50 × 75 cm
19⅝ × 29½"
Courtesy of Georg Kargl
Fine Arts

2
*Vasarely Go Home*
2011
Six objects with
photographs and marble
Each: 148 × 110 × 36 cm
58¼ × 43¼ × 14⅛"
Courtesy of Georg Kargl
Fine Arts

3
*Vasarely Go Home –
Weaving (Dóra Maurer)*
2012
Inkjet print and coloured
paper on grey Carrara
marble
30 × 25 × 3 cm
11¾ × 9⅞ × 1⅛"
Courtesy of Georg Kargl
Fine Arts

# Andreas Fogarasi

Cultural identity, urban space and
national branding are recurrent
concerns for Andreas Fogarasi.
*Vasarely Go Home* (2011) began as an
interview-led documentary film about
Hungarian artist Victor Vasarely's first
exhibition of abstract art in Budapest;
during the 1969 opening, artist János
Major showed friends a small sign
with the injunction 'Vasarely go home!'
The video explores the political–
personal underpinnings behind this
action, which occurred at a key juncture
for avant-garde art in Hungary.
Fogarasi's objects, photographs and
installations often develop from his
historical and urban design research:
for the exhibition of the same title,
he extended the documentary into the
exhibition space, where photographs
were pasted on marble objects, nodding
to Modernist sculpture while serving
as wall dividers. PL

ARTISTS

1

2

**Selected by**
Mary Mary J3

**Biography**
Born 1981
Lives in London

Frost has been the subject
of solo exhibitions at
venues that include:
BolteLang, Zurich (2013);
Mary Mary, Glasgow
(2012); Christian
Andersen, Copenhagen
(2012); Hotel, London
(2011); Galerie Micky
Schubert, Berlin (2009);
and Jerwood Space,
London (2006). Recent
group shows include:
'Open Heart Surgery',
The Moving Museum,
London (2013); 'Signs
and Messages II', Kate
MacGarry, London
(2013); 'Managing
Bounces', Cell Project
Space, London (2013);
and 'Dovble Trovble',
Centre for Contemporary
Arts, Glasgow (2012).
Frost recently presented
a solo off-site project at
Glasgow International
Festival (2014).

1
*And Then I Met Some Tech
People Who Could Make
It Look Like I Was Talking
< > AZQ*
2014
Acrylic on linen
1.5 × 1.4 m
4' 11" × 4' 7⅛"
Courtesy of Mary Mary

2
*You Suck At Chiaroscuro
< > 2.0*
2014
Acrylic on linen
1.6 × 1.5 m
5' 3" × 4' 11"
Courtesy of Mary Mary

3
*AZQ <> AZQ <> ART*
2013
Installation view at
BolteLang, Zurich
Mixed media
Dimensions variabe
Courtesy of Mary Mary

3

# Alistair Frost

Alistair Frost clicks on painting and
drags it into an art operating system
of ready-made graphics and pre-loaded
expressive gestures. In his canvases and
wall paintings, icons purloined from
outmoded computer clip art and
characters that look like they have been
borrowed from literary cartoons offer
a droll take on obsolescence and the
rendering of abstract art. Paint motifs
and canned brushstrokes abound, as do
Martini-glass watermarks, jauntily
penned office equipment and pastel-
coloured leisurewear. Filed under titles
such as *You Suck at Chiaroscuro < > 2.0*
(2014), Frost's paintings have been shown
alongside cocktail-filled water-coolers
and dressing-gowned mannequins—
they're jocular and at ease, as if décor
from the office of some party-hard
tech start-up. MA

**Selected by**
Galerie Meyer Kainer F12

**Also shown by**
Green Tea Gallery L3
Gió Marconi B2
Overduin & Co. B20

**Biography**
Born 1979
Lives in New York

Gambaroff received his MFA from Bard College School of Visual Arts in New York. Recent solo exhibitions include: 'Tales from the Crypt', Galerie Meyer Kainer, Vienna (2014); 'Quality Interiors', Gió Marconi, Milan (2013); 'Tools for Living', Overduin & Co, Los Angeles (2012); 'I Am Real Estate', The Power Station, Dallas (2012); and 'Der Herrische Säugling', Balice Hertling, Paris (2011). He has participated in recent group shows at Galerie Meyer Kainer, Vienna (2013), and the Australian Center for Contemporary Art, Melbourne (2013).

*Untitled*
2014
Paper and acrylic on honeycomb aluminium
2.44 × 1.22 m
8' ⅛" × 4'
Courtesy of Galerie Meyer Kainer

# Nikolas Gambaroff

Sitting at an unexpected crossroads between gestural abstraction and Pop, Nikolas Gambaroff's paintings are constructed through a process of embedding passages of paint within layers of printed matter (newspapers, advertising posters), sections of which are then torn away to create what appear to be calligraphic marks, letters from a secret and perhaps nonsensical alphabet. In his recent works, such as *Untitled* (2014), the artist has employed American comic books, among them Alan Moore and Dave Gibbons's seminal *Watchmen* (1986). Gambaroff's mock-chaotic ripping of *Watchmen*'s pages (famous among comics fans for their symmetrical structure and use of a rigid, nine-panel grid) is a playful profaning of an acknowledged classic, speaking to ideas of artistic patrimony, the anxiety of influence and generational revolt. TM

1

2

3

**Selected by**
Laura Bartlett Gallery H3

**Biography**
Born 1978
Lives in London

Gibson has been the
subject of solo exhibitions
held at: Centre
d'art contemporain
Brétigny, France
(2013); Index – The
Swedish Contemporary
Art Foundation,
Stockholm: (2013); The
Showroom, London
(2012); Kunstverein
Amsterdam (2011);
Künstlerhaus Stuttgart
(2010); Serpentine Sackler
Gallery, London (2010);
and Contemporary Art
Museum St. Louis, MO
(2008). Solo screenings
of Gibson's work have
taken place at: the High
Line, New York (2014);
Whitechapel Gallery,
London (2013); Centre
Pompidou, Paris (2013);
Anthology Film Archives,
New York (2012); and the
Centre for Contemporary
Arts, Glasgow (2010).
Her work was recently
included in 'Assembly:
A Survey of Artist's Film
and Video in Britain
2008–2013', Tate Britain,
London (2014). Gibson
was nominated for the
2014 Max Mara Prize for
Women Artists and The
Jarman Award in 2013.

1
*A Necessary Music*
2008
HD video
29 min.
Courtesy of Laura
Bartlett Gallery

2, 3
*The Tiger's Mind*
2012
16 mm film transferred to
HD video
23 min.
Courtesy of Laura
Bartlett Gallery

4
*The Future's Getting Old
Like the Rest of Us*
2010
16 mm film transferred to
HD video
48 min.
Courtesy of Laura
Bartlett Gallery

4

# Beatrice Gibson

A breathtaking, panoramic tracking shot takes in the iconic New York skylines of Manhattan, Queens and Roosevelt Island, opening Beatrice Gibson's *A Necessary Music* (2008), an ambitious and at times hauntingly austere piece exploring the lives of Roosevelt Island's inhabitants and the idea of community. In her 2012 work *The Tiger's Mind*, Gibson's interest in experimental group processes and modes of composition as practised by British musician Cornelius Cardew finds form as a surreal crime-thriller set within the grounds of a Modernist villa. Gibson explores collectivity again in *The Future's Getting Old Like the Rest of Us* (2010), taking inspiration from B.S. Johnson's innovative novel *House Mother Normal* (1971) to create a complex polyvocal narrative within the setting of an old people's home. MQ

1

2

6

5

**Selected by**
Laura Bartlett Gallery H3

**Biography**
Born 1978
Lives in London

Gibson has been the subject of solo exhibitions held at: Centre d'art contemporain Brétigny, France (2013); Index – The Swedish Contemporary Art Foundation, Stockholm: (2013); The Showroom, London (2012); Kunstverein Amsterdam (2011); Künstlerhaus Stuttgart (2010); Serpentine Sackler Gallery, London (2010); and Contemporary Art Museum St. Louis, MO (2008). Solo screenings of Gibson's work have taken place at: the High Line, New York (2014); Whitechapel Gallery, London (2013); Centre Pompidou, Paris (2013); Anthology Film Archives, New York (2012); and the Centre for Contemporary Arts, Glasgow (2010). Her work was recently included in 'Assembly: A Survey of Artist's Film and Video in Britain 2008–2013', Tate Britain, London (2014). Gibson was nominated for the 2014 Max Mara Prize for Women Artists and The Jarman Award in 2013.

1
*A Necessary Music*
2008
HD video
29 min.
Courtesy of Laura Bartlett Gallery

2, 3
*The Tiger's Mind*
2012
16 mm film transferred to HD video
23 min.
Courtesy of Laura Bartlett Gallery

4
*The Future's Getting Old Like the Rest of Us*
2010
16 mm film transferred to HD video
48 min.
Courtesy of Laura Bartlett Gallery

4

# Beatrice Gibson

A breathtaking, panoramic tracking shot takes in the iconic New York skylines of Manhattan, Queens and Roosevelt Island, opening Beatrice Gibson's *A Necessary Music* (2008), an ambitious and at times hauntingly austere piece exploring the lives of Roosevelt Island's inhabitants and the idea of community. In her 2012 work *The Tiger's Mind*, Gibson's interest in experimental group processes and modes of composition as practised by British musician Cornelius Cardew finds form as a surreal crime-thriller set within the grounds of a Modernist villa. Gibson explores collectivity again in *The Future's Getting Old Like the Rest of Us* (2010), taking inspiration from B.S. Johnson's innovative novel *House Mother Normal* (1971) to create a complex polyvocal narrative within the setting of an old people's home. MQ

2

1

3

4

5

**Selected by**
303 Gallery E5

**Biography**
Born 1953
Lives in New York

Gordon has been the focus
of solo exhibitions held at
galleries and institutions
that include: Gagosian
Gallery, Los Angeles
(2014); White Columns,
New York (2013); KS
ART, New York (2010
and 2008); Glaspaleis,
Heerlen, Netherlands
(2008); and Participant
Inc., New York (2003).
She has participated in
two-person and group
shows held at venues
that include: Renwick
Gallery, New York
(2013); 303 Gallery, New
York (2012); Kunsthalle
Düsseldorf (2009);
Malmö Konsthall (2009);
Reena Spaulings Fine
Art, New York (2007);
MoMA PS1, New York
(2006); and South London
Gallery (2005). In 2015
Gordon will present a solo
show at 303 Gallery, New
York.

1
*Chelsea Series (Goldchrome
Wreath)*
2014
Spray paint on canvas
1.52 × 1.22 m
5 × 4'
Courtesy of 303 Gallery

2
*Chelsea Series (Copper
Wreath)*
2014
Spray paint on canvas
1.52 × 1.22 m
5 × 4'
Courtesy of 303 Gallery

3
*Yellow Tears*
2009
Acrylic on linen
1.4 × 1 m
4' 7" × 3' 3½"
Courtesy of 303 Gallery

4
*Pussy Galore*
2009
Acrylic on linen
35.5 × 28 cm
14 × 11"
Courtesy of 303 Gallery

5
*Chelsea Series (Silver
Wreath 2)*
2014
Spray paint on canvas
1.52 × 1.22 m
5 × 4'
Courtesy of 303 Gallery

# Kim Gordon

Kim Gordon found fame with the
post-punk band Sonic Youth. Having
originally studied at the Otis Art Institute
in Los Angeles in the late '70s, she has
since worked in film, sculpture and
painting, as seen in her retrospective at
White Columns in New York in 2013.
The show included several of her 'Noise
Paintings', such as *Pussy Galore* (2009),
in which the name of this garage-rock
band is pasted across the canvas in bold,
dripping brushstrokes, alongside recent
'Twitter Paintings' featuring biting
excerpts from popular streams such
as critic @jerrysaltz. The spray-painted
wreaths of her 'Chelsea' series,
meanwhile, recall her earlier *Black
Glitter Circle* (2008): a floor piece with
the exact circumference of Gordon's
arm span that imagines a moment of
'rock trance'. EN

1

2

6

5

3

4

**Selected by**
Salon 94 A1

**Biography**
Born 1969
Lives in Berkeley, CA

Grannan has been the
subject of solo exhibitions
held at: Fraenkel Gallery,
San Francisco (2014,
2011 and 2008); Salon 94,
New York (2011, 2008
and 2003); Greenberg
Van Doren Gallery, St.
Louis, MO (2008, 2006
and 2005); Fifty One
Fine Art Photography,
Antwerp (2005, 2003 and
2001); and Michael Kohn
Gallery, Los Angeles
(2004). Select group shows
include: 'Something
about a Tree', The
FLAG Art Foundation,
New York (2013);
and 'We the People',
Robert Rauschenberg
Foundation, New York
(2012); and the two-
person exhibition 'The
Sun and Other Stars: Katy
Grannan and Charlie
White', shown at Los
Angeles County Museum
of Art (2012).

1
*Anonymous, Modesto, CA
2012*
2012

2
*Anonymous, Modesto, CA
2011*
2011

3
*Anonymous, Bakersfield,
CA 2012*
2012

4
*Anonymous, Oakland, CA
2012*
2012

5
*Anonymous, Bakersfield,
CA 2011*
2011

6
*Anonymous, Fresno, CA
2011*
2011

Archival pigment prints
on cotton rag paper
Each 99 × 73.5 cm
39 × 29"
All images courtesy of
Salon 94

# Katy Grannan

The light in Katy Grannan's
large-scale colour photographs and
video installations is vertical and without
pity. It's the light of LA or San Francisco
at noon, a light that lets no wrinkle,
scar, tattoo or even pore escape its
relentless cataract. Grannan's subjects
are sluiced with it, they have nowhere
to hide. There are precursors—Walker
Evans, Diane Arbus, Philip-Lorca
diCorcia—for this stark isolation of
her subjects, around whom background
detail fades to white. Her '99' series,
shot along the highway in central
California, returns to the region
photographed by Dorothea Lange.
But the figures don't look like archetypes;
their presentation and predicaments
seem too fragile for that. Poor, homeless,
marginal, eccentric: they so clearly want
to be something else or somewhere else
that they seem rooted to the spot. BD

1

2

3

**Selected by**
Galerie Perrotin A16

**Biography**
Born 1972
Lives in Paris

Grasso has presented
select solo shows at:
Galerie Perrotin,
Paris (2014); Musée
d'art contemporain de
Montréal (2013); Jeu de
Paume, Paris (2012);
Hirschhorn Museum
and Sculpture Garden,
Washington DC (2011);
Palais de Tokyo, Paris
(2009); Centre Pompidou,
Paris (2009); MIT List,
Visual Arts Center,
Cambridge, MA (2006);
and de Appel, Amsterdam
(2005). His work has been
exhibited in group shows
at venues that include:
Galeries nationales du
Grand Palais, Paris (2013);
Turner Contemporary,
Margate, UK (2013); the
9th Gwangju Biennial
(2012); and Mori Art
Museum, Japan (2011).

1
*Anechoic Wall (A)*
2010
Copper
1.01 × 1.61 × 0.19 m
3' 3¾" × 5' 3⅜" × 7½"
Courtesy of Galerie
Perrotin

2
*Anechoic Pavilion*
2011
Installation view at
Donjon de Vez, France
Mixed media
Courtesy of Galerie
Perrotin

3
*Studies into the Past*
Undated
Oil on wood panel
1.3 × 1 m
4' 3⅛" × 3' 3⅜"
Courtesy of Galerie
Perrotin

# Laurent Grasso

Laurent Grasso works across various
media, but has shown a consistent
interest in how authority manifests
itself—whether through the architecture
of power, through surveillance and
observation or through narrative, both
art-historical and other. In *On Air*
(2009) Grasso attached a camera to
the head of a falcon before releasing
the bird to soar up into the sky, drone-
like; *Anechoic Pavillion* (2011) provides
a frame for viewing the outside world
in the form of an imposing, monolithic
structure. But Grasso's exploration of
power goes beyond tools of surveillance.
He has appropriated the language of
art history in paintings that combine
Renaissance techniques with startlingly
incongruous details (*Studies into the Past*,
undated), calling into question our
assumptions about the image's gestation,
and the authority of history. KK

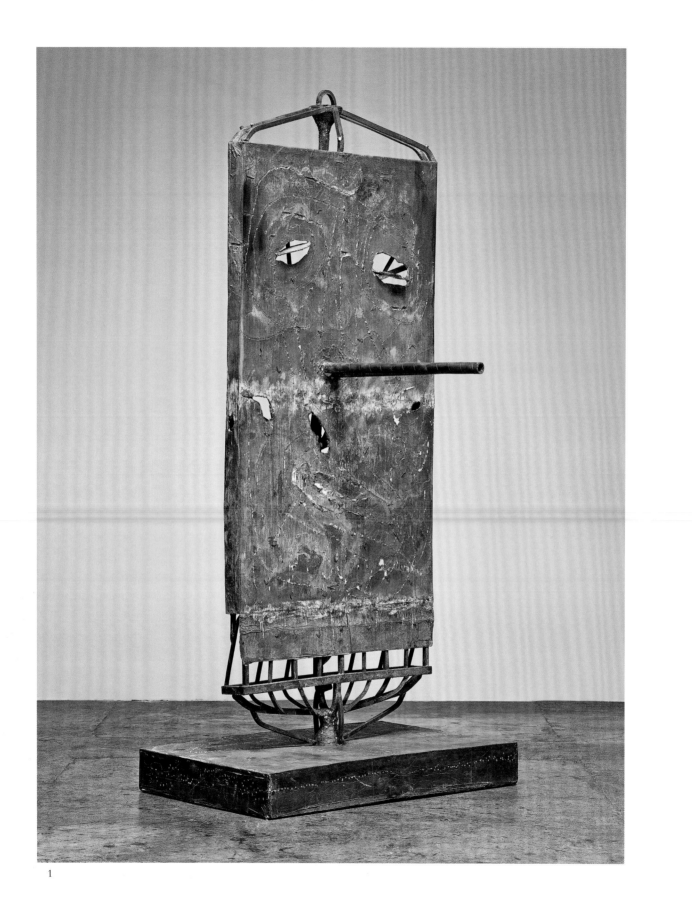

1

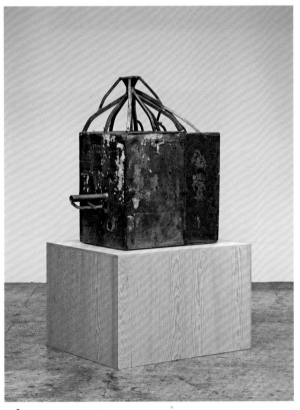

2

**Selected by**
Anton Kern Gallery E3

**Also shown by**
Blum & Poe A3
Gagosian Gallery C3

**Biography**
Born 1968
Lives in Los Angeles

Californian artist
Grotjahn has been the
subject of solo exhibitions
held at: Nasher Sculpture
Center, Dallas (2014);
Kunstverein Freiburg,
Germany (2014); Aspen
Art Museum, CO (2012);
Anton Kern Gallery, New
York (2011 and 2003);
Portland Art Museum,
OR (2010); and Whitney
Museum of American
Art, New York (2006).
He has participated in
select group shows at
Carnegie Museum of
Art, Pittsburgh (2013);
Gagosian Gallery,
London (2013); MoCA,
Los Angeles (2013);
Solomon R. Guggenheim
Museum, New York
(2012); San Francisco
Museum of Modern Art
(2011); Walker Art Center,
Minneapolis (2010);
New Museum, New
York (2010); and Saatchi
Gallery, London (2009).

1
*Untitled (Free-Standing Large Garden Sculpture Mask M24.f)*
2014
Bronze
2.77 × 1.36 × 1.31 m
9' 1" × 4' 4½" × 4' 3½"
Courtesy of Anton Kern Gallery

2
*Untitled (Top and Interior Gates, DeWalt Mask M33.b)*
2014
Bronze
1.14 × 0.6 × 1.07 m
3' 9" × 1' 11½" × 3' 6"
Courtesy of Anton Kern Gallery

# Mark Grotjahn

Few people know that beneath each of Mark Grotjahn's radiant 'Butterfly' paintings (2001–8) the artist first painted a face, the pictorial structure on which he hung the final abstract compositions. In subsequent paintings the straight lines of the 'Butterfly' paintings gave way to ropes of colour that wove around shapes denoting eyes, noses and mouths. Grotjahn's most recent works are bronze casts of masks that the artist once made, as studio exercises, from discarded cardboard boxes. Casts of more elaborate, mixed-media assemblages such as *Untitled (Free-Standing Large Garden Sculpture Mask M24.f)* (2014) demonstrate Grotjahn's commitment to reconfiguring powerful, Primitivist tropes of Modernist art through contemporary trash. JG

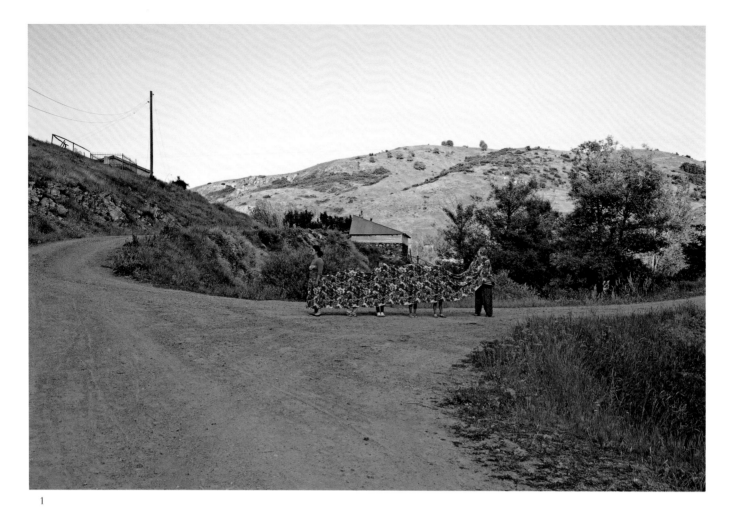

1

2

**Selected by**
Rampa G8

**Also shown by**
Galerie Martin Janda B12

**Biography**
Born 1977
Lives in Istanbul and
Vienna

Turkish artist Güreş has
exhibited solo shows
at: Galerie Martin
Janda, Vienna (2013);
Rampa, Istanbul (2013
and 2011); Künstlerhaus
Stuttgart (2011); InIVA,
London (2010); and
Salzburger Kunstverein,
Salzburg (2009). She has
participated in group
exhibitions that include
the 11th Istanbul Biennial
(2009); 'Nouvelles
Vagues/A History of
Inspiration', Palais de
Tokyo, Paris (2013);
'In Which Language
Shall I Tell My Story…',
Stedelijk Museum
Schiedam, Netherlands
(2012); and 'Dream and
Reality', Istanbul Museum
of Modern Art (2012).

1
*Cloth-Skirt*
2011
C-type print
1.2 × 1.8 m
3' 11¼ × 5' 10⅞"
Courtesy of Rampa and
Galerie Martin Janda

2
*Playing with a Water Gun*
From the series 'Çırçır'
2010
C-type print
1.2 × 1.8 m
3' 11¼ × 5' 10⅞"
Courtesy of Rampa and
Galerie Martin Janda

# Nilbar Güreş

In Nilbar Güreş's photographs and
videos there is a remarkable quantity
of fabric, artfully and eccentrically
deployed. In front of signposts in the
countryside, pointing in opposite
directions, stand two women joined
by a single headscarf. Four women sit
about on armchairs and a sofa, covered
in expanses of pale cloth over which
their dresses have been carefully draped.
On a dirt road in the sunshine, an
adult and four children hide under the
absurdly long skirt of another woman
(*Cloth-Skirt*, 2011). Güreş's staged but
matter-of-fact scenes are wryly related
to the history and present reality of
woman's place in Turkish society. BD

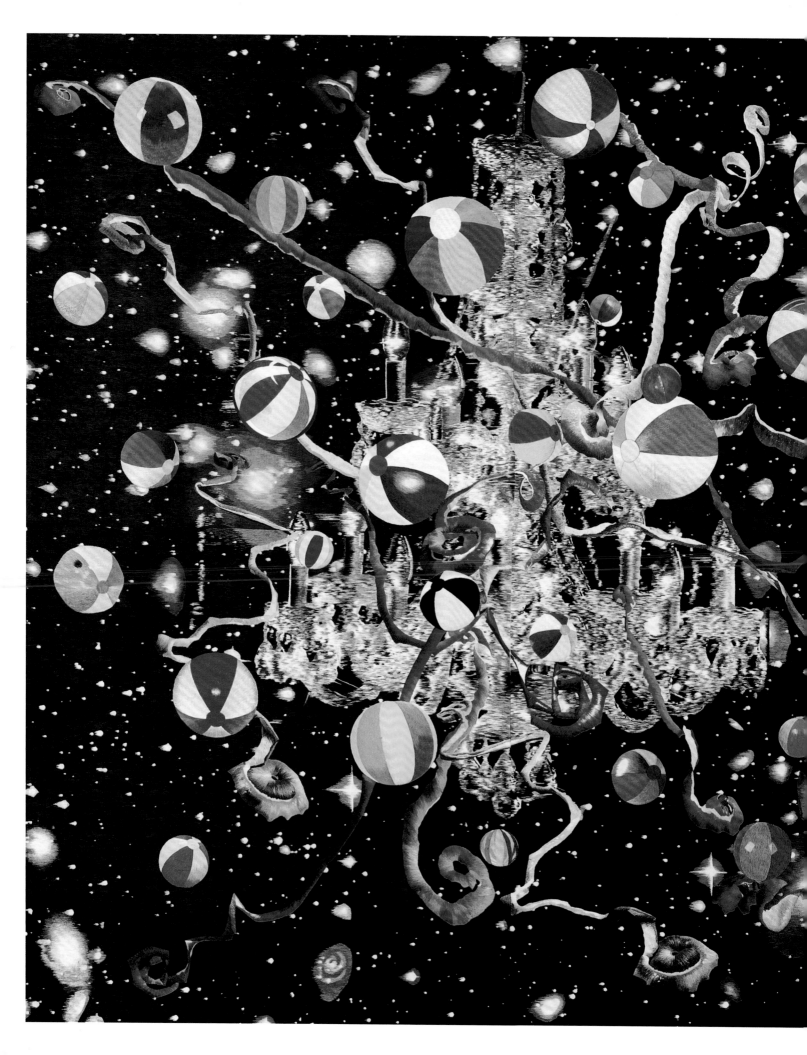

**Selected by**
Tina Kim Gallery B6

**Also shown by**
Kukje Gallery B6

**Biography**
Born 1966
Lives in Seoul

Korean artist Ham, who
in 2015 will exhibit a solo
show at Kukje Gallery,
Seoul, has previously
shown: 'Desire and
Anesthesia', Artsonje
Center, Seoul (2009);
'Such Game', Ssamzie
Space, Korea (2008);
and 'Room with a
View', Gallery Loop,
Seoul (1999). She has
participated in group
shows at venues that
include: Kunsthalle
Düsseldorf (2013);
National Museum of
Contemporary Art, Seoul
(2013); 9th Guangzhou
Triennial, Guangdong
Museum of Art, China
(2012); Singapore Art
Museum (2011); and
InIVA, London (2010).

*Until Dawn the Chessboard
Keeps Them in Its Strict
Confinement with Its Two
Colors Set at Daggers
Drawn*
2012–13
North Korean hand
embroidery on silk
1.85 × 1.88 m
6' ⅞" × 6' 2"
Courtesy of Tina Kim
Gallery

# Kyungah Ham

Whether fashioning vases containing bouquets of rifle butts from Korean blue and white porcelain or introducing a slick of oil to a Persian carpet, Kyungah Ham is concerned with how objects may be inhabited by traces of their own complex and, at times, bloody social and political histories. For her ongoing series of textile works, such as *Until Dawn the Chessboard Keeps Them in Its Strict Confinement with Its Two Colors Set at Daggers Drawn* (2012–13), the artist collects and collages images of violent unrest from the news media and sends them, via China, to a group of female artisans in North Korea, who embroider them on silk using traditional techniques. A model of cooperation in the face of conflict, these works are testament to the human will to communicate. TM

1

2

3

**Selected by**
Galerie Krinzinger A6

**Biography**
Born 1975
Lives in Madrid and
Berlin

Hernández has been
the focus of recent solo
presentations held at:
Galerie Krinzinger,
Vienna (2014 and 2010);
Salon Dahlmann, Berlin
(2013); and Mendez Wood
DM, São Paulo (2012).
Select group shows to
which Hernández has
contributed include:
'Alone Together', Rubell
Family Collection
Contemporary Arts
Foundation, Miami
(2013); 'Painting at the
Edge of Reality', Victoria
Miro, London (2013);
and 'Berlin Status 1',
Künstlerhaus Bethanien,
Berlin (2012).

1
*Untitled*
2014
Gouache, acrylic, alkyd
and oil on canvas
2.66 × 2.31 m
8' 8¾" × 7' 7"
Courtesy of
Galerie Krinzinger

2
*Untitled*
2014
Gouache, acrylic, alkyd
and oil on canvas
0.51 × 2.99 m
1' 8⅛" × 9' 9¾"
Courtesy of Galerie
Krinzinger

3
*Untitled*
2014
Gouache, acrylic, alkyd
and oil on canvas
2 × 1.7 m
6' 6¾" × 5' 6⅞"
Courtesy of
Galerie Krinzinger

# Secundino Hernández

Many histories of paintings collide, explode, are shredded and fall as confetti-like fragments of lines and colour in the paintings of Secundino Hernández. A canvas might contain the frenzied lines of Cy Twombly's early works, the massed daubs of colour of earlier Impressionist antecedents and looser, more rhythmic, almost Abstract Expressionist compositions, alongside firm illustrative lines seemingly taken from comic-book action sequences. Hernández is in thrall to all of these histories of what painting is and what it can do, recycling and recombining them, magpie-like, to produce works that make a statement about the innumerable and endlessly developing techniques we have at our disposal to address and to reflect on the complex, multifaceted reality that we inhabit. AS

**Selected by**
Sommer Contemporary
Art A19

**Also shown by**
Galerie Perrotin A16
Almine Rech Gallery F8

**Biography**
Born 1974
Lives in Bad Homburg,
Germany

Hildebrandt has
been the focus of solo
exhibitions presented at:
Galerie Perrotin, New
York (2014); Sommer
Contemporary Art, Tel
Aviv (2013 and 2010);
and Contemporary Art
Museum St. Louis, MO
(2008). Recent select
group shows include:
'The Show is Over',
Gagosian Gallery,
London (2013); and 'Klaus
Nomi – 2013', Neuer
Aachener Kunstverein,
Aachen, Germany (2013).
His works are held in
the public collections
of: Centre Pompidou,
Paris; Berlinische
Galerie, Berlin; Rubell
Family Collection, New
York; and Sammlung
Südhausbau, Munich.

*Orgongenerator dunkel
(Cure)*
2013
Cassette tape on canvas
and wooden structure
117 × 92 × 92 cm
46⅛ × 36¼ × 36¼"
Courtesy of Sommer
Contemporary Art

# Gregor Hildebrandt

Gregor Hildebrandt is an artist
perhaps best known for works that
reference the past. Redundant media
such as VHS and audio cassette tapes
are often pulled into works that make
a nostalgic reference to cinematic or
real-world events from a fairly recent
past. In *Orgongenerator dunkel (Cure)*
(2013) a black polygonal shape created
by applying the tapes from audio
cassettes to canvas, Kazimir Malevich's
zero degree of painting is infused
with an implied aurality. 'I have
always been fascinated by the
intangibility of music and the fact
that it can't be represented to the eye,'
says Hildebrandt, and in *Orgongenerator
weiss (Cure)* that impossibility is
addressed in striking form. MQ

**Selected by**
Hollybush Gardens H9

**Biography**
Born 1956
Lives in Preston, UK

Himid has presented solo
exhibitions at venues
that include: Hollybush
Gardens, London (2013);
Harris Museum and
Art Gallery, Preston,
UK (2012 and 2007);
Sudley House, Liverpool,
UK (2010); Mostyn,
Llandudno, UK (1999);
Tate St Ives, UK (1999);
and the Chisenhale
Gallery, London (1989).
Himid has participated
in select group shows
at: Tate Liverpool,
Liverpool, UK (2013–14);
InIVA, London (2013);
Whitworth Art Gallery,
Manchester (2012); Tate
Britain, London (2011);
Leeds Art Gallery, UK
(2011); Birmingham City
Art Gallery, UK (1999);
and the Studio Museum
in Harlem, New York
(1997–8). Himid currently
has work exhibited at the
10th Gwangju Biennial
(until November 2014).

*The Carrot Piece*
1985
Acrylic on wood and
mixed media
2.43 × 3.35 m
8' ⅝" × 10' 11⅞"
Courtesy of Hollybush
Gardens

# Lubaina Himid

Over the last 30 years Lubaina Himid
has devoted herself to filling a
glaring gap in contemporary art: the
representation of the black body in art.
She's drawn on 18th-century gadflies
such as James Gillray and William
Hogarth: *The Carrot Piece* (1985), with
its unicycling white man dangling a
carrot on a string while a black figure
walks away, resembles an extract
from an antique satire that never was.
*Singer* (2011) is one of a series of works
drawing on a costume museum's
African textile collection, asking the
viewer to examine their own aspirations:
the singer, she writes, 'is the person
who writes the poetry and songs, tells
the stories, remembers the histories,
makes sure the truth is told'. It sounds
like a self-portrait. MH

1

2

3

**Selected by**
Galerie Max Hetzler A10

**Biography**
Born 1974
Lives in London

Holyhead has presented
solo exhibitions at
galleries that include:
Galerie Max Hetzler,
Berlin (2014); Karsten
Schubert, London
(2012, 2010 and 2009);
PEER, London (2012);
and Kontainer Gallery,
Los Angeles (2006). His
work has been seen in
group shows at venues
that include: Stag –
Berlin/London, Dispari
& Dispari, Reggio
Emilia, Italy (2013);
Tate Britain, London
(2012); Fondazione
MACC, Museo d'Arte
Contemporanea di
Calasetta, Italy (2012);
and the Whitechapel
Gallery, London (2012).
His works are held in the
Arts Council Collection
of Great Britain,
London; Government Art
Collection, London; and
Tate collection, UK.

1
*Untitled (Eye)*
2014
Oil on canvas
33 × 50 cm
13 × 19⅝"
Courtesy of Galerie Max
Hetzler

2
*Untitled (Shapes)*
2014
Oil on canvas
119 × 76 cm
46⅞ × 29⅞"
Courtesy of Galerie Max
Hetzler

3
*Untitled (Vent)*
2014
Oil on canvas
55 × 38 cm
21⅝ × 15"
Courtesy of Galerie Max
Hetzler

# Robert Holyhead

The paintings in Robert Holyhead's
most recent series are full of gaps.
Neat holes, formed as if by the precise
blade of a scalpel, these blank areas of
canvas (into which the faintest five
o'clock shadow of banished pigment
occasionally bleeds) evoke real-world
openings such as eyes or vents.
Holyhead takes his paint right to the
edge of this designated blankness but
stops there (occasional stray brushmarks
reveal where he has come close to
overstepping). However, the division
between presence and absence, pigment
and the white of the canvas, is not quite
clean-cut: he paints with single colours
that are washed out with scumbled
brushstrokes to create a patchwork
of shades that develop and recede,
so that blankness and colour suffuse
one another. AS

1

3

2

**Selected by**
Maureen Paley D13

**Also shown by**
Mai 36 Gallerie C4

**Biography**
Born 1934
Lives in New York

The photographs of
American artist Hujar
have been presented
internationally.
Posthumous solo
exhibitions have been
held at venues including:
Maureen Paley, London
(2014); ICA, London
(2007); MoMA PS1, New
York (2005); daadgalerie,
Berlin (1996); and the
Stedelijk Museum,
Amsterdam (1994). Group
shows include: 'Glam!
The Performance of
Style', Tate Liverpool, UK
(2013); 'This Will Have
Been: Art, Love, & Politics
in the 1980s', Museum
of Contemporary Art,
Chicago, travelling to the
ICA, Boston (2012–13);
and 'Mixed Use,
Manhattan: Photography
and Related Practices
1970s to Present', Museo
Nacional Centro de Arte
Reina Sofía, Madrid
(2010).

1
*Paul Thek (in Hooded
Sweatshirt)*
1975
Digital pigment print
37.5 × 37.5 cm
14¾ × 14¾"

2
*Merce Cunningham and
John Cage Seated (II)*
1986
Vintage silver gelatin
print
23 × 22.5 cm
9 × 8⅞"

3
*David Wojnarowicz
Reclining (II)*
1981
Vintage silver gelatin
print
23 × 23 cm
9⅛ × 9"

4
*Self-Portrait Smoking*
1958
Vintage silver gelatin
print
35.5 × 28.5 cm
14 × 11⅛"
All images courtesy of
the Estate of Peter Hujar,
Maureen Paley and Pace/
MacGill Gallery

# Peter Hujar

Even before the AIDS crisis ravaged
New York's underground scene in the
1980s, Peter Hujar's black and white
photography expressed a keen sensitivity
for the medium's memorial qualities.
An early self-portrait from 1958
(*Self-Portrait Smoking*) shows Hujar
with eyes half-closed and mouth in a
grimace. A much later photograph
of Hujar's lover, *David Wojnarowicz
Reclining (II)* (1981), shows the young
artist regarding the camera like one
of Caravaggio's languorous muses.
Tragically, many of his photographs
now stand as documents of a community
lost to AIDS; Paul Thek, who died
in 1988, appears in a photograph from
1975 (before he was ill) with arms raised,
like Christ carrying an invisible cross.
Death shadows even the liveliest of
Hujar's images. JG

4

**Selected by**
Stuart Shave/Modern
Art E2

**Also shown by**
Greene Naftali C14

**Biography**
Born 1960
Lives in New York

Recently the subject
of a solo show at
Stuart Shave/Modern
Art, London (2014;
previously 2010 and
2007), Humphries has
also exhibited at: the
Whitney Museum of
American Art, New
York (2014); Museum
of Contemporary Art
Cleveland, OH (2012);
Greene Naftali, New
York (2012, 2009, 2006
and 2001); Dallas
Museum of Art (2010);
Nagoya City Art
Museum, Japan (2004);
ICA, Philadelphia
(2001); Fundacão Centro
Cultural de Belem, Lisbon
(2000); and Museum of
Fine Arts, Boston (1995).

*Untitled*
2014
Oil on linen
2.54 × 2.82 m
8' 4" × 9' 3"
Courtesy of Stuart
Shave/Modern Art and
Greene Naftali

# Jacqueline Humphries

To talk about gestural painting as self-conscious might seem to imply an element of ironic posturing. For Jacqueline Humphries, who covers large, abstract canvases by pouring, scraping and smearing pigment over layers of reflective silver paint, irony is not part of the equation. Her paintings are sincerely felt, even if Humphries is acutely conscious—and critical—of the history of Abstract Expressionism, to which they posthumously correspond. A painting such as *Untitled* (2014), in which red and black borders frame abstract marks within, instils self-consciousness in viewers, who catch glimpses of their own reflections in the silver as they move around in order to get the best viewpoint on its optically unstable surface. JG

1

2

3

# David Jablonowski

**Selected by**
Raucci/Santamaria A8

**Biography**
Born 1982
Lives in Amsterdam

Jablonowski has exhibited
solo shows at galleries and
institutions that include:
Raucci/Santamaria,
Naples (2014); Max
Wigram Gallery, London
(2014); Baltic Centre
for Contemporary Art,
Gateshead, UK (2013);
Galerie Fons Welter,
Amsterdam (2012); and
Kunstverein Düsseldorf
(2009). His works are
owned by the public
collections of Stedelijk
Museum, Amsterdam;
Gemeentemuseum Den
Haag, Netherlands; and
Bundeskunstsammlung,
Bonn.

1
*Hard Copy*
2013/14
Cipollino ondulato
marble, aluminium,
grinder discs, signatures
on thermo-plastic
15 × 163 × 150 cm
5⅞ × 64¼ × 59"
Courtesy of Raucci/
Santamaria

2
*Multiple*
2013
HP Envy 120 printer,
onyx, aluminium, offset
printing plate, acrylic
glass, plaster
29 × 105 × 97 cm
11⅜ × 41⅜ × 38¼"
Courtesy of Raucci/
Santamaria

3
*Imposition*
2009
Brass, ceramics, wood and
transparencies
28 × 20 × 28 cm
11 × 7⅞ × 11"
Courtesy of Raucci/
Santamaria

David Jablonowski's sculptural reflections on digitized mediation are perversely materialistic, heavy and monumental. Certainly, his works seem to belong to a generation weaned on computers: they are not welded or moulded, but operate according to the Photoshop logic whereby sampled layers might be rendered at a mouse-click. The title of *Hard Copy* (2013/14), for example, suggests that the work is a physical manifestation of an electronic document. But *Hard Copy*—an assemblage of a marble sheet, an aluminium bar and sandpaper discs—is also a linguistic upending of New Media's promised immateriality. Jablonowski's work is shot through with a sense of humour that is to do with the joys and slippages of art as the inverse of digital media: art as miscommunication. CP

1

2

**Selected by**
Galerie Eva Presenhuber
F3

**Also shown by**
T293 A21

**Biography**
Born 1983
Lives in New York

Kahn has been the focus
of solo exhibitions held at:
Galerie Eva Presenhuber,
Zurich (2014); T293,
Rome (2013); Hannah
Barry Gallery, London
(2012); and Pike Untitled,
New York (2011). Select
group shows in which
he has participated
include: 'Abstract
America Today', Saatchi
Gallery, London (2014);
'The Shaped Canvas,
Revisited', Luxembourg
& Dayan, New York
(2014); and 'Wyatt Kahn,
Matteo Callegari and
Wesley Berg', curated by
Ugo Rondinone, Sommer
Contemporary Art, Tel
Aviv (2013). In 2015
Kahn will present
a solo exhibition at
Contemporary Art
Museum St. Louis, MO.

1
*Untitled*
2014
Canvas on panel
2.05 × 1.49 m
6' 7¼" × 4' 8⅜"
Courtesy of Galerie Eva
Presenhuber

2
*Night Flight*
2012
Canvas on panel
1.25 × 0.99 m
4' 1¼ × 3' 3"
Courtesy of Galerie Eva
Presenhuber

# Wyatt Kahn

Failure and imperfection, combined
with a delicately architectural quality,
lend Wyatt Kahn's often paint-less
paintings their peculiar beauty. After
stretching sections of unprimed canvas
on shaped panel pieces, he joins them
like awkward puzzle pieces. The
resulting abstractions can suggest
shattered mirrors or windows, sliding
tectonic plates, ravaged buildings or
landscapes and even a figure with a
ribcage and limbs. That these paintings
are not only sculptural but function
like wall drawings—with the edges
of the panels serving as drawn lines—
is especially visible in the butterfly-like
form in *Untitled* (2014), as well as in the
rectangular *Night Flight* (2012), *Boxed*
(2013) and *Still* (2013). In many recent
works Kahn has stretched translucent
linen or muslin over painted canvas,
creating subtle tinting. KMJ

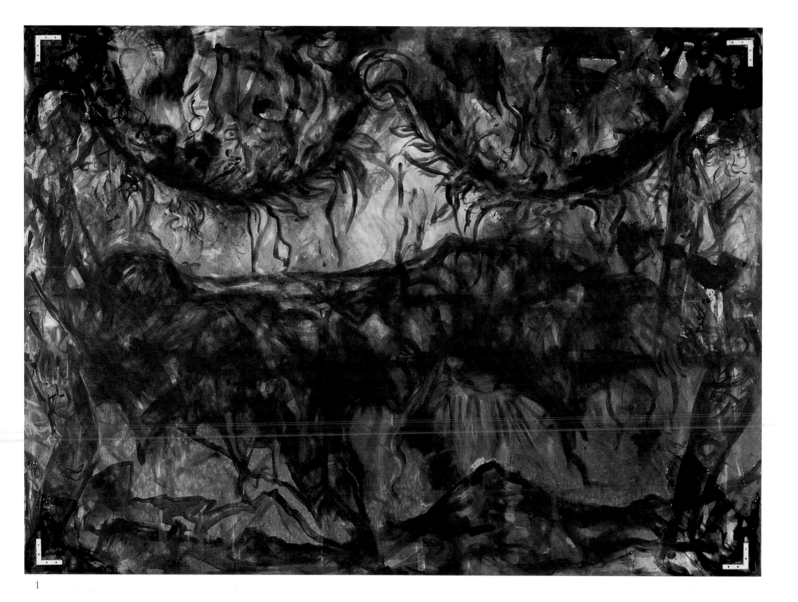

1

**Selected by**
Galerie Francesca Pia C11

**Also shown by**
Galerie Buchholz C10
Campoli Presti B9

**Biography**
Born 1958
Lives in New York

Koether has been the
focus of solo exhibitions
shown at: Arnolfini,
Bristol, UK (2014);
New Museum, New
York (2013); Campoli
Presti, London (2013);
Bortolami, New York
(2012); Moderna Museet,
Stockholm (2011);
Kunstverein München,
Munich (2010); Van
Abbemuseum, Eindhoven
(2009); Galerie Francesca
Pia, Zurich (2008);
and Galerie Buchholz,
Cologne (2002 and
2000). Select group
shows in which he has
participated include: 'A
Bigger Splash: Painting
after Performance', Tate
Modern, London (2012);
'Blues for Smoke', MoCA,
Los Angeles (2012);
and the 76th Whitney
Biennial, Whitney
Museum of American Art
(2012).

1
*Black Garland BERLIN
(# 1:WTF)*
2011
Mixed media
1.6 × 2.2 × 0.06 m
5' 3" × 7' 2⅝" × 2⅜"
Courtesy of Galerie
Francesca Pia

2
*Untitled*
2011
Acrylic on canvas
30 × 30 cm
11¾ × 11¾"
Courtesy of Galerie
Francesca Pia

# Jutta Koether

Jutta Koether's paintings have a palpable, almost unhinged energy. Their instability—with lines tearing off towards the edge of the canvases and contorted forms that become momentarily visible before the eye is pulled away elsewhere—evokes the performative (masculine) tradition of action painting, although in Koether's paintings the unruliness seems more consciously provocative, more punk. The artist, herself in a band, has frequently collaborated with musicians, including Kim Gordon of Sonic Youth. In paintings such as *Black Garland BERLIN (# 1:WTF)* (2011), an inky re-imaging of Nicolas Poussin's *The Funeral of Phocion* (1648), colours and forms seem to surface and then recede, like occasional melodies amid scumbled bass lines, or the figures of the dead in the murky netherworld to which Phocion's soul is descending. AS

2

1

2

3

**Selected by**
Annet Gelink Gallery
A20

**Biography**
Born 1976
Lives in Tokyo

Koizumi has presented
solo exhibitions at
venues that include:
Annet Gelink Gallery,
Amsterdam (2014, 2012
and 2010) and Rotterdam
(2013); MoMA, New
York (2013); Sàn Art, Ho
Chi Minh City (2012);
Mori Art Museum, Tokyo
(2009); and Mary Mary,
Glasgow (2005). He has
contributed work to
group exhibitions that
include: the 9th Shanghai
Biennial (2012); 5th
Jakarta International
Video Festival (2011); and
the 6th Liverpool Biennial
(2010). Koizumi has
works held in the public
collections of: MoMA,
New York; the Stedelijk
Museum, Amsterdam;
De Hallen Haarlem,
Netherlands; Centro de
Arte Contemporáneo de
Caja de Burgos, Burgos,
Spain; and the Museum
of Contemporary Art
Tokyo.

1
*Double Projection #1
(Where the Silence Fails)*
2014
Double-channel video
projection
15 min. 40 sec.
Courtesy of Annet Gelink
Gallery

2
*Defect in Vision*
2011
Double-channel video
installation
12 min. 9 sec.
Courtesy of Annet Gelink
Gallery

3
*Smiling Woman # 2*
2014
Charcoal on paper
42.7 × 31 cm
16¾ × 12¼"
Courtesy of Annet Gelink
Gallery

# Meiro Koizumi

Meiro Koizumi's videos delve into
the emotionally charged history of
Japan's involvement in World War II.
His work uses the language of
documentary interview and observation,
but stages interventions that make clear
the artificial underpinnings of these
constructs. In *Double Projection #2
(When Her Prayer Was Heard)* (2014),
Koizumi interrupts an elderly woman
reminiscing about a lover who died
as a kamikaze pilot, urging her to
impersonate the dead soldier. In
*Defect in Vision* (2011) a blind couple
discusses the husband's supposedly
imminent kamikaze mission as
production crew move in and out of
the frame. Intimate and haunting,
Koizumi's work is an elegant assertion
of William Faulkner's well-known
observation 'The past is never dead.
It's not even past.' KK

**Selected by**
Pilar Corrias B19

**Biography**
Born 1967
Lives in London

Koo has held solo
exhibitions at venues
that include: Kunsthalle
Düsseldorf (2012);
Pilar Corrias, London
(2012); Centro de Arte
Moderna Fundação
Calouste Gulbenkian,
Lisbon (2011); Aspen Art
Museum (2008); Leeum,
Samsung Museum of
Art, Seoul (2007); Centre
Pompidou, Paris (2004);
Centre for Contemporary
Art Kitakyushu, Japan
(2002); and Moderna
Museet, Stockholm (1998).
Her 2010 exhibition for
the Dia Art Foundation,
New York, spanned
three locations: Hispanic
Society of America,
New York; Dia:Beacon,
Beacon, NY; and The
Dan Flavin Art Institute,
Bridgehampton. In 2005
she was awarded the
Hermès Korea Prize for
Contemporary Art.

*Curioussssa*
2012
Ink print, graphite on
paper
119.2 × 84.4 cm
50 × 33¼"
Courtesy of Pilar Corrias

# Koo
# Jeong A

Koo Jeong A creates an effect of
disorientation, whether through
subtle architectural interventions in the
gallery space—installing an expanse of
coloured Perspex, elevating the floor—
or through the release of olfactory
triggers designed in collaboration with
perfumer Bruno Jovanovic. Humour
and subtlety are the common strands
running through her disparate practice,
which has included such gestures as
making miniature mountains out of
dust collected a decade earlier by the
artist and carefully stored. Those same
qualities are evident in drawings such
as *Curioussssa* (2012), which features a
cartoonish figure, part human and
part spotted abstraction. In her work
Koo stages an encounter with the
ephemeral, and heightens our powers
of perception. KK

**Selected by**
BQ D9

**Also shown by**
Blum & Poe A3
White Cube D4

**Biography**
Born 1974
Lives in Los Angeles

Currently the subject
of a solo exhibition at
Kunsthalle Bremerhaven
(until November 2014),
German-born Kunath
has previously held solo
shows across venues
that include: Capri,
Dusseldorf (2014); Centre
d'art contemporain – le
Crédac, Ivry-sur-Seine,
France (2014); White
Cube, London (2013
and 2011); Modern Art
Oxford, UK (2013);
Sprengel Museum,
Hanover (2012); BQ,
Berlin (2012 and 2009),
and Cologne (2004);
Kunstverein Hannover
(2009); Aspen Art
Museum (2008); and
The Modern Institute,
Glasgow, UK (2000).

*What Difference It Makes
When It Doesn't Make Any
Difference Anymore*
2013
Painted polystrene foam
and LP record
30.5 × 184 × 30 cm
12 × 72½ × 11¾"
Courtesy of BQ

# Friedrich Kunath

Polymath artist Friedrich Kunath might borrow equally from cartoons or medieval art, from 18th-century German Romantic engravings or from 1970s West-Coast rock. The paintings, sculptures and films that emerge from this cultural *dérive* conform to no single organizing logic, despite the recurrence of motifs (Kunath has referred to them as 'characters') including a man's loafer, a match, a banana and the game of tennis. In his recent exhibition 'Raymond Moody's Blues' (2013), sculptures and paintings were arranged on a green floor with markings borrowed from a tennis court. The sculpture *What Difference It Makes When It Doesn't Make Any Difference Anymore* (2013) consists of two otters with grotesquely humanoid feet supporting a Barbra Streisand LP; in Kunath's work, such apparent jests are serious business. JG

1

2

**Selected by**
Mendes Wood DM H2

**Biography**
Born 1977
Lives in São Paulo and
Malmö

Lagomarsino has shown
solo exhibitions at venues
that include: Umberto Di
Marino, Naples (2014);
Ignacio Liprandi Arte
Contemporáneo, Buenos
Aires (2013); Index – The
Swedish Contemporary
Art Foundation,
Stockholm (2012); Galeria
Luisa Strina, São Paulo
(2011); and Mummery +
Schnelle, London (2009).
His work has also been
featured in group shows:
'Under the Same Sun',
Solomon R. Guggenheim
Museum, New York
(2014); 'Meeting Points 7',
Beirut Art Center (2014);
30th Bienial de São Paulo
(2012); 12th Istanbul
Biennial (2011); and 'The
Future Generation Art
Prize', PinchukArtCentre,
Kiev (2010).

1
*Runo Is Not a Nation*
2011
Letters and MDF shelf
21.5 × 70 × 10.5 cm
8½ × 27½ × 4⅛"
Courtesy of Mendes
Wood DM

2
*Pergamon (A Place in Things)*
(detail)
2014
Installation view at Nils
Stærk, Copenhagen
Dimensions variable
Courtesy of Mendes
Wood DM

# Runo Lagomarsino

'People are trapped in history,
and history is trapped in them,'
James Baldwin once wrote. Runo
Lagomarsino's Italian–Argentinian–
Spanish–Swedish family history often
works its way into his energetic and
elegiac sculptures and installations, as
a quiet commentary on colonial history,
nomadism and personal agency.
*Pergamon (A Place in Things)* (2014)
is more than 100 light bulbs: neon,
filament and the newer energy-saving
designs, all in various states of use,
filth and disrepair, arranged in a neat
taxonomy on the floor and presented
behind a display barrier. The bulbs
are stolen from Berlin's Pergamon
Museum, itself filled with reconstructed
monuments from around the world;
enlightenment and provenance,
Lagomarsino suggests, depend on
where you're standing. CFW

1

2

3

**Selected by**
Goodman Gallery H1

**Biography**
Born 1975
Lives in Amsterdam and
Paris

South African artist
Langa has presented
solo exhibitions of his
work at venues that
include: ifa (Institut für
Auslandsbeziehungen)
Galerie, Stuttgart (2014);
Goodman Gallery, Cape
Town (2013 and 2007)
and Johannesburg (2012,
2005 and 2000); Krannert
Art Museum, University
of Illinois, Champaign,
IL (2013); Kunsthalle
Bern (2011); Modern
Art Oxford, UK (2007);
MAXXI, Rome (2005);
Kunstverein Düsseldorf
(2004); and Centre d'art
contemporain Genève,
Geneva (1999). Select
group shows include the
11th Biennale de Lyon
(2011); 29th Bienal de São
Paulo (2010); and the 50th
Venice Biennale (2000).

1
*Mokwena Meets Mujaji*
2013
Tape, thread and mixed
media on paper
2.04 × 1.71 m
6' 8⅜" × 5' 7⅜"
Courtesy of Goodman
Gallery

2
*Malizana*
2013
Sewing thread, ink, tea,
glitter, coffee, acrylic and
transparent lacquer
1.62 × 1.22 m
5' 3¾" × 4'
Courtesy of Goodman
Gallery

3
*Tshamahandze*
2013
Acrylic, spray paint, salt,
tea, coffee, beetroot and
collage elements
1.62 × 1.22 m
5' 3¾" × 4'
Courtesy of Goodman
Gallery

# Moshekwa Langa

Langa burst onto the South African
art scene in the mid-1990s with work
that made use of cement bags and other
discarded detritus from construction
taking place in his neighbourhood.
Since then, the raw materials with
which he first began making art as a
young man—experiments conducted
in his backyard with paper, cardboard,
pigment, wax and a clothes line—have
shifted. Langa's subsequent layered
collages, such as *Mokwena Meets Mujaji*
(2013), incorporate materials that reflect
his international peregrinations. Langa
draws regularly on his own biography
as a starting-point—and yet, as with
his early use of those cement bags,
which indexed a complex history of
building development and racial
politics, Langa's 'minor' materials
always form a palimpsest with many
layers to scrape away. SNS

**Selected by**
David Kordansky Gallery
C1

**Also shown by**
303 Gallery E5
Massimo De Carlo B1
Galerie Francesca Pia C11
White Cube D4

**Biography**
Born 1977
Lives in Los Angeles

Israel-born Lassry has
exhibited solo shows
at venues that include:
Museum Boijmans van
Beuningen, Rotterdam
(2014); The Kitchen,
New York (2012);
David Kordansky
Gallery, Los Angeles
(2012); Contemporary
Art Museum St. Louis,
MO (2010); Kunsthalle
Zürich (2010); Whitney
Museum of American
Art, New York (2009);
and the Art Institute
of Chicago (2008). He
recently participated in
the group show 'A World
of Its Own: Photographic
Practices in the Studio',
held at MoMA, New York
(2014).

Exhibition view, 'Sensory
Spaces 3', Museum
Boijmans van Beuningen,
Rotterdam
2014
Courtesy of David
Kordansky Gallery and
Museum Boijmans van
Beuningen

# Elad Lassry

Lassry inherits the lessons of the Pictures
Generation, combining appropriated
photographs with ones of his own
creation and, in his own words, ensuring
that 'a picture that was shot for a certain
purpose gets reactivated'. But Lassry's
photographs are also sculptural. His
frames take their colours from the
images themselves, as if the photographs'
colour had seeped outwards to become
objects, and he routinely throws up
physical obstacles or interventions within
the space of the gallery that shape the
viewer's ability to view the images, as in
'Sensory Spaces 3' (2014) at the Museum
Boijmans van Beuningen. Lassry has
even gone so far as to conceive of dance
performances that he has choreographed
and staged—such as *Untitled (Presence)*,
performed at The Kitchen in New York
in 2012—as 'nervous pictures', tableaux
as much as actions. SNS

**Selected by**
Galerie Greta Meert B16

**Also shown by**
Sprüth Magers C5

**Biography**
Born 1947
Lives in New York

Lawler has presented
solo exhibitions at venues
that include: Museum
Ludwig, Cologne (2013);
Dia Art Foundation,
New York (2013); David
Kordansky Gallery, Los
Angeles (2012); Wexner
Center for the Arts,
Columbus, OH (2006–7);
Kunstverein in Hamburg
(2005); and Museum
für Gegenwartskunst,
Basel (2004). She has
participated in select
group shows at galleries
and museums that
include: Casey Kaplan,
New York (2013);
Kunstverein Düsseldorf
(2013); The Metropolitan
Museum of Art, New
York (2012); Museum
of Contemporary
Art, Chicago (2012);
MUMOK, Vienna (2011);
MoMA, New York (2010);
and MACBA, Barcelona
(2009).

1
*Big*
2002–3
Cibachrome mounted on
museum box
134 × 118 cm
52¾ × 46½"
Courtesy of Galerie
Greta Meert

2
*It Could Be Anthony
D'Offay*
1999/2000
Cibachrome mounted on
museum box
76.2 × 55.9 cm
30 × 22"
Courtesy of Galerie
Greta Meert

# Louise Lawler

Louise Lawler's interest in how artworks sit within nexuses of distribution (and money) long pre-dates, and frequently outsmarts, that of the current generation of young artists. Her cool, mordantly humorous photographs of display situations, such as *It Could Be Anthony D'Offay* (1999/2000), where a ghostly, balding figure stands amid photography and sculpture, give as much weight to infrastructure (figured by the eponymous gallerist) as to art. *Big* (2002–3), apparently photographed during an exhibition install, finds Maurizio Cattelan's sculpture of Picasso disassembled, staring at us, while a Thomas Struth photograph behind him features museum-goers observing statuary. Multiple gazes, ironies and appropriations are operant here, set in motion by an artist acutely aware that context defines meaning and delivers value. MH

1

2

**Selected by**
Vitamin Creative Space
F1

**Biography**
Born 1978
Lives in Hong Kong and
Taipei

Lee has presented solo
shows of his work at
venues that include: the
55th Venice Biennale
(2014); Minsheng Art
Museum, Shanghai
(2012); and Para/Site Art
Space, Hong Kong (2007).
Recent select group shows
include: 'Room Service',
shown at Staatliche
Kunsthalle Baden-Baden,
Germany (2014); and
'The Part in the Story
Where a Part Becomes a
Part of Something Else',
at Witte de With Centre
for Contemporary Art,
Rotterdam (2014). In
2015 Lee has forthcoming
shows at S.M.A.K.,
Ghent (from spring), and
mother's tankstation,
Dublin, Ireland (in the
autumn).

1
*My Pillow Seems Like a
Bed, a Pillow Seems Like
My Bed*
2008
Mixed media
Dimensions variable
Courtesy of Vitamin
Creative Space

2
*Another Sunny Day: Picnic
with Friends and Hand-
Painted Cloth at Wan Chai,
Sai Kung*
2003
Acrylic on fabric,
photographic document
Courtesy of Vitamin
Creative Space

3
*Scratching the Table Surface*
2006–10
Acrylic on plywood,
photo documentation and
300 postcards
Courtesy of Vitamin
Creative Space

3

# Lee Kit

Across painting, video, drawing and
installation Lee Kit draws on quotidian
materials and ready-mades in order
to examine the socio-cultural rituals,
practices and behaviours that structure
and constitute modern life. In *Scratching
the Table Surface* (2006–10), a set of
photographs that document the artist
scraping a small hole into a table-top,
a banal procedure speaks of the traces
that physical labour can leave on
the environment that surrounds us.
Meanwhile the value of interpersonal
exchange is commemorated in *Another
Sunny Day: Picnic with Friends and Hand-
Painted Cloth at Wan Chai, Sai Kung*
(2003), a photograph of a summer picnic
that marked the end of government-
promoted indoor seclusion during the
2003 SARS epidemic in China. MQ

1

2

3

**Selected by**
Massimo De Carlo B1

**Biography**
Born 1979
Lives in New York

Lowman has presented
solo exhibitions at:
Massimo De Carlo,
London (2014, 2012 and
2010), and Milan (2012);
Maccarone, New
York (2014, 2011 and
2009); American
Academy in Rome
(2011); Astrup Fearnley
Museet, Oslo (2009); and
Midway Contemporary
Art, Minneapolis (2006).
He has participated
in select group shows
held at: the Peggy
Guggenheim Collection,
Venice (2014); Zachęta
National Gallery of Art,
Warsaw (2013); MoCA,
Los Angeles (2011); New
Museum, New York
(2010); and Palais de
Tokyo, Paris (2010).

1
*Lights Out*
2014
Oil and alkyd on canvas
137 × 84 cm
53⅞ × 33"
Courtesy of Massimo De
Carlo

2
*Swimmer Dropcloth*
2013
Oil and alkyd on canvas
2.48 × 1.58 m
8' 1¾" × 5' 2¼"
Courtesy of Massimo De
Carlo

3
*Painters Painting*
*2013*
Oil and alkyd on canvas
79 × 79 cm
31 × 31"
Courtesy of Massimo De
Carlo

# Nate Lowman

Delving into an airless realm of
mute violence and cheerfulness,
Nate Lowman's work has often alluded
to consumer culture at its darkest or most
vapid. Ben-Day-dot bullet holes and
demented smiley-faces have riddled his
work. The air-freshener tree, as seen in
the black, shaped-canvas painting
*Lights Out* (2014), has been another
frequent motif. *Painters Painting* (2013),
a paint-spattered canvas in the form
of a smiley with a line through it, with
a brush attached, depicts the artist's
act of negation; while *Swimmer
Dropcloth* (2013) has an abject lyricism.
Other recent works have included
monochromes based on hand-drawn
shapes as well as paintings—resembling
grainy photographs or illustrations in
washes and lines—of grim subjects
including gravestones, cairns or airline
safety leaflets. KMJ

1

2

**Selected by**
Kate MacGarry A4

**Also shown by**
Andrew Kreps Gallery
D11
Galerie Rüdiger Schöttle
B21

**Biography**
Born 1967
Lives in London

Macuga, who recently
presented a joint
exhibition with Eustachy
Kossakowski at Kate
MacGarry, London
(2014), has previously
been the focus of solo
shows exhibited at:
Index – The Swedish
Contemporary Art
Foundation, Stockholm
(2013); Museum of
Contemporary Art,
Chicago (2012); Kate
MacGarry, London
(2012 and 2005); Zachęta
National Gallery of Art,
Warsaw (2011); Walker
Art Center, Minneapolis
(2011); Whitechapel
Gallery, London (2009);
Kunsthalle Basel (2009);
and Tate Britain, London
(2007). In 2008 she was
nominated for the Turner
Prize.

1
*The Nature of the Beast*
2009
*Guernica* tapestry, wood
and glass table, 16 leather
and metal chairs
2.9 × 5.6 m
9' 6⅛" × 18' 4½"
Courtesy of Whitechapel
Gallery

2
*Of What Is, That It Is; Of
What Is Not, That Is Not
(I)*
2012
Wool tapestry
5.2 × 17.4 m
17' ¾" × 57' 1"
Courtesy of Documenta
13, Kassel

# Goshka Macuga

By turns a curator, historian and social
anthropologist, Goshka Macuga
delves into archives of knowledge and
emerges with objects and installations
that activate the past by embodying it
in the present. An installation and site-
specific project at London's Whitechapel
Gallery, *The Nature of the Beast* (2009)
used a tapestry replica of Picasso's
*Guernica* (1937) that had previously hung
in the United Nations building, and
which was infamously covered by a blue
cloth during Colin Powell's 2003 speech
defending the US intervention in Iraq.
Commissioned for Documenta 13, the
diptych *Of What Is, That It Is; Of What
Is Not, That Is Not* (2012) depicts two
crowds—one of Westerners and one
Afghans—in front of Darul Aman
Palace, outside Kabul. MQ

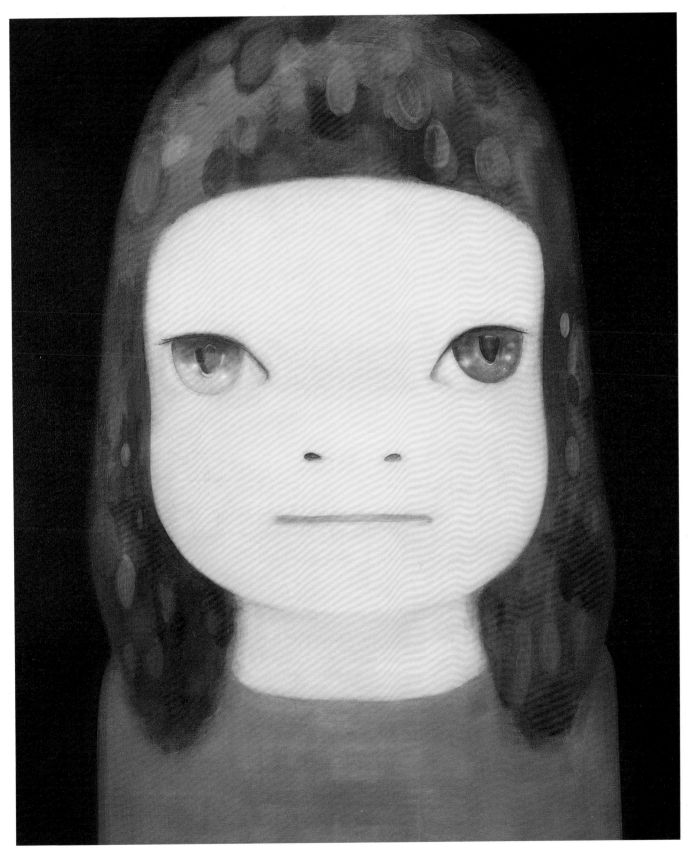

**Selected by**
The Third Line J1

**Biography**
Born 1972
Lives in New York

Nabil has been the
focus of recent solo
exhibitions held at: The
Third Line, Dubai (2013,
2009, 2007 and 2005),
and Doha (2009); La
Maison Européenne
de la Photographie,
Paris (2012); and Villa
Medici, Rome (2009).
He has participated in
select group shows at
venues that include:
Museum für Moderne
Kunst, Frankfurt (2014);
L'Institut du monde
arabe, Paris (2012 and
2013); Victoria and Albert
Museum, London (2012);
Museum of Photography,
Thessaloniki (2011); and
the 53rd Venice Biennale
(2009).

*The Last Dance # 1,
Denver*
2012
Hand-coloured silver
gelatin print (12 prints)
26 × 39 cm
10¼ × 15⅜"
Courtesy of The Third
Line

# Youssef Nabil

The art of hand-colouring monochrome
photographs reached a pitch of delicate
perfection in Egypt in the 1950s. As a
young artist, Youssef Nabil befriended
the photographer Van Leo, whose
glamorous portraits of blushing
Egyptian actresses are the acme of
that art. Nabil learnt the skill, and used
it for his 'Veiled Women' series (2010–
ongoing). Catherine Deneuve, Isabelle
Huppert, Alicia Keys and Charlotte
Rampling—all appear veiled and
hand-tinted. Nabil repurposes aspects
of his country's modern culture
for a time of receding modernity: in
*The Last Dance #1, Denver* (2012) he
photographs a belly-dancer almost
abstracted by gold fabric. His
aestheticism has a political import:
'At this time in the history of Egypt …
anything could be for the last time.' BD

**Selected by**
Thomas Dane Gallery E6

**Also shown by**
Galerie Chantal Crousel
F11
Galerie Greta Meert B16

**Biography**
Born 1955
Lives in Paris

Moulène has presented solo exhibitions at venues that include: Transpalette, Bourges, France (2014); Galerie Greta Meert, Brussels (2014); Beirut Art Center (2013); Modern Art Oxford, UK (2012); Thomas Dane Gallery, London (2012); Dia:Beacon, New York (2011); Musée d'art contemporain de Nîmes, France (2009); and Musée d'art moderne de la Ville de Paris (2009). Recent group shows in which his work was exhibited include 'Codex', at the CCA Wattis Institute for Contemporary Arts, San Francisco (2014), and 'The Way of the Shovel: Art as Archeology', held at the Museum of Contemporary Art, Chicago (2013).

1
*Blown Knot 632 (Borromean) Varia 03*
2012
Glass
34 × 30 × 18.5 cm
13⅜ × 11¾ × 7¼"
Courtesy of Thomas Dane Gallery

2
*Blown Knot 632 (Borromean) Varia 08*
2012
Glass
34 × 30 × 18.5 cm
13⅜ × 11¾ × 7¼"
Courtesy of Thomas Dane Gallery

# Jean-Luc Moulène

Well known for photographic work in the 1990s, Jean-Luc Moulène has recently created tangled glass sculptures that are an attempt to represent complexity in three dimensions. Contrary to how they may at first appear, Moulène's three-strand knots, comprising red, yellow and blue tubes, are not meditations on frustration, deadlock or dialectical impasse. Moulène is interested in Jacques Lacan's conception of the tripartite Borromean knot, which, for the psychoanalyst, was a visual representation of the symbolic, the imaginary and the real. Though inspired by Lacan's idea, Moulène's project is not simply demonstrative. In *Blown Knot 632 (Borromean) Varia 03* and *08* (both 2012) he manipulates this basic form in order to seek out its aesthetic possibilities in combination. MQ

1

2

**Selected by**
Carl Freedman Gallery
G5

**Biography**
Born 1973
Lives in Massachusetts

American McAllister has
presented his paintings
in solo exhibitions at
venues that include:
Carl Freedman Gallery,
London (2014 and 2012);
James Fuentes, New
York (2014, 2011 and
2010); Shane Campbell
Gallery, Chicago (2012);
and Richard Telles, Los
Angeles (2012). He has
participated in select
group shows that include:
'Inside Arrangement',
Mary Mary, Glasgow,
UK (2014); 'L'Almanach
14', Le Consortium,
Paris (2014); 'American
Exuberance', Rubell
Family Collection
Contemporary Arts
Foundation, Miami
(2011–12); and 'Impossible
Vacation', White Flag
Projects, St. Louis, MO
(2011).

*venerable articulate complete*
2013
Oil on canvas
94 × 76 cm
37 × 29⅞"
Courtesy of Carl
Freedman Gallery

# John McAllister

Trading the lush hues of the French Riviera for a post-industrial fluoro-palette of tangerine, fuchsia and cerulean, John McAllister's paintings of interiors knowingly crank up the volume on the vibrato scenes painted by pattern-enamoured painters such as Pierre Bonnard or Henri Matisse. Any sense of perspective falls away in these dazzling rooms, as the artist calls attention to art history's ongoing negotiations with flatness, decoration and colour. *venerable articulate complete* (2013) would appear to depict a domestic interior wallpapered in pure pattern itself—fizzy diagonal stripes of pink and purple—yet there are many frames within frames in the painting, suggesting multiple, layered scenes. McAllister joyfully presents a series of glimpses into a bright, seductive hall of mirrors from which there is little desire to escape. LMcLF

3

2

**Selected by**
Blum & Poe A3

**Also shown by**
Stephen Friedman
Gallery C7
Galerie Meyer Kainer F12
Pace A2

**Biography**
Born 1959
Lives in Tokyo

Hirosaki-born Nara has
presented recent solo
shows at Blum & Poe,
Los Angeles (2014, 2008
and 2004); Pace, New
York (2013); Yokahoma
Museum of Art, Japan
(2012); Asia Society, New
York (2010); Reykjavik
Art Museum (2009);
and Baltic Centre for
Contemporary Art,
Gateshead, UK (2008).
He has works held in
the public collections of
institutions that include:
MoMA, New York;
National Museum of
Modern Art Tokyo; and
San Francisco Museum of
Modern Art.

1
*Midnight Silence*
2014
Acrylic on canvas
1.94 × 1.62 m
6' 4⅜" × 5' 3⅞"
Courtesy of Blum & Poe

2
*Fountain of Life*
2001/2013
Fibre-reinforced plastic,
lacquer, urethane, motor,
water
1.75 × 1.8 m
5' 3⅞" × 5' 10⅞"
Courtesy of Blum & Poe
and Hara Museum of
Contemporary Art

3
*Untitled (1,2,3,4!)*
2008
Coloured pencil on
envelope
40.5 × 30.5 cm
16 × 12"
Courtesy of Blum & Poe

# Yoshitomo Nara

Despite the ubiquity of his aesthetic,
and the commercial dissemination of
his work through prints, T-shirts,
stickers, rubber stamps and other
collectables, Yoshitomo Nara remains
a solitary, introspective figure. His
artistic persona is less akin to a brand
manager (the role adopted by other
prominent Japanese artists of his
generation) and more like a fan making
art in his bedroom—an *otaku* figure,
traditionally associated with manga
culture. His drawing of a childlike singer
*Untitled (1, 2, 3, 4!)* (2008) is done in
coloured pencil on an opened envelope.
Recent paintings such as *Midnight Silence*
(2014), though much grander, retain the
tenderness and quietude of his earliest
work, and transcend *kawaii* cuteness
to achieve something profound and
almost supernatural. JG

1

2

**Selected by**
Galleria Franco Noero
D12

**Also shown by**
Mendes Wood DM H2
Meyer Riegger B2

**Biography**
Born 1977
Lives and works
throughout the world

Nazareth has been the
subject of solo exhibitions
held at: Galleria Franco
Noero, Turin (2014);
Museu de Arte de São
Paulo (2012–13); Mendes
Wood DM, São Paulo
(2012); and Museu de
Arte de Pampulha, Belo
Horizonte (2007). He
has contributed to group
exhibitions shown at:
Astrup Fearnley Museet,
Oslo (2013–14); 12th
Biennale de Lyon (2013);
55th Venice Biennale
(2013); and Itaú Cultural,
São Paulo (2011).
Nazareth has works in
the public collections of:
Thyssen-Bornemisza Art
Contemporary, Vienna;
Museu de Arte Moderna
do Rio, Rio de Janeiro;
and Pinacoteca do Estado
de São Paulo.

1
*Cadernos de Africa*
2014
15 piles of 1,000 prints on
newsprint
Dimensions variable
Courtesy of Galleria
Franco Noero

2
*Drawings of African Flags*
2014
Installation of 62
drawings
Dimensions variable
Courtesy of Galleria
Franco Noero

3
*Drawings of African Flags*
(detail)
2014
Installation of 62
drawings
Dimensions variable
Courtesy of Galleria
Franco Noero

3

# Paulo Nazareth

Paulo Nazareth describes himself
as delighted by life. The power of his
work lies in the simplicity of ideas that
offer a sense of the shape of lived
experience. In 2011 he spent nine months
travelling thousands of miles from his
home town, Governador Valadares,
in the Minas Gerais region of Brazil,
to the Miami Basel Art Fair, where he
set up shop in a green Volkswagen van
brimming with fresh bananas—a fruit
grown throughout Latin America,
which he had been unable to carry
across international borders as
planned. Issues of social justice pierce
the good-humoured refrain of
Nazareth's work, and recent pieces
such as *Cadernos de Africa* (2014) and
*Drawings of African Flags* (2014) have
reached beyond the Americas and
touched on his African heritage. EN

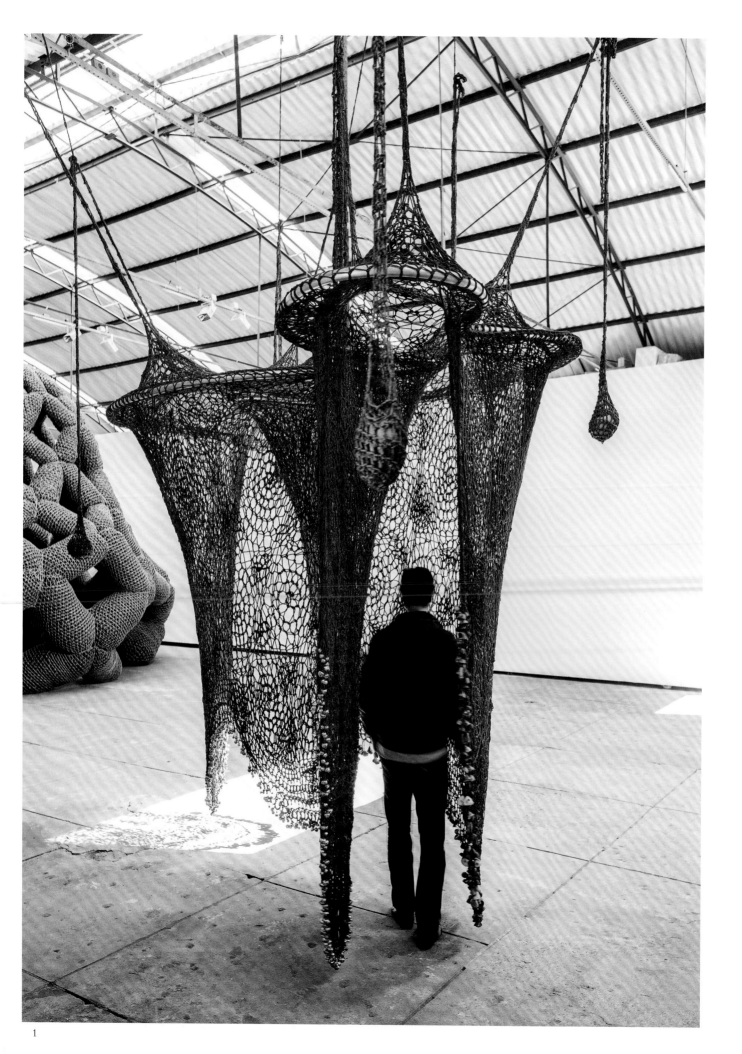

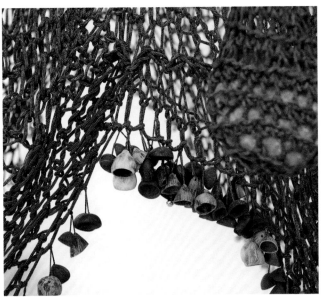

2

**Selected by**
Galeria Fortes Vilaça D5

**Also shown by**
Galería Elba Benítez H6
Tanya Bonakdar Gallery
E7
A Gentil Carioca G6
Galerie Max Hetzler A10

**Biography**
Born 1964
Lives in Rio de Janeiro

Brazilian artist Neto has
presented solo exhibitions
internationally, at
venues that include:
Guggenheim Bilbao
(2014); Galeria Fortes
Vilaça, São Paulo (2013,
2012, 2009, and 2006–7);
Nasher Sculpture Center,
Dallas (2012); Museo de
Arte Contemporáneo
de Monterrey, Mexico
(2011); Museu de Arte
Moderna de São Paulo
(2010); Hayward Gallery,
London (2010); MoMA,
New York (2010); Astrup
Fearnley Museet, Oslo
(2010); Museum of
Contemporary Art San
Diego (2007); Museum
of Contemporary Art
Australia, Sydney (2003);
MoCA Los Angeles
(2003); and the ICA
London (2000).

1, 2
*A Borda [Telepassagem]*
2012
Aluminium, crochet,
stone, rattles and seeds
4.9 × 2.95 × 4.35 m
16' ⅞" × 9' 8⅛" × 14' 3¼"
Courtesy of Galeria
Fortes Vilaça

# Ernesto Neto

Since the 1990s Ernesto Neto has
been creating soft, immersive sculptures
that invite visitors to wander through
womb-like spaces, curl up in cushioned
crannies, and take shelter in woven
tent-like constructions, such as *A Borda
[Telepassagem]* (2012). Neto's sculptures—
often adapted for individual sites—
possess the simultaneous internality and
externality of skin. They are permeable,
relying on sun or external light for their
full corporeality. Colour is a key
element—yellow, red and green serve as
chromatic codings for the natural world,
for bodily and mental experience—as is
scent: he frequently incorporates dried
spices in his efforts to engage all five of
the visitor's senses. As Neto puts it,
'I don't want to discuss sexuality like a
sociologist, but rather create a sensuous
atmosphere in the work.' SNS

**Selected by**
Galerie Eigen + Art A11

**Biography**
Born 1962
Lives in Berlin

Nicolai has been the subject of solo exhibitions and projects held at: Musée du Louvre, Paris (2013); Galerie Eigen+ Art, Berlin (2011); Pinakotek der Moderne, Munich (2011); Royal Academy of Arts, London (2008); Museum Boijmans van Beuningen, Rotterdam (2008); and Kunstverein Hamburg (2007). His works are held in the following public collections: MoMA, New York; Thyssen-Bornemisza Art Contemporary, Vienna; Migros Museum für Gegenwartskunst, Zurich; and Museum Boijmans van Beuningen, Rotterdam.

Study for the work
*Rhythmen, La Tourette*
2014
Film still
Dimensions variable
Courtesy of Galerie
Eigen +Art

# Olaf Nicolai

The interweaving of economy and ecology informs the sculptures, photographs, videos and installations of Olaf Nicolai. Both words are based on the Greek work *oikos* ('house'), the 'home' of our bodies that we use for sense and perception being Nicolai's true subject. His study *Rythmen, La Tourette* (2014) is an image of the windows at a priory near Lyon that architect and musician Iannis Xenakis designed with Le Corbusier. Using the windows' musical composition as the basis for a series of wall drawings and sound installations, Nicolai creates ambiguous environments that hover between different forms of knowledge. The histories of science, design and music are released into poetic musings on orientation and observation that leave us to make our own way through. CFW

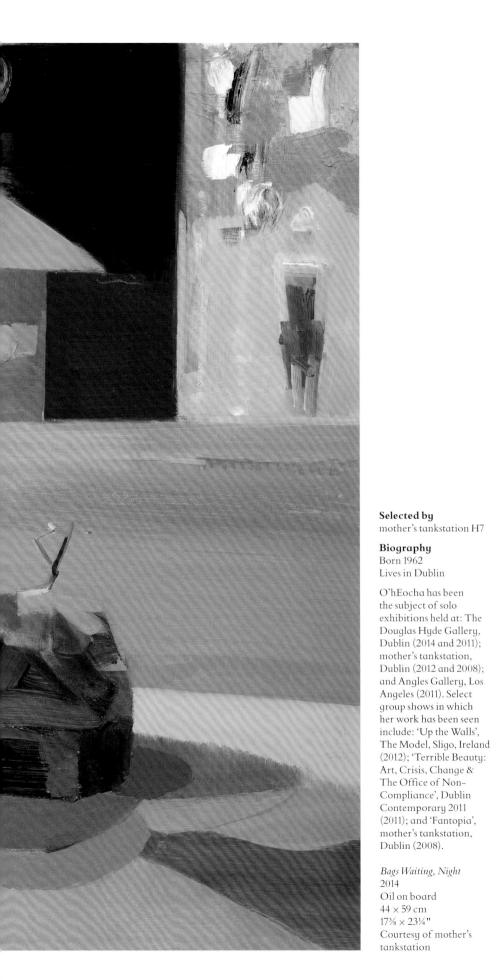

# Mairead O'hEocha

**Selected by**
mother's tankstation H7

**Biography**
Born 1962
Lives in Dublin

O'hEocha has been the subject of solo exhibitions held at: The Douglas Hyde Gallery, Dublin (2014 and 2011); mother's tankstation, Dublin (2012 and 2008); and Angles Gallery, Los Angeles (2011). Select group shows in which her work has been seen include: 'Up the Walls', The Model, Sligo, Ireland (2012); 'Terrible Beauty: Art, Crisis, Change & The Office of Non-Compliance', Dublin Contemporary 2011 (2011); and 'Fantopia', mother's tankstation, Dublin (2008).

*Bags Waiting, Night*
2014
Oil on board
44 × 59 cm
17⅜ × 23¼"
Courtesy of mother's tankstation

The small-scale paintings of Mairead O'hEocha are in a state of suspense, like empty sets, as if waiting for someone to enter stage-left or for a car to pass through the suspiciously tranquil suburban scenes that they depict. Her small oils-on-board show kerbsides, backyards, car parks and silent squares, painted in the just-off pastels of a particularly melancholy kind of Fauvism. Familiar from art history— the sickly yellow glow of a petrol station at night is Edward Hopper without the human drama, while the luminous impasto-slathered skies draw on a Romantic tradition that stretches through John Constable and beyond— these paintings draw us in to their soft-skyed worlds where the ever so slightly off-kilter contours and hues of the everyday make us look and look again. AS

1

2

**Selected by**
Taka Ishii Gallery C6

**Biography**
Born 1923
Died 2001

The work of Japanese
artist Ōtsuji has been
exhibited in solo shows
at venues that include:
Taka Ishii Gallery,
Tokyo (2013); Shoto
Museum of Art, Tokyo
(2007); and National
Museum of Modern
Art, Tokyo (1999). Select
group shows include:
'Japanese Photography:
Postwar–Present', Taka
Ishii Gallery, Tokyo
(2013); 'Jikken Kōbō
Experimental Workshop',
The Museum of Modern
Art, Kamakura, Japan
(2013); 'Tokyo 1955–1970:
A New Avant-Garde',
MoMA, New York
(2012); and 'Experimental
Workshop: Japan
1951–58', Annely Juda
Fine Art, London (2009).
In 1996 Ōtsuji received
The Photographic Society
of Japan Distinguished
Contributions Award.

1
*Discarded Crumpled Paper*
1975/2008
Silver gelatin print
24 × 24 cm
9½ × 9½"
Courtesy of Taka Ishii
Gallery

2
*Two Mineral Samples on
Table*
1974/2008
Silver gelatin print
24 × 24 cm
9½ × 9½"
Courtesy of Taka Ishii
Gallery

# Kiyoji
Ōtsuji

Kiyoji Ōtsuji's place in the history
of Japanese photography is assured,
but dizzyingly varied. He began his
career in the 1940s as a commercial
photographer, absorbed the influence
of Surrealism and then Japanese avant-
garde tendencies of the 1950s, played a
key role in documenting Performance
art in the 1960s and was an influential
teacher and theorist for subsequent
generations. But at the heart of his
body of work is what Ōtsuji called
'the mystery of things': a concentrated
relay between photographer and object.
A pair of artificial legs is poised as
though the invisible owner might spring
at us; a piece of crumpled paper, or a
couple of geological specimens, look
self-involved and also demanding of
reflection, meditation.  BD

1–3

**Selected by**
Galería Juana de Aizpuru
B15

**Biography**
Born 1983
Lives in Moscow and Paris

Moscow-born Parchikov
has been the focus of
solo presentations held
at: Domus Artium
2002, Salamanca, Spain
(2013); Galería Juana de
Aizpuru, Madrid (2012);
Centro Andaluz de la
Fotografía, Almería,
Spain (2011); Krasnoyarsk
Museum Center, Moscow
(2011); and Moscow
Museum of Modern Art
(2010). He has been a
participant in the 54th
Venice Biennale (2009),
the 3rd Moscow Biennial
(2009) and the 2008
Pingyao International
Photography Festival,
China.

1–3
*Untitled*
From the series 'Dead Sea'
2014
C-type prints siliconed
under methacrylate
Each 1.1 × 1.65 m
3' 6¼ × 5' 5"
Courtesy of Galería
Juana de Aizpuru

# Tim Parchikov

Tim Parchikov trained as a
cinematographer, and his photographs
are indebted to the compositions and
lighting effects of film noir. Accordingly,
his work courts a kind of luridly coloured
chiaroscuro: black shadows against
Venetian sunsets, a crowd of deep-red
parasols at dusk in Israel, the blare
of a security light against a concrete
wall in Istanbul—all of these unpeopled
atmospheres suggestive of a cinematic
style of suspense. But equally he
photographs Dead Sea resorts as bright
azure vacuities, with only the sculptural
forms of sunshades to suggest anyone
has been there. At his most extreme,
in photographs of his native Moscow,
whole portions of the cityscape are
washed away. BD

**Selected by**
Almine Rech Gallery F8

**Biography**
Born 1982
Live in New York

Parke and Barrow have
exhibited solo shows
collectively at venues
that include: Elizabeth
Dee, New York (2012
and 2010); ZERO,
Milan (2012); and White
Columns, New York
(2008). The pair have
contributed to group
shows held at: Almine
Rech Gallery, Paris
(2014); Power Station of
Art, Shanghai (2014);
Stephen Friedman
Gallery, London (2013);
Musée d'art moderne
de la Ville de Paris,
Paris (2013); Centre for
Contemporary Art,
Warsaw (2012); Muzeul
National de Artă Cluj-
Napoca, Romania (2012);
the 5th Prague Biennial
(2011); and Lisa Cooley
Gallery, New York

*RGB2*
2011
Acrylic on hand-loomed
linen
76 × 66 cm
29⅞ × 26"
Courtesy of Almine Rech
Gallery

# Sarah Parke & Mark Barrow

Image and ground enjoy an unusual intimacy in the paintings of Sarah Parke and Mark Barrow. Bespoke fabrics are hand-loomed by Parke, their patterns often based on number permutations thrown up by a computer programme. Barrow coats these textiles with a translucent primer and highlights the topographical features of the weave with stippled, pixel-like dots of pigment. Looking at the pair's collaborations, such as *RGB2* (2011), we recall both folksy Americana and geometric Modernism, the technique of the Pointillists and feminist re-readings of the history of craft. Barrow relates these works to the phenomenon of synaesthesia, in which words may be tasted, or sounds experienced as textures. Here, he has said, 'numbers become coloured threads that become dots of paint'. TM

1

2

3

**Selected by**
Galerie Gisela Capitain
D10

**Biography**
Born 1970
Lives in Berlin

Pinckearnelle has exhibited at galleries and institutions that include: Galerie Gisela Capitain, Cologne (2014 and 2009); Bayerisches Armeemuseum, Ingolstadt, Germany (2013–14); Museum für Gegenwartskunst, Berlin (2011); Temporäre Kunsthalle, Berlin (2010); Capitain Petzel, Berlin (2008); Hara Museum Tokyo/Daimler Collection, Berlin (2008); Kunstmuseum Stuttgart (2006); and the ICA, London (2004).

1
*Untitled*
2010
Oil, graphite and tempera on canvas
48 × 80 cm
19 × 31½"
Courtesy of Galerie Gisela Capitain

2
*Untitled*
2013
Ink on glazed arches watercolour paper
48 × 26 cm
18½ × 10"
Courtesy of Galerie Gisela Capitain

3
*Untitled*
2013
Ink on paper
51 × 23 cm
20 × 9"
Courtesy of Galerie Gisela Capitain

# Ascan Pinckernelle

The spare, precisely rendered paintings of Ascan Pinckernelle each represent a single, real subject: a Modernist building, a Chinese mountain landscape. The specificity of Pinckernelle's source material, however, is quelled by the abstracted, architectural austerity of the final works. Two untitled mountain landscapes (both 2013) should be seen at once as expert emulations of real Chinese genre paintings from the Song and Ming eras and as Conceptual interventions into them. In these works Pinckernelle reproduces the moody, muted earth tones of her source landscapes; these, however, are anonymized and dehistoricized when stripped of any contextualizing referent present in the original, such as clothing or human figures. When freed from the incidental, these mountain landscapes are lent a stony, stark, abstract character.  PL

**Selected by**
Galería Helga de Alvear
A12

**Biography**
Born 1965
Lives in London

Spanish artist Prada has been the subject of solo exhibitions shown at Sala Parpalló, Valencia, Spain (2010); Galería Helga de Alvear, Madrid (2008); Seventeen, London (2007); New Museum, New York (1998); and the Witte de With Center for Contemporary Art, Rotterdam (1996). She has contributed work to group shows that include: 'Phantoms', Angus-Hughes Gallery, London (2012); Bloomberg Space, London (2008); Museo de Arte Contemporáneo de Castilla y León, Spain (2007); South London Gallery (2000); and Jerwood Space, London (1999).

1
*A Feminine Touch. Nylon Sock, Paper Plate.*
2014
C-type print
86 × 100 cm
33⅞ × 39⅜"
Courtesy of Galería Helga de Alvear

2
*Tennis Racquet – Football*
2014
Ink and coloured pencil on paper
29 × 42 cm
11⅜ × 16½"
Courtesy of Galería Helga de Alvear

# Ana Prada

Scalping only the most mundane, common items of everyday life— the most bog-standard, generic and mass-produced—Spanish artist Ana Prada creates rhythmic sculptural patterns that allow them to transcend their basic nature. Objects often meet in quasi-erotic fashion, fixed to a wall. Polystyrene bowls are glued together in such a way that they form a chorus of open, gaping mouths. Owing to the fragile nature of Prada's materials, many installations are destroyed following their exhibition, giving these meetings the drama of an event. The artist has begun to capture such suggestive moments of coming together in photographs and drawings such as *Tennis Racquet – Football* (2014), in which the grip of a headless tennis racquet is swallowed by a hungry, yet seemingly flaccid, football. LMcLF

**Selected by**
Galerie Chantal Crousel
F11

**Also shown by**
Galerie Gisela Capitain
D10

**Biography**
Born 1973
Lives in New York

Price has been the subject of solo exhibitions presented at: Reena Spaulings Fine Art, New York (2013 and 2009); Galerie Gisela Capitain, Cologne (2013 and 2007); Galerie Chantal Crousel, Paris (2011); Museo d'Arte di Bologna, Italy (2009); Kunsthalle Zürich (2008); ICA, London (2008); and Modern Art Oxford, UK (2007). Select group shows in which he has exhibited include: 'Pictures in Time', Haus der Kunst, Munich (2014); 'A Sense of Things', Zabludowicz Collection, London (2014); 'Test Pattern', Whitney Museum of American Art, New York (2014); Documenta 13, Kassel (2012); and the 8th Gwangju Biennial (2011).

*Untitled*
2014
Acrylic polymer, gesso, pigments, screenprint, and enamel on plywood
1.2 × 2.13 m
3' 11½" × 7'
Courtesy of Zhana Clic

# Seth Price

Seth Price's work exemplifies a kind of multidisciplinary practice and includes essays, lectures, video, wall sculpture, publishing, music and curating. It is united by an interest in digital culture, modes of distribution and gestures of appropriation. The Internet is often a source of material; images found via keyword searches are the basis for a series of wall sculptures, in which an already free-floating, context-less image is further abstracted. Price uses the negative space of the digital image to create a material work (as in the wall piece *Charm Against Business*, 2012). Price also reworks his own work, both updating and re-contextualizing it, capturing a world in which it is not only knowledge that is open source, but our own work and history. KK

1

2

**Selected by**
Timothy Taylor Gallery
B17

**Biography**
Born 1963
Lives in London

Rae has been the focus of
solo exhibitions presented
at venues that include:
Nottingham Castle
Museum & Art Gallery,
UK (2014); Southampton
City Art Gallery, UK
(2014); Leeds Art Gallery,
Leeds, UK (2012); Musée
d'art contemporain de
Nimes, France (2002–3);
the ICA, London (1993–
4); and Kunsthalle Basel
(1992). Her work has been
acquired for the public
collections of institutions
that include: Arts Council
of Great Britain, UK;
MUDAM, Luxembourg;
Fonds national d'art
contemporain, Paris;
Government Art
Collection, London;
Centre Pompidou, Paris;
Tate collection, UK;
and the Smithsonian
Institution, Washington,
DC.

1
*Does Now Exist?*
2013
Oil and acrylic on canvas
2.13 × 1.75 m
7' × 5' 9"
Courtesy of Timothy
Taylor Gallery

2
*See Your World*
2013
Oil and acrylic on canvas
2.13 × 1.75 m
7' × 5' 9"
Courtesy of Timothy
Taylor Gallery

# Fiona Rae

Fiona Rae's paintings partake equally
of orphaned painterly gestures,
splinters of cute pop culture recalling
Japanese *kawaii* and precision-cut
graphics to evoke how it feels to move
through today's overwhelming, schizoid,
increasingly dematerialized economy
of images. In the techno-nocturne
*Does Now Exist?* (2013) complex
brushstrokes resembling balloon dogs
float over gridded space while laser-like
vectors shoot around them. The
painting, both dark and cartoonish,
suggests an imagined, martial, sci-fi
world and an embattled, distracted
interiority, and toggles between
ambivalent representation and
abstract materiality. In Rae's hands
this bright myriad of disparate and
ambiguous signals—the hallmark of
her work since the late 1980s—is,
however, redemptive. Invariably, her
compositional nous holds semiotic
clamour in virtuosic balance. MH

1

2

**Selected by**
Project 88 J4

**Also shown by**
Experimenter G22
Frith Street Gallery B4

**Biography**
Jeebesh Bagchi born
1965; Monica Narula
born 1969; Shuddhabrata
Sengupta born 1968
Live in Delhi

Raqs Media Collective
has been the focus of
solo exhibitions held
internationally, at
venues that include:
Centro de Arte Dos de
Mayo, Madrid (2014);
Bonniers Konsthall,
Stockholm (2013); Isabella
Gardner Museum,
Boston, MA (2012); The
Photographers' Gallery,
London (2012); Baltic
Centre for Contemporary
Art, Newcastle, UK
(2010); Tate Britain,
London (2009); and Ikon
Gallery, Birmingham,
UK (2009). Select group
shows have included:
Sharjah Biennial 11
(2013); Multitudes Art
Prize, Ullens Center
for Contemporary Art,
Beijing (2013); and
Manifesta 9, Ghent
(2012). In 2015 the
collective will present a
solo exhibition at Museo
Universitario Arte
Contemporáneo, Mexico
City.

1
*An Afternoon Unregistered
on the Richter Scale*
2011
Looped video
3 min. 34 sec.
Courtesy of Project 88

2
*The Philosophy of the
Namak Haraam*
2012
Lambda print
0.61 × 2.11 m
2' × 6'11"
Courtesy of Project 88

3
*Whenever the Heart Skips
a Beat*
2011
Looped video, single
channel
4 min. 20 sec.
Courtesy of Project 88

3

# Raqs Media Collective

Raqs Media Collective has a research-based practice that is as frenetic and inquisitive as its name suggests: 'raqs', which refers in Arabic and Urdu to the trance of whirling dervishes, is also an acronym for 'rarely asked questions'. Their agile interrogation of topics such as the flows of capital includes *Respect to Residue* (2004), in which 10,000 table mats—featuring an image of a map of the world strewn with peanut shells and cigarette butts—appeared in cafés throughout Liverpool. Time is a recurrent concern too; *Whenever the Heart Skips a Beat* (2011) is a video clock-face in which the errant hands run backwards and forwards, playfully empowering our subjective experience of time.  EN

1

**Selected by**
Sfeir-Semler Gallery B8

**Biography**
Born 1964
Lives in Beirut

The work of Lebanese
artist Rechmaoui has
been shown in exhibitions
held at: Musée Granet,
Aix-en-Provence,
France (2013); 11th
Sharjah Biennial (2013);
Serpentine Gallery,
London (2012); Sfeir-
Semler Gallery, Beirut
(2011–12); Saatchi
Gallery, London (2009);
Zentrum Paul Klee,
Bern, Switzerland
(2009); Musée d'art
contemporain de Nîmes,
France (2008); Palais
des Beaux-Arts, Brussels
(2008); 27th Bienal de São
Paulo (2006); Townhouse
Gallery of Contemporary
Art, Cairo (2001); and
the 12th Cairo Biennial
(1998), where he was
awarded the UNESCO
Prize.

1
*Spectre*
2006–8
Non-shrinking grout,
aluminium, glass
2.25 × 4.2 × 0.8 m
7' 4⅝" × 13' 9⅜" × 31½"
Courtesy of Sfeir-Semler
Gallery

2
*Veni, Vidi, Vici*
(I Came, I Saw, I
Conquered)
2013
1,000 marble blocks
1 × 1 × 1 m
3' 3⅜" × 3' 3⅜" × 3' 3⅜"
Courtesy of Sfeir-Semler
Gallery

# Marwan Rechmaoui

History, in the installations of
Conceptual artist Marwan Rechmaoui,
is not progressive but complexly and
paradoxically accumulative. His work
maps the gaps and slippages of Lebanese
history through urban development
and social histories. *Spectre* (2006–8)
is a replica of the Yacoubian Building,
a Modernist apartment complex in
Beirut, which stands as a symbol of the
socio-political processes that have taken
place within Lebanese society since the
civil war. *Veni, Vidi, Vici* (I Came, I Saw,
I Conquered, 2013) is a pile of 1,000
grey marble cubes; 26 are engraved
in Latin and Arabic letters with names
of former rulers, conquerors and
presidents who left monuments at the
mouth of the Nahr el-Kalb river: from
ancient Egyptians and Babylonians,
colonial French and British troops, to
current politicians. CFW

2

an oar, the tejolote of a metate, a crab-shaped brass ashtray

a chewed up vinyl Boba Fett next to a squatting Memín Pinguín

a pantograph, slides, a cemetary of SLR cameras

a bottle opener made of an goat's horn

a cast model of Torre Latinamericana

a Commodore 64, an unopened bottle of Orange Crush

letterpress type, vintage porn, old money, seashells

the full discography of Chac Mool

Laurel and Hardy silkscreened on a mirror

a green melodika, a Lite Brite, Erich Fromm

a dried starfish with only four legs

a wooden dresser from some bygone hotel room

a giant matchstick

a shortwave radio, the Aztec Calendar, Ava Gardner, concrete marbles

1

2

**Selected by**
Galeria Luisa Strina D8

**Biography**
Born 1972
Lives in Mexico City

Mexican artist Reyes has
been the focus of recent
solo exhibitions held
at venues that include:
Galeria Luisa Strina,
São Paulo (2013); Labor,
Mexico City (2012 and
2010); Walker Art Center,
Minneapolis (2011);
Solomon R. Guggenheim
Museum, New York
(2011); and San Francisco
Art Institute (2008).
Select group shows
include: Documenta
13, Kassel (2012); 'K',
CCA Wattis Institute
for Contemporary Art,
San Francisco (2012);
Yokahoma Triennial
(2008); and 'Tlatelolco',
New Museum, New York
(2008).

1, 2
*Navajas Suizas III (Sonora)*
[Swiss Army Knives III
(Sonorous)]
2013
Various objects, wood and
metal
86 × 45 × 62 cm
33⅞ × 17¾ × 24⅜"
Courtesy of Galeria Luisa
Strina

3
*Omni Man*
2013
Fabric, wood and metal
2.8 × 0.9 × 0.3 m
9' 2¼" × 2' 11⅜" × 11¾"
Courtesy of Galeria Luisa
Strina

# Pedro Reyes

Pedro Reyes finds humorous responses
to grave, global problems. Are his art
works humorous because they would
never work or because, in theory, they
really could? *The Grasswhopper* (2013)
is his proposed solution to world
hunger: a nutritious burger made from
grasshoppers. *Disarm* (2013) is a network
of self-playing musical instruments
made from decommissioned guns.
That's armed conflict taken care of.
Reyes's sculptures and installations are
often interactive, and so inadvertently
become social experiments in themselves.
His sculpture *Navajas Suizas III (Sonora)*
(Swiss Army Knives III [Sonorous], 2013)
can be adapted by viewers to wield
whichever sound-making tool (from a
radio to a telephone to a music stand)
they deem most appropriate for the
situation at hand. JG

1

2

**Selected by**
Wilkinson G1

**Biography**
Born 1971
Lives in New York

Rhii has held solo
exhibitions at galleries
and institutions that
include: Wilkinson
Gallery, London
(2014); Artsonje Centre,
Seoul (2013); Museum
für Moderne Kunst,
Frankfurt (2013); Van
Abbemuseum, Eindhoven
(2013); and Galerie Ursula
Walbröl, Dusseldorf
(2012, 2009 and 2008 and
2007). Select group shows
in which Rhii's work has
been seen include: 'Some
End of Things', Museum
für Gegenwartskunst,
Basel (2013); 'Intense
Proximity, 2012 Paris
Triennale', Palais de
Tokyo, Paris (2012); and
the 7th Gwangju Biennial
(2008).

1
*Cooling System*
2010
Mixed media
Dimensions variable
Courtesy of Van
Abbemuseum

2
*Moving Floor*
2013
Mixed media
Dimensions variable
Courtesy of Van
Abbemuseum

# Jewyo Rhii

The conditions of Korean artist Jewyo
Rhii's life are those of movement and
precariousness, and the artist divulges
her constant negotiations with the
specifics of her environment through
her installations. After years of itinerant
existence, Rhii returned to Korea for
a period in 2008, taking up residence
in the Itaewon district of Seoul. Her
'Night Studio' works (2008–11) were
originally exhibited in her home studio.
Fans blowing across blocks of ice
provided an ad-hoc air conditioner in
*Cooling System* (2010) to soothe the sultry
heat, while text-producing sculptures
such as *Recitation of Itaewon Poetry* (2013),
in which letter stamps smash messily
against walls, narrate the artist's locale,
from night-time street fights to loud fish
sellers outside her window, in blurry
textual fragments. LMcLF

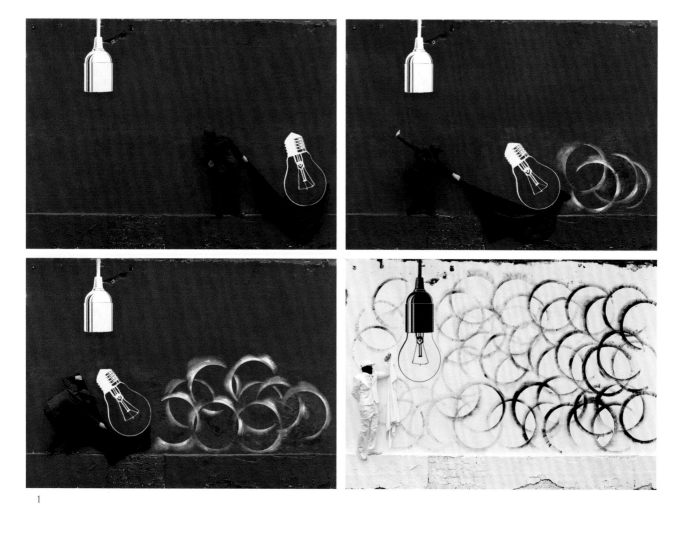

1

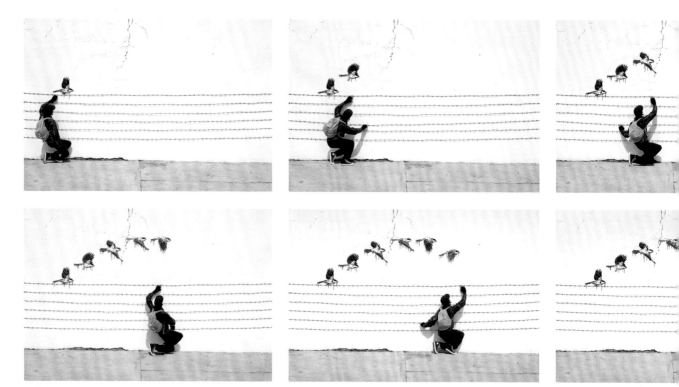

2

**Selected by**
Lehmann Maupin A18

**Also shown by**
Stevenson G10

**Biography**
Born 1976
Lives in Berlin

South African artist
Rhode has exhibited
solo shows at: Lehmann
Maupin, Hong Kong
(2014); Braverman
Gallery, Tel Aviv (2014);
Neuberger Museum of
Art, Purchase, NY (2014);
Kunstmuseum Luzern,
Lucerne (2014); National
Gallery of Victoria,
Melbourne (2013); Los
Angeles County Museum
of Art (2010); Hayward
Gallery, London (2008);
and Haus der Kunst,
Munich (2007). Notable
group shows include: 18th
Sydney Biennial (2012);
'Staging Action', MoMA,
New York (2011); and
the 51st Venice Biennale
(2005). His work can
be found in such public
collections as: Castello
di Rivoli, Turin; Centre
Pompidou, Paris;
Solomon R. Guggenheim
Museum, New York;
and Johannesburg Art
Gallery.

1
*Latimer's Light*
2014
Four mounted C-type
prints
Each 50 × 70 cm
19⅝ × 27½"
Courtesy of Lehmann
Maupin

2
*Bird on Wires*
2012–13
Eight mounted C-type
prints
Each 41.6 × 61.6 cm
16⅜ × 24¼ × 1½"
Courtesy of Lehmann
Maupin

# Robin Rhode

Robin Rhode intervenes in the urban palimpsest. He considers his wall paintings as the mere remnants of performances. In *Bird on Wires* (2012–13) a sequence of photographs shows a stencilled bird flying over a stave of (real) barbed wire into the hand of a man. Exhibited as if frames of a stop-motion film, these photographs reify the passage of time. Like much animation, they appear laced with symbolic meaning, particularly relating to the politics of Rhode's native South Africa. In *Latimer's Light* (2014) a figure lugs a giant light bulb across three black frames until it is switched on in the fourth and all is suddenly painted white—save for the man's ominously black-masked face. EN

1

2

3

**Selected by**
Cabinet F4

**Also shown by**
Rodeo L2

**Biography**
Born 1984
Lives in Berlin and
London

Cardiff-born Richards,
who was awarded the
2014 Ars Viva Prize,
has been the focus of
solo exhibitions held at:
Cabinet, London (2014);
Centre for Contemporary
Art Kitakyushu, Japan
(2012); Chisenhale
Gallery, London (2011);
Rodeo, Istanbul (2011);
Tramway, Glasgow, UK
(2009); and the ICA,
London (2008). He has
participated in select
group shows held at: the
10th Gwangju Biennial
(2014); Artists Space,
New York (2013); and
Kunstverein Munich
(2012). Richards has also
participated in film and
performance programmes
at Tate Modern, London
(2012) and Performa
11, New York (2011).
He recently curated the
group show 'Alms for
the Birds', exhibited at
Cabinet, London (2014).

1
*Rosebud*
2013
Digital video
10 min.
Courtesy of Cabinet

2
*Rosebud*
2013
Digital video
10 min.
Courtesy of Cabinet

3
*Untitled (The Screens)*
2013
35 mm slide installation
Dimensions variable
Courtesy of Cabinet

# James Richards

In his moving image works James
Richards samples and edits found
footage in order to create ripples
of undefined pathos and desire. His
works are exercises in the techniques
and affect of melodrama, hewn of
their narrative context. In *Rosebud* (2013)
we see panning footage of Alexander
Hamilton's face on a ten-dollar bill,
abstract underwater imagery and
censored homoerotic photographs
(by artist Robert Mapplethorpe) found
by Richards in a Tokyo library, in which
male genitals have been scratched out.
The resulting video is an associative
montage of sexuality, power and
repression. *Rosebud*'s title references the
mysterious word uttered by the dying
protagonist in Orson Welles's film
*Citizen Kane* (1941)—the word is a
MacGuffin, whose function is ultimately
one of desire. CP

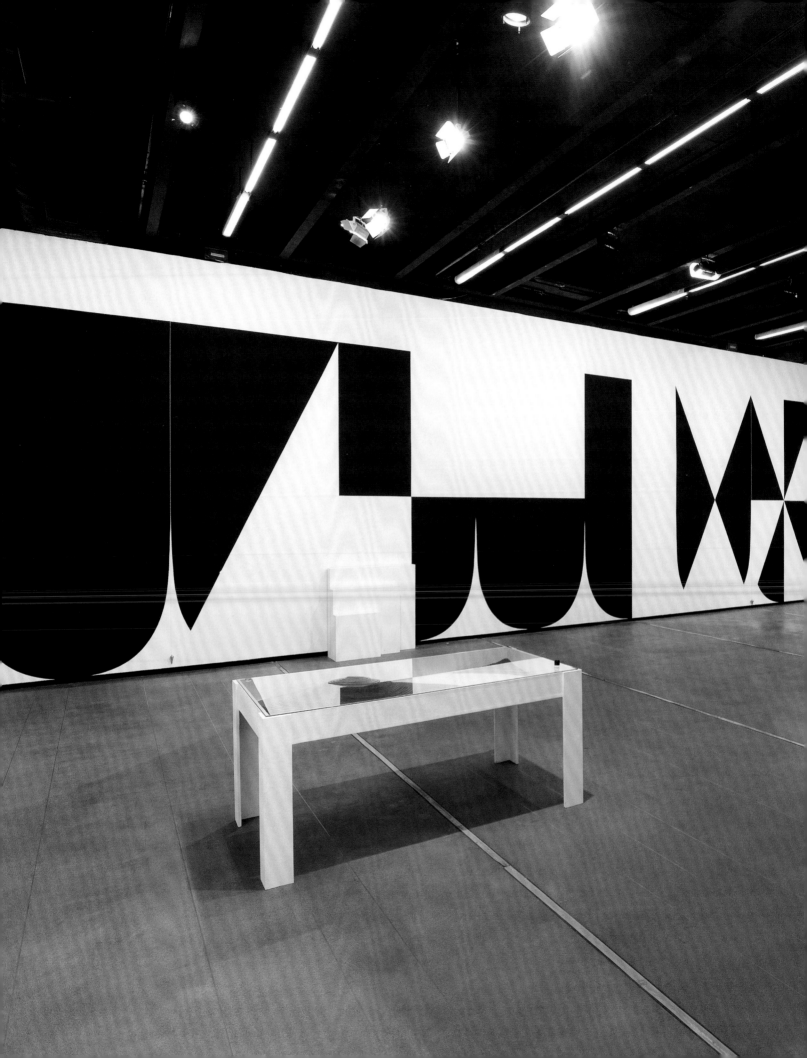

**Selected by**
Vermelho G11

**Biography**
Born 1975
Lives in São Paulo

Argentinian Robbio
has presented his work
in solo shows held at:
Instituto Tomie Ohtake,
São Paulo (2014); Galeria
Vermelho, São Paulo
(2014, 2012, 2010, 2007
and 2005); Nueveochenta
Arte Contemporâneo,
Bogotá (2011 and 2008);
and Künstlerhaus
Bethanien, Berlin (2007).
He has particpated
in select group shows
at venues including:
Centro Cultural dos
Correios, Rio de Janeiro
(2013); Astrup Fearnley
Museet, Oslo (2013);
CCA Wattis Institute for
Contemporary Art, San
Francisco (2012); and
Museu de Arte Moderna
de São Paulo (2011).

*How to Divide a Plan For
Portuguese Heraldry*
2014
Mural painting and 2
plumb lines
Dimensions variable
Courtesy of Vermelho

# Nicolás Robbio

Nicolás Robbio's work varies greatly in scope and scale: from very modestly proportioned drawings and objects shown in vitrines, through large wall drawings (such as *How to Divide a Plan for Portuguese Heraldry*, 2014) to intricate sculptural pieces that invade and divide the gallery. These different registers, however, are linked by images, motifs and objects that often begin life in the artist's notebooks, as records of things and images close to hand. Robbio's is in part an art of projection, between dimensions for one thing: daylight, and therefore an exterior, replicated via directed light from overhead projectors. But also between materials: the cutaway shapes of musical instruments perforate a floor. At times Robbio seems like an extraordinarily subtle engineer, finely weighting the world otherwise. BD

2

**Selected by**
Vilma Gold F2

**Biography**
Born 1978
Lives in Mexico City

Rojas, who is currently
the focus of a solo show
at Vilma Gold (until
November 2014), has
previously presented solo
exhibitions at galleries
that include: Karma
International, Zurich
(2013); and Gaga Fine
Arts, Mexico City (2012
and 2009). Venues at
which his work has been
exhibited in group shows
include: Artspace, New
York (2014); Soloway,
New York (2013); Museo
Experimental El Eco,
Mexico City (2010);
Zentrum für Kunst und
Medientechnologie
Karlsruhe, Germany
(2010); and Tensta
Konsthall, Sweden (2008).

1
*Final Presentation Table*
2013
Mixed media
120 × 60 × 100 cm
47¼ × 23⅝ × 39⅜"
Courtesy of Vilma Gold

2
*Motif*
2013
Steel nails and tissue
paper
70 × 70 cm
27½ × 27½"
Courtesy of Vilma Gold

# José Rojas

Incorporating elements that include walls of water and carpets of moss, José Rojas's installations take an open-ended, ephemeral approach to architecture and materials. In one series, 'JR-M#Starphire' (2012), he etched marble table-tops with acid, poured wine into the exposed veins and then made and erased patterns on glass placed on the marble. In other works paper and cloth evoke veils or masks while carrying indexical marks or impressions of the artist's body. In *Motif* (2013) a facial tissue is nailed onto the wall like a relic. In *Final Presentation Table* (2013) a tracing of Rojas's facial features has been reproduced on packaged paper towels displayed on a pedestal, as if inviting the disappearance of both the work and the artist's identity—in a dreamlike fade to white. KMJ

**Selected by**
Contemporary Fine Arts
F6

**Also shown by**
White Cube D4

**Biography**
Born 1982
Lives in Los Angeles

The work of Brazilian-born Rosa has been presented in solo and group shows internationally, at venues that include: Contemporary Fine Arts, Berlin (2014); La Fondazione Sandretto Re Rebaudengo, Turin (2014); Ibid, Los Angeles (2013); MUMOK, Vienna (2011); and the 3rd Athens Biennial (2011).

*…Oh Shit Ostrovsky*
2014
Oil, charcoal, pencil, resin, spray paint and oil stick on canvas
2.6 × 2 m
8' 6⅜ × 6' 6¾"
Courtesy of
Contemporary Fine Arts

# Christian Rosa

Christian Rosa does not search for truth or transcendence through abstraction. His large, sparsely populated paintings, in which partial, linear forms bisect or separate across swathes of raw canvas, have worldly titles—*Oh Fuck* (2013), *Weather in Vienna* (2014), *…Oh Shit Ostrovsky* (2014, presumably a reference to fellow abstract painter David Ostrowski)—and express quotidian concerns. Rosa's use of spray paint points to an outside world and the canvas of the streets, while pencil evokes paper and preparatory sketchbooks: the artist invokes other material realities and other art histories even as he immerses himself in the insular language of abstraction. AS

1

2

3

**Selected by**
The Approach E1

**Biography**
Born 1975
Lives in Los Angeles

Ross-Ho has been the
focus of solo exhibitions
presented at: Museum
of Contemporary
Art Cleveland
(2014); Museum of
Contemporary Art,
Chicago (2013); Mitchell-
Innes & Nash, New York
(2013 and 2010); MoCA,
Los Angeles (2012); and
The Approach, London
(2011). Her work has
been seen in select group
shows that include:
'Shakti', Brand New
Gallery, Milan (2014);
'In the Cut: Collage as
Idea', Australian Centre
for Contemporary
Art, Melbourne (2013);
'Pairings: The Collection
at 50', Orange County
Museum of Art, Newport
Beach, CA (2012); and
'New Photography',
MoMA, New York (2010).

1
*Tarnished Diamond*
2013
Fibreglass, steel, copper
and gold plate
167.5 × 56 cm
66 × 22"
Courtesy of The
Approach

2
*Black Rags (I STILL
HATE TUESDAYS)*
2013
Dyed jersey and rib,
thread
2.41 × 1.12 m
7' 11" × 3' 8"
Courtesy of The
Approach

3
*Untitled Still Life
(ANYWHERE,
ANYTIME)*
2011
Mixed media
61 × 45.5 cm
24 × 18"
Courtesy of The
Approach

# Amanda Ross-Ho

A recent exhibition by Amanda Ross-Ho
contained, at its centre, an enormous,
hyperrealistic replica of a photographic
enlarger. The sculpture was, in one sense,
a verbal gag about enlargement, but it
also signalled Ross-Ho's fundamental
commitment to photography, even
considered through sculptural means.
The content of her art is invariably
drawn from Ross-Ho's home or studio;
its autobiographical significance,
however, is secondary to her conceptual
experiments around issues of
representation and the archive.
*Tarnished Diamond* (2013) is a huge
replica earring, remade as tall as the
artist herself. The framed panel *Untitled
Still Life (ANYWHERE, ANYTIME)*
(2011) is a rectangle of plasterboard,
peppered with pinholes and taped-up
photographs, as if cut directly from
Ross-Ho's studio wall. JG

**Selected by**
T293 A21

**Also shown by**
Project Native Informant
L1

**Biography**
Born 1985
Lives in London

Graduating with an MA in Painting from the Royal College of Art in 2013, Röhss has since presented solo exhibitions at galleries that include: Carl Kostyál, Stockholm (2014); Project Native Informant, London (2014); and Museo de la Ciudad, Querétaro, Mexico (2013). Select group shows in which his work has been exhibited include: 'Oliver Osborne, Emanuel Röhss and Max Ruf', Carl Kostyál, London (2014); 'T293 in Residence', Sadie Coles HQ, London (2014); and 'Bloomberg New Contemporaries', held at the ICA, London (2012).

1
Exhibition view at T293, Naples. Works from left to right, clockwise:

*Hellman Family 1, Stockholm*
2014
Acrylic and alkyd enamel on canvas
2.1 × 1.45 m
6' 9" × 4' 7"

*Claudia Radclyffe 1, London*
2014
Acrylic and alkyd enamel on canvas
2.1 × 1.45 m
6' 9" × 4' 7"

*Claudia Radclyffe 2, London*
2014
Acrylic and alkyd enamel on canvas
2.1 × 1.45 m
6' 9" × 4' 7"

*Rose Foulkner 3, London*
2014
Reinforced concrete
80 × 170 × 10 cm
31½ × 70 × 4"

2
*Claudia Radclyffe 4, London*
2014
Reinforced concrete
115 × 20 × 15 cm
45¼ × 7⅞ × 5⅞"

All images courtesy of T293

# Emanuel Röhss

'Where does the frame take place[?]' asks Jacques Derrida in *The Truth in Painting* (1987). 'Does it take place[?] Where does it begin[?] Where does it end[?]' Emanuel Röhss's work extracts decorative details and architectonic supports from rooms and buildings— a face in the sculpted capital of a column, a swatch of wallpaper pattern—elements which, like the frame, are always just out of focus, seen without demanding to be looked at. Stripping them of their context, he casts these in a starring role, spotlighting them in the blank space of the gallery. Dividing and framing the space, Röhss's sculptural elements are also bridges to exterior worlds and other interiors, confusing outside and inside, asking where one begins and the other ends. AS

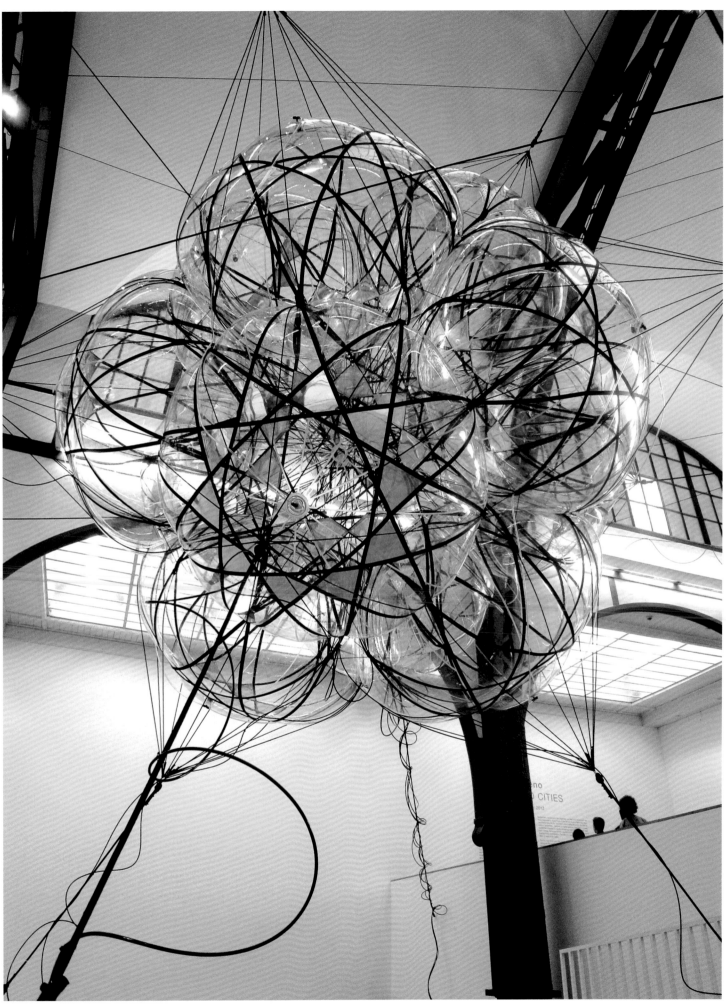

**Selected by**
Esther Schipper C12

**Also shown by**
Tanya Bonakdar Gallery
E7

**Biography**
Born 1973
Lives in Berlin

Argentinian artist
Saraceno has been the
subject of solo exhibitions
held internationally,
at venues that include:
Esther Schipper, Berlin
(2013); Maison Hermès,
Tokyo (2012); The
Metropolitan Museum
of Art, New York (2012);
Hamburger Bahnhof,
Berlin (2011–12); Tanya
Bonakdar Gallery,
New York (2010); and
the Walker Art Center,
Minneapolis (2008).
Saraceno was awarded
the 2010 Calder Prize by
the Calder Foundation,
New York, and in
2009 he participated
in a residency with the
International Space
Studies Program, NASA
Ames Research Center,
Silicon Valley, CA (2009).

1
*12MW Iridescent/Flying
Garden/Air Port City*
2008
Air pillows, polyester
webbing, iridescent foil,
air pressure regulator
system
3.5 × 3.5 × 3.5 m
11' 5¾" × 11' 5¾" × 11' 5¾"
Courtesy of Esther
Schipper

2
*Air Port City/Cloud City/
6 Cloud Modules 30 SC*
2013
Plywood, polyester rope,
fishing line
52 × 70 × 52 cm
20½ × 27½ × 20½"
Courtesy of Esther
Schipper

2

# Tomás Saraceno

Our heads should be up in the clouds,
insists Tomás Saraceno. His sculptures,
installations and ambitious architectural
projects point to the skies as our future
destiny. Drawing as much on cloud
structure and spiders' webs as on the
Utopian visions of Buckminster Fuller
and Yona Friedman, Saraceno envisions
an airborne civilization. *Air Port City/
Cloud City/6 Cloud Modules 30 SC*
(2013) is a hanging plywood cluster of
pentagonal globules, an engaging
geometric sculpture that also acts as a
maquette for his full-size structures so
far realized in New York and Dusseldorf.
His works act as anticipatory blueprints
that encourage us to be bold in imagining
what the next step can be. CFW

1

2

3

**Selected by**
Gagosian Gallery C3

**Biography**
Born 1970
Lives in Oxford

British artist Saville
has presented solo
exhibitions of her
paintings at galleries and
institutions that include:
Gagosian Gallery,
London (2014 and 2010)
and New York (2011,
2003 and 1999); Norton
Museum of Art, West
Palm Beach, FL (2011);
Modern Art Oxford,
UK (2011); and Museo
d'Arte Contemporanea
Roma, Rome (2005).
She has works held in
the public collections
of: the Museum of
Contemporary Art, San
Diego; Saatchi Gallery,
London; and The
Metropolitan Museum of
Art, New York.

1
*Odalisque*
2012–14
Oil and charcoal on
canvas
2.17 × 2.36 m
7' 1½" × 7' 9⅛"
Courtesy of Gagosian
Gallery

2
*Oxyrynchus*
2012–14
Pastel and charcoal on
canvas
1.7 × 2.5 m
5' 6¾" × 8' 2½"
Courtesy of Gagosian
Gallery

3
*Study for Witness*
2011
Oil on linen
2 × 1.6 m
6' 6¾" × 5' 3"
Courtesy of Gagosian
Gallery

# Jenny Saville

Deeply engaged with painting's past, and the contested politics of art history, Jenny Saville's large-scale, vividly corporeal canvases and drawings confront eternal, and inescapable, human experiences, among them sexuality, parenthood and death. In works such as *Study for Witness* (2011) the commonplace equation of paint with flesh and bodily fluids is given forceful life. Here a woman (perhaps anaesthetized, perhaps dead, perhaps lost in some strange, violent rapture) lies with her eyes closed, her mouth a mess of shattered teeth and jagged brushstrokes. *Odalisque* (2012–14), meanwhile, is a contemporary revisiting of that art-historical mainstay the reclining nude, in which a mirror becomes a force for disruption, not least of the viewer's hungry and totalizing gaze. TM

1

2

3

**Selected by**
Sprüth Magers C5

**Also shown by**
Tanya Bonakdar Gallery
E7

**Biography**
Born 1968
Lives in Berlin

Scheibitz has presented
solo exhibitions at
galleries and institutions
that include: Sprüth
Magers, Berlin (2014,
2011 and 2008), London
(2010) and Cologne
(2006); Baltic Centre
for Contemporary Art,
Gateshead, UK (2013);
Museum für Moderne
Kunst, Frankfurt
(2012); abc art berlin
contemporary (2009);
Camden Arts Centre,
London (2008); Irish
Museum of Modern
Art, Dublin (2007); UC
Berkeley Art Museum,
San Francisco (2001);
and Stedelijk Museum,
Amsterdam (2001).

1
*Utopia*
2013
Oil, vinyl and pigment
marker on canvas
1.9 × 2.9 m
6' 2¾" × 9' 6⅛"
Courtesy of Sprüth
Magers and licensed by
VG Bild-Kunst

2
*GP 160*
2011
Oil, vinyl and pigment
marker on rag paper
2.16 × 1.66 m
7' 1" × 5' 5⅜"
Courtesy of Sprüth
Magers and licensed by
VG Bild-Kunst

3
*Chronik*
2014
Oil, vinyl and pigment
marker on canvas
2.5 × 1.4 m
8' 2⅜" × 4' 7⅛"
Courtesy of Sprüth
Magers and licensed by
VG Bild-Kunst

# Thomas Scheibitz

The cryptographic paintings and
sculptures of Thomas Scheibitz
turn on approximation, on vague
remembrance or fleeting allusion, the
familiar reconstituted in unfamiliar
ways. Motifs, or perhaps more
accurately visual tics, recur throughout
his *oeuvre*—here a curve, there a tonal
passage, there a compositional
solution—but never approach full
legibility. If this is a language, then
it is one concerned more with the
grain of speech than with meaning—
as the artist has said, 'I like the phonetic
aspect of a word better than what it
expresses.' His recent canvas *Chronik*
(2014) continues his beguiling
explorations of his own hermetic
universe. Is that form a figure? A cello?
A raindrop? It is what it is, and—just as
importantly—it is not what it is not. TM

1

2

3

**Selected by**
Galerija Gregor Podnar
A14

**Biography**
Born 1980
Lives in Berlin

Schlesinger has been
the focus of solo
exhibitions held at:
Kunsthalle Baselland,
Muttenz, Switzerland
(2014); Galerija Gregor
Podnar, Berlin (2014,
2011, 2010 and 2008);
Dvir Gallery, Tel Aviv
(2013, 2009 and 2005);
and Herzliya Museum
of Contemporary
Art, Israel (2003). He
has presented work
in select group shows
at: the Contemporary
Art Museum Estonia,
Tallinn (2014); Israel
Museum, Jerusalem
(2014); Künstlerhaus
Bethanien, Berlin (2013);
Swiss Institute, New York
(2011); and Museum of
Modern Art, Warsaw
(2009).

1
*Inside-Out Urn #1*
2013
Earthenware terracotta
and glue
47 × 41 × 41 cm
18½ × 16⅛ × 16⅛"
Courtesy of Galerija
Gregor Podnar

2
*The Kid #20*
2014
Inkjet print, glass, wood
125 × 118 cm
49¼ × 46½"
Courtesy of Galerija
Gregor Podnar

3
*The Kid #12*
2013
Inkjet print, glass, wood
47 × 38 cm
18½ × 15"
Courtesy of Galerija
Gregor Podnar

# Ariel Schlesinger

Ariel Schlesinger makes small tweaks
to everyday objects to reveal their
hidden potential, both practical and
poetic. In *Oil Lamp* (2010) a disposable
lighter is given a glass handle and a wick
that makes it usable as a means of
illumination—albeit one that feels
slightly hazardous to carry. Minor risk
and a hint of disaster thread through all
of Schlesinger's work, where destruction
becomes a mode of production, and
fire and gas make regular appearances.
*Inside-Out Urn #1* (2013) is a
reconstituted vase that, smashed
into countless fragments, has been
reconstructed with the inside facing out.
Burnt carpets, the broken glass in a series
of objects titled 'The Kid' (2013–
ongoing) and a photo series about
'Minor Urban Disasters' (2005–ongoing)
—all simultaneously convey a sense of
persistence and vulnerability. SNS

1

2

**Selected by**
Konrad Fischer Galerie
A9

**Also shown by**
Sadie Coles HQ D2

**Biography**
Born 1969
Lives in Rheydt,
Germany

Schneider has been the
focus of solo presentations
shown at galleries
including: Zachęta
National Gallery of Art,
Warsaw (2014); Konrad
Fischer Galerie (2013,
2008, 2005, 2002, 1997
and 1993); Art Gallery of
New South Wales, Sydney
(2012); Kunstraum
Innsbruck, Austria
(2012); Kunstsammlung
Nordrhein-Westfalen,
Dusseldorf (2007); Museu
Serralves, Porto, Portugal
(2005); Artangel, London
(2004); Hamburger
Kunsthalle, Hamburg
(2003); MoCA, Los
Angeles (2003); Musée
d'art moderne de la Ville
de Paris (1998); Kunsthalle
Bern (1996); and Museum
Haus Lange, Krefeld
(1994). At the 49th Venice
Biennale (2001) he
represented Germany and
was awarded the Golden
Lion.

1
*Bondi Beach, 21 Beach
Cells*
2007
Mixed media
2.5 × 20 × 20 m
8 2⅜' × 65' 7⅜" × 65' 7⅜"
Courtesy of Konrad
Fischer Galerie

2
*Totes Haus u r, Keller*
(Dead House u r, Cellar)
1985/2001
Installation view at 49th
Venice Biennale, 2001
One of 24 rooms, mixed
media
22 × 8.5 × 18 m
72' 2⅛" × 27' 10⅝" ×
59' ⅝"
Courtesy of Konrad
Fischer Galerie

# Gregor Schneider

Grim, gruesome and with a distinctly German *Angst*, Gregor Schneider's works often take the form of constructed or modified rooms, in houses such as one in Mönchengladbach-Rheydt that he has worked on since 1985. At the 2001 Venice Biennale he received the Golden Lion for *Totes Haus u r* (Dead House u r), a house of horrors replete with fake partitions, rotting interiors and a crumbling basement in which a disco ball hung. Schneider's dark psychological interiors, in which the viewer is engaged as participant, also nod to exterior human catastrophes such as Guantánamo. For *Bondi Beach, 21 Beach Cells* (2007) he installed a giant steel cage on Sydney's Bondi Beach, where beachgoers lay on cots under umbrellas within individual 4 x 4-metre cells: at once place of respite and a large, beach-bound prison. PL

1

2

**Selected by**
MOT International G9

**Also shown by**
Peres Projects G2

**Biography**
Born 1977
Lives in Berlin

Winner of the 2014
MAXXI Award, Senatore
has been the focus of
solo exhibitions shown
at venues that include:
MOT International
(2014); Kunst Halle Sankt
Gallen, Switzerland
(2014); Museum of
Contemporary Art, Santa
Barbara, CA (2014);
MAXXI, Rome (2014);
Italian Institute, New
York (2013); Künstlerhaus
Bethanien, Berlin
(2012); and Museo d'arte
contemporanea Roma,
Rome (2011). Select group
shows include: the 2nd
Bienal de Montevideo
(2014); 8th Liverpool
Biennial (2014); 11th
Havana Biennial (2012);
and the 54th Venice
Biennale (2011).

1
*Rosas: The Trilogy*
2013
Opera in 3 acts, with the
participation of citizens
from Berlin, Derby and
Madrid
3 HD videos
23 min., 35 min., 30 min.
Courtesy of MOT
International and Peres
Projects

2
*The School of Narrative
Dance: Little Chaos #1*
2013
Fine art print on
Hahnemühle paper
1.6 × 3 m
5' 3" × 9' 10⅛"
Courtesy of MOT
International

# Marinella Senatore

Marinella Senatore is an artist
and activator drawn to the creative
potential of crowds. As she explained
for her exhibition at the Museum
of Contemporary Art, Santa Barbara,
she casts herself in the role of 'a director
who has a score through which people
negotiate, or contest, their participation'.
Each project is an elaborate
undertaking: *Rosas* (2012), for example,
is a three-act opera for the screen,
produced collaboratively with more
than 20,000 people from communities
in Berlin, Derby and Madrid, who
co-authored the libretto and produced
and directed each film. In these works,
what matters is not the product so much
as the process; at the end of *Rosas*
the artist gifted the sets and technical
equipment to local community members
for their continuing use. EN

**Selected by**
MOT International G9

**Also shown by**
Peres Projects G2

**Biography**
Born 1977
Lives in Berlin

Winner of the 2014
MAXXI Award, Senatore
has been the focus of
solo exhibitions shown
at venues that include:
MOT International
(2014); Kunst Halle Sankt
Gallen, Switzerland
(2014); Museum of
Contemporary Art, Santa
Barbara, CA (2014);
MAXXI, Rome (2014);
Italian Institute, New
York (2013); Künstlerhaus
Bethanien, Berlin
(2012); and Museo d'arte
contemporanea Roma,
Rome (2011). Select group
shows include: the 2nd
Bienal de Montevideo
(2014); 8th Liverpool
Biennial (2014); 11th
Havana Biennial (2012);
and the 54th Venice
Biennale (2011).

1
*Rosas: The Trilogy*
2013
Opera in 3 acts, with the
participation of citizens
from Berlin, Derby and
Madrid
3 HD videos
23 min., 35 min., 30 min.
Courtesy of MOT
International and Peres
Projects

2
*The School of Narrative
Dance: Little Chaos #1*
2013
Fine art print on
Hahnemühle paper
1.6 × 3 m
5' 3" × 9' 10⅛"
Courtesy of MOT
International

# Marinella Senatore

Marinella Senatore is an artist
and activator drawn to the creative
potential of crowds. As she explained
for her exhibition at the Museum
of Contemporary Art, Santa Barbara,
she casts herself in the role of 'a director
who has a score through which people
negotiate, or contest, their participation'.
Each project is an elaborate
undertaking: *Rosas* (2012), for example,
is a three-act opera for the screen,
produced collaboratively with more
than 20,000 people from communities
in Berlin, Derby and Madrid, who
co-authored the libretto and produced
and directed each film. In these works,
what matters is not the product so much
as the process; at the end of *Rosas*
the artist gifted the sets and technical
equipment to local community members
for their continuing use. EN

**Selected by**
The Box G3

**Biography**
Born 1931
Lives in Los Angeles

Born in Pasadena,
Smith studied painting
at Pomona College in
the early 1950s and later
entered into University
of California Irvine's
first Masters of Arts
programme (1969-
71), alongside Nancy
Buchanan and Chris
Burden. She has been the
focus of solo presentations
held at venues that
include: The Box, Los
Angeles (2013, 2010 and
2008); University Art
Gallery, UC Irvine, CA
(2011); Galerie Parisa
Kind, Frankfurt (2009);
and Maccarone, New
York (2008). She has
participated in group
shows that include:
'State of Mind: New
California Art circa 1970',
Smart Museum of Art,
University of Chicago
(2013–14); 'Pacific
Standard Time: Art in
L.A. 1945–1980', Getty
Foundation (2011–12);
'WACK! Art and the
Feminist Revolution',
MoMA PS1, New York
(2008); and 'Los Angeles
1955–1985: The Birth of
an Art Capital', Centre
Pompidou, Paris (2006).

*A + B*
1965–6
Xerox print
35.5 × 65 cm
14 × 25 ⅝"
Courtesy of The Box

# Barbara T. Smith

Barbara T. Smith spent formative years
in her artistic development as a volunteer
and then Educator at the Pasadena
Art Museum during the 1960s, where
she was encouraged by Walter Hopps.
Her bold, immersive installations,
such as *Field Piece* (1968–72), bestow
the monumental with an organic,
rhizomatic spirit, while Smith's radical
Performance art of the 1970s and '80s
was reappraised as part of the multi-site
West Coast retrospective 'Pacific
Standard Time' in 2011–12. In 1965 the
artist installed a photocopier in her house
and copied everything in sight—flowers,
children, her own body in various states
of sexual arousal or cool objectivity—
documenting transformations wrought
on the home, the family, bodies and
minds by changes in labour and
technology. LMcLF

# Julian Stair

**Selected by**
Corvi-Mora C13

**Biography**
Born 1955
Lives in London

Stair has been the subject
of solo exhibitions shown
at: Somerset House,
London (2014); York St
Mary's, York, UK (2013);
National Museum of
Wales, Cardiff (2013);
Middlesbrough Institute
of Modern Art, UK
(2012); and The Scottish
Gallery, Edinburgh
(2010). He has works held
in the public collections
of institutions that
include: Museum of Art &
Design, New York; British
Council Collection, UK;
Hong Kong Museum of
Art; Museum Boijmans
van Beuningen,
Rotterdam; and the
Victoria and Albert
Museum, London.

*Quietus*
2012
Installation view at
Middlesbrough Institute
of Modern Art
Dimensions variable
Courtesy of Corvi-Mora

For more than 30 years Julian Stair
has been making ceramic vessels that
summon the common rituals and
practices of human beings across time
and space. His teapots, cups and other
quotidian objects register the value of
daily use and touch, although these
muted and matte works in earthbound
tones have a solid, luxuriant simplicity
to them. Stair's sculptures took on a more
monumental scale a decade ago, when
he began to respond directly to the
dimensions of the human body, and
specifically to engage with ceramics as
a resting site for the human body after
death. His 'Quietus' series of pots, urns
and sarcophagi (2012) softly suggests that
we give funerary rituals our full
attention rather than shuttering them
from our consciousness. LMcLF

**Selected by**
Tanya Bonakdar Gallery
E7

**Also shown by**
White Cube D4

**Biography**
Born 1944
Lives in New York

Israeli-American artist Steinbach has been the focus of solo and two-person shows at venues that include: The Menil Collection, Houston (2014); Hessel Museum of Art, Bard College, Annandale-on-Hudson, NY, travelling to Kunsthalle Zürich and Serpentine Gallery, London (2013–14); Statens Museum for Kunst, Copenhagen (2013); The Artist's Institute, New York (2012); Solomon R. Guggenheim Museum, New York (1993); and the Witte de With Centre for Contemporary Art, Rotterdam (1992). He has participated in group exhibitions that include: 'Take It or Leave It: Institution, Image, Ideology', Hammer Museum, Los Angeles (2014); 'Le Surréalisme et l'objet - la sculpture au défi', Centre Pompidou, Paris (2013); and 'This Will Have Been: Art, Love and Politics in the 1980s', Museum of Contemporary Art Chicago (2012).

1
*Particle Board Panel with Black Shapes*
1976
Oil stick on particle board
58.5 × 58.5 cm
23 × 23"
Courtesy of Tanya Bonakdar Gallery

2
*Shelf with Kettle*
1981
Imitation plastic wood shelf with driftwood, 1950s chrome kettle
30.5 × 43 × 43 cm
12 × 17 × 17"
Courtesy of Tanya Bonakdar Gallery

2

# Haim Steinbach

Haim Steinbach's practice turns on the appropriation of mass-produced objects, which he commonly arranges in a single line on laminated wooden shelves—an action he has compared to arranging 'words in a sentence'. Early 2D works such as *Particle Board Panel with Black Shapes* (1976) explore Minimalism and the limits and codes of a reduced visual idiom, and 3D works such as *Shelf with Kettle* (1981), evoke both shop displays and the domestic life of consumer goods, while exploring the formal and semantic relationships between their components with a sharp and economic visual wit. Steinbach's objects—which have included everything from detergent boxes to bowling balls, children's toys to sneakers—are more than simple swipes at consumer capitalism. Rather, they speak of how every human artefact, no matter how mundane, is a repository for a value, a feeling or a fantasy. TM

1

2

3

**Selected by**
Galerie Martin Janda B12

**Biography**
Born 1947
Lives in Zagreb

Stilinović has been
the focus of solo
presentations held at:
Galerie Martin Janda,
Vienna (2014 and 2011);
e-flux, New York (2014);
Galerie Frank Elbaz,
Paris (2014); Museum
of Contemporary
Art, Zagreb (2012);
Ludwig Museum of
Contemporary Art,
Budapest (2011); the
Museum of Modern
Art, Warsaw (2010); and
Centre for Contemporary
Arts, Glasgow (2008). He
has contributed work to
group shows at venues
that include: Centre
Pompidou, Paris (2014);
Carnegie Museum of
Art, Pittsburgh (2013);
New Museum, New
York (2011); MACBA,
Barcelona (2011); and
Documenta 12, Kassel
(2007).

1
*Plaža*
(Beach)
2006
Collage on cardboard
25 × 20 cm
9⅞ × 7⅞"
Courtesy of Galerie
Martin Janda

2
*Zašto se proturječnosti treba
više bojati nego tautologije?
(Ludwig Wittgenstein)*
(Why is Contradiction
More Dangerous than
Tautology? [Ludwig
Wittgenstein])
2011
Acrylic on linen
0.54 × 2.94 m
1' 9⅛" × 9' 7¾"
Courtesy of Galerie
Martin Janda

3
*Skok*
(Jump)
2005
Collage on cardboard
33 × 22 cm
13 × 8⅝"
Courtesy of Galerie
Martin Janda

# Mladen Stilinović

Whether smearing one of his own
paintings with cake or declaring, in
his 1992 banner, 'An artist who cannot
speak English is no artist', Mladen
Stilinović stares down conventions of
money, political rhetoric, creativity
and individuality. In the collage *Plaža*
(Beach, 2006) a faded black and white
photograph of a sunny, relaxed seaside
afternoon is pocked with black holes,
the sky's few clouds cut out and
repositioned as if lounging on the grass
or about to dive into the water. One
of the leading Conceptual artists of
Central and Eastern Europe, Stilinović
has since the late 1960s used an all-
absorbing sense of absurdity to show
that we have nothing to fight, and
nothing to change, but ourselves. CFW

1

**Selected by**
Zeno X Gallery E4

**Biography**
Born 1974
Lives in Ghent

Stolle has been the focus
of solo exhibitions held at:
Zeno X, Antwerp (2012
and 2009); S.M.A.K.,
Ghent (2006); De Brakke
Grond, Amsterdam
(2006); and STUK
Kunstencentrum, Leuven,
Belgium (2006). His work
has been seen in select
group shows at venues
that include: S.M.A.K.,
Ghent (2014); Zeno X
Gallery, Antwerp (2014,
2013 and 2012); Museum
of Contemporary Art,
Shanghai (2009); Centre
for Contemporary Art,
Warsaw (2007); and
National Gallery, Prague
(2005).

3

1
*Radar*
2014
Acrylic on canvas
51 × 124 cm
20⅛ × 48⅞"
Courtesy of Zeno X
Gallery

2
*Beach*
2013
Acrylic on canvas
136 × 110 cm
53½ × 43¼"
Courtesy of Zeno X
Gallery

3
*Reconstructing the Original
Formula (2)*
2012–13
Acrylic on canvas
59.5 × 67 cm
23⅜ × 26⅜"
Courtesy of Zeno X
Gallery

# Bart Stolle

The short digital animations of
Bart Stolle—grouped for the past
decade under the name Low Fixed
Media Show—have a deliberately
lo-fi aesthetic that harks back to the
days of Microsoft PowerPoint and
early Internet art. These shorts, often
black and white and intermittently
abstract, are aflutter with stick figures,
HTML digits, broken lines and
occasional glitches. A cheeky playfulness
runs throughout animations such as
*Run* (2013), an *hommage* to Eadweard
Muybridge depicting simply
a running stick figure. Stolle's acrylic
paintings transplant this universe to the
canvas. The ocean-blue *Radar* (2014)
looks like a radar display panel
populated by colourful square bodies;
in *Beach* (2013) stick figures with bobbing
heads float on a beach-like white
canvas under spare 2D umbrellas. PL

1

2

3

**Selected by**
Frith Street Gallery B4

**Biography**
Born 1966
Lives in Amsterdam

Indonesian artist
Tan, who in 2007
was nominated for
the Deutsche Börse
Photography Prize,
has been the focus of
solo exhibitions held at:
National Museum of Art,
Osaka (2014); Bonniers
Konsthall, Stockholm
(2014); Philadelphia
Museum of Art (2014);
MAXXI, Rome (2013);
The Photographers'
Gallery, London (2012);
Frith Street Gallery,
London (2010, 2006 and
2003); Vancouver Art
Gallery (2010); the Dutch
Pavilion, 53rd Venice
Biennale (2009); Museum
of Contemporary Art,
Chicago (2004); and
Kunstverein Hamburg
(2000).

1
*Ghost Dwellings I*
2014
HD video
4 min. 10 sec.
Courtesy of Frith Street
Gallery

2
*Ghost Dwellings II*
2014
HD video
4 min. 53 sec.
Courtesy of Frith Street
Gallery

3
'1 to 87'
2014
Mixed media installation
1.4 × 3 × 7 m
4' 7⅛ × 9' 10⅛ × 22' 11⅝"
Courtesy of Frith Street
Gallery

# Fiona Tan

For her three-part video work *Ghost Dwellings* (2014), Fiona Tan travelled to three places currently defined by the wake of sudden or protracted calamity: Fukushima in the aftermath of the 2011 nuclear catastrophe, Detroit in its industrial and civic decline and post-property-crash Cork, in Ireland. An accompanying series of sculptural works, '1 to 87' (2014) interjects scenes of disaster and protest into the bright, uncanny landscapes that surround model railways. Both the filmic portraits of domestic ruin and these sculptural miniatures are quite of a piece with Tan's prior interest in vernacular photography, collecting and memory—fragile self-definition in the shadow of history. BD

1

2

3

4

**Selected by**
Stevenson G10

**Biography**
Born 1967
Lives in Paris, France, and
Bandjoun, Cameroon

Toguo has been the
subject of solo exhibitions
shown at venues that
include: Uppsala Art
Museum, Sweden
(2014); Woosen Gallery,
Daegu, South Korea
(2013); Musée d'art
contemporain de Sainte
Etienne, France (2013);
Galerie Lelong, Paris
(2013, 2012 and 2010);
FRAC Île de la Réunion,
Saint-Denis, France
(2009); Baltic Centre
for Contemporary Art,
Gateshead, UK (2008);
and Palais de Tokyo,
Paris (2004). Recent
group shows include
the 11th Biennial of
Contemporary African
Art, Dak'art, Senegal,
Dakar (2014); and
'Body Language', Studio
Museum in Harlem, New
York (2013).

1
*The New World Climax*
2001–12
Wood, ink
115 × 135 × 82 cm
45¼ × 53⅛ × 32¼"
Courtesy of Stevenson

2
*Love's Divine Together*
2014
Watercolour on paper
113 × 90 cm
44½ × 35⅜"
Courtesy of Stevenson

3
*A Room with a View on
the Eggs*
2014
Watercolour on paper
113 × 90 cm
44½ × 35⅜"
Courtesy of Stevenson

4
*The Gardner Solitaire*
2014
Watercolour on paper
113 × 90 cm
44½ × 35⅜"
Courtesy of Stevenson

# Barthélémy Toguo

Barthélémy Toguo adopts transit as a permanent state of being, which colours his own life and is the overarching theme in his work. In works produced both pre- and post-9/11, he probes the fraught and evolving contemporary politics of travel and border-crossing. In more recent watercolours such as *The Gardner Solitaire* (2014) grotesque silhouettes and indistinct organic forms bleed into each other, providing a dark picture of individual isolation and human angst. *The New World Climax* (2001–12), which features a pile of stamps like those used in passports, made exaggeratedly large, monumentalizes the mechanisms of border control, but with a critical twist: rather than national seals, the stamps bear the phrases '*inégalité*', '*south sudan*', '*apatride*' and '*printemps arabe*'. Are these condemnations? Admonitions? Or an optimistic call for solidarity? SNS

1

2

**Selected by**
Galeria Plan B H5

**Biography**
Born 1986
Lives in Paris

Moroccan artist Touloub,
who in 2013 graduated
from the École des
Beaux-Arts, Paris, has
exhibited at galleries that
include: Plan B, Berlin
(2014); Courtesy, Los
Angeles (2013); Galerie
de Roussan, Paris (2013);
Art-Cade, Galerie des
bains douche de la Plaine,
Marseille (2012); Galerie
Martine et Thibault de La
Châtre, Paris (2012 and
2011); and Maison Rouge,
Paris (2009).

1
*Pensées assises*
2014
Ink and gouache on paper
115 × 190 cm
45¼ × 74¾"
Courtesy of Galeria
Plan B

2
*Variations on Burning
Figures*
2014
Ink and gouache on paper
125 × 205 cm
49¼ × 80¾"
Courtesy of Galeria
Plan B

# Achraf Touloub

Achraf Touloub's drawings, sculptures and videos balance references to classical Middle and Far Eastern art with contemporary concerns: see a work such as the ink-and-gouache *Pensées assises* (2014), with its sinuously drawn pattern of lamenting figures surrounded by screens or mirrors from which hands reach out. There's no temporal schism in this mix as he sees it: our drift away from materiality correlates directly with the revival of metaphysics—the rise of radical Islam, for example. Here the powers of tradition and technology are seen as complicit in reshaping society, as a result of which the symbolic, rather than the real, serves as a controlling force. And if that's the case in life, Touloub asserts, so should it be in a critical art practice. MH

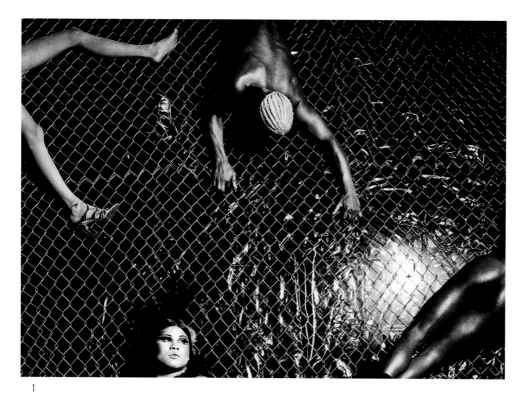

1

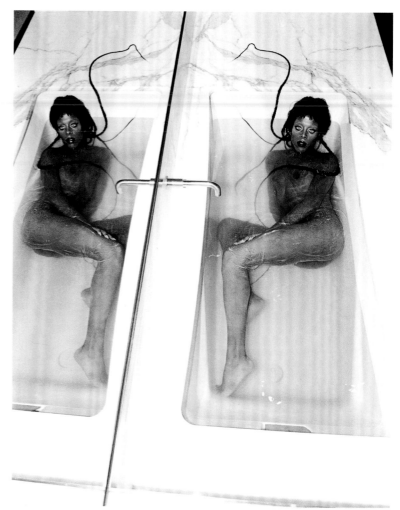

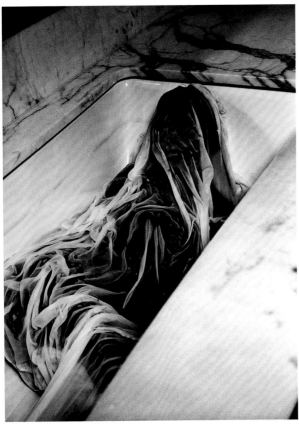

3

**Selected by**
Galerie Buchholz C10

**Biography**
Born 1985
Lives in New York

Uoo has been the subject
of solo exhibitions shown
at venues that include:
Galerie Buchholz,
Berlin (2014); Whitney
Museum of American
Art, New York (2013);
and 47 Canal, New York
(2012). Select group shows
include: 'Prodigal in Blue',
Laura Bartlett Gallery,
London (2013); 'The
Anti-Social Majority',
Kunsthall Oslo (2011);
'179 Canal/Anyways',
White Columns,
New York (2010); and
'Performa 09: Betteraves
Club', 179 Canal, New
York (2009).

1
*When It Rains*
2014
C-type print
72 × 101 cm
28⅜ × 39¾"
Courtesy of Galerie
Buchholz

2
*Huxtable Effect*
2014
C-type print
89 × 70 cm
35 × 27½"
Courtesy of Galerie
Buchholz

3
*No Secrets*
2014
C-type print
61 × 44 cm
24 × 17⅜"
Courtesy of Galerie
Buchholz

# Stewart Uoo

Trailing vein–like cables and atmospheric tatters, Stewart Uoo's mannequin cyborgs, like his videos, paintings and drawings, offer multiple narrative threads. In recent works he has also embellished the kind of security gates found on tenement windows, adding sprouting hair, silicone and fake rust—lending vulnerability to these iron bones of the urban landscape through an artificial, ravaged carnality. Moody and intimate, Uoo's photographic collaborations with Heiji Shin— featuring Juliana Huxtable, DeSe Escobar and Eliot Glass—combine intimations of death with hallucinatory vitality, as in the veiled body in a marble tub in *No Secrets* (2014), the uncanny double nude in *Huxtable Effect* (2014) or the figures clinging to a chain-link fence as if falling from the frame in *When It Rains* (2014). KMJ

1

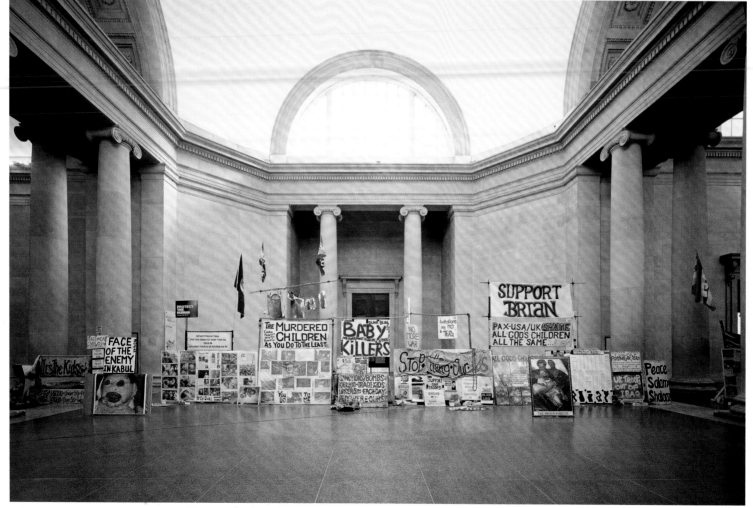

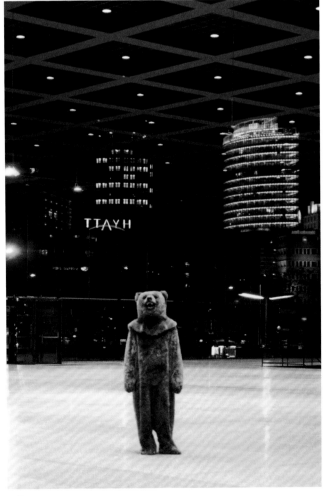

3

**Selected by**
Hauser & Wirth D6

**Also shown by**
Galerie Krinzinger A6

**Biography**
Born 1959
Lives in London

British artist Wallinger, who in 2013 presented *Labyrinth*, a major artwork commission marking the 150th anniversary of the London Underground, has previously held solo exhibitions at venues that include: carlier | gebauer, Berlin (2014, 2010, 2004 and 2003); Baltic Centre for Contemporary Art, Gateshead, UK (2012); Kunstverein Braunschweig, Germany (2007); Tate Modern, London (2007); New Art Gallery Walsall, UK (2006); Whitechapel Gallery, London (2001); Palais de Beaux-Arts, Brussels (1999); and the Serpentine Gallery, London (1995). In 2001 he represented Britain at the 49th Venice Biennale; in 2007 Wallinger was awarded the Turner Prize.

1
*Labyrinth #232 Green Park*
2013
Vitreous enamel on steel plate
63.5 × 63.5 cm
25 × 25"
Courtesy of Hauser & Wirth

2
*State Britain*
2007
Installation view at Tate Britain, London
Courtesy of Hauser & Wirth

3
*Sleeper*
2004
Performance at Neue Nationalgalerie, Berlin
Courtesy of Hauser & Wirth

# Mark Wallinger

Since the mid-1980s Mark Wallinger's art has stood for stylistic variety, tactical wit, a deeply ethical world-view, double meanings and a fascination with what divides and unites humanity. Politics and ideology, for example—in *Sleeper* (2004), a performance and video, Wallinger dressed as a bear wandering a Berlin museum after nightfall to address the Cold War, loneliness and assimilation (whether for a spy or any individual living abroad), while *State Britain* (2007) reconstructed peace protester Brian Haw's huge anti-Iraq War display as an intricate ready-made of sorts. Or spirituality, in Wallinger's repeated punning on earthly and elevated meanings of 'transport'—most recently *Labyrinth* (2013), a discrete graphic-design labyrinth concocted for each of London's 270 Underground stations, allusively conflating underground, underworld and unconscious. MH

1

2

**Selected by**
Herald St C2

**Also shown by**
Andrew Kreps Gallery
D11

**Biography**
Born 1967
Lives in Berlin

Weber has been the focus of solo presentations held at: Fondazione Morra Greco, Naples (2013); Herald St, London (2012 and 2009); Andrew Kreps Gallery, New York (2012 and 2007); Nottingham Contemporary, UK (2011); Hayward Gallery, London (2007); Kunstverein Hamburg (2005); and Cubitt Gallery, London (2004). His work has been seen in select group shows that include: 'Painting Forever!', KW Institute for Contemporary Art, Berlin (2013); 'The Kaleidoscopic Eye', Mori Art Museum, Tokyo (2009); and 'Ecstasy: In and About Altered States', held at MoCA, Los Angeles (2005).

1
*Untitled Vitrine*
2012
Mixed media
92 × 57.5 × 170 cm
36¼ × 22⅝ × 66⅞"
Courtesy of Herald St

2
*Sandfountain*
2012
Prefabricated concrete fountain and sand
2.5 × 4 × 4 m
8' 2⅜ × 13' 1½ × 13' 1½"
Courtesy of Herald St

3
*Cat (phantom box)*
2014
Plaster cast
42 × 81 × 20 cm
16½ × 31⅞ × 7⅞"
Courtesy of Herald St

# Klaus Weber

Klaus Weber is a nature artist for an era in which the idea of nature is no longer tenable. His installations and sculptures often frame natural occurrences—drifting dunes of sand, for example, or ecstatic sprays of water—within culturally predetermined structures. In *Sandfountain* (2012) Weber has achieved the miraculous by forcing sand to pass through four tiers of an elaborate concrete fountain. Culture has tamed and contained nature, he seems to imply. *Cat (phantom box)* (2014) is an empty cast of a taxidermied cat, with tufts of hair still sticking to the plaster. As with the cast death mask that appears in *Untitled Vitrine* (2012) alongside a dead grasshopper, Weber provokes us with empty and broken vessels. JG

3

**Selected by**
Anthony Reynolds
Gallery F10

**Also shown by**
kurimanzutto D7

**Biography**
Born 1970
Lives in Chang Mai,
Thailand

Awarded the 2013
Fukuoka Prize for Art
and Culture, and the
11th Sharjah Biennial
Prize, Weerasethakul
has presented solo
exhibitions across venues
that include: Anthony
Reynolds Gallery,
London (2014); Institute
for Contemporary Art,
Copenhagen (2011); Haus
der Kunst, Munich (2009);
Münchnerstadt Museum,
Munich (2009); Wexner
Center for the Arts,
Columbus, OH (2009);
Musée d'art modern de
la Ville de Paris (2009);
New Museum, New York
(2008); and the Irish
Museum of Modern Art,
Dublin.

Installation view at
Anthony Reynolds
Gallery. Works from left
to right:

*Blow Up*
2009
Archival digital print on
Di-bond
1.47 × 2.22 m
4' 9¾" × 7' 3⅜"

*Teem*
(detail)
2007
3 videos shot on mobile
phone
Durations variable
Courtesy of Anthony
Reynolds Gallery

# Apichatpong Weerasethakul

Apichatpong Weerasethakul makes feature-length films and shorter video works that capture the feeling of flux and disorientation that many people experience in a rapidly modernizing world. The Thai director and artist is interested in slippery dualities, whereby traditional spirituality coexists with profane careerism, bucolic nature and chaotic urbanity interpenetrate, and dreams merge with reality. Drawing on traditions of American experimental film, Weerasethakul's works are rendered with a distinctively ambulatory pace of storytelling that demands attentive viewing. Works such as *Dilbar* (2013, with Chai Siri) are oblique portraits: in this case, of an immigrant Bangladeshi worker in the United Arab Emirates. In *Teem* (2007) the artist used his phone to video his boyfriend sleeping, capturing a moment that is as intimate as it is tender. CP

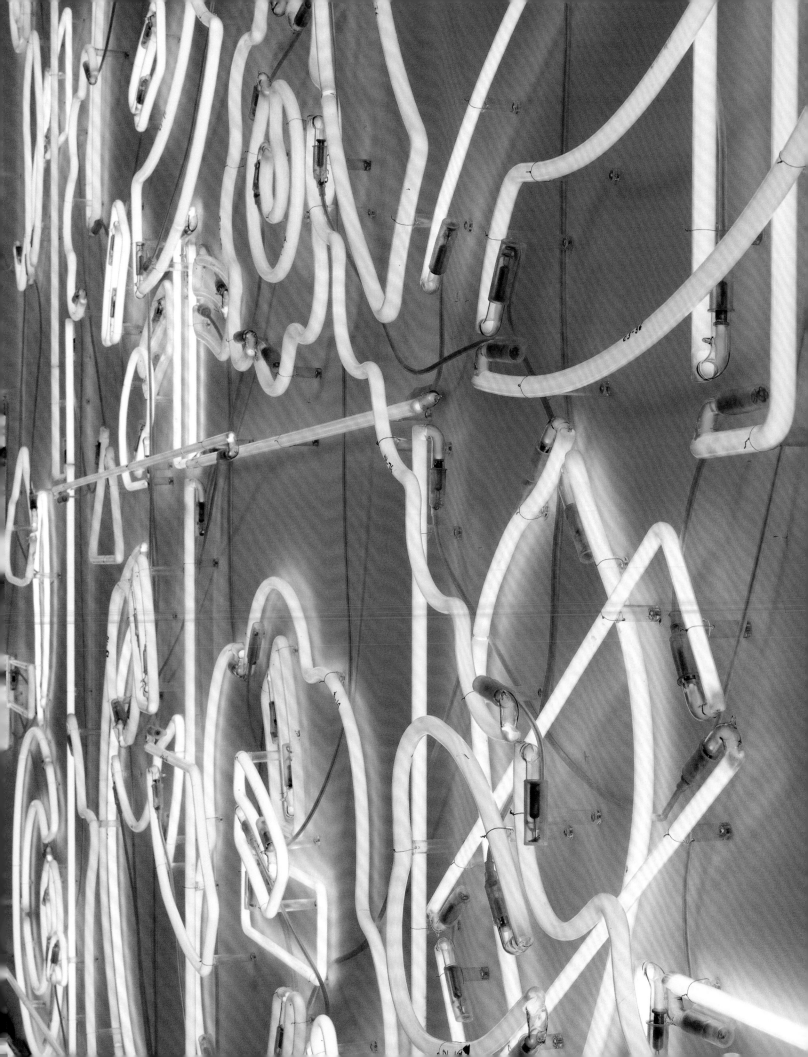

**Selected by**
greengrassi D3

**Biography**
Born 1963
Lives in Los Angeles

White has been the focus of solo exhibitions presented at galleries and institutions that include: greengrassi, London (2014, 2007, 2005 and 2002); MAK, Vienna (2013); South London Gallery (2013); the Art Institute of Chicago (2011); Saint Louis Museum, St Louis, MO (2010); Manchester Art Gallery, UK (2006); and Hammer Museum, Los Angeles (2004). Her work is held in the public collections of: MoMA, New York; Tate collection, UK; MoCA, Los Angeles; Jumex Collection, Mexico City; Art Institute of Chicago; and Hammer Museum, Los Angeles.

*Genau or Never*
2014
Neon
Dimensions variable
Courtesy of greengrassi

# Pae White

Pae White's work is often highly chromatic, and always joyfully skewed. Embracing the ephemeral leavings of nature and culture—cobwebs, birdsong and popcorn have all provided inspiration—her practice skips between sculpture, installation art, graphic and product design, and architecture with a rare freedom and ease. White's *Genau or Never* (2014) is a reconfiguration of an unrealized commission, planned for Gloucester Road tube station, consisting of some 2,450 neon tubes shaped after the motifs of a mythical magic carpet. A small portion of the original work's blueprint was fed into a randomizer; the result might be an unravelling, a scrambling of design logic, but it still has the power to uplift, and transport. TM

1

2

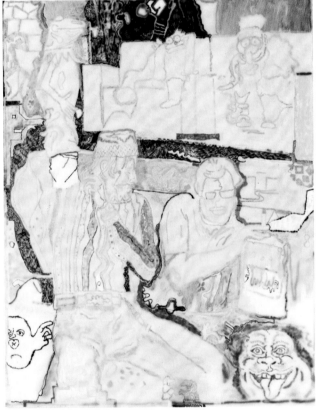

3

**Selected by**
Michael Werner A7

**Also shown by**
Canada J6
Galerie Eva Presenhuber
F3

**Biography**
Born 1978
Lives in New York

The work of American artist Williams has been the focus of solo presentations held at: Michael Werner, London (2014); Galerie Eva Presenhuber, Zurich (2014); Canada, New York (2013, 2011 and 2007); Franklin Parrasch Gallery, New York (2012); and Perugi Artecontemporanea, Padua, Italy (2008). He has participated in select group shows held at venues that include: MoMA, New York (2014); The Journal Gallery, Brooklyn, NY (2013); Office Baroque, Antwerp (2013); White Flag Projects, St Louis, MO (2011); and MoMA, New York (2007).

1
*Bidet King*
2014
Inkjet, airbrush and graphite on canvas
2.46 × 1.93 m
8' 1" × 6' 4"
Courtesy of Michael Werner Gallery

2
*Super Chill Lunch Date*
2013
Airbrush and inkjet on canvas
2.49 × 1.98 m
8' 2" × 6' 6"
Courtesy of Michael Werner Gallery

3
*Warm Mammals*
2012
Mixed media on canvas
2.44 × 1.95 m
8' ⅛" × 6' 5"
Courtesy of Michael Werner Gallery

# Michael Williams

Michael Williams's canvases are intricate, humorous and richly embellished, containing a riot of colour and exuberantly cartoonish figures. While Williams has been working as a painter for many years, of late he has embraced digital processes. He draws on a computer before printing on to canvas; some works, such as *Bidet King* (2014), are then further embellished with airbrush paint, a retro touch that contrasts with the use of new technologies. The result is images that have a peculiar and beguiling flatness. *Super Chill Lunch Date* (2013) is a hallucinatory canvas that appears to contain numerous textures and brushstrokes within a single, relentless flatness; in this way Williams uses the digital to subtly rework the parameters of painting. KK

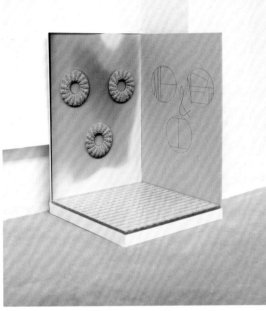

2

**Selected by**
Andrew Kreps Gallery
D11

**Biography**
Born 1981
Lives in Poznań, Poland

Zamojski has shown solo
exhibitions at venues
that include: Andrew
Kreps Gallery, New York
(2014); Zachęta National
Gallery of Art, Warsaw
(2013); and Foksal
Gallery Foundation,
Warsaw (2013). His
work has been shown in
select group shows that
include: 'Twisted Entities',
Museum Morsbroich,
Leverkusen, Germany
(2013); 'Respect Paper',
Piktogram, Warsaw
(2012); 'Makeshift',
Municipal Gallery
Arsenal, Poznań (2012);
and 'Seeing New York',
held at the Czech Center,
New York (2010).

1
*Self-Portrait with Fish*
2013
Graphite on timber with
framed collage
Installation view at
Andrew Kreps Gallery,
New York, 2014
Courtesy of Andrew
Kreps Gallery

2
*Self-Portrait (Two-Faced
Prick)*
2011
Drawing on cardboard,
photograph, glass
32 × 21 × 21 cm
12⅝ × 8¼ × 8¼"
Courtesy of Andrew
Kreps Gallery

# Honza Zamojski

We naturally find faces everywhere:
clouds, house fronts, postboxes. Honza
Zamojski turns this instinct into an
absurd, self-conscious game in which
his drawings, paintings and sculptures
are all shape-shifting self-portraits.
*Self-Portrait with Fish* (2013) is a large
stickman sculpture touching all six
sides of the room he occupies, his face
caught in something like surprise at his
elongated nose and penis butting into
the wall. *Self-Portrait (Two-Faced Prick)*
(2011) sets a photograph of three ring-
shaped biscuits alongside a drawing
of three similarly placed circles that
respectively contain the words 'me',
'myself' and 'I'. In his playful remaking
of the self, Zamojski makes a two-way
mirror that asks what we're actually
looking for. CFW

1

2

3

**Selected by**
Foksal Gallery
Foundation F5

**Also shown by**
Hauser & Wirth D6
Galerie Martin Janda B12

**Biography**
Born 1980
Lives in Kraków

The work of Polish artist Ziółkowski has been exhibited in solo shows held at: BWA Gallery, Zielona Góra, Poland (2014); Hauser & Wirth, Zurich (2013 and 2008); Foksal Gallery Foundation, Warsaw (2012 and 2005); Parasol Unit, London (2011); Zachęta National Gallery, Warsaw (2010); and BWA Wrocław, Gallery of Contemporary Art, Wrocław (2010). He has participated in select group shows held at The Box, LA (2013); 55th Venice Biennale (2013); and 'Painting Between the Lines', at the CCA Wattis Institute for Contemporary Arts, San Francisco (2011).

1
*Manotaur*
2013
Oil on canvas
46 × 55 cm
18⅛ × 21⅝"
Courtesy of Foksal
Gallery Foundation

2
*Emmamah*
2013
Oil on panel
34 × 25 cm
13⅜ × 9⅞"
Courtesy of Foksal
Gallery Foundation

3
*Untitled (Self-Portrait)*
2013
Oil on canvas
41 × 38 cm
16⅛ × 15"
Courtesy of Foksal
Gallery Foundation

# Jakub Julian Ziółkowski

The world conjured in Jakub Julian Ziółkowski's nightmarish paintings is one of pain, cruelty and danger, where eroticism is befouled by death and ugliness. The horrifying *Emmamah* (2013) shows a six-breasted, hairy toad-like figure dropping men into her enormous maw. Her tiny prey's kicking legs are reminiscent of Pieter Brueghel's painting *Landscape with the Fall of Icarus* (1590–95), but her nipple piercings and inner-thigh tattoos are resoundingly contemporary. Ziółkowski's paintings are not all ugly, however, nor are they without humour. In *Untitled (Self-Portrait)* (2013) the artist drops his cards to reveal his self-image: an alien, gazing sadly at us, in front of a ravishing starry night sky. JG

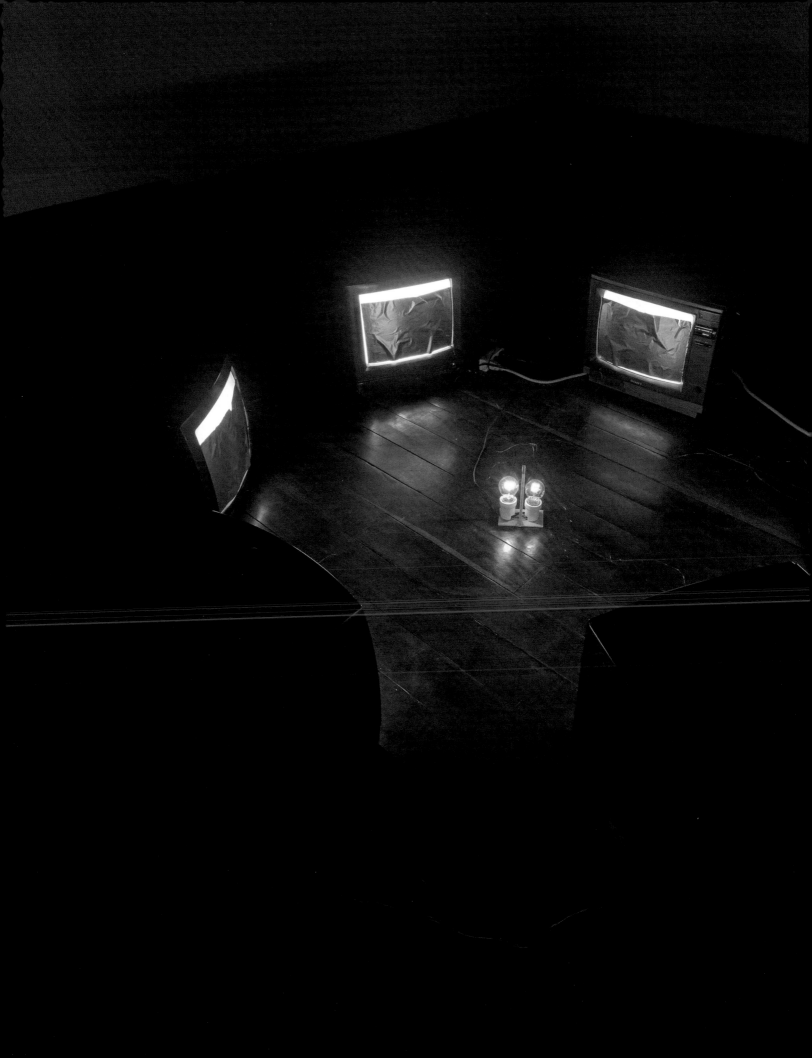

# Icaro Zorbar

**Selected by**
Casas Riegner J5

**Biography**
Born 1977
Lives in Bergen

Colombia-born Zorbar
has presented solo
exhibitions at venues that
include: Volt, Bergen,
Norway (2014); Casas
Riegner, Bogotá (2013
and 2009); Museo de Arte
Moderno de Medellín,
Colombia (2011); and
Fundación Teorética,
San José, Costa Rica
(2009). Select group
shows include: 'Música',
Casas Riegner, Bogotá
(2013); 30th Bienal de
São Paulo (2012); 'Pop
Politics: Activism at 33
Revolutions', Centro
de Arte Dos de Mayo,
Madrid (2012); and 'The
Generational: Younger
than Jesus', New Museum,
New York (2009).

*El títere y el tiempo*
(The Puppet and Time)
2013
TVs, copper wire,
aluminium paper and
light bulbs
Dimensions variable
Courtesy of Casas
Riegner

Icaro Zorbar is an artist charmed by obsolete machineries; he describes the contraptions that populate his work as 'like children' that demand regular care and attention. For his piece in the New Museum's acclaimed 2009 exhibition 'The Generational: Younger than Jesus', four turntables were modified to play different sections of the same LP simultaneously, producing a kind of improvised fugue. In these installations Zorbar encourages our temptation to anthropomorphize: look at the linked 'arms' of the record players in *The Golden Triangle* (2006) or the inclined 'faces' of the CRT monitors in *El títere y el tiempo* (The Puppet and Time, 2013). In his hands technology feels intensely human; a series of characters who are as sympathetic—and certainly as fallible—as any human subjects. EN

1

2

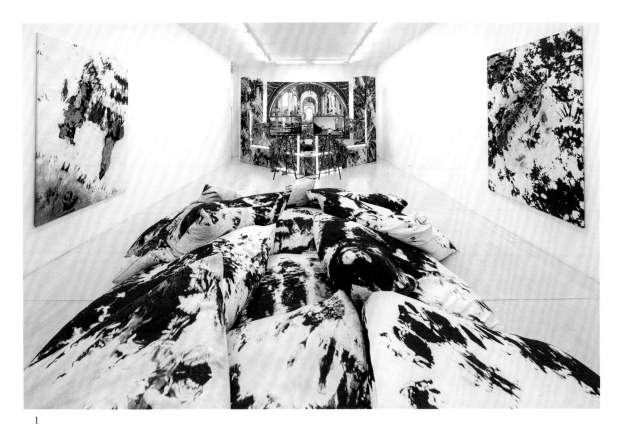

1

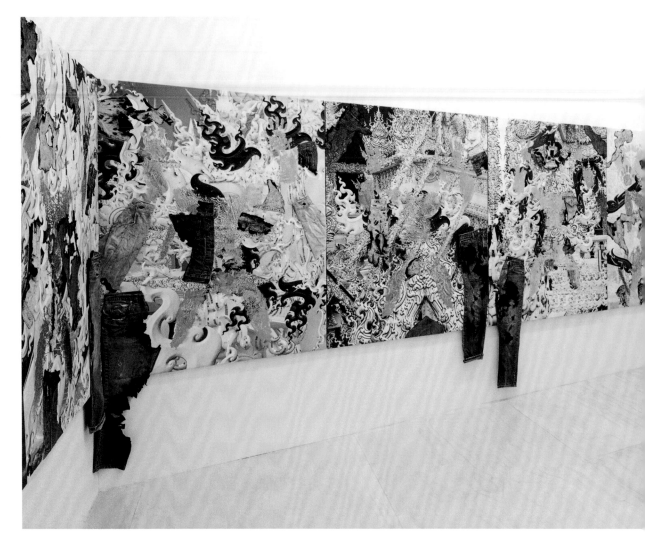

2

**Selected by**
Carlos/Ishikawa G26

**Biography**
Born 1986
Lives in New York and
Bangkok

Bangkok-born artist
Arunanondchai is
currently the subject of
a solo exhibition held at
Carlos/Ishikawa, London
(until October 2014). His
work can also be seen in
the group show 'Beware
Wet Paint', at the ICA,
London (until November,
2014, also touring to
Fondazione Sandretto Re
Rebaudengo, Turin, from
October 2014 to February
2015). Previously he
has exhibited at: The
Mistake Room, Los
Angeles (2014); MoMA
PS1, New York (2014);
The Jim Thompson
House, Bangkok (2013);
and Sculpture Center,
New York (2012). In 2013
Arunanondchai was the
recipient of a Rema Hort
Mann Foundation Grant.

1
'Korakrit Arunanondchai'
2014
Exhibition view at
MoMA PS1, New York
Courtesy of MoMA PS1
and Carlos/Ishikawa

2
*Untitled (White Temple
Paintings)*
2014
Installation view at
MoMA PS1, New York
Courtesy of MoMA PS1
and Carlos/Ishikawa

# Focus
# Korakrit
# Arunanondchai

Korakrit Arunanondchai's videos
and paintings often originate as a
performance—including appearances by
a denim-clad troupe called the Bangkok
Boys, rap music and performance-
paintings by the artist and his twin
brother. His work delves into the fraught
discourse of Thai national identity and
generational change. One emblematic
incident that Arunanondchai draws
upon took place in 2012, on the television
show *Thailand's Got Talent*, when a part-
time go-go dancer created a painting by
pressing her naked, paint-covered torso
against a canvas. Arunanondchai's
*Untitled (Muen Kuey No. 17)* (2013)
refers directly to this incident and the
media furore that ensued. Other
works explore contemporary fashion
obsessions in Thailand with denim
and a tourist-friendly temple site
known as the 'White Temple'. CP

1

2

**Selected by**
Bureau G14

**Biography**
Born 1961
Lives in New York

Baum, who is currently
the focus of a solo
presentation at Bureau,
New York (until
October 2014), has
previously held solo
exhibitions at: Galerie
Mark Müller, Zurich
(2014); Kunstverein
Langenhagen,
Germany (2013); Melas
Papadapoulos, Athens
(2013); Bureau, New York
(2012, 2011 and 2009);
and Marc Jancou, Geneva
(2012). Her work is held in
the public collections of:
the Whitney Museum of
American Art, New York;
Solomon R. Guggenheim
Museum, New York; The
Metropolitan Museum
of Art, New York;
Centre national des arts
plastiques, Paris; and
FRAC Île de France,
Paris.

1
*Wild Orchids*
2014
Archival pigment print
38 × 38 cm
15 × 15"
Courtesy of Bureau

2
*Leopard*
2013
Archival pigment print
48.5 × 40.5 cm
19 × 16"
Courtesy of Bureau

# Focus Erica Baum

Erica Baum's photographs give found text strange and seductive new life. Objects on which she has turned her lens have included blackboards, library card catalogues, filing systems, newspapers and player-piano rolls. Works from her series 'The Naked Eye' (2008–ongoing), such as *Leopard* (2013), capture slivers of photographs or film stills glimpsed in the fanned-out pages of open paperbacks— viewed as if voyeuristically through windows or slightly cracked doors— with the books' dyed edges lending a disorienting formal complexity. In the 'Dog Ear' series (2009–ongoing) neatly turned-down corners of pages yield concrete poetry or visual revelations. *Wild Orchids* (2014), from her new series 'Stills', shows flirty legs uncannily joined to a blurry blob; and in *The Pitfall* ('Blanks', 2013) green borders frame textured emptiness. KMJ

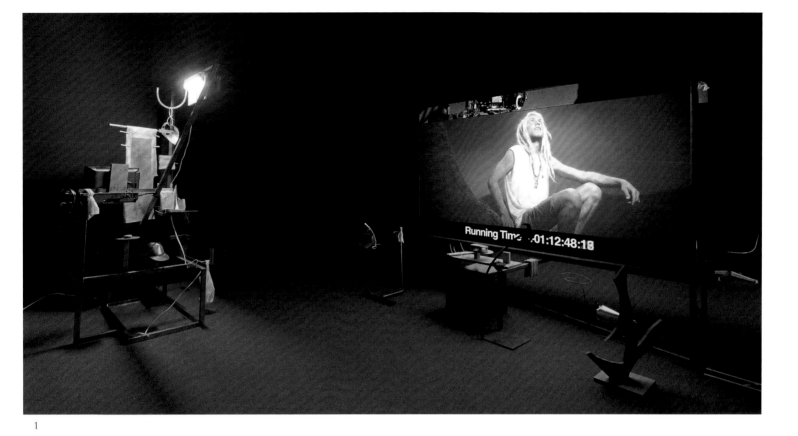

1

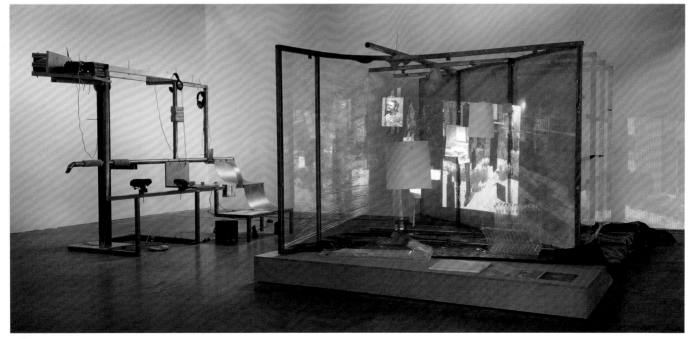

2

**Selected by**
François Ghebaly Gallery
G12

**Also shown by**
Mendes Wood DM H2

**Biography**
Born 1985
Lives in Paris

Beloufa has been the focus of solo presentations held at: François Ghebaly Gallery, Los Angeles (2013); Hammer Museum, Los Angeles (2013); Palais de Tokyo, Paris (2012); Kunstraum Innsbruck, Austria (2012); Kunsthaus Glarus, Switzerland (2011); and New Museum, New York (2011). Select group shows include: 'Dissident Futures', Yerba Buena Center for the Arts, San Francisco (2013); 12th Biennale de Lyon (2013); and 55th Venice Biennale (2013).

1
*Production Value*
2013
Mixed media
Dimensions variable
Courtesy of François Ghebaly Gallery and the Hammer Museum

2
*People's Passion, Lifestyle, Beautiful Wine, Gigantic Glass Towers, All Surrounded by Water: The Superlative Resolution Bed*
2013
Mixed media
Dimensions variable
Courtesy of François Ghebaly Gallery and Robert Wedemeyer

3
*Spaceship Door*
2012
4-colour double-printed vinyl, stretched on steel with bolts
20 × 24 × 3 cm
7⅞ × 9½ × 1⅛"
Courtesy of François Ghebaly Gallery and Robert Wedemeyer

# Focus Neïl Beloufa

Neïl Beloufa's videos and installations use documentary methods in order to construct productive fictions. He often begins a project by conducting interviews with people in a given locale about a specific topic; he then uses these dialogues as the basis for videos that explore ideas of mediation, fantasy and self-performance. In *Production Value* (2013) Beloufa put out an open call for participants to work with him on a project that resulted in a video centred on the motif of the red bandana— an iconic item of clothing worn by subculture groups from gangsters to hippies, rock stars, cowboys and anarchists. *Production Value* calls into question these identities, at the same time as collaboratively exploring the social value of such myths. CP

3

1

**Selected by**
Callicoon Fine Arts J11

**Biography**
Born 1973
Lives in New York

Benning, who in 2005 was
awarded a Guggenheim
Fellowship, has been the
subject of solo shows
held at: Callicoon Fine
Arts, New York (2013);
Participant Inc., New
York (2011); Whitney
Museum of American
Art, New York (2009);
Dia Art Foundation,
New York (2007); and
Walker Art Center,
Minneapolis (2005).
She has participated
in group shows at
venues that include:
Contemporary Art
Museum St. Louis, MO
(2014); Carnegie Museum
of Art, Pittsburgh (2013),
in the 56th Carnegie
International; ICA,
Boston (2011); 7th
Gwangju Biennial,
South Korea (2008); Tate
Modern, London (2004);
and MoMA, New York
(2000).

2

1
*Morphing Solids*
2013
Medite, plaster, milk
paint, acrylic
2.44 × 4.06 m
8' ⅛" × 13' 3⅞"
Courtesy of Callicoon
Fine Arts

2
*Blue Monochrome*
2014
Medite, aqua resin and
casein
1.24 × 0.94 m
4' ⅞ × 3' 1"
Courtesy of Callicoon
Fine Arts

# Focus Sadie Benning

Sadie Benning gained early acclaim
for her political and highly personal
video work; at the age of 19 she was
included in the 1993 Whitney Biennial.
More recently, she has introduced a
parallel body of work, abstract
paintings that are often modest in scale,
with an emphasis on colour and texture.
Poised between the digital and the
analogue—a grid series exhibited
at the 2013 Carnegie International
was initially sketched on an iPhone—
Benning's paintings have a notable
weight and tactile density, as exemplified
by *Blue Monochrome* (2014). Meanwhile,
in the grid work *Morphing Solids* (2013)
the geometric forms bear the
imperfection of the handmade and
drawn—even as their colour is
saturated, their surface glossy, and their
texture luxuriously artificial. KK

STOP

# Focus
# Vern
# Blosum

**Selected by**
Essex Street H12

**Biography**
Active 1961–64
Lives in (Unknown)

Blosum has been the subject of solo exhibitions held at venues that include Kunsthalle Bern, Switzerland (2014) and Essex Street, New York (2013). Recent group shows include 'Hired Hand', Art Institute of Chicago (2014) and 'Sub-Pop', Cardwell Jimmerson Contemporary Art, Culver City (2011). Previously his work has been seen in group shows 'Alcoa Collection of Contemporary Art: Works from the Collection of G. David Thompson', Carnegie Museum of Art, Pittsburgh (1967) and 'Pop Art USA', Oakland Art Museum, California (1963).

*Stop (Department of Traffic)*
1964
Oil on canvas
1.75 × 1.22 m
5' 9" × 4'
Courtesy of Essex Street

The mysterious Vern Blosum's deadpan word-and-image paintings evoke simple signage, dictionary entries or children's flashcards, while suggesting something deeper at stake. In fact, the artist, whose work infiltrated major exhibitions and MoMA, was a creation reportedly fabricated by an Abstract Expressionist who aimed to send up Pop. Paintings such as *Homage to Ivan K.* (1963), depicting a phallic fire hydrant, or *Zip Code* (1964), showing a postbox, have affinities with work by Marcel Broodthaers and John Baldessari as much as Pop; Blosum's elusive persona also anticipated that of recently invented artists such as Reena Spaulings. Images of parking meters, including *Twenty Minutes* (1962), signal a wished-for expiry date for the movement they satirized; *Stop (Department of Traffic)* (1964) signalled the conclusion to Blosum's career. KMJs

**Selected by**
Experimenter G22

**Biography**
Founded 2007
Based in Mumbai

Recipients of the Jury
Main Award at the
9th Sharjah Biennial
(2009), CAMP have held
screenings and exhibited
projects at venues that
include: MoMA, New
York (2014); Berlin
Documentary Forum
(2014); Museum of
Modern Art, Warsaw
(2014); Migrating Forms
Film Festival, New York
(2013); Viennale – 50th
Vienna International
Film Festival (2013); BFI
London Film Festival
(2013); 11th Sharjah
Biennial (2013); National
Gallery of Modern
Art, Delhi (2013); 9th
Gwangju Biennial
(2012); Documenta 13,
Kassel (2012); Serpentine
Gallery, London (2012,
2009 and 2008); Yerba
Buena Center for
Contemporary Art, San
Francisco (2011); and
SOMA Museum of Art,
Seoul (2010).

1–2
*From Gulf to Gulf to Gulf*
2013
HDV, SDV, VHS,
cellphone videos
83 min.
Courtesy of
Experimenter

# Focus
# CAMP

In 2013 Shaina Anand and Ashok
Sukumaran—part of the collaborative
studio known as CAMP—completed
*From Gulf to Gulf to Gulf*, an 83-minute
video depicting the experience of
merchant seamen who work the Arabian
Sea. The footage at sea was entirely shot
by the sailors themselves, often marrying
image to songs in their camera phones.
The result is in part a documentary study
of life and logistics at sea, but it is also,
in common with previous works such
as the film *The Country of the Blind and
Other Stories* (2011), a treatise on the
'invisible seas' of global trade. Anand
and Sukumaran's raw material is the
intersection of impersonal and
international forces with individual
lives, habits and habitats. BD

1

2

3

**Selected by**
Arcade J9

**Biography**
Born 1979
Lives in New York

Finneran has presented
solo exhibitions at venues
that include: 47 Canal,
New York (2013); Arcade,
London (2011); Tony
Wight Gallery, Chicago
(2010); and Rivington
Arms, New York (2006
and 2003). Select group
shows in which he has
participated include:
'The Stairs', Algus
Greenspon, New York
(2013); 'A Night in
Tunisia', Arcade, London
(2012); 'Darren Bader:
Images', MoMA PS1, New
York (2011); and 'The
Living and the Dead',
Gavin Brown's enterprise,
New York (2009).

1
*Spirits with Omens*
2014
Oil on linen
2 × 1.7 m
6' 7" × 5' 7"
Courtesy of Arcade

2
*Figures at the River*
2014
Oil on linen
2 × 1.7 m
6' 7" × 5' 7"
Courtesy of Arcade

3
*Two Figures Sleeping*
2014
Oil on linen
1.6 × 1.19 m
5' 10" × 4' 2"
Courtesy of Arcade

# Focus John Finneran

Egyptian pyramids, Roman goddesses or Matisse-like figures: any scrap of iconography from painting's long history can be dragged into John Finneran's gentle whirlpool. Recent paintings are harmonized with the gloaming light of crescent moons, washing the painterly space with an uncanny afterglow. In *Figures at the River* (2014) three female nudes occupy the foreground, their bodies registered in pieces. Perfect triangles of pubic hair are reflected in pyramids behind, dark hair flows into waters beyond. Whether these are three graces, Yves Klein models or anonymous muses, Finneran suggests a collective, animated spirit world collectively made over thousands of years. A tenebrous landscape of dark geometric shapes and gleaming figures: the place in which we meet as viewers of paintings. LMcLF

1

2

3

**Selected by**
Tempo Rubato H11

**Biography**
Born 1921
Died 1975

German-born artist
Hatzor, who worked
reclusively in Israel for
most of his adult life, has
been the subject of solo
shows only posthumously,
held at Tempo Rubato,
Tel Aviv (2014), and at
Bait Ha'am, Ganei-Am,
Israel (2005). His work
was shown in group
exhibitions that include
'beKomisia', Blim, Tel
Aviv (1975); and 'Yad
leBanim', Petach Tikva
Art Museum, Israel (1974);
and at Dugit Gallery, Tel
Aviv (1969).

1
*Idol*
1970
Watercolour on paper
54 × 39 cm
21¼ × 15⅜"
Courtesy of the Lutz
Hatzor Estate and Tempo
Rubato

2
*Paralyzed Girl*
1968
Watercolour on paper
62 × 45 cm
24⅜ × 17¾"
Courtesy of the Lutz
Hatzor Estate and Tempo
Rubato

3
*Poet and Warlord*
1969
Watercolour on paper
53 × 34 cm
20⅞ × 13⅜"
Courtesy of the Lutz
Hatzor Estate and Tempo
Rubato

# Focus
# Lutz
# Hatzor

Lutz Hatzor was a visionary painter
who rarely showed his work during
his lifetime. Having fled from Nazi
Germany and settled in Israel, he
gained employment as a teacher who
entertained troubled youth with his
skills as a storyteller and puppeteer.
His semi-abstract and quasi-figurative
watercolours are more taciturn: they
hold something back from the viewer.
In *Paralyzed Girl* (1968) we might
imagine the unnamed sitter to be an
archetypal mid-century victim, seated
stoically, with rouged lips and a tousled
mass of raven hair. In *Poet and Warlord*
(1969) a spectral nebula of amber, green
and blue floats freely, as if challenging
us to make visual sense of the startling
juxtaposition of peace and conflict in
the work's title. CP

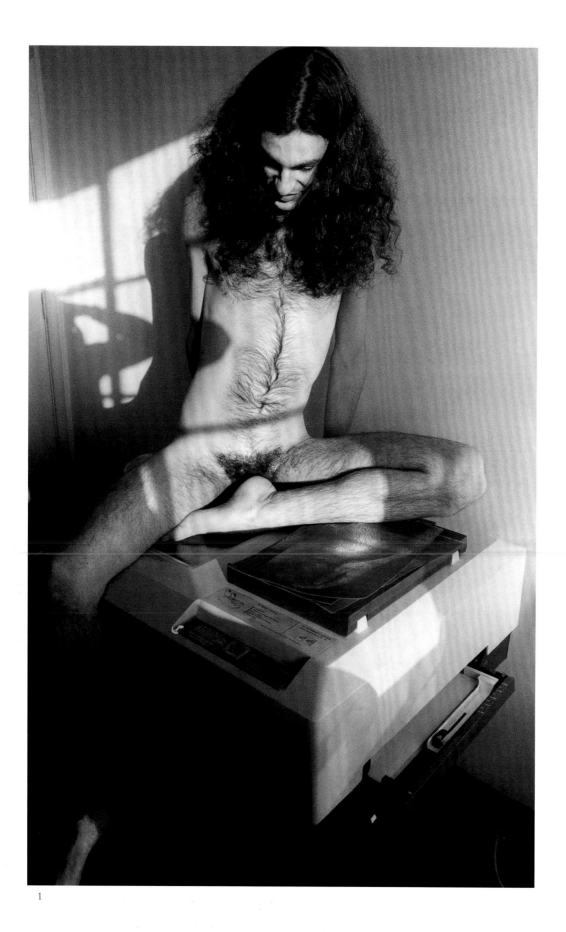

1

2

**Selected by**
Galeria Jaqueline Martins
H22

**Biography**
Born 1957
Died 2013

In 2014 Hudinilson Jr
is the subject of solo
exhibitions at: Galeria
Jaqueline Martins, São
Paulo (2014); Museu de
Arte Contemporânea
da Universidade de
São Paulo (2014); and
McLellan Galleries,
Glasgow, as part of
Glasgow International
Festival (2014). Previously,
his solo presentations
included Centro Cultural
de São Paulo (1986) and
Pinacoteca do Estado de
São Paulo (1984 and 1981).
His work has been seen in
these select group shows:
García Galería, Madrid
(2014); Phosphorus,
São Paulo (2013); Itaú
Cultural, São Paulo
(2003); and 3rd Mercosul
Biennial, Porto Alegre,
Brazil (2001).

1
*'Narcisse' Exercício de Me
Ver II*
('Narciussus' Exercise in
Seeing Myself II)
1982
Photograph,
documentation of
performance
61 × 37 cm
24 × 14⅝"
Courtesy of Galeria
Jaqueline Martins

2
*Untitled*
1979
5 dice, 9 brazilian gem
stones, 1 box covered with
cloth and a wooden box
13 × 20 × 13 cm
5⅛ × 7⅞ × 5⅛"
Courtesy of Galeria
Jaqueline Martins

# Focus
# Hudinilson
# Jr

Operating on the margins of the
Brazilian art world and lately,
gratifyingly, discovered by a wider
audience, Hudinilson Jr worked on
urban interventions in the São Paulo
collective 3NOS3; he also accumulated
a huge *oeuvre* of photographs, collages,
performance works, mail art, crammed
sketchbooks, ludic sculpture—such as
*Untitled* (1979), a plush Duchampian
nest of dice, stones and gems—and
more. The performance and questioning
of narcissism were often central to this:
see his various documentations of the
performance *Narcisse* (1982), in which
a nude Hudinilson photocopied his
body parts. If the artist's aptitude to
be a moving target looks admirable
decades on, it barely needs stating that
his articulation of the relationship
between technology and self-love
finds clear analogues today.  MH

1

2

3

**Selected by**
Christian Andersen H14

**Biography**
Born 1972
Lives in London

Humphreys has been the
subject of solo exhibitions
presented at: Christian
Andersen, Copenhagen
(2014 and 2012); High
Art, Paris (2014); Rob
Tufnell, London (2014);
and Pro Choice, Vienna
(2011 and 2009). Select
two-person and group
shows include: 'Holes',
with Lucie Stahl, What
Pipeline, Detroit (2013);
'Homes and Gardens',
Freedman Fitzpatrick,
Los Angeles (2013); and
'Tom Humphreys, Laure
Provost', CourtenyBlades,
Chicago (2013). From
2003 to 2007, Humphreys
ran the artist space Flaca
in London. He has an
upcoming solo show at
What Pipeline, Detroit,
from January 2015.

1
*Thank You for Nothing*
2014
Ink, acrylic and charcoal
on paper
1.78 × 1.2 m
5' 10⅛" × 4'
Courtesy of Rob Tufnell

2
*Untitled*
2014
Glazed ceramic with
ceramic transfer, foam,
Perspex, wood and
aluminium
2.05 × 0.75 × 0.12 m
6' 8¾" × 2' 5½" × 4¾"
Courtesy of Christian
Andersen

3
*Untitled*
2014
Glazed ceramic, foam
and plywood
2 × 0.63 × 0.1 m
6' 6¾" × 2' ¾" × 3⅞"
Courtesy of Christian
Andersen

# Focus Tom Humphreys

Employing painting, drawing and
printing, the artist and sometime
curator Tom Humphreys creates
works in which the support—from
a canvas to a ceramic plate—becomes
the site where incongruous images
meet. Often resembling, as in his
*Thank You for Nothing* (2014), a studio
pinboard stuck with cherished postcards,
or reproductions torn from the pages
of catalogues and magazines, these
pieces seem preoccupied with their
own inscrutable logic. In *Untitled* (2014)
an oblong of freckled foam, of the
type used to prop up paintings during a
gallery install, becomes the ground for
three roundels: one a red panic button,
another a dark vortex, and a third
bearing the image of a young woman,
overlaid with pigmented fingerprints.
Intention, here, is signalled but never
fully disclosed. TM

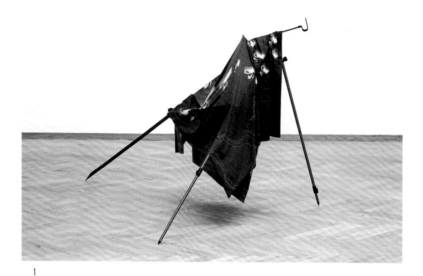

1

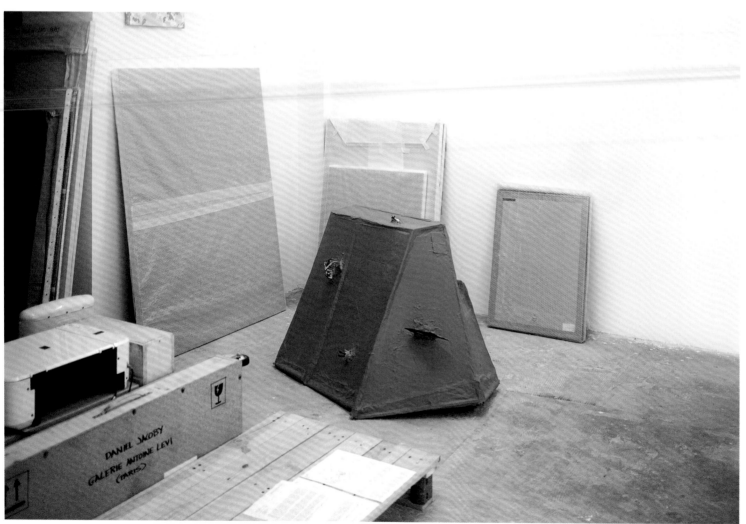

2

**Selected by**
Galerie Antoine Levi J10

**Biography**
Born 1985
Lives in Amsterdam

The work of Peruvian
artist Jacoby has been
exhibited in solo shows
held at: Galerie Antoine
Levi, Paris (2014); Galería
Maisterravalbuena,
Madrid (2014); espacio
trapézio, Madrid (2011);
Galeria Toni Tàpies,
Barcelona (2010); and
Museu de l'Empordà,
Figueres, Spain (2010).
He has participated in
group shows at venues
that include: Kunsthal
Charlottenborg,
Cophenhagen (2014);
Palais de Tokyo, Paris
(2013); and Kunstverein
Harburger Bahnhof,
Hamburg (2013).

1
*Moderations Trabeations
Mapmakings: Layer 3*
2013
Printed Spandex and
ultra-light tripod
Dimensions variable
Courtesy of Galerie
Antoine Levi

2
*Klimhal*
2014
Mixed media
74 × 103 × 73 cm
29⅛ × 40½ × 28¾"
Courtesy of Galerie
Antoine Levi

3
*Untitled (Beach, Flowers,
Blue, Orange, Purple,
Yellow)*
2012
Towel
Dimensions variable
Courtesy of Galerie
Antoine Levi

# Focus Daniel Jacoby

Daniel Jacoby makes sculptures by taking fluid, flexible stuff such as fabric or towels, then scrunching them into hybrid, living-looking arrangements, often buoyed by a man-made object: in *Moderations Trabeations Mapmakings: Layer 3* (2013) a piece of indigo-print Spandex is draped over the interstices of a blue ultra-light tripod. The works allude to decorative and craft-based traditions—such as furniture-making and design—but remain autonomous, while oscillating between the synthetic and the organic. For *Untitled (Beach, Flowers, Blue, Orange, Purple, Yellow)* (2012) Jacoby arranged a towel into folds and stiffened it with glue. Affixed to the wall (and installed with other towel sculptures), the sculpture looks conspicuously 'natural', like a crustacean or a barnacle, although we recognize it at once as a garish, flower-printed beach towel. PL

# Focus
# Ken
# Kagami

**Selected by**
Misako & Rosen J8

**Biography**
Born 1974
Lives in Tokyo

Tokyo-born Kagami has presented solo exhibitions at: Misako & Rosen, Tokyo (2014); NADiff Gallery, Tokyo (2013); Taka Ishii Gallery, Tokyo (2009 and 2003); and Krinzinger Projekte, Vienna (2006). He has participated in select group shows at venues that include: Tokyo Opera City Art Gallery (2013); The Green Gallery, Milwaukee, WI (2013); Misako & Rosen, Tokyo (2013 and 2012); Arken Museum for Moderne Kunst, Ishøj, Denmark (2006); and Hong Kong Arts Centre (2005).

*High-Class Bra*
2014
Bronze, found photograph
18 × 33 cm
7⅛ × 13"
Courtesy of Misako & Rosen

*High-Class Bra* (2014), in which low-class undergarments receive the elevated treatment of cast bronze, is a classic Kagami mash-up. In additional sculptures, cotton balls, crushed aluminium cans, noodles and toilet-paper rolls have also been made fancy, placed on pedestals and mockingly revalued. Other Kagami projects—he has produced works on paper, artist's books, installations and a store selling used clothes and objects—bring together erotic photographs and children's toys, not neglecting to include some excrement wherever possible. This combination of cuteness and abjection, rooted in the stuff of popular and consumer culture, aligns Kagami with figures like Mike Kelley and Paul McCarthy. For Kagami this juvenile thrill of bad words and dirty concepts never loses the novelty of adolescent discovery. SNS

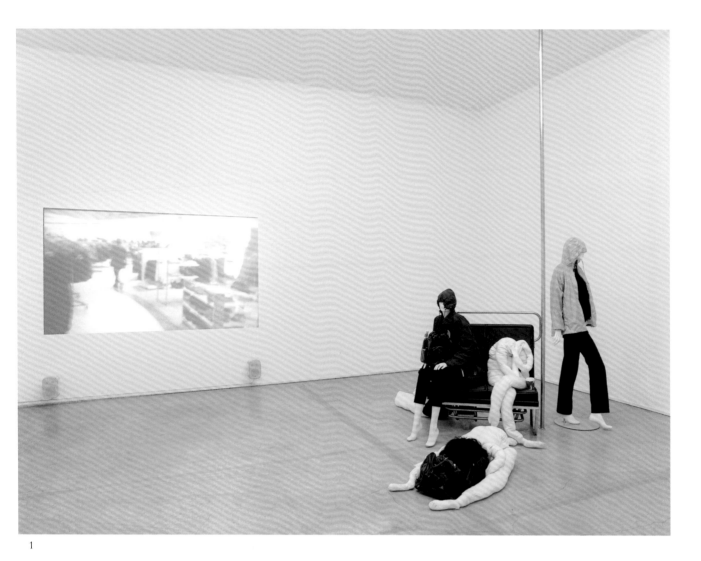

1

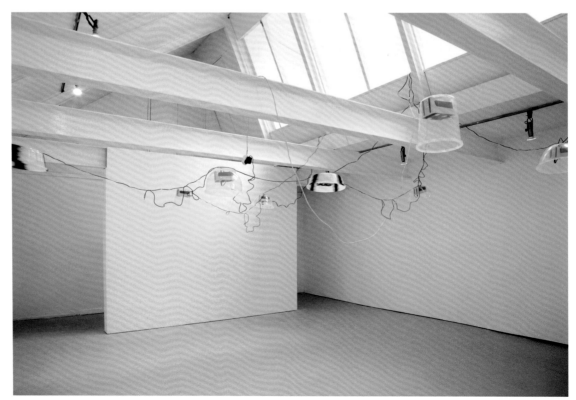

2

**Selected by**
Real Fine Arts H20

**Biography**
Born 1985
Lives in London

Scottish artist Keil has
made solo presentations
at venues that include:
Real Fine Arts, New York
(2014); Cubitt Gallery,
London (2013); Neue
Alte Brücke, Frankfurt
(2013 and 2007); Outpost,
Norwich, UK (2012);
Palais de Tokyo, Paris
(2011); Neuer Aachen
Kunstverein, Aachen,
Germany (2011); and
Wilkinson Gallery,
London (2010). She has
participated in group
shows at venues that
include: Artists Space,
New York (2014);
Arnolfini, Bristol, UK
(2013); CEO Gallery,
Malmö (2013); and
Chisenhale Gallery,
London (2010)

3

1
*Moarg Kiel*
2011
Sex machine, digital
video, mannequins, train
seats, dolls and bags
Dimensions variable
Courtesy of Real Fine
Arts

2
*Civil War*
2012
Computer speakers and
plastic bowls
Dimensions variable
Courtesy of Real Fine
Arts

3
*Potpourri*
2013
Digital video presented
on work station
1.7 × 1 × 0.7 m
5' 6⅞" × 3' 3⅜" × 2' 3½"
7 min.
Courtesy of Real Fine
Arts

# Focus
# Morag
# Keil

Morag Keil's work is concerned with,
among other things, the instability
of subject-hood in the contemporary
world. She investigates this broad notion
in a bewildering variety of forms, from
soundworks that sample the murderous
cries on the computer game *Tekken 6*
(in *Civil War*, 2012) to installations with
mannequins and a seat from the Paris
Metro (*Prix Lafayette*, 2011). Keil has also
side-stepped her own authorial presence
by collaborating with artist friends
such as Fiona MacKay and Manuela
Gernedel, creating a suite of paintings
('84 Paintings', 2010) as the product of
a collaborative endeavour. In the video
*Potpourri* (2013) Keil's questioning of
role-playing takes a dark, sexualized
turn as she examines the relationship
between interactivity and coercion in
the media and online pornography. CP

**EN**

**Create your own private Palm Island**
Take a box of matches and with 18 matchsticks build your own artificial Palm Island. Carefully bend the matchsticks so they don't snap, put them together in the shape of a palm tree and use scotch tape to hold them in place. Then insert into a recipient which is permanently filled with water.
**Warning:** in the event of inserting the object in a toilet bowl, do not forget to remove it before flushing. This is to avoid an effect similar to a cyclone, which could cause irremediable damage to the island.

**PT**

**Crie a sua Palm Island privada**
Adquira uma caixa de fósforo, e com 18 palitos de fósforo construa a sua Palm Island artificial. Encurve os palitos de fósforos cuidadosamente para que não partam definitivamente, coloque-os juntos em forma de palmeira, e passe uma fita-cola para uni-los. A seguir coloque num recipiente onde tenha água permanentemente.
**Atenção:** No caso de colocar na pia (vaso sanitário), não se esqueça de retirar o objecto antes de descarregar o autoclismo para evitar um efeito similar a um ciclone sobre a ilha o que poderia danifica-la irremediavelmente.

**AR**

إنشاء جزيرة النخلة الخاصّة بك
قم بإحضار علبة أعواد كبريت. وباستعمال ١٨ عوداً يمكنك اختلاق جزيرة النخلة الخاصّة بك. كل ما عليك فعله هو ثني الأعواد بحذر وجمعهم بلاصق مناسب. ومن ثم وضعهم في إناء مملوء دائماً بالماء.
تحذير: في حالة وضع أعواد الكبريت في المرحاض. يجب أن يتم إزالتهم لاحقاً قبل سحب المياه وذلك لتجنّب الحالة المشابهة للإعصار التي يمكن أن تضر بجزيرتك.

**Selected by**
Fonti G19

**Biography**
Born 1979
Lives in Luanda

Angolan artist Kia Henda
has had solo exhibitions
at galleries and
institutions that include:
Kunstraum Innsbruck,
Austria (2013); Fonti,
Naples (2012 and 2007);
Fondazione Bevilacqua
La Masa, Venice (2010);
and Goethe-Institut,
Nairobi (2008). He has
participated widely in
group shows, at venues
that include: Indira
Gandhi National
Centre for the Arts,
New Delhi (2014);
Museum für Moderne
Kunst, Frankfurt
(2014); 11th Biennale
of Contemporary
African Art, Dak'art,
Dakar (2014); the Studio
Museum in Harlem,
New York (2013); Museo
Rufino Tamayo, Oaxaca,
Mexico (2012); and
Bétonsalon, Paris (2011).

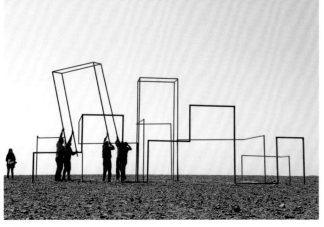

1
*Instructions to Create Your
Personal Dubai at Home*
(detail)
2013
Prints of 7 photographs
and texts
Each 60 × 40 cm
23⅝ × 15¾"
Courtesy of Fonti

2
*Rusty Mirage (Skyline)*
(detail)
2013
8 photo prints on cotton
paper mounted on
aluminium
Each 70 × 100 cm
27½ × 39⅜"
Courtesy of Fonti

# Focus
# Kiluanji
# Kia Henda

Kia Henda reframes figureheads of
Western civilization—public
monuments to colonial power,
Shakespeare plays, Manet's *Olympia*—
in photographic series that critique the
legacy of colonialism and provide
alternative historical accounts of this
violent past. Focusing specifically on
the history of Portuguese colonialism
in his native Angola, Kia Henda has
photographed an eerie repository
outside Luanda where the material
remnants of several past regimes and
invasions are stored together, and has
invented an imaginary space flight
programme for the first African
spaceship, ironically named *Icarus 13*.
Recent works such as *Instructions to
Create Your Personal Dubai at Home*
(2013) bring a more humorous, even
nonsensical, take on the recent waves of
globalization and development that, in
the view of many, represent today's own
neo-colonialist currents. SNS

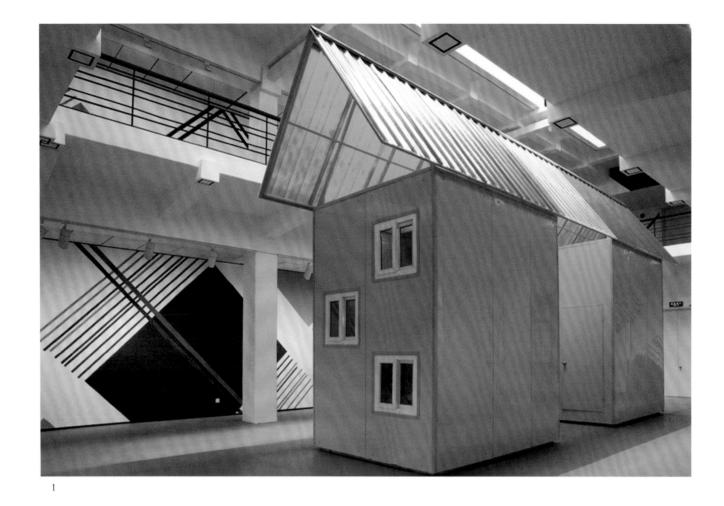

1

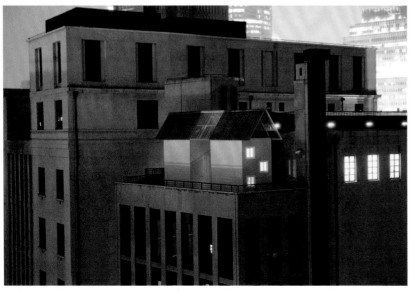

2

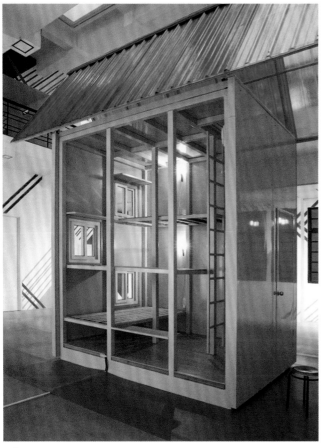

3

**Selected by**
Leo Xu Projects H19

**Biography**
Born 1964
Lives in Shanghai,
Brussels and Taipei

Tokyo-born Lin has
been the subject of
solo exhibitions held
at venues that include:
Tang Contemporary
Art, Beijing (2013); Leo
Xu Projects, Shanghai
(2012); Rockbund Art
Museum, Shanghai
(2012); Vigo Museum of
Contemporary Art, Vigo,
Spain (2011); Shanghai
Gallery of Art (2008);
Kunsthalle Wien, Vienna
(2005); Contemporary
Art Museum St. Louis,
MO (2004); and Palais
de Tokyo, Paris (2003).
He has participated in
such select group shows
as: 'Reading', Leo Xu
Projects, Shanghai (2013);
5th Auckland Triennial
(2013); 3rd Singapore
Biennial (2011); 10th
Biennale de Lyon (2009);
and the 2nd Moscow
Biennial.

1, 2, 3
*RAM (Workers' House)*
2012
Steel, wood, insulation
board
5.3 × 9.3 × 2.4 m
17' 4⅝" × 30' 6⅛" ×
7' 10½"
Courtesy of Leo Xu
Projects

# Focus Michael Lin

Preoccupied with how people inhabit their surroundings, and how the thinking of the 20th-century avant-garde might speak to our globalized world, Michael Lin's work focuses on creating what he has called 'an unremarkable space of respite'. To this end, he has produced a number of works that seesaw between objects of contemplation and objects of use, among them *Kiasma Day Bed* (2001), a Minimalist sculpture-cum-divan on which visitors were invited to take a nap. Created in collaboration with Atelier Bow-Wow, his *RAM (Workers' House)* (2012) is a temporary living space designed to house migrant workers installing a show at Shanghai's Rockbund Art Museum. Displayed within the exhibition space, this structure speaks of the complex social and economic relationships that underpin art, and its display. TM

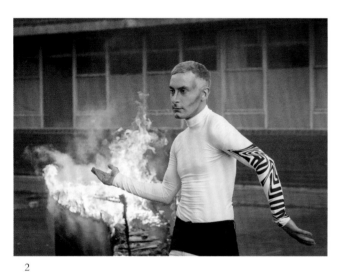

2

**Selected by**
Freedman Fitzpatrick H17

**Biography**
Born 1984
Lives in Berlin

New York-born
Lutz-Kinoy has been
the focus of solo
exhibitions at: Freedman
Fitzpatrick, Los Angeles
(2014); Museum für
Gegenwartskunst,
Basel (2013); Outpost,
Norwich, UK (2013); and
Silberkuppe, Berlin (2011).
He has participated in
group shows at venues
that include: Project
Native Informant,
London (2014); Nomas
Foundation, Rome
(2013); Stedelijk Museum,
Amsterdam (2013);
Bruce High Quality
Foundation, New York
(2012 and 2008); and
Hayward Gallery,
London (2009).

1
*Port*
2014
Video projection and
acrylic on unprimed
canvas
3 × 16 m
9' 10⅛" × 52' 5⅞"
Courtesy of Freedman
Fitzpatrick

2
*Fire Sale*
2013
Documentation of
performance at Outpost,
Norwich, 2013
Courtesy of Freedman
Fitzpatrick

# Focus Matthew Lutz-Kinoy

Matthew Lutz-Kinoy employs a
multitude of media to investigate an
expanded art–social space. His recent
exhibition 'Port' (2014) at Freedman
Fitzpatrick included a 53-foot painting
of a florid dreamscape, which formed
the backdrop to a video projection
of the artist's dancing body—the body
as moving sculpture. Lutz-Kinoy's work
often hinges on creative collaboration
and its politics: the performance *Donna
Harraway's Expanded Benefits Package*
at the New Museum in 2011 featured
Chicago-based artist and curator
Chelsea Culp and London producer
SOPHIE; *Keramikos* (2012–13) comprises
a joint presentation of ceramic work
with artist Natsuko Uchino. Lutz-Kinoy
taps into the rich histories of the avant-
garde, of feminist and queer practice,
to question artists' labour within and
outside the creative community. EN

1

2

3

**Selected by**
Galeria Stereo H24

**Biography**
Born 1984
Lives in Warsaw

Mickiewicz, who in
2014 has been artist in
residence at Gasworks,
London, has been the
focus of solo exhibitions
held at: Frutta, Rome
(2013); BWA Zielona
Góra, Poland (2013); and
Galeria Stereo, Poznań,
Poland (2011). Select
group shows include:
'As You Can See Today',
Museum of Modern Art,
Warsaw (2014); 'The
New Morals', Galeria
Stereo, Warsaw (2014);
'Makeshift', Arsenal
Municipal Gallery,
Poznań, Poland (2012);
and 'Museum Problem',
Frutta, Rome (2012).

1
*Focusing on Foreground*
2013
Mixed media
150 × 60 × 40 cm
59 × 23⅝ × 15¾"
Courtesy of Galeria
Stereo

2
*Clear Power Distribution*
2013
Mixed media
70 × 70 × 50 cm
27½ × 27½ × 19⅝"
Courtesy of Galeria
Stereo

3
*Not Too Far*
2012
Mixed media
40 × 30 × 30 cm
15¾ × 11¾ × 11¾"
Courtesy of Galeria
Stereo

# Focus
# Gizela
# Mickiewicz

Gizela Mickiewicz's downbeat, slyly
humorous sculptures and installations
focus on things that have been broken
and then provisionally and imperfectly
fixed—everyday objects that have fallen
from consumerist grace but might still
function, given what she calls the correct
'short-range domestic knowledge'.
A faulty object, she has said, 'gains
strength from being flawed. It's no
longer just another member of the
family of objects it was part of; it
acquires individuality, an identity. It
becomes this particular object. It dictates
the terms on which it works. It matters.'
In her *Clear Power Distribution* (2013) an
upright bicycle pump is attached to a
rubber inner tube, which bulges like a
python digesting a heavy meal consisting
of several jungle critters. A bumpy ride,
here, seems guaranteed. TM

**3 580**
**TOULON**
**Une nouvelle place de la ville**
**avec la figure de proue**

Les Éditions

*Aris*

BANDOL 04 94 29 52 98 - Rep. int. ©

*LA POSTE AGREMENT N° 133*

FRANCE

*LUMIERE ET BEAUTE DE LA COTE D'AZUR*

1

2

**Selected by**
Sultana G25

**Biography**
Born 1974
Lives in Bandol, France

Millagou has exhibited
solo and two-person
shows at venues that
include: Sultana, Paris
(2014, 2011 and 2009);
Maison Blanche,
Marseille (2013); Le
Confort Moderne,
Poitiers (2011); Galerie
de la Marine, Nice
(2009); Bischoff/
Weiss, London (2008
and 2007); and Musée
d'art contemporain,
Marseille (2002). He has
participated in select
group shows at: Centre
d'art contemporain
Genève, Geneva (2013);
Centre Pompidou,
Paris (2011); and Tokyo
Metropolitan Museum of
Photography (2006).

1
*Scratch Postcard*
2013
Rollerball on postcard
10 × 15 cm
3⅞ × 5⅞"
Courtesy of Sultana

2
*Necklaces*
2013
Pebbles
84 × 44 × 25 cm
33⅛ × 17⅜ × 9⅞"
Courtesy of Sultana
and with the support of
CNAP Centre national
des arts plastiques

# Focus
# Olivier
# Millagou

Olivier Millagou's multidisciplinary
practice brings a ludic sensibility to
bear on one of the most enduring of
art-historical binaries: the tension
between the sacred and the profane.
By interpreting this dichotomy as
geographical reality, Millagou creates
works that problematize normative ideas
of culture, value and otherness that still
surround meetings between the occident
and the orient, here and elsewhere, the
domestic and the exotic. *Necklaces* (2013),
comprising several necklaces made of
pebbles, deals with the alchemical magic
conferred by reclaiming worthless
natural materials as art; the impression
of a palm tree on card in *Scratch Postcard*
(2013) is perhaps a whimsical reference
to France's colonial history. MQ

1

2

**Selected by**
Frutta G24

**Biography**
Born 1981
Lives in Como

Argentinian artist Alek
O. has presented solo
exhibitions at venues
that include: Frutta,
Rome (2014); Meessen De
Clercq, Brussels (2013);
Mostyn, Llandudno,
Wales (2013); and
317 Association pour
l'art contemporain,
Nice (2009). She has
participated in group
shows at such venues
as: Laura Bartlett
Gallery, London (2014);
Fondazione Bevilacqua
La Masa, Venice (2013);
Marianne Boesky
Gallery, New York
(2012); Galerie Andreas
Huber, Vienna (2012);
Fondazione Casa Giorgio
e Isa de Chirico, Rome
(2012); and Castello di
Rivoli, Turin (2010).

4

3

1
*Tangram (Seal)*
2013
Stretched polyester fabric
from an umbrella
0.98 × 1.29 m
3' 2⅜" × 4' 2¾"
Courtesy of Frutta

2
*Tangram (Fox)*
2013
Stretched fabric from a
parasol
1.53 × 2.88 m
5' ⅜" × 9' 5⅜"
Courtesy of Frutta

3
*Edward Higgins White, II*
2011
Found glove threads,
embroidery on canvas
40.5 × 70 cm
16 × 27½"
Courtesy of Frutta

4
*Edward Higgins White, I*
2010
Found glove threads,
embroidery on canvas
40.5 × 70 cm
16 × 27½"
Courtesy of Frutta

# Focus Alek O.

Alek O. starts from the found object,
yet her artworks all but leave the source
behind. Her *Tangram* pieces, for instance,
disassemble umbrellas, using triangular,
sometimes patterned pieces of
waterproof fabric in flattened geometric
abstractions that verge wryly on the
figurative, as in *Tangram (Fox)* (2013).
The design's punchy sharpness, though,
does not mask the signs of use; O. favours
objects to which she has a personal
connection—old keys, an Aldo Rossi
coffee pot, a corkscrew—and which
vibrate quietly with personal histories.
There is no clean slate in art or in life,
her aesthetic proposals suggest: if her
artworks seemingly cannot help
resolving themselves into pre-existing
aesthetics, particularly minimal ones,
they also cannot be unhitched from the
maker's prior experience. MH

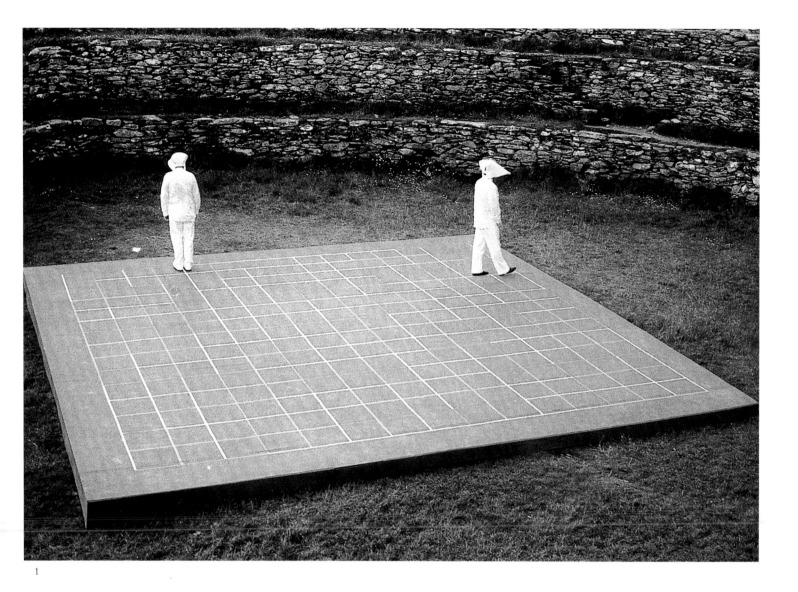

1

2

**Selected by**
P! H15
Simone Subal Gallery H15

**Biography**
Born 1928
Lives in New York

Born in Ireland, but
USA-based since 1958,
O'Doherty has been the
focus of solo presentations
at venues that include:
Simone Subal Gallery/P!
Gallery, New York
(2014); Kunstmuseum
Bayreuth, Germany
(2013); Irish Museum
of Modern Art, Dublin
(2008); MoMA PS1, New
York (1993); Brooklyn
Museum, New York
(1982); and Los Angeles
County Museum of Art
(1975). He has works held
in the public collections
of: The Metropolitan
Museum of Art, New
York; MoMA, New York;
Centre Pompidou, Paris;
Irish Museum of Modern
Art, Dublin; Seattle Art
Museum; and many
others.

1
*Structural Play: Vowel Grid*
1970
Performance, Grianán
Fort, Donegal, 1998
Standard definition video
15 min. 43 sec.
Courtesy of P! and
Simone Subal Gallery

2
*Portrait of Marcel Duchamp,
Lead 1, Slow Heartbeat*
1966
Wood, glass, liquitex,
motor
43 × 43 × 20.5 cm
17 × 17 × 8"
Courtesy of P! and
Simone Subal Gallery

# Focus
# Brian
# O'Doherty

The polymath Brian O'Doherty is
well known as a writer (author of the
highly influential *Inside the White Cube:
Ideologies of the Gallery Space*; Booker-
short-listed novelist). As an artist
(working under the name Patrick Ireland
1972–2008), his work is Conceptual,
using games of logic and language
across several media. His portraits of
his friend Marcel Duchamp take the
form of cardiograms (*Portrait of Marcel
Duchamp, Lead 1, Slow Heartbeat*, 1966).
Elsewhere, a series of sculptures,
including *Babel* (1970), employ Ogham,
an ancient Celtic script, as a point of
departure, while the performance
*Structural Play: Vowel Grid* (1970),
features hooded figures moving across
a grid, enunciating designated vowel
sounds. The figures evoke the stratagems
of chess, power relationships and battles
of will; the sounds they articulate
explore the boundaries of language. KK

1

2

3

**Selected by**
Galerie Micky Schubert
G13
Wallspace H4

**Also shown by**
Galerie Nordenhake B11
Overduin & Co. B20

**Biography**
Born 1976
Lives in Kent, OH

Olson has been the
focus of solo shows
held at: Galerie Micky
Schubert, Berlin (2014);
Wallspace, New York
(2013); Overduin & Co.,
Los Angeles (2012 and
2008); Misako & Rosen,
Tokyo (2009); and
Galerie Nordenhake,
Stockholm (2009). He
has contributed to group
shows held at venues
that include: Brand
New Gallery, New
York (2013); Museum
of Contemporary Art
Cleveland (2013); Walker
Art Center, Minneapolis
(2013); and Centre for
Contemporary Art,
Kitakyushu, Japan (2002).

1
*Untitled*
2014
Oil, wax, marble dust on
wood, maple frame
71 × 59.5 cm
28 × 23½"
Courtesy of Wallspace

2
*Untitled*
2013
Oil and wax on marble
dust, ground on panel
with maple frame
71 × 58 cm
28 × 22⅞"
Courtesy of Overduin &
Co. and Galerie Micky
Schubert

3
*Untitled*
2012
Oil, egg tempera, wax,
and marble dust ground
on panel with mahogany-
stained cherry frame
84 × 73 cm
33⅛ × 28¾"
Courtesy of Overduin &
Co. and Galerie Micky
Schubert

# Focus Scott Olson

Scott Olson's paintings feature carefully delineated forms and contrasting use of colour. His small-scale paintings recall the work of Paul Klee, and the canvases have a dusty, aged quality, as if produced long ago. Olson often employs natural elements in his pigments (such as ground beetle or pollen) and draws attention to process by including a variety of treatments and textures, thereby creating mesmerizing variations within his frame, as in the oil, wax, marble dust and wood of *Untitled* (2014). Elsewhere, Olson places his abstract forms inside a blank field, creating a frame within the canvas, as in *Untitled* (2013). He invites the viewer to look closer, luring the eye in with the elaborate details of his canvas. KK

**Selected by**
Gregor Staiger H21

**Also shown by**
The Modern Institute F7

**Biography**
Born 1980
Lives in Brussels

The work of Swiss artist
Party has been presented
in solo shows at: Kunsthall
Stavanger, Norway
(2014); Galerie Gregor
Staiger, Zurich (2014
and 2012); The Modern
Institute, Glasgow (2013);
Swiss Institute, New
York (2012); and The
Woodmill, London (2011).
He has participated
in select group shows
at venues including:
Museum Folkwang,
Essen, Germany; Neues
Museum Nürnberg,
Nuremberg (2013);
Bonner Kunstverein,
Bonn (2013); Eastside
Projects, Birmingham,
UK (2011); and the
Gallery of Modern Art,
Glasgow (2011).

*Still Life*
2014
Pastel on canvas
100 × 90 cm
39⅜ × 35⅜"
Courtesy of Gregor
Staiger

# Focus Nicolas Party

Nicolas Party's is an art of abundance.
Moving smoothly from spray-paint to
acrylic, oil and pastel, he can cover a
vast outdoor brick wall (at Glasgow's
Bothy Project, 2013) just as well as a
canvas, or paint rocks to disguise them
as fruits (*Blakam's Stones*, 2005–ongoing)
just as easily as adorn a table or a stool.
Adept at decorative abstraction and
smooth-edged figuration, he is best
known for his contemporary take on the
still life, Cézanne-like in its intensity,
drily executed but soaked in colour.
Despite his distinctive style, his subjects
frequently seem anonymous, amorphous
and strange: never quite at home in their
painted palpability. Party approaches
the paradox of the painted surface—a
material plane that can communicate an
infinite variety of other surfaces—with
a freshness that verges on wonder. MMcL

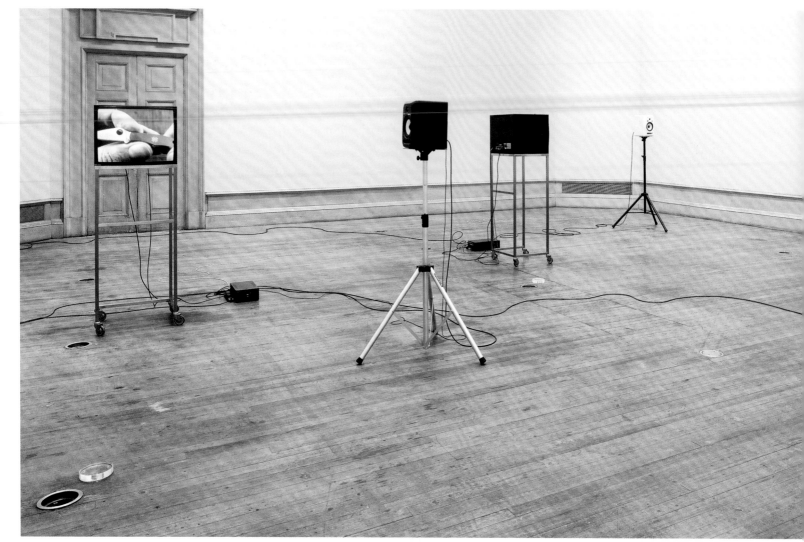

2

**Selected by**
Kendall Koppe H13

**Biography**
Born 1974
Lives in Glasgow

British artist Prodger
has been the focus of
solo presentations held
at: McLellan Galleries,
Glasgow (2014); Studio
Voltaire, London (2012);
and Kendall Koppe,
Glasgow (2011). She
has participated in
two-person and group
shows held at: the ICA,
London (2014); Wysing
Arts Centre, Cambridge,
UK (2014); Kunsthalle
Freiburg, Switzerland
(2013); Artists Space,
New York (2013); Essex
Street, New York (2012);
Centre for Contemporary
Arts, Glasgow (2012);
and Pieter Performance
Space, Los Angeles (2011).
She has a forthcoming
solo show at Inverleith
House, Edinburgh (from
January 2015).

1
*AAB*
2014
Video and audio
Dimensions variable
Courtesy of Kendall
Koppe

2
*Prospex*
2013
Acrylic and steel
183 × 49 × 58.5 cm
72 × 19¼ × 23"
Courtesy of Kendall
Koppe

# Focus
# Charlotte
# Prodger

Charlotte Prodger's sculptural
installations are pared-back and
functional-looking—comprising blocky
Hantarex video monitors on minimal
metal supports, and speakers whose
wires trail across the floor. These project
asynchronous sounds and images—
subcultural fetish videos culled from
YouTube, snippets of personal anecdote,
comments from online forums read
aloud—to create drifting narratives in a
constant state of flux, like the seemingly
entranced bull terriers swaying amid the
potted foliage in *Nephatiti* (2014). The
ripped videos crop and isolate parts of
bodies, making them anonymous,
while identities are lost beneath online
usernames. Simultaneously concealed
and exhibitionistic, they express the ebb
and flow of desire, but also of danger—
the hand holding a glinting, finely
pointed knife in *AAB* (2014) offers
both a love token and a threat. AS

1

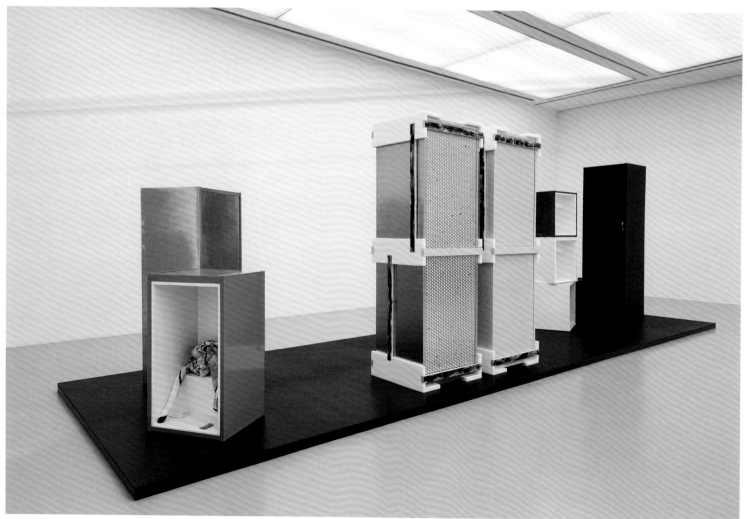

2

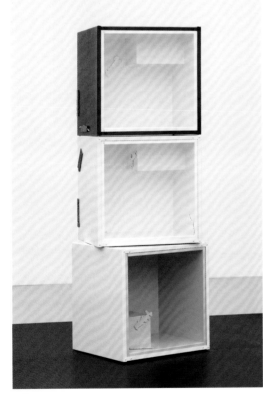

3

**Selected by**
Freymond-Guth Fine
Arts G18

**Also shown by**
The Approach E1

**Biography**
Born 1981
Lives in London

Dutch artist Reus has
been the subject of solo
exhibitions shown at:
The Approach,
London (2014 and
2011); Kunsthalle
Fridericianum,
Kassel (2014); De
Hallen, Haarlem,
Netherlands (2014);
Kestnergesellschaft,
Hanover (2014); Galerie
Fons Welters, Amsterdam
(2013 and 2010); Space
Studios, London (2012);
IBID Projects, London
(2010); and MOT
International, London
(2008). She recently
participated in the group
show 'Post/Post Minimal',
Kunstmuseum St.Gallen,
Switzerland (2014).

1
*Parking (Disc)*
2013
Mixed media
57 × 142 × 49 cm
22½ × 55⅞ × 19¼"
Courtesy of The
Approach

2
*Lukes (Dinosaurs)*
2014
Installation view at
Kestnergesellschaft,
Hanover
Mixed media
190 × 64 × 58 cm
74¾ × 25¼ × 22⅞"
Courtesy of The
Approach & Freymond-
Guth Fine Arts

3
*Lukes (Black Cherry
Lactox)*
(detail)
2014
Mixed media
156 × 53 × 44 cm
61⅜ × 20⅞ × 17⅜"
Courtesy of Freymond-
Guth Fine Arts

# Focus Magali Reus

With their slippery-smooth surfaces
and clean-lined forms, Magali Reus's
sculptures can seem restrained,
stand-offish even. They feel like the
immaculate products of digital post-
production made physical in a messy
world that they approximate, yet from
which they remain aloof. But the nearly
human scale of the 'Parking' chair series
(2013–ongoing) and the fetid processes
of consumption, absorption and
excretion evoked by the leftovers or
residues that sit in or on the works' clean
surfaces suggest the abject and unruly
materiality of the human body. Bin-
juice-brown resin slicks stain the fridge-
like 'Lukes' (whose sculptural clusters are
often interspersed with sanitary-white
toilet seats) and pizzas lie in charred
ceremony at the bottom of the steel
cooking pots that she terms 'Dregs'
(both 2013–ongoing). AS

# Focus
# Ben Schumacher

**Selected by**
Croy Nielsen G16

**Biography**
Born 1985
Lives in New York

Schumacher has been
the focus of solo shows
held at: Musée d'art
contemporain de Lyon
(2014); Croy Nielsen,
Berlin (2013 and 2012);
Bortolami, New York
(2013); and Sculpture
Center, New York (2011).
He has exhibited in group
shows at venues that
include: Ullens Center
for Contemporary Art,
Beijing (2014); Museum
of Contemporary Art
North Miami, FL (2013);
McCabe Fine Art,
Stockholm (2013); Tanya
Leighton, Berlin (2013);
and Galerie Rodolphe
Janssen, Brussels (2013).

1
*One Calorie as Good as
Another/Epoch Defining
Broadcast (black, thin)*
2013
Mixed media
Dimensions variable
Courtesy of Croy Nielsen

2

2
*Colombian Payphone*
2013
Polymer powder print
13 × 44 cm
5⅛ × 17⅜"
Courtesy of Croy Nielsen

Upon finding forgeries, Andy Warhol
signed some of them with the statement
'I didn't make this.' Ben Schumacher's
densely layered objects, images and
installations exuberantly update this
history for the Internet age, making
use of discarded architectural projects,
3D printing, found technology and
fonts created by dozens of designers.
*One Calorie as Good as Another/Epoch
Defining Broadcast (black, thin)* (2013)
is an Ikea floor lamp, its original
packaging and a cable-management
arm bound together to make an
elongated sculpture that hangs from the
ceiling, suggesting an unknown office
tool whose use has yet to be determined.
At times referencing Esperanto,
corporate aesthetics, phreaking,
Renaissance viewing platforms or the
universalist ideologies of the Internet,
Schumacher consciously accumulates
the history of communications systems
to make multi-temporal collages. CFW

1

2

3

**Selected by**
Raster G23

**Also shown by**
The Third Line J1

**Biography**
Founded 2006
Live in Eurasia

Artist collective Slavs and
Tatars has presented solo
exhibitions and publishing
projects at a range of
venues internationally.
These include: Dallas
Museum of Art (2014);
Art Space Pythagorion,
Samos, Greece (2013);
REDCAT, Los Angeles
(2013); MoMA, New
York (2012); Raster,
Warsaw (2012); Secession,
Vienna (2012); and Neuer
Aachener Kunstverein,
Aachen, Germany (2011).
Select group shows
include: 'Take Liberty!',
National Museum of Art,
Architecture and Design,
Oslo (2014); 'L'Ange
de l'histoire', Palais des
Beaux-Arts, Paris (2013);
and 'I Decided Not to
Save the World', Tate
Modern, London (2011).

1
*Madame MMMorphologie*
2013
Book, artificial eye,
blinking mechanism,
movement sensor
150 × 35 × 40 cm
59 × 13¾ × 15¾"
Courtesy of Art Space
Pythagorion

2
*Pajak Study No. 9 (for
Friendship of Nations:
Polish Shi'ite Showbiz)*
2013
Copper tubes, thread and
fishing line
100 × 90 × 90 cm
39⅜ × 35⅜ × 35⅜"
Courtesy of Raster

3
*Other People's Prepositions*
2013
Glass and steel
112 × 45 × 45 cm
44⅛ × 17¾ × 17¾"
Courtesy of Raster

# Focus
# Slavs and Tatars

Slavs and Tatars investigate the myriad
micro-histories that complicate and
undermine the grand meta-arc of
history 'east of the former Berlin Wall
and west of the Great Wall of China'.
Meticulous research accompanies each
project, which might manifest as a
lecture, a publication or a sculpture.
*Madame MMMorphologie* (2013) is a giant
book with mechanized winking eye that
welcomed visitors to 'Long-Legged
Linguistics' (2013) at the Art Space
Pythagorion in Samos—an exhibition
that responded to 60 years of linguistic
change in the former Soviet Turkophone
world, from Arabic to Latin to Cyrillic
to Latin. With such poignant, playful
forms the artists hope to wriggle free
from 'the girdle of the singular … and
spill joyously, into the plural and the
polyphonic'. EN

1

2

3

**Selected by**
Clifton Benevento J7

**Biography**
Born 1977
Lives in Hopkinton, NH

Smith has been the subject
of solo exhibitions held at:
The Power Station, Dallas
(2014); Zabludowicz
Collection, London
(2014); CAPC musée
d'art contemporain de
Bordeaux (2013); Clifton
Benevento, New York
(2013 and 2010); Ludwig
Forum für Internationale
Kunst, Aachen (2013);
and Contemporary
Art Museum St. Louis,
MO (2011). His work
has been included in
recent group shows at
venues including: David
Roberts Art Foundation,
London (2014), and
Frankfurter Kunstverein,
Frankfurt (2014). Smith
has upcoming shows
opening at: Lulu, Mexico
(December/January,
2014/15); Etablissement
d'en face projects,
Brussels (from April,
2015); Kunstverein
Hannover, Germany
(from November, 2015);
and de Appel Art Center,
Amsterdam (opening
summer 2015).

1
*Untitled*
2013
Plastic, macaw feathers
48 × 48 cm
19 × 19"
Courtesy of Clifton
Benevento & Michael
Benevento

2
*Mike*
2013
Two roosters, plastic
30.5 × 38 × 28 cm
12 × 15 × 11"
Courtesy of Clifton
Benevento & Michael
Benevento

3
*Bubbles*
2013
Sweatpants, plastic,
windowpane oysters
43 × 20.5 × 20.5 cm
17 × 8 × 8"
Courtesy of Clifton
Benevento & Michael
Benevento

# Focus Michael E. Smith

The sculptures and paintings that
Michael E. Smith creates from grimy,
urban detritus often seem to contain
within their fragile forms all the weight
of the modern world. Many readings of
Smith's work draw significance from
his years living in the city of Detroit;
sculptures made from Chrysler car parts,
and sweatpants (*Bubbles*, 2013), seem
to back up this assertion. Another
interpretation might point instead to
Smith's sensitivity to the depleted natural
world. The poignantly titled *Mike* (2013)
is an abject ball of rooster feathers;
Smith has also smeared gorgeous macaw
feathers with clear resin in *Untitled*
(2013). Also in evidence throughout his
videos, Smith's strategy is to split the
difference between dumb objects and
sentient, sensitive bodies. JG

1

2

HOME FALLOUT SHELTER
Snack bar – Basement Location

A snack bar built of brick or concrete block can be converted into Shelter. The hinged canopy can be tilted down for filling with brick or concrete block.

3

**Selected by**
Dan Gunn G27

**Also shown by**
Greene Naftali C14

**Biography**
Born 1951
Lives in New York and
Austin, TX

Chicago-born Smith has
presented solo exhibitions
at: Tramway, Glasgow
(2014); Hales Gallery,
London (2013); Dan
Gunn, Berlin (2012);
ICA, Philadelphia
(2008); and Le Magasin
– Centre national d'art
contemporain, Grenoble
(2000). Select two-
person and group shows
include: 'A Voyage of
Growth and Discovery',
a collaboration with
Mike Kelley presented
at the Baltic Centre for
Contemporary Art,
Gateshead, UK (2011),
and West of Rome Public
Art, Los Angeles (2010);
and 'Rituals of Rented
Island: Object Theater,
Loft Performance, and
the New Psychodrama—
Manhattan, 1970–1980',
Whitney Museum of
American Art, New York
(2013).

1, 2, 3
*Government Approved
Home Fallout Shelter
Snack Bar*
1983
Mixed media installation
Courtesy of Dan Gunn

# Focus Michael Smith

Since he emerged as a pioneer of
post-portapak video art in the late 1970s,
Michael Smith's critically astute and
hilariously satirical work has revolved
around the misadventures of his
hapless *alter ego*, 'Mike'. In each work
Smith places Mike—part 20th-century
Candide, part 'Joe the Plumber'
everyman—in social situations that test
his limited means. In collaboration
with Alan Herman, Smith's *Government
Approved Home Fallout Shelter/Snack Bar*
(1983) puts Mike into the picket-fence
paranoia of American Cold-War-era
suburbia. Here Mike, dependably naive
and earnestly incongruous, seeks to use
his skills as a party planner for nuclear
preparedness. Even the threat of nuclear
apocalypse can't dampen Mike's passion
for hosting: impending annihilation
becomes another opportunity for
'uninterrupted leisure'. MQ

1

2

**Selected by**
Supportico Lopez G21

**Biography**
Born 1978
Lives in Brussels

Canadian-born Taylor
has been the focus of
solo shows at: Jessica
Bradley Gallery, Toronto
(2014, 2012 and 2007);
Supportico Lopez,
Berlin (2013 and 2011);
Kunsthal Charlottenborg,
Copenhagen (2013);
The Artist's Institute,
New York (2011);
and Ursula Blickle
Stiftung, Kraichtal,
Germany (2011). He
has participated in
recent group exhibitions
'The Way of the
Shovel', Museum of
Contemporary Art,
Chicago (2013),
'Storytelling', National
Gallery of Canada,
Ottawa (2013), and 'Salon
der Angst', Kunsthalle
Wien, Vienna (2013).

1
*A String of Eyeballs,
a Spectrum of Color, a
Structure of Form in Black
and White*
2013
Mixed media
2.05 × 2.2 × 1 m
6' 8¾" × 7' 2⅝" × 3'3⅜"
Courtesy of Supportico
Lopez

2
*Thoughts Collected on the
Surface of a Panel (These
Thirty-Six Points Are a
Field of Thought)*
2013
MDF, acrylic paint, ink,
brass
Each panel 80 × 60 cm
31½ × 23⅝"
Courtesy of Supportico
Lopez

3
*The Proposal of a Surface
(Lichen Wall)*
2013
Printed wallpaper and
Xerox text
Dimensions variable
Courtesy of Supportico
Lopez

# Focus Zin Taylor

Storytelling with form is at the heart of Zin Taylor's work, and the artist's latest, open-ended, narrative is *The Story of Stripes and Dots* (2012–ongoing), of which there have now been several exhibitions, or 'chapters'. Always appearing in black and white, stripes might be narratives or units of time, whereas dots might be events or gestures. The two forms have emerged in play as Calder-like mobiles, as roughly hewn relic-objects such as cups or tools and as patterns on pyjamas for performers directed to play the roles of stripe or dot in a lichen-dappled landscape. Invigorating the Modernist project of abstraction while playfully experimenting with figuration, Taylor dramatizes relationships between the two units of his artistic cosmology, which can stand in for modes of thinking, behaving and being. LMcLF

**Selected by**
Galerie Emanuel Layr
G20

**Also shown by**
Vilma Gold F2

**Biography**
Born 1989
Lives in Vienna

Timischl has presented
solo exhibitions at:
Vilma Gold, London
(2014); Neue Alte
Brücke, Frankfurt
(2013); and Perfect
Present, Copenhagen
(2013). Select group
shows include: Jessica
Silverman Gallery,
San Francisco (2014);
'Über das Radikale
Nebeneinander',
Halle für Kunst,
Lüneburg, Germany
(2014); 'Okonomie
der Aufmerksamkeit',
Kunsthalle Wien, Vienna
(2014); 'Serpentine 89+
Marathon', Serpentine
Gallery, London (2013);
and 'No Brow', Galerie
Emanuel Layr, Vienna
(2013). Timischl will open
a solo show at KM–K
Graz in December 2014.

*Yet, The Alternatives On Offer*
2014
Installation view at
Galerie Emanuel Layr
Dimensions variable
Courtesy of Galerie
Emanuel Layr

# Focus
# Philipp
# Timischl

Pairing flat-screen monitors with canvas frames, Philipp Timischl's distinctive, free-standing sculptures upset easy distinctions between the digital and the painterly, the flat and the 3D, the mediated and the real. Sampling heavily circulated imagery, from television shows such as *Lost* and *Gossip Girl*, and personal footage, the sequences assembled in Timischl's installations not only unfold on-screen but bleed across canvases, walls and floors. Through this repetition and mutation, narratives of hope and confusion emerge. Conveying a generational anxiety about the ever-expanding image-world (his 2013 exhibition at Vienna's 21er Raum was titled 'Philipp, I have the feeling I am incredibly good looking, but have nothing to say'), the work speaks to our profound emotional investment in the things we see on screens. MMcL

# Focus
# Ante
# Timmermans

**Selected by**
Barbara Seiler J12

**Biography**
Born 1976
Lives in Ghent and Zurich

Belgian artist
Timmermans, who will
present his third solo
exhibition at Barbara
Seiler, Zurich, in late
2014, has previously
held solo shows at:
Kunstmuseum St.Gallen,
Switzerland (2012);
Raum für aktuelle
Kunst, Lucerne (2010);
and Kunstverein Ahlen,
Germany (2007). He
has participated in
group exhibitions that
include: Manifesta 9,
Genk, Belgium (2012);
13th Venice Architecture
Biennale (2012); and
'Tomorrow is the
Question: A Selection
of Recent Acquisitions',
S.M.A.K., Ghent (2011).

2

1, 2
*Make a Molehill out of a
Mountain (of Work)*
2012
Performative installation
Dimensions variable
Courtesy of Barbara
Seiler and Kunstmuseum
St.Gallen, Switzerland

Ante Timmermans makes installations,
performances, video fragments and
paintings that operate according to
the logic of drawing: mark-making,
perforating and delineating. Often
these works conjoin aspects of mass
modernity and urbanity in the late 19th
and early 20th centuries: the toil of
mine labour and drudgery of white-
collar wage-earning; the regimes of
spectacular mass pleasure evident in
World Fairs, Ferris wheels, big dippers
and city-wide panoramas. *Make a
Molehill out of a Mountain (of Work)*
(2012) is a Sisyphean, performance-
based installation staged at Manifesta 9
(2012), in which the artist punched
holes in sheets of paper and filed them
in binders, producing as a by-product a
small 'molehill' of paper discs. With
references to Beckett, Camus and
Kafka, the work suggests the frequent
purposelessness of both white- and
blue-collar labour under modernity. CP

1

2

3

**Selected by**
Limoncello H23

**Biography**
Born 1979
Lives in Como, Italy

Tolone has been the
focus of solo exhibitions
held at: Castello di
Rivoli, Turin (2013);
Limoncello, London
(2012); and TCB Art
Inc., Melbourne (2007).
He has participated in
group exhibitions at
venues that include:
Fondazione Sandretto
Re Rebaudengo, Turin
(2014); Instituto Italiano
de Cultura de Madrid,
Madrid (2014); Almanac,
London (2013); Galerie
Perrotin, Paris (2013);
Limoncello, London
(2011); and Le Magasin
– Centre national d'art
contemporain, Grenoble
(2010).

1
*Nuvola*
2013
Mixed media
170 × 80 × 80 cm
66⅞ × 31½ × 31½"
Courtesy of Limoncello

2
*Billy Shadows*
2012
Painted MDF
195 × 76.5 × 26.5 cm
76¾ × 30⅛ × 10⅜"
Courtesy of Limoncello

3
*Mandarini*
2012
Screenprint on paper
130 × 106.5 cm
51⅛ × 41⅞"
Courtesy of Limoncello

# Focus Santo Tolone

Famously, a rose by any other name
would smell as sweet; but what if it
didn't smell at all, or if the petals were a
different shape, or it didn't have thorns?
Could we still call it a rose? Santo
Tolone's work is about legibility—
about the relationship between signs
and things—and the artist continually
probes the extent to which an object
can be manipulated and yet remain
able to communicate something of its
fundamental essence. Like the tangerine-
peel forms scattered across a flat blue
expanse in the screenprint *Mandarini*
(2012), which seem to form their own
spidery alphabet, Tolone's work plays
with our impulse to read into, or read
between the lines of, even the most
banal-seeming objects and situations. AS

1

2

3

**Selected by**
Société G15

**Also shown by**
Real Fine Arts H20

**Biography**
Born 1982
Lives in New York

Vena has presented solo
exhibitions at venues that
include: Société, Berlin
(2014 and 2011); Real Fine
Arts, New York (2014);
White Flag Projects, St.
Louis, MO (2012); and
Midway Contemporary
Art, Minneapolis (2009).
He has participated in
such recent group shows
as 'Collaborative Painting
& Text - Ned Vena, Dave
Miko, Antek Walczak',
Algus Greenspon, New
York (2014); 'Jeanette
Mundt & Ned Vena',
Federico Vavassori, Milan
(2014); 'A Brief History
of Spots, Stripes and
Holes', Carlson Gallery,
London (2013), and 'Sous
l'Amazone coule un
fleuve', FRAC Auvergne,
Clermont-Ferrand,
France (2013).

1
*Untitled*
2013
Polyurethane, rubber
on gessoed canvas,
aluminium frame with
adhesive vinyl
84 × 48 cm
33⅛ × 18⅞"
Courtesy of Société

2
*Untitled*
2013
Polyurethane and rubber
on gessoed canvas in 6
parts
2.95 × 4.4 m × 0.04 m
9' 8⅛" × 14' 5¼" × 1⅝"
Courtesy of Société

3
*Untitled*
2012
Adhesive vinyl, steel door,
hinges
2 × 1.8 × 0.04 m
6' 6¾" × 5' 10⅞" × 1⅝"
Courtesy of Société

# Focus
# Ned
# Vena

It is interesting that a recent body of
work by Ned Vena (an untitled series
from 2012) should include fire doors,
given that his paintings give you no
suggestion of worlds hidden behind
them. His cool monochrome
abstractions—whose rich art-historical
lineage stretches back to Frank Stella's
'Black Paintings' (1959–60) by way
of the contemporary output of artists
such as Wade Guyton—feature
perpendicular lines that function like
a labyrinth, trapping the eye on the
surface of the work and upholding
Stella's own adage that 'What you see
is what you see.' Many of the artist's
processes and materials derive from
his time working as a commercial sign-
maker—his 'paint' palette includes
polyurethane, spray rubber and Rust-
Oleum enamel treatment, materials
designed to protect, to preserve and
to keep out. AS

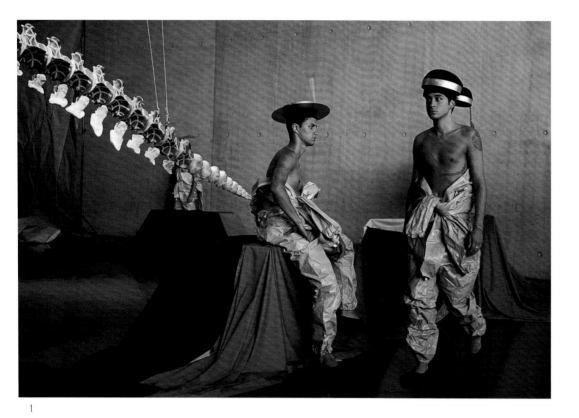

1

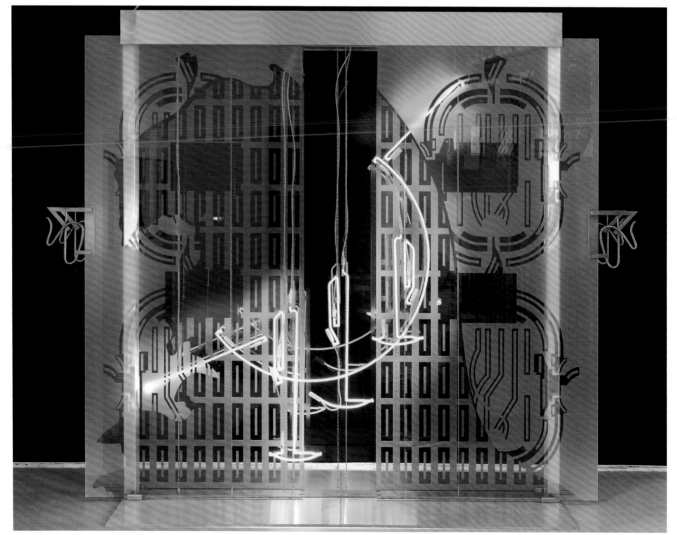

2

3

**Selected by**
Mathew Gallery H18

**Biography**
Founded 2011
Offices in London and
Berlin

The work of Villa
Design Group has been
exhibited at venues that
include: Mathew Gallery,
Berlin (2014 and 2013);
Lima Zulu, London
(2013); Betongalerie,
Hamburg (2013); and
Bundeskunsthalle,
Bonn (2012). They
have presented projects
and performances at
Kunsthaus Bregenz,
Austria (2013); George
& Dragon Cabaret Bar,
London (2012); and
Goldsmiths, University of
London (2011).

1
*Spring 2007: Fall 2007*
2013
Documentation of
performance at KUB
Arena, Kunsthaus
Bregenz
Courtesy of Mathew
Gallery

2
*Tectonic Slide Partition
– Blue Neon Isolation
(Entrance, Separation, Exit)*
2014
Mixed media
2.15 × 1.8 × 0.9 m
7' ⅝" × 5' 10⅞" × 2' 11⅜"
Courtesy of Mathew
Gallery

3
*Cock Rotation Hat Stand
(Be quiet. And sit below the
awning: how dull to speak
of horizons where here there
is no edge. Everything is
calculated to be flat above.)*
2014
Water-cut aluminium,
powder-coated steel,
hand-lathed walnut,
lacquer
1.98 × 0.8 × 0.8 m
6' 6" × 31½" × 31½"
Courtesy of Mathew
Gallery

# Focus
# Villa Design
# Group

The young trio of artists that make up
Villa Design Group willingly present
themselves as interior designers of
hyper-designed luxury settings for their
performances, installations and objects.
Mining secluded histories, their project
*Inauguration of the Russian Season* (2014)
narrates in fragments a hypothetical
architectural competition to house the
lost works of Russian author Nikolai
Gogol. *Cock Rotation Hat Stand (Be
quiet. And sit below the awning: how dull to
speak of horizons where here there is no
edge. Everything is calculated to be flat
above.)* (2014) is one of a series of surreal
hat stands, the silhouette of a flaccid
penis forming an inverted, useless hook.
Intimate details, design history and
neglected fictions mingle in a bizarre,
angular, camp future. CFW

Collared Dove

Live

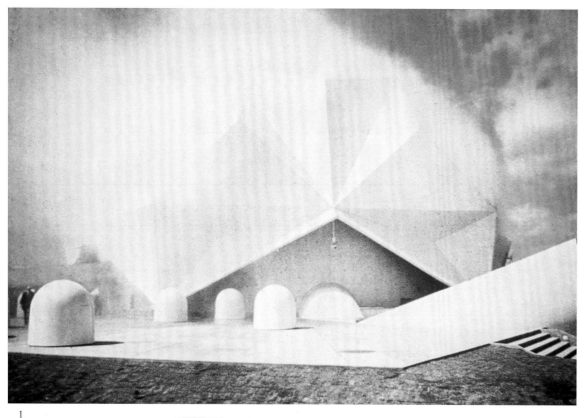

1

2

3

**Selected by**
gb agency L6

**Biography**
Born 1926
Died 2011

Born in 1926 in 'Motor
City', Detroit, Robert
Breer first studied
engineering before
turning to painting.
Breer lived in Paris from
1949 to 1959, when he
moved to New York and
began experimenting
with animating his
paintings in mutoscopes
and folioscopes. From
1973 to 2001 he led the
filmmaking department
at Cooper Union. His
work has been the focus
of numerous exhibitions
and screenings, as well as
a touring retrospective
at the Tinguely Museum,
Basel, Baltic Centre
for Contemporary
Art, Gateshead, UK,
and CAPC musée
d'art contemporain de
Bordeaux (2010–11).

1
*Floats* at the Pepsi-Cola
Pavilion
Osaka 1970
Motorized sculpture,
resin, paint, motor,
wheels
1.83 × 1.8 m
6' × 5'10⅞"
Courtesy of
gb agency

2
Robert Breer at the
installation of *Floats* in
the Pepsi-Cola Pavilion
Osaka 1970
Courtesy of gb agency

3
'Robert Breer'
2013
Exhibition view at gb
agency, Paris
Courtesy of gb agency

Live
# Robert Breer

Breer's creative development describes a
trajectory from classical modes of artistic
expression to the possibility of autonomous
art works. Starting with drawing and
painting, Breer soon began animating his
still images into films. In the mid-1960s
he experienced an 'epiphany' when he first
made the moving sculptures he called *Floats*
or *Creepies*. A background in engineering,
together with his own studies and his
father's work designing Chrysler cars,
afforded Breer a keen understanding of
the physical properties of materials and
motors. To this day, his moving sculptures
continue to confound viewers, causing
them to question their experience and
examine their faculties of perception.

The *Floats* are 'self-propelled dome-shape
sculptures' on rubber wheels, which slowly
move around the exhibition space at
random, retreating from any solid edges
or obstacles they encounter. Breer cites
John Cage's pioneering use of chance in
his musical compositions as influential
to the *Floats*, which are 'designed not to
make the same trajectory all the time'.
Breer was keen to distinguish his *Floats*
from kinetic sculptures whose parts move
in relation to one another, emphasizing
the *Floats*'s autonomy and the way they
delineate a given space as they move around
and through it. They reached their apogee
in 1970, when Breer created a group of
6-foot-high sculptures for Expo '70 in
Osaka, Japan, as part of the EAT
(Experiments in Art and Technology)
project for Pepsi Co. Inc. EDW

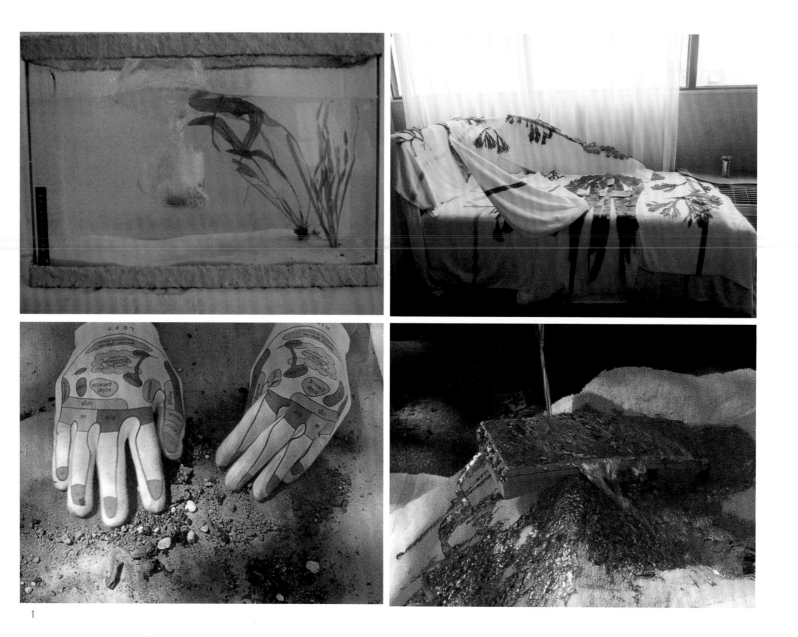

2

**Selected by**
Rodeo L2

**Biography**
Born 1982
Lives in Vancouver,
Canada, and New York

After studying at
the Städelschule in
Frankfurt, Germany, and
the Royal Institute of Art
in Stockholm, Sweden,
Henderson returned
to her native Canada,
although she maintains
an itinerant practice.
Her work has been the
focus of solo exhibitions
at: Grazer Kunstverein,
Graz, Austria (2014);
the ICA, Philadelphia
(2014); Kunstverein
Nürnberg, Nuremberg
(2013); and A1C Gallery
in Newfoundland
(2010). Recent group
exhibitions include shows
at Kunstverein Toronto
(2014) and Fahrenheit,
Los Angeles (2014), as
well as Documenta 13,
Kassel (2012).

1
*What's Up Doc?*
2014
Stills, 16 mm colour film,
optical sound (Sound
Dan Riley)
2 min. 55 sec.
Courtesy of Rodeo

2
*Three Pockets di O Getti*
2013
Still, 16 mm colour
film, optical sound,
in collaboration with
Tiziana La Melia
2 min. 55 sec.
Courtesy of Rodeo

Live
# Tamara
# Henderson

Unwinding, reclining, tanning, resorting.
Henderson's participatory installation
*Resorting* (2014) is suggestive of terms
promising a future state of blissful
relaxation. We are invited to experience
the work with all our senses: to gaze at the
16 mm film projected onto a beach towel;
to touch and sit on the resin-encased
holiday accessories. But this allusion to
escapism is tinged with evidence of the
decline of travel agencies who provided
some of the material Henderson has
incorporated into her sculptures. Textures
suggest a seaside location, the wetness of
bodies emerging from the sea or the
sensuality of dripping fabrics now encased
in hard resin and gritted with colourful
sand. As a whole, *Resorting* has a mission to
lull us into a different state of mind and
body, hinting at the possibility of
transforming one's spirit.

Concurrently on show at Rodeo during
Frieze, Henderson's film *What's Up Doc?*
(2014) takes us to a doctor's office on
Klamath Lake, where the E3Live
aphanizomenon flos-aquae algae is
grown. It takes us onwards to Colorado,
for a 'marijuana tour' of sites where the
plant is grown. This work seduces us as it
parodies the holistic—hollow?—promises
of the well-being industry and the myth-
making of travel agencies. EDW

1

2

# Live
# Adam Linder

**Selected by**
Silberkuppe L5

**Biography**
Born 1983
Lives in Berlin

Originally trained
as a ballet dancer
and choreographer,
Linder has danced with
The Royal Ballet in
London and Michael
Clark Company. His
performance works have
been presented at venues
including: the Abrons
Arts Center, New York
(2014); Sophiensäle,
Berlin (2013); Museum
für Gegenwartskunst,
Basel (2013); Kunstverein
Nürnberg, Nuremberg
(2013); and Halle für
Kunst, Lüneburg,
Germany (2012). In
June 2014 Shahryar
Nashat's film adaptation
of Linder's stage work
*Parade* (2013) premièred
at the 8th Berlin Biennial.
His choreographic
service *Some Cleaning*
was presented at
Silberkuppe in 2013.

1
*Some Cleaning*
2013
Performance
documentation
Courtesy of Silberkuppe

2
*Ma Ma Ma Materials*
2012
Performance
documentation
35 min.
Courtesy of Silberkuppe

'How do we value something as ephemeral as choreographic activity today?' asks Linder about *Writing Service: Body Language* (2014). Presented as a demonstration at Frieze London, it involves two dancers and a critic, and can be hired by the hour. The work occurs in three stages: the critic collects language material—words, statements, colloquialisms—throughout the fair; he then collaborates with the dancers to create musical–poetic scores vocalizing the linguistic artefacts he has found; and finally these linguistic scores enable a choreography to be performed.

*Writing Service* builds on Linder's *Some Cleaning* (2013), which consisted of a lexicon of actions based on movements made when cleaning, through which he metaphorically and experientially cleaned the space in which he performed. As services, these works are offered for a fixed price, and are therefore not subject to financial speculation. They exist solely during the time in which they are being performed and they rely on the service provider's presence to exist.

By situating his work in relation to a service rather than a material economy, Linder ensures that the desirable components of the work—the skill and corporeal knowledge intrinsic to the bodies of its performers— remain with the performers. They do not give up what is most valuable to them, although they do turn a profit by using it to provide a service. EDW

SHANZHAI BIENNIAL, Campaign 1

E  cyan magenta yellow black  F  blind_final.tif

**Selected by**
Project Native Informant
L1

**Biography**
Founded in 2012
Live and work in New
York and Shanghai

Shanzhai Biennial is a collective comprising artist Cyril Duval (a.k.a. Item Idem), stylist Avena Gallagher and Creative Director of *Bidoun* magazine Babak Radboy. The group has previously presented three editions of the Biennial: at Project Native Informant, London (2014); at the Centre Pompidou, Paris and MoMA PS1, New York (2013); and at Beijing Design Week (2012). Their projects have also been included in 'DISown', curated by *DISmagazine* at the Red Bull Studios New York (2014) and the New Museum Next Generation Triennial Party, New York (2013).

1
*Shanzhai Biennial No. 1 Advertising Campaign, Beijing Weekly*
2012
Print advertising campaign
Dimensions variable
Courtesy of Project Native Informant

2
*Taste*
2013
Screenprint on water bottle, coloured water
Dimensions variable
Courtesy of Project Native Informant

# Live
# Shanzhai Biennial

'Shanzhai' isn't a place; it's a state of mind. A widespread Chinese cultural movement that incorporates manufacturing, fashion, music and film, shanzhai is different from counterfeiting. While the counterfeit object wants to be taken for the original it mimics, a shanzhai product is happy to be the bastard child that it is. Shanzhai distorts logos, turning Chanel into Canal and iPhone into HiPhone. The phenomenon is the result of factory workers taking their skills home and manufacturing products for themselves and their peers, rather than for the international market. Shanzhai Biennial founder Babak Radboy says the movement keys into 'the desire that years of investment have produced for those brands but, at the same time, it's actually affordable for all the people in the factories'.

Shanzhai Biennial describes itself as 'A multinational brand posing as an art project posing as a multinational brand posing as a biennial.' With jobs in art and fashion, its members are ideally placed to perform a sharp satire on the systems governing those industries. *Taste* (2013), a plastic bottle containing coloured water with a label that resembles the logo of Chase Manhattan Bank, was presented as part of *TASTE®-Makers™* at New York's New Museum Next Generation Triennial Party. Shanzhai Biennial exposes the culture and product industries' exploitation of desire as an abstract commodity, with goods that verge on the absurd and generate a kinky kind of longing. EDW

# Live
# UNITED BROTHERS

In April 2011 a devastating earthquake and nuclear disaster hit the prefecture of Fukushima, Japan, where UNITED BROTHERS's hometown of Iwaki is situated. In the wake of the tragedy, Ei, an internationally renowned artist, and Tomoo, who owned several tanning shops in Iwaki before the catastrophe, began to invite artists from outside Japan to produce projects in Fukushima. Their intention was to explore the events that had marked the area and to 'reinvent them with aesthetic awareness', for example by offering members of the public a homemade soup containing ingredients grown on Fukushima soil.

The gift of food represents the essence of hospitality, sharing and humanity. However, the soup UNITED BROTHERS offer is laced with the (conceptual) possibility that it may be radioactive. Although the ingredients used in its preparation are approved by the Japanese Farmers' Association, and the artists assure us that the soup is safe (their mother has prepared and eaten it), it still poses a theoretical threat. By tying the work to family and presenting it in a gallery or at an art fair as a gift, UNITED BROTHERS lend the ecological disaster an ethical dimension and an aesthetic quality that also comments on the status of art as a commodity.

While eating the soup can be seen as a symbol of solidarity, the question remains: are we willing to risk our well-being for such a gesture? As the brothers point out, *Does This Soup Taste Ambivalent?* (2014) 'is very ambiguous, and plays with the speculation by the public especially outside Japan'. EDW

**Selected by**
Green Tea Gallery L3

**Biography**
Founded in 2011
Live in Iwaki, Japan

Brothers Ei and Tomoo Arakawa set up UNITED BROTHERS and the itinerant Green Tea Gallery in 2011. Their work together has been the focus of an exhibition at Halle für Kunst Lüneburg, Germany, with DAS INSTITUT and Nhu Dong. They have also shown as part of group exhibitions and projects at: Gerrit Rietveld Academie, Amsterdam (2013); MoMA PS1, New York (2013); Tate Modern, London (2012); Fukushima Biennial, Japan (2012); and the Art Institute of Chicago (2012).

*Does This Soup Taste Ambivalent?*
2014
Performance documentation
Courtesy of Green Tea Gallery

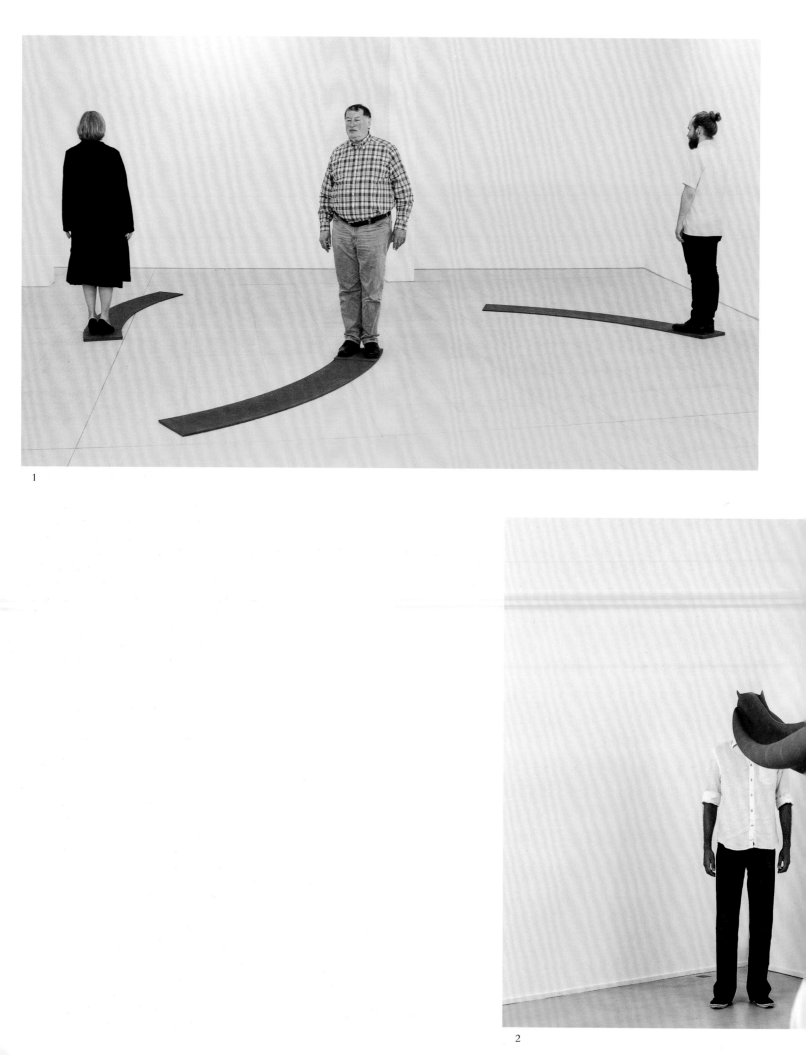

**Selected by**
Galerie Jocelyn Wolff L4

**Biography**
Born 1939
Lives and works in Fulda,
Germany

German artist Walther
lived in New York in
the late 1960s, during
which time his work was
included in the seminal
'Spaces' show at MoMA
(1969–70). His work
has been included in
numerous exhibitions,
notably Documenta
8, 7, 6 and 5 in Kassel
(1987, 1982, 1977, 1972),
and Harald Szeemann's
'When Attitudes Become
Form', at the Kunsthalle
Bern (1969). From 1971 to
2005 he taught sculpture
at the Hochschule
für Bildende Künste
Hamburg, where his
students included Martin
Kippenberger, Christian
Jankowksi, Santiago
Sierra, John Bock,
Lilly Fischer, Jonathan
Meese and Andreas
Slominski. His work has
also been the focus of a
touring retrospective at
WIELS Contemporary
Art Centre, Brussels,
and CAPC musée
d'art contemporain de
Bordeaux (2014–15).

1
*Drei Standstellen. Sechs
Richtungen*
1975
Steel
8 × 35 × 105 cm
3⅛ × 13¾ × 41⅜"
Courtesy of Galerie
Jocelyn Wolff

2
*Sehkanal (1. Werksatz
No. 46)*
1968
Green cotton fabric
30 × 740 × 20 cm
11¾ × 291⅜ × 7⅞"
Courtesy of Galerie
Jocelyn Wolff

# Live
# Franz Erhard Walther

With a practice that incorporates drawing,
writing, painting and sculpture, Walther
is a pioneer of the idea that action can be
a type of formal production in art. His
practice marks a development away from
the Minimal art of the 1960s and towards
an action-based approach, which carries
with it the potential for the gallery to
become a social and interactive space. His
sculptures invite the participation of people
in order to be activated, although they also
carry meaning as inert objects untouched
by visitors. While we may be familiar with
this kind of hands-on approach today, the
suggestion that a visitor could touch or
even 'use' an artwork was a radical new
proposition when Walther first introduced
it into his practice in the early 1960s.

Walther's interactive sculptures are
characterized by their emphasis on the
body, movement, place and time; aspects
of the work that lie beyond the control of
the artist. He points out that: 'While in a
stored state the work pieces are forms, […]
in action they become instruments and
the actions become forms and thus works.'
A core work in Walther's *oeuvre* is
*1. Werksatz* (First Work Set) (1963–9),
a series of 58 sculptures made of
materials including stitched fabric,
wood and foam, to be activated by
members of the public. These works invite
us to explore sculptural potentiality
by engaging with physical forces such
as gravity, tension and equilibrium, as
they blur the dividing line between
individual bodies and sculptures. EDW

## ArtWorks
by Deutsche Bank

## Art builds.
## Art questions.
## Art transcends borders.
## *Art works.*

Art questions. It sprawls new ideas for shaping our future. It inspires people, opens up new perspectives, and enables them to embrace unusual and innovative solutions. This is why art has been at the forefront of Deutsche's cultural activities for 35 years, and our partnership with Frieze London, now in its eleventh year, provides the perfect platform for sharing our passion.

db.com/art

**London**
Regent's Park
15–18 October 2014
Preview Day
Tuesday 14 October
friezelondon.com

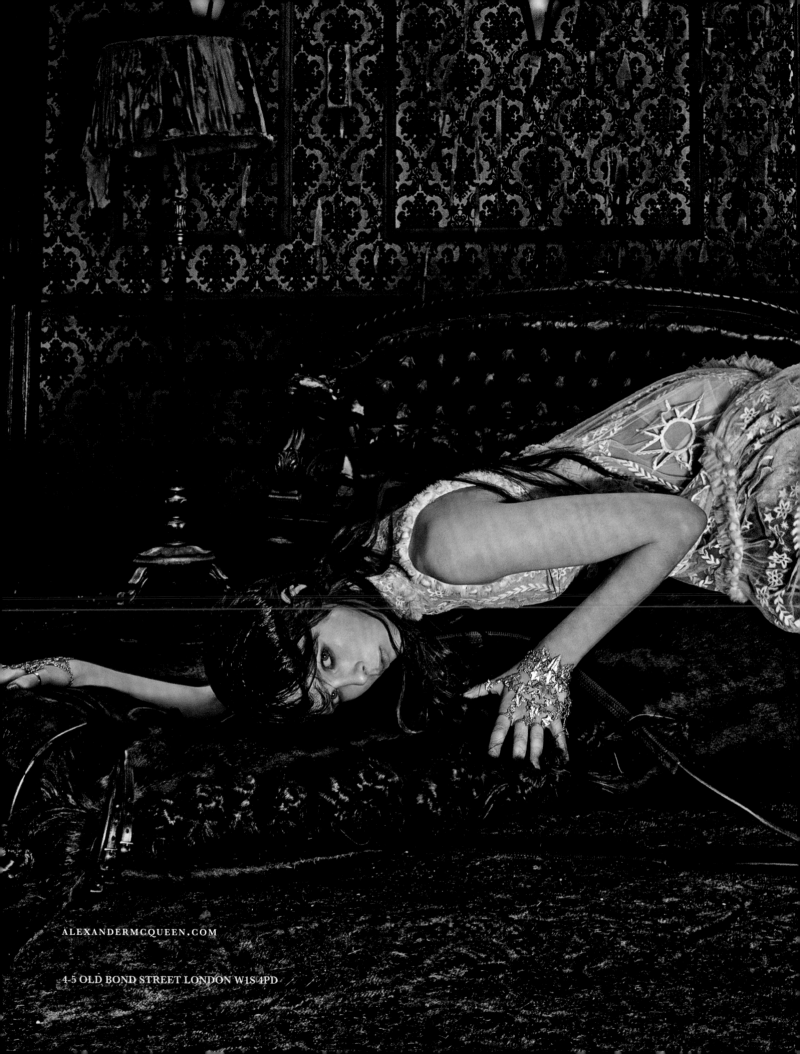

ALEXANDERMCQUEEN.COM

4-5 OLD BOND STREET LONDON W1S 4PD

# Simmons & Simmons

## Painting About Painting

Simmons & Simmons is more than just an international law firm. At the heart of our business is a culture that fosters initiative and embraces creativity.

We have been collecting contemporary art for more than 25 years and are delighted to support Frieze London for the twelfth consecutive year.

Today the firm has a leading collection of contemporary art comprising works by British and international artists. Our objective is to continue to support artists early in their careers while providing our staff, our clients and others with the opportunity to engage with some of the most interesting aspects of contemporary art and culture.

Our current exhibition 'Painting About Painting' explores the attention and opprobrium that painting can attract within contemporary art.

View our collection online at simmonscontemporary.com
or follow us on Twitter @Simmons_Art

Detail: Hurvin Anderson
Skinny Dipping 1999
Oil on canvas
The Simmons & Simmons collection
Acquired 2002
Courtesy of the artist

# I AM i8.
## THE NEW BMW i8.

Visit bmw.co.uk/bmwi8

BMW i

BMW

The Ultimate
Driving Machine

# L'ART DU CHAMPAGNE
## SINCE 1836

CHAMPAGNE
**POMMERY**
À REIMS·FRANCE

# outset.

**Supporting New Art**

ft.com/weekendsub

# Life.
# Arts.
# Culture.

## Read beyond the expected

# diptyque
### paris

*Revisiting diptyque's identity and story to express new facets characterised by a joyful modernity.*
*The 34 Collection covers all diptyque's domains: personal fragrances, home fragrances but also,*
*and this is a first, eclectic objects, each revealing an original art of living.*
*A nice way to reconnect with the "bazaar" spirit that was so dear to the founders*
*and so intimately entwined with their story.*

*Essences Insensées eau de parfum, Essences Insensées solid perfume, Le Redouté scented candle,*
*Plumage, Feuillage & Paysage candle holders, Notebooks*

Available Early September in all diptyque boutiques
diptyqueparis.co.uk

# Helium

# Oxygen

The National Art Pass. Free entry to over 200 galleries and museums across the UK and half-price entry to the major exhibitions.

**Buy yours today at artfund.org**

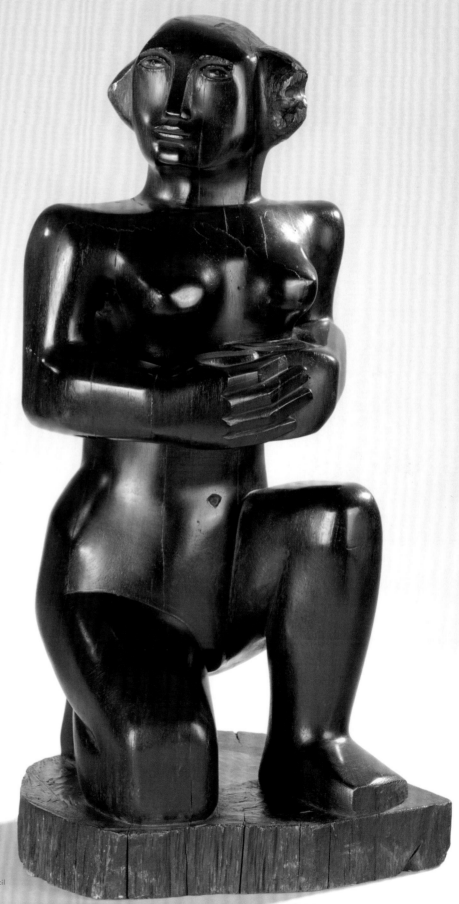

# THE HEPWORTH WAKEFIELD

## CONFLICT AND COLLISIONS: NEW CONTEMPORARY SCULPTURE
OCT 2014 – JAN 2015

Alexandra Bircken
Folkert de Jong
Toby Ziegler including
Charles Sargeant Jagger

## LYNDA BENGLIS
FEB – JULY 2015

## ANTHONY CARO
JULY – NOV 2015

## COLLECTION DISPLAYS
2014 – 2015

Lynn Chadwick
Magda Cordell
Jean Dubuffet
Naum Gabo
Henri Gaudier-Brzeska
Alberto Giacometti
Maggi Hambling
Richard Hamilton
Stanley William Hayter
Nigel Henderson
Barbara Hepworth
Fernand Leger
L.S. Lowry
Paul Klee
Bernard Meadows
Henry Moore
Ben Nicholson
Eduardo Paolozzi
Jackson Pollock
William Roberts

Free Admission
www.hepworthwakefield.org

**wakefield**council

Supported using public funding by
**ARTS COUNCIL ENGLAND**

The Hepworth Wakefield is a registered charity no. 1138117

Barbara Hepworth, *Kneeling Figure*, 1932. The Hepworth Wakefield (Wakefield Council Permanent Art Collection) ©Bowness, Hepworth Estate. Photo Norman Taylor.

# A MASTERPIECE RESTORED
# A VISION REIMAGINED

# VANITY FAIR *ON ART*

*Vanity Fair On Art* has a unique take on the people, events, and ideas that put the art world in a whirl

**ON SALE OCTOBER 10TH**

# WHY OUR MINERAL WATER LEAVES A BETTER TASTE IN THE MOUTH.

I. We are a 100% carbon neutral company. 2. All of our bottles use either recycled glass or plastic. 3. We donate all of our profits to the charity WaterAid. All of which proves that not all bottled water companies are the same. Belu. Made with mineral water and ethics.

**BELU**

SPARKLING
NATURAL MINERAL WATER

DEAR
DAVE,

DEARDAVEMAGAZINE.COM

# Kilgour

SAVILE ROW LONDON

Skin, hair and body care for men and women, formulated from botanical and laboratory-made ingredients of the highest quality.

Soins pour le visage, les cheveux et le corps pour les femmes et les hommes, formulés avec des ingrédients de la plus haute qualité issus des plantes ou de notre laboratoire.

**Aesop Richmond**
19 King Street Richmond
TW9 1ND London

**Aesop Bibliotekstan**
Jakobsbergsgatan 5-9
111 44 Stockholm

**Aesop Saint-Sulpice**
5, rue du Vieux Colombier
75006 Paris

**Aesop Pfeilstrasse**
Pfeilstrasse 45
50672 Cologne

« L'existence serait intolérable si l'on ne rêvait jamais. » **Anatole France**

# artpress
## lance sa version numérique

■ Retrouvez désormais l'édition d'artpress au sein du kiosque numérique **press reader**. Disponible sur le web et via l'application press reader pour smartphones et tablettes.

■ Acheter le dernier numéro en ligne quand vous voulez et sans vous déplacer, c'est désormais possible en quelques clics.

■ Cette évolution technologique permet de vous proposer chaque numéro pour seulement 5,49 €. Le numéro ainsi acheté est ensuite conservé dans votre historique et il vous sera possible de le lire, jusqu'à la dernière page, quand bon vous semble.

■ Un système intelligent de notification vous permet de mettre artpress "en favori" pour être alerté par un email dès que le nouveau numéro est disponible en ligne.

■ Parce que la lecture d'une page entière au format PDF n'est pas toujours aisée, nous avons mis en place une technologie vous permettant, si vous le souhaitez, d'afficher à l'écran, en un clic, uniquement l'article que vous voulez lire. Vous découvrirez une nouvelle mise en page totalement adaptée à la navigation sur supports numériques : vous pouvez ajuster la taille des caractères à votre convenance et faire défiler les articles aussi simplement que vous tourneriez les pages.

■ Nous avons aussi intégré une synthèse vocale gratuite permettant à l'internaute d'écouter la lecture de son journal. Cliquez sur le bouton siglé d'écouteurs, et une voix démarre la lecture de l'article sélectionné. Cette fonction est accessible aussi bien depuis un ordinateur que depuis les versions smartphone et tablette du kiosque numérique.

■ *Pourquoi le journal numérique est-il moins cher ?*
La version numérique d'artpress présente le même contenu ainsi que les mêmes pages que sa version papier traditionnelle. Néanmoins, l'absence de coûts d'impression et de transport nous permet de vous proposer cette version numérique à seulement 5,49 €.

■ **En pratique**
Découvrez le kiosque numérique d'artpress sur www.artpress.com et cliquez sur "Journal numérique".

■ **Achat de la version numérique à l'unité : 5,49 €**

## www.artpress.com

# artpress
## goes digital

■ Art press is now available on the digital newsstand **press reader**. It can be accessed online and using the Press Reader app on smartphones and tablets.

■ Wherever you are, you are just a few clicks away from the latest issue.

■ 5.49 euros gives you full access to the digital magazine, which is recorded in your history, meaning that you can access the whole issue whenever you want.

■ And you can record art press among your favorites so as to be informed whenever a new issue is available online.

■ You can go from full page-format reproductions (pdfs) of the magazine straight into the articles that interest you in a digital layout designed for comfort of reading. Adjustable text size means that every text, whether a long essay or short note, is as easy on the eye. And with all the fingertip navigability of tablet and online formats.

■ There is also a special vocal feature. Click on the headphone symbol and, within a few seconds, a voice will start reading the article you have chosen. This function is available on online as well as on smartphone and tablet versions.

■ *Why is the digital version cheaper?*
Simple. If the content is strictly the same as the traditional paper version, we pass on the savings on printing and distribution costs. Hence the price of only 5.49 €.

■ **Access**
To access the digital version, click on "artpress digital" on www.artpress.com

■ **Art press digital version: 5.49 € per issue**

Download Now

All the content from the current issue in a beautifully designed app.

from just £24.99   digital.frieze.com

# PIPELINE

**Bilingual contemporary art magazine**

## 當代藝術雙語雜誌

www.pipelinemag.com

# GALLERY GUIDE
by Pipeline

www.hkgalleryguide.com

New York

Randall's Island Park
May 14–17, 2015
Preview Day
Wednesday, May 13

friezenewyork.com

FRIEZE
ART
FAIR

# frieze
# masters

**Regent's Park, London**
**15–19 October 2014**
**Preview Tuesday 14 October**

**Tickets at friezemasters.com**

## Participating Galleries

1900-2000, Paris
Didier Aaron & Cie, Paris
Acquavella, New York
Applicat-Prazan, Paris
Ariadne, New York
Bacarelli Botticelli, Florence
Jean-Luc Baroni, London
Bastian, Berlin
Berinson, Berlin
Bernheimer, Munich
Berwald, London
Blum & Poe, Los Angeles
Brimo de Laroussilhe, Paris
Ben Brown, London
Cahn International, Basel
Gisela Capitain, Cologne
Caylus, Madrid
Cheim & Read, New York
Le Claire, Hamburg
Jonathan Clark, London
Coll & Cortés, London
Colnaghi, London
Paula Cooper, New York
Corbett vs. Dempsey, Chicago
Alan Cristea, London
Daniel Crouch, London
Dan, São Paulo
Thomas Dane, London
Daxer & Marschall, Munich
Dickinson, London
Andrew Edmunds, London
Donald Ellis, New York
Entwistle, London
Faggionato, London
Richard L. Feigen & Co., New York

MD Flacks, London
Sam Fogg, London
Eric Franck, London
Peter Freeman, New York
Gagosian, London
Thomas Gibson, London
Elvira González, Madrid
Marian Goodman, London
Graça Brandão, Lisbon
Richard Green, London
Johnny Van Haeften, London
Hauser & Wirth, London
Hazlitt Holland-Hibbert, London
Edwynn Houk, New York
Sebastian Izzard, New York
Ben Janssens, London
De Jonckheere, Geneva
Annely Juda, London
Daniel Katz, London
Jack Kilgore & Co., New York
Tina Kim, New York
Koetser, Zurich
Kohn, Los Angeles
Hans P. Kraus Jr., New York
Kukje, Seoul
Lampronti, London
Kunstkammer Laue, Munich
Simon Lee, London
Lefevre, London
Dominique Lévy, New York
Salomon Lilian, Amsterdam
Lisson, London
Luxembourg & Dayan, London
Matthew Marks, New York
Marlborough, London
Fergus McCaffrey, New York
McKee, New York
Anthony Meier, San Francisco
Metro Pictures, New York
Meyer, Paris
Victoria Miro, London

Mitchell-Innes & Nash, New York
Mnuchin, New York
Moretti, London
Helly Nahmad, London
Otto Naumann, New York
David Nolan, New York
Stephen Ongpin, London
Pace, London
Franklin Parrasch, New York
Benjamin Proust, London
Robilant + Voena, London
Sanct Lucas, Vienna
G. Sarti, Paris
Schönewald, Düsseldorf
Bruce Silverstein, New York
Skarstedt, London
Rob Smeets, Geneva
Sperone Westwater, New York
Sprüth Magers, Berlin
Craig F. Starr, New York
Timothy Taylor, London
Tomasso Brothers, London
Ubu, New York
Van de Weghe, New York
Vedovi, Brussels
Rupert Wace, London
Offer Waterman & Co., London
Weiss, London
W&K, Vienna
Adam Williams, New York
David Zwirner, New York

## Spotlight

Agial, Beirut
*Huguette Caland*
Anita Beckers, Frankfurt
*Peter Weibel*
Broadway 1602, New York
*Rosemarie Castoro*
Castelli, New York
*Robert Morris*
Paulo Darzé, Salvador
*Mestre Didi*
espaivisor, Valencia
*Graciela Carnevale*
A Gentil Carioca, Rio de Janeiro
*Hélio Oiticica*
Goodman, Johannesburg
*Sue Williamson*
Leila Heller, New York
*Charles Hossein Zenderoudi*
Hyundai, Seoul
*Seung-taek Lee*
Ivan, Bucharest
*Horia Bernea*
Alison Jacques, London
*Hannah Wilke*
Jhaveri, Mumbai
*Lionel Wendt*
Lelong, New York
*Zilia Sánchez*
Meem, Dubai
*Dia Azzawi*
DC Moore, New York
*Romare Bearden*
Almine Rech, Brussels
*Mary Corse*
Richard Saltoun, London
*Jo Spence*
Hubert Winter, Vienna
*Marcia Hafif*
Yumiko Chiba Associates, Tokyo
*Keiji Uematsu*

**Media partner**

FT
FINANCIAL TIMES

**Main sponsor**
**Deutsche Bank**

Grey Heron

# Gallery Index

## 303 Gallery

**Stand Number E5**
Tel +1 212 255 1121

507 West 24th Street
New York NY 10011
United States
Tel +1 212 255 1121
info@303gallery.com
www.303gallery.com

**Contact**
Lisa Spellman
Kathryn Erdman
Cristian Alexa
Erika Weiss
Thomas Arsac

**Artists**
Doug Aitken
Valentin Carron
Hans-Peter Feldmann
Ceal Floyer
Karel Funk
Maureen Gallace
Tim Gardner
Dominique Gonzalez-
Foerster
Kim Gordon
Rodney Graham
Mary Heilmann
Jeppe Hein
Larry Johnson
Matt Johnson
Jacob Kassay
Karen Kilimnik
Alicja Kwade
Elad Lassry
Florian Maier-Aichen
Nick Mauss
Mike Nelson
Kristin Oppenheim
Eva Rothschild
Collier Schorr
Stephen Shore
Sue Williams
Jane & Louise Wilson

## Galería Juana de Aizpuru

**Stand Number B15**
Tel +34 91 310 55 61

Barquillo 44
Madrid 28004
Spain
Tel +34 91 310 55 61
aizpuru@juanadeaizpuru.es
www.juanadeaizpuru.es

**Contact**
Juana de Aizpuru

**Artists**
Art & Language
Elena Asins
Mirosław Bałka
Eric Baudelaire
Tania Bruguera
Jean-Marc Bustamante
Pedro Cabrita Reis
Luis Claramunt
Jordi Colomer
Alicia Framis
Philipp Fröhlich
Sandra Gamarra
Carmela García
Dora García
Alberto García Alix
Cristina García Rodero
Pierre Gonnord
Georg Herold
Rogelio López Cuenca
Cristina Lucas
Yasumasa Morimura
Markus Oehlen
Tim Parchikov
Fernando Sánchez Castillo
Andres Serrano
Montserrat Soto
Wolfgang Tillmans
Franz West
Heimo Zobernig

## Allied Editions

**Stand Number J13**
A consortium of 7 public
galleries

c/o Whitechapel Gallery
77–82 Whitechapel High
Street
London E1 7QX
United Kingdom
Tel + 44 20 7522 7882

**Participating Gallery
Contacts**
Camden Arts Centre
(Jacqueline Jeffries)
Chisenhale Gallery
(Isabelle Hancock)
Institute of Contemporary
Arts (Ruta Radusyte)
Serpentine Gallery
(Tom Harrisson)
South London Gallery
(Anna Gritz)
Studio Voltaire
(Emily Marsh)
Whitechapel Gallery
(Johanna Melvin)

**Artists**
Marina Abramović
Paweł Althamer
Ed Atkins
Becky Beasley
Duncan Campbell
Ernst Caramelle
Marvin Gaye Chetwynd
Moyra Davey
Ed Fornieles
Mark Leckey
Camille Henrot
Ian Kiaer
Ella Kruglyanskaya
Glenn Ligon
Shinro Ohtake
Laure Prouvost
Smiljan Radić
Richard Sides
Juergen Teller
Richard Tuttle
Lawrence Weiner

## Galería Helga de Alvear

**Stand Number A12**
Tel +34 606 761 169

Doctor Fourquet 12
Madrid 28012
Spain
Tel +34 91 468 05 06
galeria@helgadealvear.com
www.helgadealvear.com

**Contact**
Helga de Alvear
Violeta Janeiro
Alberto Gallardo

**Artists**
Helena Almeida
Slater Bradley
José Pedro Croft
Ángela de la Cruz
Marcel Dzama
Michael Elmgreen & Ingar
Dragset
Jorge Galindo
Katharina Grosse
Axel Hütte
Prudencio Irazabal
Isaac Julien
Jürgen Klauke
Thomas Locher
Dan Perjovschi
Ana Prada
Thomas Ruff
Adrian Sauer
Santiago Sierra
D.J. Simpson
Ettore Spalletti
Jane & Louise Wilson

## Ancient & Modern

**Stand Number G4**
Tel +44 20 7253 4550

201 Whitecross Street
London EC1Y 8QP
United Kingdom
Tel +44 20 7253 4550
mail@
ancientandmodern.org
www.
ancientandmodern.org

**Contact**
Bruce Haines
Julia Dziumla

**Artists**
Ketuta Alexi-Meskhishvili
Eva Berendes
Tim Braden
Matthias Dornfeld
Volker Eichelmann
Jane England
Luke Gottelier
Raphael Hefti
Des Hughes
Paul Johnson
Alan Kane
Markus Karstiess
Jan Pleitner
Rudolf Polanszky
The Estate of Norbert
Prangenberg
Audrey Reynolds

# Gallery Index

## Christian Andersen

**Stand Number H14**
Tel +45 25 37 41 01

Høkerboderne 17–19
Copenhagen 1712
Denmark
Tel +45 33 25 41 01
info@christianandersen.net
www.christianandersen.net

**Contact**
Christian Andersen

**Artists**
Benjamin Bernt
Julia Haller
Lasse Schmidt Hansen
Benjamin Hirte
Tom Humphreys
Till Megerle
Rolf Nowotny
Morten Skrøder Lund
Astrid Svangren
Lina Viste Grønli

## The Approach

**Stand Number E1**
Tel +44 20 8983 3878

1st Floor, 47 Approach Road
London E2 9LY
United Kingdom
Tel +44 20 8983 3878
info@theapproach.co.uk
www.theapproach.co.uk

**Contact**
Jake Miller
Emma Robertson
Mary Cork

**Artists**
Phillip Allen
Helene Appel
Cris Brodahl
Heidi Bucher
Sophie Bueno-Boutellier
Alice Channer
Stuart Cumberland
Peter Davies
Patrick Hill
Evan Holloway
Germaine Kruip
Rezi van Lankveld
Jack Lavender
Edward Lipski
Dave Muller
Lisa Oppenheim
Magali Reus
Amanda Ross-Ho
John Stezaker
Evren Tekinoktay
Sara VanDerBeek
Gary Webb
Sam Windett

## Arcade

**Stand Number J9**
Tel +44 20 7608 0428

87 Lever Street
London EC1V 3RA
United Kingdom
Tel +44 20 7608 0428
info@arcadefinearts.com
www.arcadefinearts.com

**Contact**
Christian Mooney
Isabel Parada Cano-Lasso

**Artists**
Caroline Achaintre
Can Altay
Anna Barham
Luca Bertolo
Jeremiah Day
John Finneran
John Wallbank
Maria Zahle

## Laura Bartlett Gallery

**Stand Number H3**
Tel +44 7771 803 606

4 Herald Street
London E2 6JT
United Kingdom
Tel +44 20 3487 0507
info@
laurabartlettgallery.com
www.
laurabartlettgallery.com

10 Northington Street
London WC1N 2JG
United Kingdom

**Contact**
Laura Bartlett
Madeleine Martin
Katharina Worf

**Artists**
Becky Beasley
Nina Beier
Sol Calero
John Divola
Simon Dybroe Møller
Harrell Fletcher
Cyprien Gaillard
Beatrice Gibson
Lydia Gifford
Ian Law
Marie Lund
Elizabeth McAlpine
Alex Olson
Martin Skauen

## Galerie Catherine Bastide

**Stand Number C15**
Tel +32 2 646 29 71

67 rue de la Régence
Regentschapstraaf 67
Brussels 1000
Belgium
Tel +32 2 646 29 71
info@catherinebastide.com
www.catherinebastide.com

**Contact**
Catherine Bastide
Nathalie Levi
Cedric Alby

**Artists**
Jacques André
Marie Angeletti
Sarah Crowner
Sebastian Diaz Morales
Jean-Pascal Flavien
Geert Goiris
William Pope.L
Ola Rindal
Josh Smith
Valerie Snobeck
Catherine Sullivan
Janaina Tschäpe
Kelley Walker

## Galería Elba Benítez

**Stand Number H6**
Tel +34 91 308 04 68

Calle San Lorenzo 11
Madrid 28004
Spain
Tel +34 91 308 04 68
info@elbabenitez.com
www.elbabenitez.com

**Contact**
Elba Benítez
Gregoria Prior

**Artists**
Ignasi Aballí
Armando Andrade Tudela
Miriam Bäckström
Carlos Bunga
Cabello/Carceller
Juan Cruz
Gintaras Didžiapetris
Fernanda Fragateiro
Hreinn Friðfinnsson
Carlos Garaicoa
David Goldblatt
Cristina Iglesias
Vik Muniz
Ernesto Neto
Francisco Ruiz de Infante
Francesc Torres

## Blum & Poe

**Stand Number A3**
Tel +1 310 836 2062

2727 South La Cienega
Boulevard
Los Angeles CA 90034
United States
Tel +1 310 836 2062
info@blumandpoe.com
www.blumandpoe.com

**Contact**
Tim Blum
Jeff Poe
Matt Bangser
Kimberly Chang Mathieu
Michael Smoler
Sarvia Jasso

**Artists**
Chiho Aoshima
Karel Appel
J.B. Blunk
Slater Bradley
Chuck Close
Nigel Cooke
Carroll Dunham
Sam Durant
Kōji Enokura
Anya Gallaccio
Mark Grotjahn
Tim Hawkinson
Drew Heitzler
Julian Hoeber
Matt Johnson
Gavin Kenyon
Susumu Koshimizu
Friedrich Kunath
Shio Kusaka
Lee Ufan
Linder
Sharon Lockhart
Florian Maier-Aichen
Victor Man
Dave Muller
Takashi Murakami
Yoshitomo Nara
Matt Saunders
Hugh Scott-Douglas
Nobuo Sekine
Jim Shaw
Dirk Skreber
Penny Slinger
Kishio Suga
Henry Taylor
Keith Tyson
Chris Vasell
Michael Wilkinson
Zhang Huan
Zhu Jinshi

## Marianne Boesky Gallery

**Stand Number B14**
Tel +1 212 680 9889

509 West 24th Street
New York NY 10011
United States
Tel +1 212 680 9889
info@
marianneboeskygallery.com
www.marianneboesky
gallery.com

**Contact**
Marianne Boesky
Adrian Turner
Serra Pradhan
Ricky Manne

**Artists**
Diana Al-Hadid
Andisheh Avini
Hannah van Bart
Sue de Beer
Matthias Bitzer
Pier Paolo Calzolari
Julia Dault
Svenja Deininiger
Robert Elfgen
Rachel Feinstein
Barnaby Furnas
Melissa Gordon
Jay Heikes
Adam Helms
Yuichi Higashionna
Jessica Jackson Hutchins
Donald Moffett
Serge Alain Nitegeka
William O'Brien
Jacco Olivier
Hans Op de Beeck
Roxy Paine
Anthony Pearson
Thiago Rocha Pitta
Salvatore Scarpitta
Mindy Shapero
Kon Trubkovich
John Waters
Claudia Wieser

## Tanya Bonakdar Gallery

**Stand Number E7**
Tel +1 917 783 5849

521 West 21st Street
New York NY 10011
United States
Tel +1 212 414 4144
mail@tanyabonakdar
gallery.com
www.tanyabonakdar
gallery.com

**Contact**
Tanya Bonakdar
Ethan Sklar
Claire Pauley McPherson
Renee Coppola
Emily Ruotolo

**Artists**
Uta Barth
Martin Boyce
Sandra Cinto
Phil Collins
Mat Collishaw
Mark Dion
Olafur Eliasson
Meschac Gaba
Siobhán Hapaska
Sabine Hornig
Teresa Hubbard &
Alexander Birchler
Carla Klein
Agnieszka Kurant
Liz Larner
Charles Long
Rita Lundqvist
Mark Manders
Jason Meadows
Ernesto Neto
Rivane Neuenschwander
Susan Philipsz
Peggy Preheim
Analia Saban
Tomás Saraceno
Thomas Scheibitz
Hannah Starkey
Haim Steinbach
Dirk Stewen
Jack Strange
Sarah Sze
Neal Tait
Jeffrey Vallance
Gillian Wearing
Nicole Wermers
Michael Wilkinson

# Gallery Index

## The Box

**Stand Number G3**
Tel +1 213 625 1747

805 Traction Avenue
Los Angeles CA 90013
United States
Tel +1 213 625 1747
info@theboxla.com
www.theboxla.com

**Contact**
Mara McCarthy
Jackie Tarquinio
Jason Underhill
Christine Varney

**Artists**
John Altoon
Judith Bernstein
Julien Bismuth
Mike Bouchet
Sarah Conaway
Simone Forti
Wally Hedrick
Leigh Ledare
Los Angeles Free Music
Society
Los Angeles Poverty
Department
Robert Mallary
No!Art (Boris Lurie, Stanley
Fisher, Sam Goodman)
Barbara T. Smith
Stan Vanderbeek
Wolf Vostell

## BQ

**Stand Number D9**
Tel +49 17 2787 9551

Weydingerstrasse 10
Berlin 10178
Germany
Tel +49 30 2345 7316
info@bqberlin.de
www.bqberlin.de

**Contact**
Jörn Bötnagel
Yvonne Quirmbach

**Artists**
Dirk Bell
Alexandra Bircken
Carina Brandes
Matti Braun
Owen Gump
Andrew Kerr
Ferdinand Kriwet
Friedrich Kunath
Ruth Nemet
Bojan Šarčević
David Shrigley
Marcus Steinweg
Reinhard Voigt
Richard Wright

## Gavin Brown's enterprise

**Stand Number F9**
Tel +1 917 477 9554

620 Greenwich Street
New York NY 10014
United States
Tel +1 212 627 5258
gallery@gavinbrown.biz
www.gavinbrown.biz

**Contact**
Gavin Brown

**Artists**
Franz Ackermann
James Angus
Uri Aran
Ed Atkins
Thomas Bayrle
Dirk Bell
Jennifer Bornstein
Joe Bradley
Kerstin Brätsch
Martin Creed
Verne Dawson
Jeremy Deller
Peter Doig
Urs Fischer
Dara Friedman
Mark Handforth
Jonathan Horowitz
Alex Israel
Joan Jonas
Alex Katz
Christopher Knowles
Udomsak Krisanamis
Ella Kruglyanskaya
Mark Leckey
Bjarne Melgaard
Silke Otto-Knapp
Laura Owens
Oliver Payne
Steven Pippin
Rob Pruitt
Nick Relph
Steven Shearer
Frances Stark
Sturtevant
Spencer Sweeney
Rirkrit Tiravanija

## Galerie Buchholz

**Stand Number C10**
Tel +49 17 0430 0153

Neven-DuMont-Strasse 17
Cologne 50667
Germany
Tel +49 221 257 4946
post@galeriebuchholz.de
www.galeriebuchholz.de

**Contact**
Daniel Buchholz
Christopher Müller

**Artists**
Tomma Abts
Lutz Bacher
Nairy Baghramian
Cosima von Bonin
Tony Conrad
Simon Denny
Liz Deschenes
Lukas Duwenhögger
Thomas Eggerer
Loretta Fahrenholz
Vincent Fecteau
Morgan Fisher
Isa Genzken
Jack Goldstein
Julian Göthe
Richard Hawkins
Cameron Jamie
John Kelsey
Jochen Klein
Jutta Koether
Michael Krebber
Mark Leckey
Sam Lewitt
Lucy McKenzie
Henrik Olesen
Paulina Olowska
Silke Otto-Knapp
Mathias Poledna
Florian Pumhösl
R.H. Quaytman
Jeroen de Rijke & Willem de
Rooij
Willem de Rooij
Frances Stark
Josef Strau
Stefan Thater
Cheyney Thompson
Wolfgang Tillmans
Stewart Uoo
Danh Võ
Martin Wong
Katharina Wulff
Cerith Wyn Evans

## Bureau

**Stand Number G14**
Tel +1 212 227 2783

178 Norfolk Street
New York NY 10002
United States
Tel +1 212 227 2783
office@bureau-inc.com
www.bureau-inc.com

**Contact**
Gabrielle Giattino
Maliea Croy

**Artists**
Erica Baum
Ellie Ga
Vivienne Griffin
Tom Holmes
Jaya Howey
Matt Hoyt
Viktor Kopp
Lionel Maunz
Christine Rebet
Julia Rommel

## Cabinet

**Stand Number F4**
Tel +44 7711 066 935

49–59 Old Street
London EC1V 9HX
United Kingdom
Tel +44 20 7251 6114
art@cabinetltd.demon.co.uk
www.cabinet.uk.com

**Contact**
Martin McGeown
Andrew Wheatley
Freddie Checketts

**Artists**
David Antin
Atelier
Ed Atkins
Lutz Bacher
Bernadette Corporation
Anna Blessmann & Peter
Saville
Bonnie Camplin
Gillian Carnegie
Marc Camille Chaimowicz
Jay Chung & Q Takeki
Maeda
Lukas Duwenhögger
Jana Euler
Cosey Fanni Tutti
Julian Göthe
Richard Kern
Pierre Klossowski
John Knight
Mark Leckey
Danny McDonald
Lucy McKenzie
Jim Nutt
Henrik Olesen
James Richards
Lily van der Stokker
Anthony Symonds
Simon Thompson
Tris Vonna-Michell
JD Williams
David Wojnarowicz

## Callicoon Fine Arts

**Stand Number J11**
Tel +1 212 219 0326

49 Delancey Street
New York NY 10002
United States
Tel +1 212 219 0326
info@callicoonfinearts.com
www.callicoonfinearts.com

**Contact**
Photios Giovanis

**Artists**
Etel Adnan
Sadie Benning
Nicholas Buffon
A.K. Burns
Hervé Guibert
James Hoff
Thomas Kovachevich
Benjamin Kress
Ulrike Müller
Luther Price
Jason Simon

## Campoli Presti

**Stand Number B9**
Tel +44 20 7739 4632

223 Cambridge Heath Road
London E2 0EL
United Kingdom
Tel +44 20 7739 4632
info@campolipresti.com
www.campolipresti.com

**Contact**
Gil Presti
Emanuela Campoli
Cora Münnich

**Artists**
Liz Deschenes
Roe Ethridge
Jutta Koether
Daniel Lefcourt
Valentina Liernur
Jason Loebs
Scott Lyall
Nick Mauss
Charles Mayton
John Miller
Olivier Mosset
Sean Paul
Pavel Pepperstein
Eileen Quinlan
Blake Rayne
Clément Rodzielski
Christoph Ruckhäberle
Nora Schultz
Amy Sillman
Reena Spaulings
Joanne Tatham & Tom
O'Sullivan
Cheyney Thompson

## Canada

**Stand Number J6**
Tel +1 212 925 4631

333 Broome Street
New York NY 10002
United States
Tel +1 212 925 4631
gallery@
canadanewyork.com
www.canadanewyork.com

**Contact**
Phil Grauer
Suzanne Butler

**Artists**
David Askevold
Katherine Bernhardt
Joe Bradley
Sarah Braman
Matt Connors
Jason Fox
Samara Golden
Xylor Jane
Lily Ludlow
Michael Mahalchick
Joanna Malinowska
Carrie Moyer
Luke Murphy
Elena Pankova
Robin Peck
Tyson Reeder
Anke Weyer
Wallace Whitney
Michael Williams

## Galerie Gisela Capitain

**Stand Number D10**
Tel +49 221 355 7010

St Apern Strasse 26
Cologne 50667
Germany
Tel +49 221 355 7010
info@galeriecapitain.de
www.galeriecapitain.de

**Contact**
Gisela Capitain
Regina Fiorito
Dorothee Sorge

**Artists**
Karla Black
Barbara Bloom
Maria Brunner
Gillian Carnegie
Günther Förg
Luke Fowler
Anna Gaskell
Wade Guyton
Uwe Henneken
Charline von Heyl
Margarete Jakschik
Rachel Khedoori
The Estate of Martin
Kippenberger
Zoe Leonard
Meuser
Marcel Odenbach
Laura Owens
Jorge Pardo
Ascan Pinckernelle
Seth Price
Stephen Prina
Sam Samore
Elfie Semotan
Richard Smith
Monika Sosnowska
John Stezaker
Kelley Walker
Franz West
Christopher Williams
Johannes Wohnseifer
Christopher Wool
Katsuhiro Yamaguchi

# Gallery Index

## Carlos/Ishikawa

**Stand Number G26**
Tel +44 20 7001 1744

Unit 4, 88 Mile End Road
London E1 4UN
United Kingdom
Tel +44 20 7001 1744
gallery@carlosishikawa.com
www.carlosishikawa.com

**Contact**
Vanessa Carlos

**Artists**
Marie Angeletti
Korakrit Arunanondchai
Steve Bishop
Ed Fornieles
Mary Hurrell
Lloyd Corporation
Oscar Murillo
Richard Sides
Pilvi Takala

## Casas Riegner

**Stand Number J5**
Tel +57 1249 9194

Calle 70A No.7–41
Bogotá
Colombia
Tel +57 1249 9194
info@casasriegner.com
www.casasriegner.com

**Contact**
Catalina Casas
Paula Bossa
Felipe Villada

**Artists**
Johanna Calle
Leyla Cárdenas
María Fernanda Cardoso
Antonio Caro
María Teresa Hincapié
Mateo López
Bernardo Ortiz
Maria Fernanda Plata
Alex Rodríguez
Miguel Ángel Rojas
Luis Roldán
Liliana Sánchez
Rosemberg Sandoval
Gabriel Sierra
Wilger Sotelo
José Antonio Suárez
Londoño
Angélica Teuta
Icaro Zorbar

## Clifton Benevento

**Stand Number J7**
Tel +1 718 844 3109

515 Broadway
New York NY 10012
United States
Tel +1 212 431 6325
info@cliftonbenevento.com
www.cliftonbenevento.com

**Contact**
Michael Clifton
Michael Benevento
Silke Lindner

**Artists**
Polly Apfelbaum
Gina Beavers
Paul Cowan
Zak Kitnick
D'Ette Nogle
Michael E. Smith
Martin Soto Climent
Wu Tsang
Miller Updegraff

## Sadie Coles HQ

**Stand Number D2**
Tel +44 20 7493 8611

62 Kingly Street
London W1B 5QN
United Kingdom
Tel +44 20 7493 8611
info@sadiecoles.com
www.sadiecoles.com

69 South Audley Street
London W1K 2QZ
United Kingdom

**Contact**
Sadie Coles
Pauline Daly
Lieselotte Seaton
Laura Lord

**Artists**
Michele Abeles
Carl Andre
Uri Aran
Darren Bader
Matthew Barney
Dirk Bell
Avner Ben-Gal
Frank Benson
John Bock
Don Brown
Marvin Gaye Chetwynd
Steven Claydon
William N. Copley
Adriano Costa
John Currin
Sam Durant
Shannon Ebner
Angus Fairhurst
Urs Fischer
Florian Hecker
Georg Herold
Jonathan Horowitz
David Korty
Gabriel Kuri
Jim Lambie
Hilary Lloyd
Sarah Lucas
Helen Marten
Victoria Morton
Laura Owens
Simon Periton
Raymond Pettibon
Elizabeth Peyton
Richard Prince
Ugo Rondinone
Wilhelm Sasnal
Gregor Schneider
Daniel Sinsel
Andreas Slominski
Christiana Soulou
Rudolf Stingel
Ryan Sullivan
Nicola Tyson
Paloma Varga Weisz
TJ Wilcox
Jordan Wolfson
Andrea Zittel

## Contemporary Fine Arts

**Stand Number F6**
Tel +49 30 288 7870

Am Kupfergraben 10
Berlin 10117
Germany
Tel +49 30 288 7870
gallery@cfa-berlin.de
www.cfa-berlin.de

**Contact**
Bruno Brunnet
Nicole Hackert
Philipp Haverkampf

**Artists**
Markus Bacher
Georg Baselitz
Avner Ben-Gal
Peter Böhnisch
Marc Brandenburg
Cecily Brown
Bruce High Quality
Foundation
Borden Capalino
Peter Doig
Max Frisinger
Georg Herold
Thomas Kiesewetter
Michael Kunze
Sarah Lucas
Chris Ofili
Raymond Pettibon
Walter Pichler
Tal R
Anselm Reyle
Daniel Richter
Christian Rosa
Julian Schnabel
Dana Schutz
Norbert Schwontkowski
Dash Snow
Katja Strunz
Gert & Uwe Tobias

## Pilar Corrias

**Stand Number B19**
Tel +44 20 7323 7000

54 Eastcastle Street
London W1W 8EF
United Kingdom
Tel +44 20 7323 7000
sales@pilarcorrias.com
www.pilarcorrias.com

**Contact**
Pilar Corrias

**Artists**
Charles Avery
Ulla von Brandenburg
Keren Cytter
Koo Jeong A
Leigh Ledare
Tala Madani
Sabine Moritz
Elizabeth Neel
Ken Okiishi
Philippe Parreno
Mary Ramsden
Tobias Rehberger
Mary Reid Kelley
Julião Sarmento
Shahzia Sikander
John Skoog
Alice Theobald
Rirkrit Tiravanija
Tunga

## Corvi-Mora

**Stand Number C13**
Tel +44 20 7840 9111

1A Kempsford Road
London SE11 4NU
United Kingdom
Tel +44 20 7840 9111
info@corvi-mora.com
www.corvi-mora.com

**Contact**
Tommaso Corvi-Mora
Tabitha Mackness
James Halliwell

**Artists**
Abel Auer
Brian Calvin
Pierpaolo Campanini
Anne Collier
Rachel Feinstein
Dee Ferris
Dominique Gonzalez-
Foerster
Richard Hawkins
Roger Hiorns
Jim Isermann
Colter Jacobsen
Dorota Jurczak
Aisha Khalid
David Lieske
Jennifer Packer
Imran Qureshi
Glenn Sorensen
Julian Stair
Tomoaki Suzuki
Naoyuki Tsuji
Lynette Yiadom-Boakye

## Galerie Chantal Crousel

**Stand Number F11**
Tel +33 1 42 77 38 87

10 rue Charlot
Paris 75003
France
Tel +33 1 42 77 38 87
galerie@crousel.com
www.crousel.com

**Contact**
Chantal Crousel
Niklas Svennung
Jeremy Dessaint

**Artists**
Jennifer Allora & Guillermo
Calzadilla
Fikret Atay
Tarek Atoui
Abraham Cruzvillegas
David Douard
Isa Genzken
Wade Guyton
Fabrice Gygi
Mona Hatoum
Thomas Hirschhorn
Pierre Huyghe
Hassan Khan
Michael Krebber
Jean-Luc Moulène
Moshe Ninio
Melik Ohanian
Gabriel Orozco
Seth Price
Clément Rodzielski
Tim Rollins and K.O.S.
Willem de Rooij
Anri Sala
Alain Séchas
José Maria Sicilia
Sean Snyder
Reena Spaulings
Wolfgang Tillmans
Rirkrit Tiravanija
Danh Võ
Wang Bing
Haegue Yang
Heimo Zobernig

## Croy Nielsen

**Stand Number G16**
Tel +49 30 6807 7976

Weydingerstrasse 10
Berlin 10178
Germany
Tel +49 30 6807 7976
info@croynielsen.de
www.croynielsen.de

**Contact**
Oliver Croy
Henrikke Nielsen

**Artists**
Martin Erik Andersen
Nina Beier
Andy Boot
Jacob Dahl Jürgensen
Thomas Kratz
Marie Lund
Benoît Maire
Marlie Mul
Joshua Petherick
Mandla Reuter
Roman Schramm
Ben Schumacher
Hugh Scott-Douglas

## Thomas Dane Gallery

**Stand Number E6**
Tel +44 20 7925 2505

11 Duke Street St James's
London SW1Y 6BN
United Kingdom
Tel +44 20 7925 2505
info@
thomasdanegallery.com
www.thomasdane
gallery.com

**Contact**
Thomas Dane
François Chantala
Tom Dingle
Elli Resvanis

**Artists**
Hurvin Anderson
Lynda Benglis
Walead Beshty
Abraham Cruzvillegas
Alexandre da Cunha
José Damasceno
Michel François
Anya Gallaccio
John Gerrard
Arturo Herrera
Phillip King
Luisa Lambri
Michael Landy
Glenn Ligon
Steve McQueen
Jean-Luc Moulène
Paul Pfeiffer
Lari Pittman
Amy Sillman
Caragh Thuring
Kelley Walker
Akram Zaatari

# Gallery Index

## Massimo De Carlo

**Stand Number B1**
Tel +39 02 70003987

Via Giovanni Ventura 5
Milan 20134
Italy
Tel +39 02 70003987
milano@massimo
decarlo.com
www.massimodecarlo.com

55 South Audley Street
London W1K 2QH
United Kingdom

**Contact**
Massimo De Carlo
Ludovica Barbieri
Roberto Moiraghi

**Artists**
John Armleder
Massimo Bartolini
Sanford Biggers
Maurizio Cattelan
Marvin Gaye Chetwynd
Steven Claydon
Dan Colen
George Condo
Michael Elmgreen & Ingar
Dragset
Roland Flexner
Gelitin
Thomas Grunfeld
Carsten Höller
Christian Holstad
Rashid Johnson
Elad Lassry
Tony Lewis
Sol LeWitt
Liu Xiaodong
Nate Lowman
Matthew Monahan
Olivier Mosset
Matt Mullican
Steven Parrino
Diego Perrone
Paola Pivi
Rob Pruitt
Jim Shaw
Josh Smith
Rudolf Stingel
Piotr Uklanski
Kaari Upson
Andra Ursuta
Kelley Walker
Yan Pei-Ming
Aaron Young
Andrea Zittel

## dépendance

**Stand Number G17**
Tel +32 4 8450 68 99

4–8 rue du Marché aux Porcs
Brussels BE-1000
Belgium
Tel +32 2 217 74 00
info@dependance.be
www.dependance.be

**Contact**
Michael Callies
Ayelet Yanai

**Artists**
Richard Aldrich
Thomas Bayrle
Will Benedict
Merlin Carpenter
Michaela Eichwald
Jana Euler
Christian Flamm
Olivier Foulon
Manuel Gnam
Thilo Heinzmann
Karl Holmqvist
Sergej Jensen
Michael Krebber
Linder
Michaela Meise
Henrik Olesen
Benjamin Saurer
Nora Schultz
Hanna Schwarz
Lucie Stahl
Josef Strau
Oscar Tuazon
Peter Wächtler
Haegue Yang

## Galerie Eigen + Art

**Stand Number A11**
Tel +49 30 280 6605

Auguststrasse 26
Berlin 10117
Germany
Tel +49 30 280 6605
berlin@eigen-art.com
www.eigen-art.com

**Contact**
Gerd Harry Lybke

**Artists**
Ákos Birkás
Birgit Brenner
Marc Desgrandchamps
Martin Eder
Tim Eitel
Nina Fischer & Maroan
el Sani
Stella Hamberg
Jörg Herold
Christine Hill
Uwe Kowski
Melora Kuhn
Rémy Markowitsch
Maix Mayer
Ryan Mosley
Carsten Nicolai
Olaf Nicolai
Neo Rauch
Ricarda Roggan
Yehudit Sasportas
David Schnell
Despina Stokou
Annelies Štrba

## Essex Street

**Stand Number H12**
Tel +1 917 263 1001

114 Eldridge Street
New York NY 10002
United States
Tel +1 917 263 1001
info@essexstreet.biz
www.essexstreet.biz

**Contact**
Maxwell Graham
Neal Curley

**Artists**
Vern Blosum
Caleb Considine
Peter Fend
Jason Loebs
Fred Lonidier
Park McArthur
Chadwick Rantanen
Cameron Rowland
Valerie Snobeck

## Experimenter

**Stand Number G22**
Tel +91 332 4630465

2/1 Hindusthan Road
Kolkata
West Bengal 700029
India
Tel +91 332 4630465
info@experimenter.in
www.experimenter.in

**Contact**
Prateek Raja
Priyanka Raja

**Artists**
Bani Abidi
Rathin Barman
CAMP
Adip Dutta
Sanchayan Ghosh
Nadia Kaabi-Linke
Naeem Mohaiemen
Mehreen Murtaza
Prabhakar Pachpute
Raqs Media Collective
Ayesha Sultana
Hajra Waheed

## Konrad Fischer Galerie

**Stand Number A9**
Tel +49 177 356 1826

Platanenstrasse 7
Dusseldorf 40233
Germany
Tel +49 21 168 5908
office@konradfischer
galerie.de
www.konradfischer
galerie.de

**Contact**
Dorothee Fischer
Claudia Pasko
Thomas Rieger
Ulla Wiegand
Petra Lehmkuhl

**Artists**
Carl Andre
Giovanni Anselmo
Bernd and Hilla Becher
Guy Ben-Ner
Marcel Broodthaers
Stanley Brouwn
Matthew Buckingham
Peter Buggenhout
Daniel Buren
Nina Canell
Alan Charlton
Tony Cragg
Ilse D'Hollander
Hanne Darboven
Jan Dibbets
Hans-Peter Feldmann
Gilbert & George
Sofia Hultén
Cristina Iglesias
Zon Ito
On Kawara
Harald Klingelhöller
Jannis Kounellis
Melissa Kretschmer
Wolfgang Laib
Jim Lambie
Sol LeWitt
Richard Long
Robert Mangold
Rita McBride
Mario Merz
Bruce Nauman
Max Neuhaus
Claes Oldenburg
Giuseppe Penone
Manfred Pernice
Magnus Plessen
Wolfgang Plöger
Charlotte Posenenske
Thomas Ruff
Robert Ryman
Gregor Schneider
Thomas Schütte
Juergen Staack
Yuji Takeoka
Tatjana Valsang
Paloma Varga Weisz
Johannes Wald
Lawrence Weiner
Petra Wunderlich
Jerry Zeniuk

## Fluxia

**Stand Number H16**
Tel +39 02 21711913

Via Giovanni Ventura 6
Milan 20134
Italy
Tel +39 02 21711913
info@fluxiagallery.com
www.fluxiagallery.com

**Contact**
Angelica Bazzana
Valentina Suma

**Artists**
Alfred Boman
Olivia Erlanger
Luca Francesconi
Marlie Mul
Andrea Romano
Timur Si-Qin
Andrea de Stefani
Benjamin Valenza

## Foksal Gallery Foundation

**Stand Number F5**
Tel +48 228 265 081

Górskiego 1A
Warsaw 00-033
Poland
Tel +48 228 265 081
mail@fgf.com.pl
www.fgf.com.pl

**Contact**
Andrzej Przywara
Joanna Diem

**Artists**
Paweł Althamer
Cezary Bodzianowski
Piotr Janas
Katarzyna Józefowicz
Edward Krasiński
Robert Kuśmirowski
Anna Molska
Anna Niesterowicz
Paulina Ołowska
Wilhelm Sasnal
Monika Sosnowska
Jakub Julian Ziółkowski
Artur Żmijewski

## Fonti

**Stand Number G19**
Tel +39 8 1411409

Via Chiaia 229
Naples 80132
Italy
Tel +39 8 1411409
info@galleriafonti.it
www.galleriafonti.it

**Contact**
Giangi Fonti

**Artists**
Michel Auder
Marc Camille Chaimowicz
Marieta Chirulescu
Peter Coffin
Christian Flamm
Nicola Gobbetto
Piero Golia
Delia Gonzalez
Delia Gonzalez & Gavin Russom
Kiluanji Kia Henda
Daniel Knorr
Fabian Marti
Birgit Megerle
Seb Patane
Manfred Pernice
Giulia Piscitelli
Gavin Russom
Lorenzo Scotto di Luzio
Eric Wesley

# Gallery Index

## Galeria Fortes Vilaça

**Stand Number D5**
Tel +55 11 9999 96257

Rua Fradique Coutinho 1500
São Paulo 05416-001
Brazil
Tel +55 11 3032 7066
galeria@fortesvilaca.com.br
www.fortesvilaca.com.br

Rua James Holland 71
São Paulo 01138-000
Brazil

**Contact**
Márcia Fortes
Alessandra D'Aloia
Alexandre Gabriel

**Artists**
Franz Ackermann
Efrain Almeida
Armando Andrade Tudela
Barrão
Carlos Bevilacqua
Tiago Carneiro da Cunha
Los Carpinteros
Rodrigo Cass
Leda Catunda
José Damasceno
Iran do Espírito Santo
Tamar Guimarães
João Maria Gusmão &
Pedro Paiva
Marine Hugonnier
Sergej Jensen
Agnieszka Kurant
Lucia Laguna
Jac Leirner
Cristiano Lenhardt
Gabriel Lima
Ivens Machado
Rodrigo Matheus
Beatriz Milhazes
Gerben Mulder
Ernesto Neto
Rivane Neuenschwander
Damián Ortega
OSGEMEOS
Sara Ramo
Nuno Ramos
Mauro Restiffe
Marina Rheingantz
Michael Sailstorfer
Julião Sarmento
Valeska Soares
Janaina Tschäpe
Adriana Varejão
Erika Verzutti
Cerith Wyn Evans
Luiz Zerbini

## Marc Foxx Gallery

**Stand Number B10**
Tel +1 323 857 5571

6150 Wilshire Boulevard
Los Angeles CA 90048
United States
Tel +1 323 857 5571
gallery@marcfoxx.com
www.marcfoxx.com

**Contact**
Marc Foxx
Rodney Nonaka-Hill
Katie Tilford
Rachel Trask

**Artists**
Leonor Antunes
Cris Brodahl
Anne Collier
Andy Collins
William Daniels
Stef Driesen
Sophie von Hellermann
Roger Hiorns
Sanya Kantarovsky
Annette Kelm
Makiko Kudo
Luisa Lambri
Kris Martin
Jason Meadows
Carter Mull
David Musgrave
Michael van Ofen
Alessandro Pessoli
Amalia Pica
Matthew Ronay
Maaike Schoorel
Frances Stark
Hiroshi Sugito
Mateo Tannatt
Guido van der Werve
Jennifer West
Sam Windett

## Carl Freedman Gallery

**Stand Number G5**
Tel +44 20 7684 8890

29 Charlotte Road
London EC2A 3PB
United Kingdom
Tel +44 20 7684 8890
info@carlfreedman.com
www.carlfreedman.com

**Contact**
Carl Freedman
Robert Diament
Kathryn Braganza

**Artists**
Nel Aerts
Armando Andrade Tudela
Billy Childish
Edith Dekyndt
Jess Flood-Paddock
Michael Fullerton
Thilo Heinzmann
John McAllister
Ivan Seal
David Brian Smith
Fergal Stapleton
Catherine Story
Pieter Vermeersch

## Freedman Fitzpatrick

**Stand Number H17**
Tel +1 323 723 2785

6051 Hollywood
Boulevard #107
Los Angeles CA 90028
United States
Tel +1 323 723 2785
ff@freedmanfitzpatrick.com
www.
freedmanfitzpatrick.com

**Contact**
Robbie Fitzpatrick
Alex Freedman

**Artists**
Mathis Altmann
Vittorio Brodmann
Matthew Lutz-Kinoy
Tobias Madison
Shimabuku
Lucie Stahl
Hannah Weinberger
Amelie von Wulffen

## Freymond-Guth Fine Arts

**Stand Number G18**
Tel +41 76 320 92 89

Limmatstrasse 270
Zurich 8005
Switzerland
Tel +41 44 240 04 81
office@freymondguth.com
www.freymondguth.com

**Contact**
Jean-Claude Freymond-Guth
Angela Weber

**Artists**
Marc Bauer
Heidi Bucher
Sophie Bueno-Boutellier
Dani Gal
Virginia Overton
Elodie Pong
Magali Reus
Tanja Roscic
Yorgos Sapountzis
Sylvia Sleigh
Loredana Sperini
Megan Francis Sullivan
Billy Sullivan

## Stephen Friedman Gallery

**Stand Number C7**
Tel +44 333 011 7051

25–28 Old Burlington Street
London W1S 3AN
United Kingdom
Tel +44 20 7494 1434
info@stephenfriedman.com
www.stephenfriedman.com

11 Old Burlington Street
London W1S 3AQ
United Kingdom

**Contact**
Stephen Friedman
David Hubbard
Ticiana Correa
Karon Hepburn

**Artists**
Mamma Andersson
Juan Araujo
Tonico Lemos Auad
Stephan Balkenhol
Claire Barclay
Huma Bhabha
Robert Buck
Melvin Edwards
Andreas Eriksson
Manuel Espinosa
Tom Friedman
Kendell Geers
Wayne Gonzales
Daniel Guzmán
Thomas Hirschhorn
Jim Hodges
Judith Lauand
Li Tianbing
Paul McDevitt
Beatriz Milhazes
Yoshitomo Nara
Rivane Neuenschwander
Thomas Nozkowski
Catherine Opie
Cornelius Quabeck
Ged Quinn
Jennifer Rubell
Lucas Samaras
Yinka Shonibare, MBE
David Shrigley
Jiro Takamatsu
Anne Truitt
Kehinde Wiley

## Frith Street Gallery

**Stand Number B4**
Tel +44 20 7494 1550

17–18 Golden Square
London W1F 9JJ
United Kingdom
Tel +44 20 7494 1550
info@frithstreetgallery.com
www.frithstreetgallery.com

**Contact**
Jane Hamlyn
Cornelia Behr
Ann Marie Peña

**Artists**
Chantal Akerman
Polly Apfelbaum
Fiona Banner
Anna Barriball
Massimo Bartolini
Ingrid Calame
Dorothy Cross
Tacita Dean
Marlene Dumas
Callum Innes
Jaki Irvine
Cornelia Parker
Raqs Media Collective
John Riddy
Thomas Schütte
Dayanita Singh
Bridget Smith
Fiona Tan
Juan Uslé
Daphne Wright

## Frutta

**Stand Number G24**
Tel +39 06 68210988

Via Giovanni Pascoli 21
Rome 00184
Italy
Tel +39 06 68210988
info@fruttagallery.com
www.fruttagallery.com

**Contact**
James Gardner

**Artists**
Gabriele De Santis
Ditte Gantriis
Jacopo Miliani
John Henry Newton
Alek O.
Oliver Osborne
Yonatan Vinitsky

## Gagosian Gallery

**Stand Number C3**
Tel +44 20 7841 9960

6–24 Britannia Street
London WC1X 9JD
United Kingdom
Tel +44 20 7841 9960
london@gagosian.com
www.gagosian.com

17–19 Davies Street
London W1K 3DE
United Kingdom

**Contact**
Larry Gagosian
Millicent Wilner

**Artists**
Kathryn Andrews
Richard Artschwager
Richard Avedon
Francis Bacon
Georg Baselitz
Jean-Michel Basquiat
Dike Blair
Cecily Brown
Glenn Brown
Chris Burden
Alexander Calder
Sir Anthony Caro
Victoire de Castellane
John Chamberlain
Dan Colen
Michael Craig-Martin
Gregory Crewdson
John Currin
Dexter Dalwood
Bob Dylan
William Eggleston
Tracey Emin
Roe Ethridge
Alberto di Fabio
Rachel Feinstein
Urs Fischer
Lucio Fontana
Helen Frankenthaler
Ellen Gallagher
Frank Gehry
Alberto Giacometti
Nan Goldin
Piero Golia
Douglas Gordon
Kim Gordon
Arshile Gorky
Mark Grotjahn
Andreas Gursky
Michael Heizer
Sir Howard Hodgkin
Carsten Höller
Dennis Hopper
Thomas Houseago
Tetsuya Ishida
Alex Israel
Neil Jenney
Y.Z. Kami
Mike Kelley
Anselm Kiefer
Karin Kneffel
Willem de Kooning
Jeff Koons
Harmony Korine
Inez van Lamsweerde &
Vinoodh Matadin
Roy Lichtenstein
Vera Lutter
Florian Maier-Aichen
Sally Mann
Piero Manzoni
Walter de Maria
Henry Moore
Joel Morrison
Takashi Murakami
Marc Newson
Paul Noble
Jean Nouvel
Albert Oehlen
Steven Parrino
Giuseppe Penone
Richard Phillips
Pablo Picasso
Richard Prince
Robert Rauschenberg
Anselm Reyle
Nancy Rubins
Thomas Ruff
Ed Ruscha
Jenny Saville
Richard Serra
Cindy Sherman
Elisa Sighicelli
Taryn Simon
David Smith
Rudolf Stingel
Hiroshi Sugimoto
Mark Tansey
Robert Therrien
Tatiana Trouvé
Cy Twombly
Piotr Uklański
Francesco Vezzoli
Edmund de Waal
Andy Warhol
Franz West
Rachel Whiteread
Richard Wright
Zeng Fanzhi

# Gallery Index

## gb agency

**Stand Number L6**
Tel +33 1 44 78 00 60

18 rue des 4 Fils
Paris 75003
France
Tel +33 1 44 78 00 60
gb@gbagency.fr
www.gbagency.fr

**Contact**
Solène Guillier
Nathalie Boutin
Eglantine Mercader

**Artists**
Mac Adams
Robert Breer
Elina Brotherus
Omer Fast
Ryan Gander
Mark Geffriaud
Július Koller
Jiří Kovanda
Deimantas Narkevičius
Roman Ondák
Dominique Petitgand
Pratchaya Phinthong
Pia Rönicke
Yann Sérandour
Hassan Sharif

## Annet Gelink Gallery

**Stand Number A20**
Tel +31 20 3302066

Laurierstraat 187–189
Amsterdam 1016
Netherlands
Tel +31 20 3302066
info@annetgelink.com
www.annetgelink.com

**Contact**
Annet Gelink
Floor Wullems

**Artists**
Yael Bartana
Keith Edmier
Ed van der Elsken
Alicia Framis
Anya Gallaccio
Ryan Gander
Roger Hiorns
Carla Klein
Meiro Koizumi
Erik van Lieshout
David Maljkovic
Dan McCarthy
Wilfredo Prieto
Muzi Quawson
Sarah van Sonsbeeck
Glenn Sorensen
Dick Verdult
Barbara Visser
Marijke van Warmerdam
Erik Wesselo

## A Gentil Carioca

**Stand Number G6**
Tel +55 21 2222 1651

Rua Gonçalves
Lêdo 17, sobrado
Rio de Janeiro 20060-020
Brazil
Tel +55 21 2222 1651
correio@
agentilcarioca.com.br
www.agentilcarioca.com.br

**Contact**
Marcio Botner
Laura Lima
Ernesto Neto
Cecilia Tanure

**Artists**
Ricardo Basbaum
José Bento
Botner & Pedro
Cabelo
Carlos Contente
Guga Ferraz
Fabiano Gonper
Maria Laet
Laura Lima
Jarbas Lopes
Renata Lucas
Evandro Machado
Matias Mesquita
Simone Michelin
João Modé
Paulo Nenflidio
Maria Nepomuceno
Helio Oiticica & Neville
d'Almeida
Opavivará!
Bernardo Ramalho
Thiago Rocha Pitta
Rodrigo Torres
Pedro Varela
Alexandre Vogler

## François Ghebaly Gallery

**Stand Number G12**
Tel +1 323 282 5187

2245 East Washington
Boulevard
Los Angeles CA 90021
United States
Tel +1 323 282 5187
info@ghebaly.com
www.ghebaly.com

**Contact**
François Ghebaly
Tyler Park
Karisa Morante

**Artists**
Davide Balula
Dan Bayles
Neïl Beloufa
Marius Bercea
Sayre Gomez
Channa Horwitz
Patrick Jackson
Mike Kuchar
Joel Kyack
Anthony Lepore
Candice Lin
Gina Osterloh
Andra Ursuta

## Goodman Gallery

**Stand Number H1**
Tel +27 11 788 1113

163 Jan Smuts Avenue
Johannesburg 2193
South Africa
Tel +27 11 788 1113
jhb@goodman-gallery.com
www.goodman-gallery.com

3rd Floor
Fairweather House
176 Sir Lowry Road
Cape Town 7915
South Africa

**Contact**
Liza Essers
Neil Dundas
Damon Garstang
Lara Koseff
Kirsty Wesson

**Artists**
Ghada Amer
Clive van den Berg
Willem Boshoff
Candice Breitz
Lisa Brice
Adam Broomberg
Carla Busuttil
Oliver Chanarin
Kudzanai Chiurai
Jabulani Dhlamini
Hasan & Husain Essop
Mounir Fatmi
Claire Gavronsky
Kendell Geers
David Goldblatt
Gabrielle Goliath
Frances Goodman
Haroon Gunn-Salie
Robert Hodgins
Alfredo Jaar
William Kentridge
David Koloane
Moshekwa Langa
Gerald Machona
Gerhard Marx
Kagiso Pat Mautloa
Brett Murray
Sam Nhlengethwa
Walter Oltmann
Stefanus Rademeyer
Thabiso Sekgala
Mikhael Subotzky
Hank Willis Thomas
Gavin Turk
Minnette Vári
Nontsikelelo Veleko
Diane Victor
Jeremy Wafer
Sue Williamson

# Marian Goodman Gallery

**Stand Number C8**
Tel +44 20 7099 0088

5–8 Lower John Street
London WIF 9HA
United Kingdom
Tel +44 20 7099 0088
goodman@marian
goodman.com
www.mariangoodman.com

24 West 57th Street
New York NY 10019
United States

79 rue de Temple
Paris 75003
France

**Contact**
Marian Goodman
Andrew Leslie
Roger Tatley
Courtney Plummer

**Artists**
Eija-Liisa Ahtila
Chantal Akerman
Giovanni Anselmo
John Baldessari
Lothar Baumgarten
Dara Birnbaum
Christian Boltanski
Marcel Broodthaers
Maurizio Cattelan
James Coleman
Tony Cragg
Richard Deacon
Tacita Dean
Rineke Dijkstra
David Goldblatt
Dan Graham
Pierre Huyghe
Cristina Iglesias
Amar Kanwar
William Kentridge
Steve McQueen
Julie Mehretu
Annette Messager
Juan Muñoz
Gabriel Orozco
Giulio Paolini
Giuseppe Penone
Gerhard Richter
Anri Sala
Matt Saunders
Tino Sehgal
Thomas Struth
Niele Toroni
Adrián Villar Rojas
Danh Võ
Jeff Wall
Lawrence Weiner
Francesca Woodman
Yang Fudong

# Green Tea Gallery

**Stand Number L3**
Tel +1 347 622 9904

4-9-17 Nakaoka
Iwaki Fukushima 974-8251
Japan
Tel +1 347 622 9904
greenteagalleryww@
gmail.com
www.greenteagallery
worldwide.com

**Contact**
Tomoo Arakawa
Ei Arakawa

**Artists**
Richard Aldrich
UB Androids
DAS INSTITUT
Nikolas Gambaroff
Lisa Jo
Jason Loebs
Tobias Madison
Gela Patashuri
Carissa Rodriguez
Sergei Tcherepnin
Stefan Tcherepnin
Hanna Törnudd
UNITED BROTHERS
Amy Yao

# Greene Naftali

**Stand Number C14**
Tel +1 212 463 7770

508 West 26th Street
New York NY 10001
United States
Tel +1 212 463 7770
info@
greenenaftaligallery.com
www.
greenenaftaligallery.com

**Contact**
Carol Greene
Vera Alemani
Jeffrey Rowledge
Alex Zachary

**Artists**
Lutz Bacher
Trisha Baga
Julie Becker
Bernadette Corporation
Paul Chan
Guy de Cointet
Tony Conrad
Jim Drain
Ida Ekblad
Harun Farocki
Günther Förg
Michael Fullerton
Gelitin
Daan van Golden
Dan Graham
Lucy Gunning
Guyton\Walker
Rachel Harrison
Richard Hawkins
Sophie von Hellermann
Jacqueline Humphries
John Knight
Joachim Koester
Michael Krebber
William Leavitt
Konrad Lueg
Helen Marten
Daniel Pflumm
Daniela Rossell
Allen Ruppersberg
Paul Sharits
Gedi Sibony
Michael Smith
Josef Strau
Katharina Wulff
Haegue Yang

# greengrassi

**Stand Number D3**
Tel +44 20 7840 9101

1A Kempsford Road
London SE11 4NU
United Kingdom
Tel +44 20 7840 9101
info@greengrassi.com
www.greengrassi.com

**Contact**
Cornelia Grassi
Maria A. Medina
Christian Baert
Davide Minuti

**Artists**
Tomma Abts
Stefano Arienti
Jennifer Bornstein
Moyra Davey
Roe Ethridge
Gretchen Faust
Vincent Fecteau
Giuseppe Gabellone
Joanne Greenbaum
Ellen Gronemeyer
Janice Kerbel
Shio Kusaka
Sean Landers
Simon Ling
Margherita Manzelli
David Musgrave
Kristin Oppenheim
Silke Otto-Knapp
Jennifer Pastor
Alessandro Pessoli
Karin Ruggaber
Allen Ruppersberg
Anne Ryan
Frances Stark
Jennifer Steinkamp
Pae White
Lisa Yuskavage

# Gallery Index

## Galerie Karin Guenther

**Stand Number J2**
Tel +49 17 0556 6994

Admiralitätstrasse 71
Hamburg 20459
Germany
Tel +49 40 3750 3450
info@
galerie-karin-guenther.de
www.
galerie-karin-guenther.de

**Contact**
Karin Guenther

**Artists**
Markus Amm
Michael Bauch
Henning Bohl
Wolfgang Breuer
Friederike Clever
Edith Dekyndt
Jeanne Faust
Berta Fischer
Ellen Gronemeyer
Michael Hakimi
Alexander Heim
Kerstin Kartscher
Janice Kerbel
Stefan Kern
Nina Könnemann
Stefan Marx
Michaela Melián
Claudia & Julia Müller
Silke Otto-Knapp
Harald Popp
Gunter Reski
Allen Ruppersberg
Torsten Slama
Dirk Stewen
Stefan Thater

## Dan Gunn

**Stand Number G27**
Tel +49 17 4246 7251

Schlesische Strasse 29
Berlin 10997
Germany
Tel +49 30 6920 6540
info@dangunn.de
www.dangunn.de

**Contact**
Dan Gunn

**Artists**
Alessio delli Castelli
Ingrid Furre
Adrià Julià
Musa paradisiaca
Alexandra Navratil
Tracey Rose
Michael Smith

## Hauser & Wirth

**Stand Number D6**
Tel +44 20 7287 2300

23 Savile Row
London W1S 2ET
United Kingdom
Tel +44 20 7287 2300
london@hauserwirth.com
www.hauserwirth.com

Durslade Farm
Dropping Lane, Bruton
Somerset BA10 0NL
United Kingdom

Limmatstrasse 270
Zürich 8005
Switzerland

32 East 69th Street
New York NY 10021
United States

511 West 18th Street
New York NY 10011
United States

**Contact**
Iwan & Manuela Wirth
Kate Smith

**Artists**
Rita Ackermann
Ida Applebroog
Phyllida Barlow
Louise Bourgeois
Mark Bradford
Berlinde de Bruyckere
Christoph Buchel
Martin Creed
Martin Eder
Ellen Gallagher
Isa Genzken
The Estate of Leon Golub
Dan Graham
Rodney Graham
Subodh Gupta
Mary Heilmann
The Estate of Eva Hesse
Andy Hope 1930
Roni Horn
Thomas Houseago
Pierre Huyghe
Matthew Day Jackson
Richard Jackson
Rashid Johnson
The Estate of Josephsohn
The Estate of Allan Kaprow
Rachel Khedoori
Bharti Kher
Guillermo Kuitca
Maria Lassnig
The Estate of Lee Lozano
Anna Maria Maiolino
Takesada Matsutani
Paul McCarthy
Joan Mitchell
Henry Moore Family
Collection
Ron Mueck
Caro Niederer
Christopher Orr
Djordje Ozbolt
Michael Raedecker
The Estate of Jason Rhoades
Pipilotti Rist
The Estate of Dieter Roth
Sterling Ruby
Anri Sala
Wilhelm Sasnal
The Estate of Mira Schendel
Christopher Schlingensief
Roman Signer
Anj Smith
Monika Sosnowska
Diana Thater
André Thomkins
The Estate of Philippe
Vandenberg
Ian Wallace
Mark Wallinger
Zhang Enli
David Zink Yi
Jakub Julian Ziółkowski

## Herald St

**Stand Number C2**
Tel +44 20 7168 2566

2 Herald Street
London E2 6JT
United Kingdom
Tel +44 20 7168 2566
mail@heraldst.com
www.heraldst.com

**Contact**
Nicky Verber
Ash L'ange
Naja Rantorp

**Artists**
Markus Amm
Alexandra Bircken
Josh Brand
Pablo Bronstein
Peter Coffin
Matt Connors
Matthew Darbyshire
Michael Dean
Ida Ekblad
Annette Kelm
Scott King
Cary Kwok
Christina Mackie
Djordje Ozbolt
Oliver Payne
Amalia Pica
Nick Relph
Tony Swain
Donald Urquhart
Klaus Weber
Nicole Wermers

## Galerie Max Hetzler

**Stand Number A10**
Tel +49 172 380 56 13

Bleibtreustrasse 45
Berlin 10623
Germany
Tel +49 30 3464 97850
info@maxhetzler.com
www.maxhetzler.com

Goethestrasse 2/3
Berlin 10623
Germany

57 rue du Temple
Paris 75004
France

**Contact**
Max Hetzler
Samia Saouma
Wolfram Aue
Jean-Marie Gallais
Florian Rehn

**Artists**
Darren Almond
Glenn Brown
André Butzer
Rineke Dijkstra
Jeff Elrod
Günther Förg
Robert Grosvenor
Mona Hatoum
Robert Holyhead
Jeff Koons
Vera Lutter
Marepe
Beatriz Milhazes
Joan Mitchell
Ernesto Neto
Christoph Niemann
Frank Nitsche
Navid Nuur
Albert Oehlen
Yves Oppenheim
Richard Phillips
Michael Raedecker
Bridget Riley
Thomas Struth
Edmund de Waal
Rebecca Warren
Christopher Wool
Toby Ziegler

## Hollybush Gardens

**Stand Number H9**
Tel +44 20 7837 5991

1–2 Warner Yard
London EC1R 5EY
United Kingdom
Tel +44 20 7837 5991
office@
hollybushgardens.co.uk
www.
hollybushgardens.co.uk

**Contact**
Lisa Panting
Malin Ståhl

**Artists**
Johanna Billing
Andrea Büttner
Knut Henrik Henriksen
Lubaina Himid
Karl Holmqvist
Claire Hooper
Anja Kirschner
Kirschner & Panos
Benoît Maire
Eline McGeorge
Bruno Pacheco
David Panos
Falke Pisano
Ruth Proctor
Reto Pulfer

## Taka Ishii Gallery

**Stand Number C6**
Tel +81 3 5646 6050

1-3-2 5F Kiyosumi
Koto-ku Tokyo 135-0024
Japan
Tel +81 3 5646 6050
tig@takaishiigallery.com
www.takaishiigallery.com

5-17-1 2F Roppongi
Minato-ku Tokyo 106-0032
Japan

**Contact**
Takayuki Ishii
Elisa Uematsu

**Artists**
Amy Adler
Ei Arakawa
Nobuyoshi Araki
Thomas Demand
Michael Elmgreen & Ingar Dragset
Luke Fowler
Mario Garcia Torres
Tomoo Gokita
Dan Graham
Naoya Hatakeyama
Nobuya Hoki
Takashi Ishida
Zon Ito
Naoto Kawahara
Annette Kelm
Yuki Kimura
Sean Landers
Yukinori Maeda
Helen Mirra
Daido Moriyama
Kyoko Murase
William J. O'Brien
Kiyoji Ōtsuji
Silke Otto-Knapp
Sterling Ruby
Hiroe Saeki
Taro Shinoda
Kunie Sugiura
Yosuke Takeda
Kei Takemura
Hirofumi Toyama
Marijke van Warmerdam
Christopher Wool
Cerith Wyn Evans

## Alison Jacques Gallery

**Stand Number C9**
Tel +44 20 7631 4720

16–18 Berners Street
London W1T 3LN
United Kingdom
Tel +44 20 7631 4720
info@
alisonjacquesgallery.com
www.
alisonjacquesgallery.com

**Contact**
Alison Jacques
Fouad Kanaan
Charlotte Marra
Simona Pizzi

**Artists**
Michael Bauer
Irma Blank
Lygia Clark
Iran do Espírito Santo
Tomory Dodge
Dan Fischer
Saul Fletcher
Fernanda Gomes
Sheila Hicks
Matt Johnson
Birgit Jürgenssen
Ian Kiaer
Klara Kristalova
Graham Little
Robert Mapplethorpe
Ryan McGinley
Ana Mendieta
Paul Morrison
Ryan Mosley
Hélio Oiticica
Alessandro Raho
Dorothea Tanning
Mathew Weir
Hannah Wilke
Catherine Yass
Thomas Zipp

## Galerie Martin Janda

**Stand Number B12**
Tel +43 664 233 54 29

Eschenbachgasse 11
Vienna 1010
Austria
Tel +43 1 585 73 71
galerie@martinjanda.at
www.martinjanda.at

**Contact**
Martin Janda
Elisabeth Konrath

**Artists**
Martin Arnold
Alessandro Balteo Yazbeck
Benjamin Butler
Adriana Czernin
Svenja Deininger
Milena Dragicevic
Werner Feiersinger
Giuseppe Gabellone
Nilbar Güreş
Christine & Irene Hohenbüchler
Christian Hutzinger
Raoul de Keyser
Jakob Kolding
Július Koller
Jan Merta
Roman Ondák
Peter Pommerer
Allen Ruppersberg
Joe Scanlan
Ene-Liis Semper
Gabriel Sierra
Roman Signer
Mladen Stilinović
Adrien Tirtiaux
Johannes Vogl
Maja Vukoje
Corinne Wasmuht
Donelle Woolford
Sharon Ya'ari
Jun Yang
Jakub Julian Ziółkowski

# Gallery Index

## Casey Kaplan

**Stand Number C16**
Tel +1 212 645 7335

525 West 21st Street
New York NY 10011
United States
Tel +1 212 645 7335
info@
caseykaplangallery.com
www.
caseykaplangallery.com

**Contact**
Casey Kaplan
Loring Randolph
Alex Fitzgerald

**Artists**
Kevin Beasley
Henning Bohl
Matthew Brannon
Jeff Burton
Nathan Carter
Jason Dodge
Trisha Donnelly
Geoffrey Farmer
Liam Gillick
Giorgio Griffa
Annika von Hausswolff
Brian Jungen
Sanya Kantarovsky
Mateo López
Jonathan Monk
Marlo Pascual
Diego Perrone
Julia Schmidt
Simon Starling
David Thorpe
Gabriel Vormstein
Garth Weiser
Johannes Wohnseifer

## Georg Kargl Fine Arts

**Stand Number B18**
Tel +43 676 624 54 90

Schleifmühlgasse 5
Vienna 1040
Austria
Tel +43 1 585 41 99
georg.kargl@
georgkargl.com
www.georgkargl.com

**Contact**
Georg Kargl
Fiona Liewehr

**Artists**
Richard Artschwager
Carter
Clegg & Guttmann
Martin Dammann
Koenraad Dedobbeleer
Mark Dion
Marcel van Eeden
Peter Fend
Andreas Fogarasi
Michael Gumhold
Jitka Hanzlová
Herbert Hinteregger
Chris Johanson
Herwig Kempinger
Bernhard Leitner
Thomas Locher
Inés Lombardi
David Maljkovic
Christian Phillip Müller
Matt Mullican
Muntean/Rosenblum
Max Peintner
Raymond Pettibon
Wolfgang Plöger
Gerwald Rockenschaub
Liddy Scheffknecht
Nedko Solakov
Erwin Thorn
Rosemarie Trockel
Nadim Vardag
Costa Vece
Ina Weber
Cerith Wyn Evans

## Anton Kern Gallery

**Stand Number E3**
Tel +1 212 367 9663

532 West 20th Street
New York NY 10011
United States
Tel +1 212 367 9663
info@antonkerngallery.com
www.antonkerngallery.com

**Contact**
Anton Kern
Christoph Gerozissis

**Artists**
Nobuyoshi Araki
Ellen Berkenblit
John Bock
Brian Calvin
Anne Collier
Saul Fletcher
Mark Grotjahn
Bendix Harms
Eberhard Havekost
Lothar Hempel
Richard Hughes
Sarah Jones
Shio Kusaka
Jim Lambie
Marepe
Chris Martin
Dan McCarthy
Matthew Monahan
Marcel Odenbach
Manfred Pernice
Alessandro Pessoli
Wilhelm Sasnal
Lara Schnitger
David Shrigley
Francis Upritchard
Andy Warhol
Jonas Wood

## Galerie Peter Kilchmann

**Stand Number A17**
Tel +41 44 278 10 10

Zahnradstrasse 21
Zurich 8005
Switzerland
Tel +41 44 278 10 10
info@peterkilchmann.com
www.peterkilchmann.com

**Contact**
Peter Kilchmann
Annemarie Reichen

**Artists**
Francis Alÿs
Hernan Bas
Michael Bauer
Armin Boehm
Monica Bonvicini
Los Carpinteros
Willie Doherty
Valérie Favre
Marc-Antoine Fehr
Fernanda Gomes
Bruno Jakob
Raffi Kalenderian
Tobias Kaspar
Zilla Leutenegger
Jorge Macchi
Teresa Margolles
Fabian Marti
Adrian Paci
David Renggli
Bernd Ribbeck
Melanie Smith
Javier Téllez
Tercerunquinto
Erika Verzutti
Artur Żmijewski

## Tina Kim Gallery

**Stand Number B6**
Tel +1 212 716 1100

545 West 25th Street
New York NY 10001
United States
Tel +1 212 716 1100
info@tinakimgallery.com
www.tinakimgallery.com

**Contact**
Tina Kim
Eliza Ravelle-Chapuis

**Artists**
Ghada Amer & Reza
Farkhondeh
Gimhongsok
Kyungah Ham
Kyung Jeon
Yeondoo Jung
Eemyun Kang
Sora Kim
Kibong Rhee
Marc André Robinson
Joanna M. Wezyk

## David Kordansky Gallery

**Stand Number C1**
Tel +1 917 859 7747

5130 West Edgewood Place
Los Angeles CA 90019
Tel +1 323 935 3030
info@davidkordansky
gallery.com
www.davidkordansky
gallery.com

**Contact**
David Kordansky
Mike Homer
Kurt Mueller

**Artists**
Markus Amm
Kathryn Andrews
Matthew Brannon
Andrea Büttner
Valentin Carron
Steven Claydon
Heather Cook
Aaron Curry
Andrew Dadson
Will Fowler
Sam Gilliam
Patrick Hill
Evan Holloway
Larry Johnson
Rashid Johnson
William E. Jones
Elad Lassry
Thomas Lawson
Chris Martin
John Mason
Alan Michael
Ruby Neri
David Noonan
Anthony Pearson
Mai-Thu Perret
Jon Pestoni
Pietro Roccasalva
Ricky Swallow
Tom of Finland
Lesley Vance
Mary Weatherford
John Wesley
Jonas Wood

## Kendall Koppe

**Stand Number H13**
Tel +44 141 248 8177

Suite 1–2 , 6 Dixon Street
Glasgow G1 4AX
United Kingdom
Tel +44 141 248 8177
info@kendallkoppe.com
www.kendallkoppe.com

**Contact**
Kendall Koppe

**Artists**
Laura Aldridge
Grier Edmundson
Ella Kruglyanskaya
Niall Macdonald
Craig Mulholland
Ciara Phillips
Charlotte Prodger
Corin Sworn

## Andrew Kreps Gallery

**Stand Number D11**
Tel +1 212 741 8849

537 West 22nd Street
New York NY 10011
United States
Tel +1 212 741 8849
contact@andrewkreps.com
www.andrewkreps.com

**Contact**
Andrew Kreps
Liz Mulholland
Alice Conconi

**Artists**
Ricci Albenda
Darren Bader
Martin Barré
Frank Benson
Andrea Bowers
Marc Camille Chaimowicz
Roe Ethridge
Uwe Henneken
Christian Holstad
Jamie Isenstein
Annette Kelm
Maria Loboda
Goshka Macuga
Ján Mančuška
Robert Melee
Robert Overby
Peter Piller
Ruth Root
Hito Steyerl
Cheyney Thompson
Padraig Timoney
Hayley Tompkins
Fredrik Værslev
Klaus Weber
Honza Zamojski

## Galerie Krinzinger

**Stand Number A6**
Tel +43 676 324 83 79

Seilerstätte 16
Vienna 1010
Austria
Tel +43 1 513 30 06
galeriekrinzinger@chello.at
www.galerie-krinzinger.at

**Contact**
Ursula Krinzinger
Thomas Krinzinger
Michael Rienzner

**Artists**
Marina Abramović
Nader Ahriman
Kader Attia
Gottfried Bechtold
Günter Brus
Chris Burden
Johanna Calle
Andy Coolquitt
Adriano Costa
Ángela de la Cruz
Vladimir Dubossarsky &
Alexander Vinogradov
Franz Graf
Sakshi Gupta
Jonathan Hernández
Secundino Hernández
Waqas Khan
Zenita Komad
Valery Koshlyakov
Angelika Krinzinger
Oleg Kulik
Ulrike Lienbacher
Atelier van Lieshout
Erik van Lieshout
Jonathan Meese
Bjarne Melgaard
Otto Muehl
Hans Op de Beeck
Meret Oppenheim
Werner Reiterer
Eva Schlegel
Erik Schmidt
Rudolf Schwarzkogler
Christian Schwarzwald
Mithu Sen
Sudarshan Shetty
Daniel Spoerri
Frank Thiel
Gavin Turk
Jannis Varelas
Martin Walde
Mark Wallinger
Zhang Ding
Thomas Zipp

## Kukje Gallery

**Stand Number B6**
Tel +1 917 376 2481

54 Samcheong-ro Jongno-gu
Seoul 110-200
Korea
Tel +82 2 735 8449
kukje@kukjegallery.com
www.kukjegallery.com

**Contact**
Hyun-Sook Lee
Eliza Ravelle-Chapuis
Charles Kim
Suzie Kim
Tina Kim

**Artists**
Ghada Amer
Louise Bourgeois
Alexander Calder
Anthony Caro
Jae-Eun Choi
Chung Chang-Sup
Chung Sang-Hwa
Gimhongsok
Ha Chong-Hyun
Kyungah Ham
Eva Hesse
Candida Höfer
Jenny Holzer
Kim Hong-Joo
Roni Horn
Kyung Jeon
Michael Joo
Yeondoo Jung
Eemyun Kang
Anish Kapoor
Bharti Kher
Anselm Kiefer
Kira Kim
Sora Kim
Kimsooja
Bohnchang Koo
Kwang-Ho Lee
Lee Ufan
Richard Long
Paul McCarthy
Joan Mitchell
Moon Sungsic
David Nash
Hein-Kuhn Oh
Julian Opie
MeeNa Park
Seo-Bo Park
Kibong Rhee
Choong-Hyun Roh
Sterling Ruby
SaSa [44]
U. Sunok
Bill Viola
Haegue Yang
Yeesookyung
Aaron Young

# Gallery Index

## kurimanzutto

**Stand Number D7**
Tel +52 55 5256 2408

Gob. Rafael Rebollar 94
Mexico City 11850
Mexico
Tel +52 55 5256 2408
info@kurimanzutto.com
www.kurimanzutto.com

**Contact**
Jose Kuri & Monica
Manzutto
Daniela Zarate
Ana Castella

**Artists**
Eduardo Abaroa
Jennifer Allora & Guillermo
Calzadilla
Carlos Amorales
Miguel Calderón
Mariana Castillo Deball
Abraham Cruzvillegas
Minerva Cuevas
Jimmie Durham
Daniel Guzmán
Jonathan Hernández
Gabriel Kuri
Dr Lakra
Sarah Lucas
Roman Ondák
Gabriel Orozco
Damián Ortega
Fernando Ortega
Wilfredo Prieto
Anri Sala
Gabriel Sierra
Monika Sosnowska
Sofía Táboas
Rirkrit Tiravanija
Adrián Villar Rojas
Danh Võ
Apichatpong Weerasethakul
Akram Zaatari

## Galerie Emanuel Layr

**Stand Number G20**
Tel +43 676 926 1349

An der Huelben 2
Vienna 1010
Austria
Tel +43 676 926 1349
gallery@emanuellayr.com
www.emanuellayr.com

**Contact**
Emanuel Layr
Felix Gaudlitz

**Artists**
Franz Amann
Julien Bismuth
Andy Boot
Plamen Dejanoff
Marius Engh
Stano Filko
Benjamin Hirte
Lisa Holzer
Tillman Kaiser
Mahony
Nick Oberthaler
Lili Reynaud-Dewar
Philipp Timischl

## Lehmann Maupin

**Stand Number A18**
Tel +1 212 255 2923

540 West 26th Street
New York NY 10001
United States
Tel +1 212 255 2923
info@lehmannmaupin.com
www.lehmannmaupin.com

201 Chrystie Street
New York NY 10002
United States

407 Pedder Building
12 Pedder Street
Central Hong Kong
China

**Contact**
Rachel Lehmann
David Maupin
Carla Camacho
Stephanie Smith
Jessica Kreps
Liz Dimmitt
Drew Moody
Amy Cosier
Li Yan

**Artists**
Kader Attia
Hernan Bas
Ashley Bickerton
Billy Childish
Mary Corse
Tracey Emin
Teresita Fernández
Anya Gallaccio
Gilbert & George
Sonia Gomes
Shirazeh Houshiary
Klara Kristalova
Lee Bul
Liu Wei
Mr.
OSGEMEOS
Angel Otero
Tony Oursler
Alex Prager
Robin Rhode
Tim Rollins and K.O.S.
Jennifer Steinkamp
Do Ho Suh
Juergen Teller
Mickalene Thomas
Adriana Varejão
Suling Wang
Nari Ward
Erwin Wurm

## Galerie Antoine Levi

**Stand Number J10**
Tel +33 6 95 65 44 67

44 rue Ramponeau
Paris 75020
France
Tel +33 6 95 65 44 67
info@antoinelevi.fr
www.antoinelevi.fr

**Contact**
Antoine Levi
Nerina Ciaccia

**Artists**
Francesco Gennari
Daniel Jacoby
G. Küng
Piotr Makowski
Olve Sande
Sean Townley
Ola Vasiljeva
Zoe Williams

## Limoncello

**Stand Number H23**
Tel +44 20 7923 7033

340–344 Kingsland Road
London E8 4DA
United Kingdom
Tel +44 20 7923 7033
limoncello@
limoncellogallery.co.uk
www.
limoncellogallery.co.uk

**Contact**
Rebecca May Marston
Rosa Tyhurst

**Artists**
Cornelia Baltes
Vanessa Billy
Alice Browne
Lucy Clout
Tomas Downes
Sean Edwards
Matt Golden
Kate Owens
Matthew Smith
Jack Strange
Santo Tolone
Yonatan Vinitsky
Jesse Wine

## Lisson Gallery

**Stand Number B5**
Tel +44 20 7724 2739

29 & 52–54 Bell Street
London NW1 5DA
United Kingdom
Tel +44 20 7724 2739
contact@lissongallery.com
www.lissongallery.com

**Contact**
Nicholas Logsdail
Claus Robenhagen
Alex Logsdail
Hana Noorali

**Artists**
Marina Abramović
Ai Weiwei
Cory Arcangel
Art & Language
Daniel Buren
Gerard Byrne
Jennifer Allora & Guillermo
Calzadilla
James Casebere
Tony Cragg
Ángela de la Cruz
Richard Deacon
Nathalie Djurberg &
Hans Berg
Spencer Finch
Ceal Floyer
Ryan Gander
Dan Graham
Rodney Graham
Carmen Herrera
Shirazeh Houshiary
Christian Jankowski
Peter Joseph
Anish Kapoor
John Latham
Tim Lee
Lee Ufan
Sol LeWitt
Liu Xiaodong
Richard Long
Robert Mangold
Jason Martin
Haroon Mirza
Tatsuo Miyajima
Jonathan Monk
Julian Opie
Tony Oursler
Giulio Paolini
Joyce Pensato
Florian Pumhösl
Rashid Rana
Santiago Sierra
Sean Snyder
Lawrence Weiner
Richard Wentworth

## Kate MacGarry

**Stand Number A4**
Tel +44 20 7613 0515

27 Old Nichol Street
London E2 7HR
United Kingdom
Tel +44 20 7613 0515
mail@katemacgarry.com
www.katemacgarry.com

**Contact**
Kate MacGarry
Lizzy McGregor

**Artists**
Josh Blackwell
Matt Bryans
Tiago Carneiro da Cunha
Marcus Coates
Iain Forsyth & Jane Pollard
Jeff Keen
Dr Lakra
Goshka Macuga
Peter McDonald
Florian Meisenberg
Ben Rivers
Luke Rudolf
Renee So
Francis Upritchard
B. Wurtz

## Mai 36 Galerie

**Stand Number C4**
Tel +41 76 322 50 24

Rämistrasse 37
Zurich 8001
Switzerland
Tel +41 76 322 50 24
mail@mai36.com
www.mai36.com

**Contact**
Victor Gisler
Samuel Mizrachi

**Artists**
Franz Ackermann
Ian Anüll
John Baldessari
Stephan Balkenhol
Matthew Benedict
Troy Brauntuch
Pedro Cabrita Reis
Ernst Caramelle
Raúl Cordero
Koenraad Dedobbeleer
Jürgen Drescher
Roe Ethridge
Pia Fries
Flavio Garciandía
General Idea
Luigi Ghirri
Daan van Golden
Jitka Hanzlová
Peter Hujar
Robert Mapplethorpe
Rita McBride
Harald F. Müller
Matt Mullican
Michel Pérez Pollo
Manfred Pernice
Magnus Plessen
Glen Rubsamen
Thomas Ruff
Christoph Rütimann
Paul Thek
Stefan Thiel
Lawrence Weiner
Rémy Zaugg
Matthias Zinn

## Gió Marconi

**Stand Number B2**
Tel +39 335 245805

Via Tadino 15
Milan 20124
Italy
Tel +39 02 29404373
info@giomarconi.com
www.giomarconi.com

**Contact**
Gió Marconi
Esther Quiroga
Teresa Bovi

**Artists**
Franz Ackermann
Trisha Baga
Rosa Barba
Will Benedict
John Bock
Kerstin Brätsch
Matthew Brannon
André Butzer
Nathalie Djurberg
Günther Förg
Simon Fujiwara
Nikolas Gambaroff
Wade Guyton
Lothar Hempel
Christian Jankowski
Annette Kelm
Atelier van Lieshout
Sharon Lockhart
Louise Nevelson
David Noonan
Jorge Pardo
Tobias Rehberger
Markus Schinwald
Dasha Shishkin
Lucie Stahl
Catherine Sullivan
Grazia Toderi
Fredrik Værslev
Francesco Vezzoli
Amelie von Wulffen

## Galeria Jaqueline Martins

**Stand Number H22**
Tel +55 11 2628 1943

Rua Dr Virgílio de Carvalho
Pinto 74
São Paulo 05415-020
Brazil
Tel +55 11 2628 1943
contato@galeriajaqueline
martins.com.br
www.galeriajaqueline
martins.com.br

**Contact**
Jaqueline Martins
Gisela Gari
Roberta Mahfuz

**Artists**
3Nós3
Nara Amelia
Martha Araújo
Arte/Ação
Stuart Brisley
Nicolás Consuegra
Equipe3
Rafael França
Hudinilson Jr
Bill Lundberg
Gastão de Magalhães
Ana Mazzei
Lydia Okumura
Edwin Sanchez
Dudu Santos
Genilson Soares
Regina Vater

# Gallery Index

## Mary Mary

**Stand Number J3**
Tel +44 141 226 2257

Suite 2/1, 6 Dixon Street
Glasgow G1 4AX
United Kingdom
Tel +44 141 226 2257
info@
marymarygallery.co.uk
www.
marymarygallery.co.uk

**Contact**
Hannah Robinson

**Artists**
Sara Barker
Ernst Caramelle
Aleana Egan
Nick Evans
Alistair Frost
Jonathan Gardner
Lotte Gertz
Barbara Kasten
Lorna Macintyre
Alexis Marguerite Teplin
Alan Reid
Gerda Scheepers
Jesse Wine
Maximilian Zentz
Zlomovitz

## Mathew Gallery

**Stand Number H18**
Tel +49 30 2102 1921

Schaperstrasse 12
Berlin 10719
Germany
Tel +49 30 2102 1921
info@mathew-gal.de
www.mathew-gal.de

**Contact**
Peter Kersten
David Lieske

**Artists**
Robin Bruch
Nicolas Ceccaldi
Than Hussein Clark
Heike-Karin Föll
Nina Koennemann
Christine Lemke
Ken Okiishi
Megan Francis Sullivan
Villa Design Group
Amy Yao

## Galerie Greta Meert

**Stand Number B16**
Tel +32 47 557 63 29

Rue du Canal 13
Brussels 1000
Belgium
Tel +32 2 219 14 22
info@
galeriegretameert.com
www.galeriegretameert.com

**Contact**
Greta Meert
Frédéric Mariën

**Artists**
Carla Accardi
John Baldessari
Robert Barry
Gianfranco Baruchello
Eric Baudelaire
Iñaki Bonillas
Koen van den Broek
Enrico Castellani
Hanne Darboven
Edith Dekyndt
Johannes Döring
Catharina van Eetvelde
Sylvie Eyberg
Suzan Frecon
Shirley Jaffe
Mimmo Jodice
Peter Joseph
Donald Judd
Brandt Junceau
Valerie Krause
Melissa Kretschmer
Louise Lawler
Sol LeWitt
Robert Mangold
Eva Marisaldi
Liliana Moro
Jean-Luc Moulène
Sophie Nys
Tobias Putrih
Fred Sandback
Thomas Struth
Grazia Toderi
Niele Toroni
Richard Tuttle
Michael Venezia
Pieter Vermeersch
Didier Vermeiren
Johannes Wald
Ian Wallace

## Mendes Wood DM

**Stand Number H2**
Tel +55 11 9832 63698

Rua da Consolação 3358
São Paulo 01416-000
Brazil
Tel +55 11 3081 1735
info@mendeswood.com
www.mendeswood.com

Rua Marco Aurélio 311
Vila Romana
São Paulo 01416-000
Brazil

**Contact**
Felipe Dmab
Matthew Wood
Pedro Mendes

**Artists**
Lucas Arruda
Neïl Beloufa
Mariana Castillo Deball
Cibelle Cavalli Bastos
Adriano Costa
Michael Dean
Deyson Gilbert
Sonia Gomes
Runo Lagomarsino
Patricia Leite
f. marquespenteado
Thiago Martins de Melo
Paulo Monteiro
Paulo Nazareth
Paulo Nimer Pjota
Marina Perez Simao
Leticia Ramos
Matheus Rocha Pitta
Daniel Steegmann
Mangrané
Tunga
Roberto Winter
Francesca Woodman

## Galerie Meyer Kainer

**Stand Number F12**
Tel +43 676 5173116

Eschenbachgasse 9
Vienna 1010
Austria
Tel +43 1 585 7277
contact@meyerkainer.com
www.meyerkainer.com

**Contact**
Christian Meyer
Renate Kainer

**Artists**
Ei Arakawa
Will Benedict
John Bock
Henning Bohl
Bernadette Corporation
Wolfgang Breuer
Olaf Breuning
Verena Dengler
Thea Djordjadze
Michaela Eichwald
Nikolas Gambaroff
Gelitin
Liam Gillick
Dan Graham
Julia Haller
Rachel Harrison
Siggi Hofer
Christian Jankowski
Annette Kelm
Elke Silvia Krystufek
Anita Leisz
Marcin Maciejowski
Michaela Meise
Sarah Morris
Yoshitomo Nara
Walter Obholzer
Jorge Pardo
Raymond Pettibon
Mathias Poledna
Stefan Sandner
Isa Schmidlehner
Nora Schultz
Gedi Sibony
Reena Spaulings
Lucie Stahl
Martina Steckholzer
Franz West
T.J. Wilcox
Amelie von Wulffen
Heimo Zobernig

## Meyer Riegger

**Stand Number B2**
Tel +49 17 3665 6258

Friedrichstrasse 235
Berlin 10969
Germany
Tel +49 30 3156 6580
info@meyer-riegger.de
www.meyer-riegger.de

**Contact**
Jochen Meyer
Thomas Riegger
Eva Scherr

**Artists**
Franz Ackermann
Rosa Barba
Katinka Bock
Armin Boehm
Björn Braun
Miriam Cahn
Henrik Håkansson
Uwe Henneken
Anna Lea Hucht
Jamie Isenstein
Korpys/Löffler
Eva Kot'átková
Ján Mančuška
Meuser
John Miller
Helen Mirra
Jonathan Monk
Melvin Moti
Scott Myles
Paulo Nazareth
Daniel Roth
Silke Schatz
Julia Schmidt
David Thorpe
Gabriel Vormstein
Waldemar Zimbelmann

## Victoria Miro

**Stand Number B3**
Tel +44 20 7336 8109

16 Wharf Road
London N1 7RW
United Kingdom
Tel +44 20 7336 8109
info@victoria-miro.com
www.victoria-miro.com

**Contact**
Victoria Miro
Glenn Scott Wright
W.P. Miro

**Artists**
Doug Aitken
Jules de Balincourt
Hernan Bas
Varda Caivano
Verne Dawson
Peter Doig
Stan Douglas
William Eggleston
Michael Elmgreen & Ingar Dragset
Inka Essenhigh
Eric Fischl
Barnaby Furnas
Ian Hamilton Finlay
David Harrison
NS Harsha
Alex Hartley
Secundino Hernández
Christian Holstad
Chantal Joffe
Isaac Julien
Idris Khan
John Kørner
Udomsak Krisanamis
Yayoi Kusama
Wangechi Mutu
Alice Neel
Maria Nepomuceno
Chris Ofili
Jacco Olivier
Celia Paul
Grayson Perry
Tal R
Conrad Shawcross
Sarah Sze
Adriana Varejão
Kara Walker
Suling Wang
Stephen Willats
Francesca Woodman

## Misako & Rosen

**Stand Number J8**
Tel +81 90 6023 0779

3-27-6 1F, Kita-otsuka
Toshima-ku
Tokyo 170-0004
Japan
Tel +81 3 6276 1452
gallery@
misakoandrosen.com
www.misakoandrosen.com

**Contact**
Jeffrey Rosen
Misako Rosen

**Artists**
Richard Aldrich
Kaoru Arima
Josh Brand
Motoyuki Daifu
Fergus Feehily
Daan van Golden
Maya Hewitt
Naotaka Hiro
Nathan Hylden
Ken Kagami
Shimon Minamikawa
Miki Mochizuka
Ayako Mogi
Mie Morimoto
Yuki Okumura
Stephen G. Rhodes
Will Rogan
Kazuyuki Takezaki
J. Parker Valentine
Erika Verzutti
Yui Yaegashi
Takashi Yasumura

## Stuart Shave/ Modern Art

**Stand Number E2**
Tel +44 20 7299 7950

4–8 Helmet Row
London EC1V 3QJ
United Kingdom
Tel +44 20 7299 7950
info@modernart.net
www.modernart.net

**Contact**
Stuart Shave
Jimi Lee
Kirk McInroy
Ryan Moore

**Artists**
David Altmejd
Karla Black
Tom Burr
Mark Flood
Tim Gardner
Lothar Hempel
Yngve Holen
Jacqueline Humphries
Ansel Krut
Phillip Lai
Paul Lee
Linder
Barry McGee
Jonathan Meese
Matthew Monahan
Katy Moran
David Noonan
Anna-Bella Papp
Eva Rothschild
Bojan Šarčević
Lara Schnitger
Collier Schorr
Steven Shearer
Ricky Swallow
Richard Tuttle

## The Modern Institute

**Stand Number F7**
Tel +44 141 248 3711

14–20 Osborne Street
Glasgow G1 5QN
United Kingdom
Tel +44 141 248 3711
mail@
themoderninstitute.com
www.
themoderninstitute.com

**Contact**
Toby Webster
Andrew Hamilton

**Artists**
Dirk Bell
Martin Boyce
Anne Collier
Jeremy Deller
Alex Dordoy
Urs Fischer
Kim Fisher
Luke Fowler
Henrik Håkansson
Mark Handforth
Thomas Houseago
Richard Hughes
Chris Johanson
William E. Jones
Andrew Kerr
Shio Kusaka
Jim Lambie
Tobias Madison
Adam McEwen
Victoria Morton
Scott Myles
Nicolas Party
Toby Paterson
Simon Periton
Manfred Pernice
Mary Redmond
Anselm Reyle
Eva Rothschild
Monika Sosnowska
Simon Starling
Katja Strunz
Tony Swain
Spencer Sweeney
Joanne Tatham & Tom O'Sullivan
Pádraig Timoney
Hayley Tompkins
Sue Tompkins
Cathy Wilkes
Michael Wilkinson
Gregor Wright
Richard Wright

# Gallery Index

## MOT International

**Stand Number G9**
Tel +44 20 7491 7208

72 New Bond Street
London W1S 1RR
United Kingdom
Tel +44 20 7491 7208
info@motinternational.com
www.motinternational.com

Place du Petit Sablon, 10
Brussels 1000
Belgium

**Contact**
Chris Hammond
Aly Afshar
Nicola Wright

**Artists**
Shahin Afrassiabi
BANK
Simon Bedwell
Alan Brooks
Raphael Danke
Braco Dimitrijević
Tom Ellis
Seung-Taek Lee
Simon Mathers
Helmut Middendorf
Beatriz Olabarrieta
Dennis Oppenheim
Katrina Palmer
Elizabeth Price
Laure Prouvost
Clunie Reid
Florian Roithmayr
John Russell
Marinella Senatore
Elisa Sighicelli
Cally Spooner
Ulrich Strothjohann
Amikam Toren
Ulay
Stephen Willats
Nil Yalter
Aishan Yu

## mother's tankstation

**Stand Number H7**
Tel +353 1 6717654

41–43 Watling Street
Dublin 8
Ireland
Tel +353 1 6717654
gallery@
motherstankstation.com
www.
motherstankstation.com

**Contact**
Finola Jones

**Artists**
Sam Anderson
Uri Aran
Ian Burns
Nina Canell
Kevin Cosgrove
Ara Dymond
Brendan Earley
Fergus Feehily
Atsushi Kaga
Shane McCarthy
Noel McKenna
Alasdair McLuckie
Mairead O'hEocha
Matt Sheridan Smith
David Sherry

## Taro Nasu

**Stand Number B13**
Tel +81-3-5856-5713

1-2-11 Higashi-Kanda
Chiyoda-ku
Tokyo 101-0031
Japan
Tel +81-3-5856-5713
Fax +81-3-5856-5714
info@taronasugallery.com
www.taronasugallery.com

**Contact**
Taro Nasu
Masako Hosoi
Takashi Kikuchi
Shino Ozawa

**Artists**
Futo Akiyoshi
Koichi Enomoto
Simon Fujiwara
Ryan Gander
Liam Gillick
Maiko Haruki
Anton Henning
Takashi Homma
Taka Izumi
Hirofumi Katayama
Tatsuo Majima
Taiji Matsue
Jonathan Monk
Takeharu Ogai
Djordje Ozbolt
Akira Rachi
Alessandro Raho
Cozue Takagi
Yuki Tawada
Satoshi Watanabe
Chie Yasuda
Kumazou Yoshimura

## Galleria Franco Noero

**Stand Number D12**
Tel +39 366 9579377

Via Mottalciata 10B
Turin 10154
Italy
Tel +39 1 1882208
info@franconoero.com
www.franconoero.com

**Contact**
Franco Noero
Pierpaolo Falone
Matteo Consonni

**Artists**
Darren Bader
Pablo Bronstein
Tom Burr
Jeff Burton
Neil Campbell
Andrew Dadson
Jason Dodge
Lara Favaretto
Martino Gamper
Henrik Håkansson
Mark Handforth
Arturo Herrera
Gabriel Kuri
Phillip Lai
Jim Lambie
Robert Mapplethorpe
Paulo Nazareth
Mike Nelson
Henrik Olesen
Kirsten Pieroth
Steven Shearer
Simon Starling
Tunga
Costa Vece
Francesco Vezzoli

## Galerie Nordenhake

**Stand Number B11**
Tel +49 17 6188 66680

Lindenstrasse 34
Berlin 10969
Germany
Tel +49 30 206 1483
berlin@nordenhake.com
www.nordenhake.com

Hudiksvallsgatan 8
Stockholm 11330
Sweden

**Contact**
Claes Nordenhake
Claudia Sorhage
Ben Loveless
Isabelle Köhncke

**Artists**
Meriç Algün Ringborg
Christian Andersson
Olle Baertling
Mirosław Bałka
Anna Barham
Iñaki Bonillas
Ann Böttcher
Gerard Byrne
John Coplans
Sarah Crowner
Jonas Dahlberg
Ann Edholm
Paul Fägerskiöld
Spencer Finch
Hreinn Friðfinnsson
Felix Gmelin
Franka Hörnschemeyer
Sofia Hultén
Gunilla Klingberg
Karl Larsson
Eva Löfdahl
Esko Männikkö
Meuser
Helen Mirra
Sirous Namazi
Walter Niedermayr
Scott Olson
Mikael Olsson
Marjetica Potrč
Håkan Rehnberg
Ulrich Rückriem
Michael Schmidt
Florian Slotawa
Leon Tarasewicz
Johan Thurfjell
Alan Uglow
Günter Umberg
Not Vital
Magnus Wallin
Stanley Whitney
Rémy Zaugg
John Zurier

## Office Baroque

**Stand Number A13**
Tel +32 484 599 228

Bloemenhofplein 5
Place du Jardin aux Fleurs
1000 Brussels
Belgium
Tel +32 484 599 228
info@officebaroque.com
www.officebaroque.com

**Contact**
Marie Denkens
Wim Peeters
Louis-Philippe Van
Eeckhoutte

**Artists**
Catharine Ahearn
Michel Auder
Aaron Bobrow
Matthew Brannon
Neil Campbell
Mathew Cerletty
David Diao
Tamar Halpern
Owen Land
Leigh Ledare
Kirsten Pieroth
Michael Rey
Davis Rhodes
Margaret Salmon
Daniel Sinsel
Kyle Thurman
B. Wurtz

## Overduin & Co.

**Stand Number B20**
Tel +1 323 350 7374

6693 Sunset Boulevard
Los Angeles CA 90028
United States
Tel +1 323 464 3600
office@overduinandco.com
www.overduinandco.com

**Contact**
Lisa Overduin

**Artists**
Ei Arakawa
Math Bass
Will Benedict
Frank Benson
Merlin Carpenter
Marc Camille Chaimowicz
Maureen Gallace
Nikolas Gambaroff
Rob Halverson
Barry Johnston
Scott Olson
Eileen Quinlan
Stephen G. Rhodes
Haim Steinbach
Sergei Tcherepnin
Cheyney Thompson
Erika Vogt
Tris Vonna-Michell

## P!

**Stand Number H15**
Tel +1 917 496 9072

334 Broome Street
New York NY 10002
United States
Tel +1 917 496 9072
info@p-exclamation.org
www.p-exclamation.org

**Contact**
Prem Krishnamurthy

**Artists**
Elaine Lustig Cohen
Karel Martens
Brian O'Doherty

## Pace

**Stand Number A2**
Tel +44 20 3206 7600

6 Burlington Gardens
London W1S 3ET
United Kingdom
Tel +44 20 3206 7600
londoninfo@
pacegallery.com
www.pacegallery.com

**Contact**
Marc Glimcher
Mollie Dent-Brocklehurst
Leng Lin

**Artists**
Josef Albers
Yto Barrada
Alexander Calder
Brian Clarke
Chuck Close
Nigel Cooke
Keith Coventry
Jim Dine
Tara Donovan
Rosalyn Drexler
Jean Dubuffet
Tim Eitel
Lee Friedlander
Adrian Ghenie
Adolph Gottlieb
Paul Graham
Kevin Francis Gray
Loris Gréaud
Hai Bo
Tim Hawkinson
Barbara Hepworth
David Hockney
Hong Hao
Robert Irwin
Alfred Jensen
Donald Judd
Ilya & Emilia Kabakov
Willem de Kooning
Lee Tzu-Hsun
Lee Ufan
Sol LeWitt
Li Songsong
Maya Lin
Liu Jianhua
Robert Mangold
Mao Yan
Agnes Martin
Roberto Matta
Vik Muniz
Elizabeth Murray
Yoshitomo Nara
Louise Nevelson
Carsten Nicolai
Isamu Noguchi
Kenneth Noland
Thomas Nozkowski
Claes Oldenburg & Coosje
van Bruggen
Adam Pendleton
Pablo Picasso
Richard Poussette-Dart
Qiu Xiaofei
Robert Rauschenberg
Bridget Riley
Mark Rothko
Michal Rovner
Robert Ryman
Lucas Samaras
Joel Shapiro
Raqib Shaw
James Siena
Kiki Smith
Bosco Sodi
Song Dong
Keith Sonnier
Saul Steinberg
Hiroshi Sugimoto
Sui Jianguo
Antoni Tàpies
Paul Thek
James Turrell
Richard Tuttle
Keith Tyson
Corban Walker
Robert Whitman
Fred Wilson
Xiao Yu
Yin Xiuzhen
Yue Minjun
Zhang Huan
Zhang Xiaogang
Zhao Yao

# Gallery Index

## Maureen Paley

**Stand Number D13**
Tel +44 7762 233 892

21 Herald Street
London E2 6JT
United Kingdom
Tel +44 20 7729 4112
info@maureenpaley.com
www.maureenpaley.com

**Contact**
Maureen Paley
Oliver Evans
Rory Mitchell

**Artists**
Keith Arnatt
AA Bronson
Kaye Donachie
Thomas Eggerer
Gardar Eide Einarsson
Morgan Fisher
Hamish Fulton
Maureen Gallace
General Idea
Liam Gillick
Andrew Grassie
Anne Hardy
Peter Hujar
Sarah Jones
Michael Krebber
Lars Laumann
Erik van Lieshout
Daria Martin
Saskia Olde Wolbers
Paul P.
Stephen Prina
James Pyman
Tim Rollins and K.O.S.
David Salle
Maaike Schoorel
Hannah Starkey
Dirk Stewen
David Thorpe
Wolfgang Tillmans
Gert & Uwe Tobias
Donald Urquhart
Banks Violette
Rebecca Warren
Gillian Wearing
James Welling

## Peres Projects

**Stand Number G2**
Tel +49 17 6248 75943

Karl-Marx-Allee 82
Berlin 10243
Germany
Tel +49 30 2759 50770
berlin@peresprojects.com
www.peresprojects.com

**Contact**
Javier Peres
Nicolas Koenigsknecht

**Artists**
assume vivid astro focus
Dan Attoe
Antonio Ballester Moreno
Mike Bouchet
Mark Flood
Leo Gabin
Dorothy Iannone
Alex Israel
Bruce LaBruce
David Ostrowski
Eddie Peake
Dean Sameshima
Marinella Senatore
Brent Wadden

## Galerie Perrotin

**Stand Number A16**

76 rue de Turenne
Paris 75003
France
Tel +33 1 42 16 79 79
info@perrotin.com
www.perrotin.com

909 Madison Avenue & 73rd
Street
New York NY 10021
United States

17th Floor
50 Connaught Road
Hong Kong
China

**Contact**
Emmanuel Perrotin
Peggy Leboeuf
Julie Morhange
Emmanuelle Orenga de
Gaffory
Lucien Terras
Raphäel Gatel
Clara Ustinov

**Artists**
Ivan Argote
Daniel Arsham
Hernan Bas
Sophie Calle
Maurizio Cattelan
Johan Creten
Wim Delvoye
Michael Elmgreen & Ingar
Dragset
Ericson & Ziegler
Lionel Estève
Daniel Firman
Bernard Frize
Gelitin
Laurent Grasso
Thilo Heinzmann
John Henderson
Gregor Hildebrandt
JR
Jesper Just
Izumi Kato
Kaws
Bharti Kher
Kolkoz
Klara Kristalova
Guy Limone
Ryan McGinley
Farhad Moshiri
Gianni Motti
Mr.
Takashi Murakami
Kaz Oshiro
Jean-Michel Othoniel
Paola Pivi
Germaine Richier
Claude Rutault
Michael Sailstorfer
Jesus Rafael Soto
Pierre Soulages
Aya Takano
Tatiana Trouvé
Xavier Veilhan
Pieter Vermeersch
Peter Zimmermann

## Galerie Francesca Pia

**Stand Number C11**
Tel +41 44 271 24 44

Limmatstrasse 268
Zurich 8005
Switzerland
Tel +41 44 271 24 44
info@francescapia.com
www.francescapia.com

**Contact**
Francesca Pia
Patricia Hartmann

**Artists**
Thomas Bayrle
Isabelle Cornaro
Stéphane Dafflon
Philippe Decrauzat
Hans-Peter Feldmann
Vidya Gastaldon
Aloïs Godinat
Joseph Grigely
Juan José Gurrola
Wade Guyton
Fabrice Gygi
Emil M. Klein
Jutta Koether
Elad Lassry
Tobias Madison
Kaspar Müller
Mai-Thu Perret
Marta Riniker-Radich
Bruno Serralongue
David Shrigley
Josef Strau
Joanne Tatham &
Tom O'Sullivan
John Tremblay
Betty Woodman

## Galeria Plan B

**Stand Number H5**
Tel +49 17 2321 0711

Potsdamer Strasse 77–87
Berlin 10785
Germany
Tel +49 17 2321 0711
contact@plan-b.ro
www.plan-b.ro

Str. Henri Barbusse 59–61
Cluj 400616
Romania

**Contact**
Mihai Pop
Mihaela Lutea

**Artists**
Ioana Batranu
Rudolf Bone
Alexandra Croitoru
Belu-Simion Fainaru
Adrian Ghenie
Gheorghe Ilea
Istvan Laszlo
Victor Man
Ciprian Muresan
Navid Nuur
Miklos Onucsan
Cristi Pogacean
Cristian Rusu
Serban Savu
Achraf Touloub
Gabriela Vanga

## Galerija Gregor Podnar

**Stand Number A14**
Tel +49 30 2593 4651

Lindenstrasse 35
Berlin 10969
Germany
Tel +49 30 2593 4651
berlin@gregorpodnar.com
www.gregorpodnar.com

**Contact**
Gregor Podnar
María Betegón
Kati Simon

**Artists**
Primož Bizjak
Irma Blank
Attila Csörgő
Vadim Fishkin
Ion Grigorescu
Alexander Gutke
Irwin
Yuri Leiderman
Anne Neukamp
Marzena Nowak
Dan Perjovschi
Goran Petercol
Tobias Putrih
Ariel Schlesinger
Goran Trbuljak
Francisco Tropa
B. Wurtz

## Galerie Eva Presenhuber

**Stand Number F3**
Tel +41 43 444 70 50

Maag Areal
Zahnradstrasse 21
Zurich 8005
Switzerland
Tel +41 43 444 70 50
info@presenhuber.com
www.presenhuber.com

**Contact**
Eva Presenhuber
Markus Rischgasser

**Artists**
Doug Aitken
Martin Boyce
Joe Bradley
Angela Bulloch
Valentin Carron
Verne Dawson
Jay DeFeo
Trisha Donnelly
Carroll Dunham
Latifa Echakhch
Matias Faldbakken
Sam Falls
Urs Fischer
Peter Fischli & David Weiss
Liam Gillick
Douglas Gordon
Mark Handforth
Candida Höfer
Alex Hubbard
Wyatt Kahn
Karen Kilimnik
Andrew Lord
Gerwald Rockenschaub
Tim Rollins and K.O.S.
Ugo Rondinone
Dieter Roth
Eva Rothschild
Jean-Frédéric Schnyder
Steven Shearer
Josh Smith
Oscar Tuazon
Franz West
Michael Williams
Sue Williams

## Project 88

**Stand Number J4**
Tel +91 22 2281 0066

Ground Floor, BMP Building
N A Sawant Road
Mumbai 400 005
India
Tel +91 22 2281 0066
contact@project88.in
www.project88.in

**Contact**
Sree Goswami

**Artists**
Shumon Ahmed
Mahesh Baliga
Sarnath Banerjee
Hemali Bhuta
Chirodeep Chaudhuri
Neha Choksi
Baptist Coelho
Desire Machine Collective
Rohini Devasher
Shreyas Karle
Sandeep Mukherjee
Huma Mulji
The Otolith Group
Pallavi Paul
Prajaka Potnis
Raqs Media Collective
Tejal Shah
Risham Syed

## Project Native Informant

**Stand Number L1**
Tel +44 20 7499 5587

17 Brooks Mews
London W1K 4DT
United Kingdom
Tel +44 20 7499 5587
write@projectnative
informant.com
www.projectnative
informant.com

**Contact**
Stephan Tanbin
Sastrawidjaja
Jackson Bateman

**Artists**
GCC
Georgie Nettell
Ruairiadh O'Connell
Emanuel Röhss
Shanzhai Biennial

# Gallery Index

## Rampa

**Stand Number G8**
Tel +90 537 855 06 70

Şair Nedim Caddesi 21A
Akaretler 34357
Istanbul
Turkey
Tel +90 212 327 08 00
info@rampaistanbul.com
www.rampaistanbul.com

**Contact**
Leyla Tara Suyabatmaz
Esra Sarıgedik Öktem
Gizem Uslu

**Artists**
Nevin Aladağ
Hüseyin Bahri Alptekin
Vahap Avşar
Canan
Ergin Çavuşoğlu
Cengiz Çekil
Hatice Güleryüz
Selma Gürbüz
Nilbar Güreş
Çağdaş Kahriman
Gülsün Karamustafa
Servet Koçyiğit
Ahmet Oran
Güçlü Öztekin
Erinç Seymen

## Raster

**Stand Number G23**
Tel +48 784 588 854

Wspólna 63
Warsaw 00-687
Poland
Tel +48 784 588 854
info@rastergallery.com
www.rastergallery.com

**Contact**
Lukasz Gorczyca
Michal Kaczynski

**Artists**
Azorro
Olaf Brzeski
Michal Budny
Rafal Bujnowski
Oskar Dawicki
Slawomir Elsner
Aneta Grzeszykowska
KwieKulik
Zbigniew Libera
Marcin Maciejowski
Przemek Matecki
Bartek Materka
Zbigniew Rogalski
Wilhelm Sasnal
Janek Simon
Slavs and Tatars

## Raucci/Santamaria

**Stand Number A8**
Tel +39 81 744 36 45

Corso Amedeo di Savoia 190
Naples 80136
Italy
Tel +39 081 744 36 45
info@
raucciesantamaria.com
www.
raucciesantamaria.com

**Contact**
Umberto Raucci
Carlo Santamaria

**Artists**
Hany Armanious
Mat Collishaw
Danilo Correale
Karl Haendel
Georg Herold
Evan Holloway
Hervé Ingrand
David Jablonowski
Merlin James
David Robbins
Tim Rollins and K.O.S.
Ugo Rondinone
Norbert Schwontkowski
Glenn Sorensen
Cheyney Thompson
Padraig Timoney
Torbjörn Vejvi
Cathy Wilkes
James Yamada

## Real Fine Arts

**Stand Number H20**
Tel +1 646 662 1785

673 Meeker Avenue
New York NY 11222
Tel ++1 347 457 6679
realfinearts@gmail.com
www.realfinearts.com

**Contact**
Tyler Dobson
Ben Morgan-Cleveland

**Artists**
Yuji Agematsu
Nicolas Ceccaldi
Whitney Clafin
Jana Euler
Flame
Manuel Gnam
Bill Hayden
Lena Henke
Morag Keil
Andrei Koschmieder
Caitlin MacBride
Mathieu Malouf
Alissa McKendrick
Dave Miko
Jon Pestoni
Sam Pulitzer
Heji Shin
Ned Vena
Antek Walczak

## Almine Rech Gallery

**Stand Number F8**
Tel +33 1 45 83 71 90

11 Savile Row
London W1S 3PG
United Kingdom
Tel +44 20 7287 3644
contact.london@
alminerech.com

64 rue de Turenne
Paris 75003
France

20 rue de l'Abbaye
Brussels 1050
Belgium

**Contact**
Thomas Dryll
Lisa Boulet
Jason Cori

**Artists**
Ziad Antar
Matthias Bitzer
Joe Bradley
Don Brown
Tom Burr
Beatrice Caracciolo
Mary Corse
Johan Creten
Aaron Curry
Philip-Lorca diCorcia
Ayan Farah
Sylvie Fleury
John Giorno
Mark Hagen
Adam Helms
Gregor Hildebrandt
Patrick Hill
Alex Israel
Isaac Julien
Thomas Kiesewetter
Jeff Koons
Joseph Kosuth
Jannis Kounellis
Ange Leccia
Daniel Lergon
Erik Lindman
Liu Wei
John McCracken
Joel Morrison
David Ostrowski
Sarah Parke & Mark Barrow
Peter Peri
Richard Prince

## Anthony Reynolds Gallery

**Stand Number F10**
Tel +44 20 7439 2201

60 Great Marlborough
Street
London W1F 7BG
United Kingdom
Tel +44 20 7439 2201
info@anthonyreynolds.com
www.anthonyreynolds.com

**Contact**
Anthony Reynolds
Tristram Pye
Jacqui Davies

**Artists**
The Atlas Group
Richard Billingham
Ian Breakwell
Erik Dietman
Peter Gallo
Paul Graham
Lucy Harvey
Emily Jacir
Kai Kaljo
Lewis Klahr
Andrew Mansfield
Asier Mendizabal
Lucia Nogueira
Walid Raad
Georgia Sagri
Nancy Spero
Sturtevant
Jon Thompson
Amikam Toren
Nobuko Tsuchiya
Apichatpong Weerasethakul

Anselm Reyle
Ugo Rondinone
Matthieu Ronsse
Taryn Simon
Katja Strunz
Eduardo Terrazas
Gavin Turk
James Turrell
Ida Tursic & Wilfried Mille
Dewain Valentine
Francesco Vezzoli
Not Vital
Brent Wadden
Franz West
Xiaobai Su
Tsuruko Yamazaki
Yeesookyung
Aaron Young

## Rodeo

**Stand Number L2**
Tel +90 212 293 5800

Yeni Hayat Apartment
Siraselviler 49 D1
Istanbul 34437
Turkey
Tel +90 212 293 5800
info@rodeo-gallery.com
www.rodeo-gallery.com

**Contact**
Sylvia Kouvali

**Artists**
Mark Aerial Waller
Duncan Campbell
Banu Cennetoğlu
Lukas Duwenhögger
Haris Epaminonda
Apostolos Georgiou
Tamara Henderson
Emre Hüner
Iman Issa
Ian Law
Shahryar Nashat
Christodoulos Panayiotou
Eftihis Patsourakis
James Richards

## Galerie Thaddaeus Ropac

**Stand Number A5**
Tel +33 1 42 72 99 00

7 rue Debelleyme
Paris 75003
France
Tel +33 1 42 72 99 00
galerie@ropac.net
www.ropac.net

69 avenue du Général
Leclerc
Paris - Pantin 93500
France

Mirabellplatz 2
Salzburg 5020
Austria

**Contact**
Thaddaeus Ropac
Arne Ehmann
Hella Pohl
Bénédicte Burrus
Séverine Waelchli

**Artists**
Claire Adelfang
Cory Arcangel
Art & Language
Donald Baechler
Mahmoud Bakhshi
Stephan Balkenhol
Ali Banisadr
Georg Baselitz
Oliver Beer
Joseph Beuys
Philippe Bradshaw
Marc Brandenburg
Jean-Marc Bustamante
Tony Cragg
Matali Crasset
Richard Deacon
Elger Esser
Harun Farocki
Sylvie Fleury
Gilbert & George
Antony Gormley
Ilya & Emilia Kabakov
Alex Katz
Anselm Kiefer
Imi Knoebel

Wolfgang Laib
Jonathan Lasker
Lee Bul
Robert Longo
Liza Lou
Marcin Maciejowski
Robert Mapplethorpe
Bernhard Martin
Jason Martin
Farhad Moshiri
Jack Pierson
Rona Pondick
Marc Quinn
Arnulf Rainer
Gerwald Rockenschaub
Tom Sachs
David Salle
Raqib Shaw
Andreas Slominski
Sturtevant
Philip Taaffe
Banks Violette
Not Vital
Andy Warhol
Lawrence Weiner
Erwin Wurm
Yan Pei-Ming

# Gallery Index

## Salon 94

**Stand Number A1**
Tel +1 212 979 0001

243 Bowery
New York NY 10002
United States
Tel +1 212 979 0001
info@salon94.com
www.salon94.com

12 East 94th Street
New York NY 10128
United States

1 Freeman Alley
New York NY 10002
United States

**Contact**
Jeanne Greenberg Rohatyn
Alissa Friedman
Fabienne Stephan
Jessica Witkin

**Artists**
Terry Adkins
Jules de Balincourt
Amy Bessone
Huma Bhabha
Liz Cohen
The Estate of Jimmy
DeSana
Francesca DiMattio
Sylvie Fleury
Katy Grannan
Paula Hayes
Jon Kessler
Takuro Kuwata
Marilyn Minter
The Estate of Carlo Mollino
Takeshi Murata
Jayson Musson
Carlos Rolon/Dzine
David Benjamin Sherry
Laurie Simmons
Lorna Simpson
Betty Woodman

## Esther Schipper

**Stand Number C12**
Tel +49 30 3744 33133

Schöneberger Ufer 65
Berlin 10785
Germany
Tel +49 30 3744 33133
office@estherschipper.com
www.estherschipper.com

**Contact**
Esther Schipper
Stefanie Lockwood
Florian Luedde
Shi-ne Oh
José Castanal

**Artists**
Matti Braun
AA Bronson
Angela Bulloch
Nathan Carter
Thomas Demand
Jean-Pascal Flavien
Ceal Floyer
The Estate of General Idea
Liam Gillick
Dominique Gonzalez-
Foerster
Pierre Huyghe
Ann Veronica Janssens
Christoph Keller
Gabriel Kuri
Isa Melsheimer
Ari Benjamin Meyers
Grönlund-Nisunen
Philippe Parreno
Ugo Rondinone
Christopher Roth
Karin Sander
Tomás Saraceno
Julia Scher
Daniel Steegmann
Mangrané

## Galerie Rüdiger Schöttle

**Stand Number B21**
Tel +49 89 333 686

Amalienstrasse 41
Munich 80799
Germany
Tel +49 89 333 686
info@galerie-schoettle.de
www.galerie-ruediger-
schoettle.de

**Contact**
Rüdiger Schöttle
Ingrid Lohaus

**Artists**
Janis Avotins
Stephan Balkenhol
Maria Bartuszova
Armin Boehm
Martin Boyce
David Claerbout
Anders Clausen
Steven Claydon
Martin Creed
Slawomir Elsner
Elger Esser
Liam Gillick
Dan Graham
Rodney Graham
Thomas Helbig
Lorena Herrera Rashid
Candida Höfer
John Knight
Bela Kolarova
Goshka Macuga
Jan Merta
Alex Mirutziu
Andrew Palmer
Thomas Ruff
Anri Sala
Thomas Schütte
Thomas Struth
Florian Süssmayr
Jeff Wall
Thomas Zipp

## Galerie Micky Schubert

**Stand Number G13**
Tel +49 30 4980 8487

Bartningallee 2–4
Berlin D-10557
Germany
Tel +49 30 4980 8487
info@mickyschubert.de
www.mickyschubert.de

**Contact**
Micky Schubert
Mihaela Chiriac

**Artists**
Ketuta Alexi-Meskhishvili
Marieta Chirulescu
Thea Djordjadze
Graham Fagen
Lydia Gifford
Manuela Leinhoss
Barry MacGregor Johnston
Alan Michael
Scott Olson
Gerda Scheepers
Daniel Sinsel
Stephen Sutcliffe
Sue Tompkins
Mark van Yetter
Maximilian Zentz
Zlomovitz

## Barbara Seiler

**Stand Number J12**
Tel +41 43 3171042

Anwandstrasse 67
Zurich 8004
Switzerland
Tel +41 43 3171042
info@barbaraseiler.ch
www.barbaraseiler.ch

**Contact**
Barbara Seiler

**Artists**
Pauline Bastard
Justin Bennett
Heimir Björgúlfsson
Sarah Conaway
Dina Danish
Sander van Deurzen
Marijn van Kreij
Shana Lutker
Alex Mirutziu
Marc Nagtzaam
Annaïk Lou Pitteloud
Pascal Schwaighofer
Ante Timmermans

## Shanghart Gallery

**Stand Number A15**
Tel +86 21 6359 3923

Building 16 & 18
50 Moganshan Road
Shanghai 200060
China
Tel +86 21 6359 3923
info@shanghartgallery.com
www.shanghartgallery.com

**Contact**
Lorenz Helbling
Chen Yan

**Artists**
Bird Head
Chen Xiaoyun
Ding Yi
Geng Jianyi
Han Feng
Hu Jieming
Hu Yang
Huang Kui
Ji Wenyu & Zhu Weibing
Li Pinghu
Li Shan
Liang Shaoji
Liang Yue
Liu Weijian
Xu Zhen/MadeIn Company
Mao Yan
Pu Jie
Shao Yi
Shen Fan
Shi Qing
Shi Yong
Sun Xun
Tang Maohong
Wang Guangyi
Wang Youshen
Wei Guangqing
Wu Yiming
Xiang Liqing
Xu Zhen
Xue Song
Yang Fudong
Yang Zhenzhong
Yu Youhan
Yuan Yuan
Zeng Fanzhi
Zhang Ding
Zhang Enli
Zhang Qing
Zhao Bandi
Zhou Tiehai
Zhou Zixi
Zhu Jia

## Sfeir-Semler

**Stand Number B8**
Tel +961 1 566550

4th Floor
Tannous Building Street 56
Jisr Sector 77
Beirut 20777209
Lebanon
Tel +961 1 566550
galerie@sfeir-semler.com
www.sfeir-semler.com

Admiralitätstrasse 71
Hamburg 20459
Germany

**Contact**
Andrée Sfeir-Semler
Anna Nowak
Rana Nasser Eddin

**Artists**
Etel Adnan
Haig Aivazian
Mounira Al Solh
Yto Barrada
Robert Barry
Taysir Batniji
Anna Boghiguian
Balthasar Burkhard
Elger Esser
Hans Haacke
Günter Haese
Ian Hamilton Finlay
MARWAN
Hiroyuki Masuyama
Rabih Mroué
Timo Nasseri
Walid Raad/The Atlas Group
Khalil Rabah
Marwan Rechmaoui
Wael Shawky
Christine Streuli
Rayyane Tabet
Akram Zaatari

## Silberkuppe

**Stand Number L5**
Tel +49 17 8454 2911

Keithstrasse 12
Berlin 10787
Germany
Tel +49 30 3744 3135
mail@silberkuppe.org
www.silberkuppe.org

**Contact**
Dominic Eichler
Michel Ziegler

**Artists**
Leidy Churchman
Michaela Eichwald
Margaret Harrison
Tobias Kaspar
Laura Lamiel
Janette Laverrière
Adam Linder
Fred Lonidier
Shahryar Nashat
Anna Ostoya

## Société

**Stand Number G15**
Tel +49 17 1689 1205

Genthiner Strasse 36
Berlin 10785
Germany
Tel +49 30 8161 8962
contact@societeberlin.com
www.societeberlin.com

**Contact**
Hans Bülow
Daniel Wichelhaus

**Artists**
Trisha Baga
Josh Kolbo
Kaspar Müller
Sean Raspet
Davis Rhodes
Bunny Rogers
Matthew Schlanger
Timur Si-Qin
Ned Vena

## Sommer Contemporary Art

**Stand Number A19**
Tel +972 52 331 6828

Rothschild Boulevard
Tel Aviv 6688116
Israel
Tel +972 3 516 6400
info@sommergallery.com
www.sommergallery.com

**Contact**
Irit Fine Sommer
Noa Resheff
Tamar Zagursky

**Artists**
Saâdane Afif
Darren Almond
Naama Arad
Yael Bartana
Guy Ben-Ner
Tom Burr
Rineke Dijkstra
Tamar Harpaz
Michal Helfman
Gregor Hildebrandt
Karl Kaendel
Itzik Livneh
Muntean/Rosenblum
Amir Nave
Adi Nes
Tal R
Ugo Rondinone
Wilhelm Sasnal
Yehudit Sasportas
Netally Schlosser
Efrat Shvily
Wolfgang Tillmans
Paloma Varga Weisz
Sharon Ya'ari
Rona Yefman
Guy Zagursky
Thomas Zipp

# Gallery Index

## Sprüth Magers

**Stand Number C5**
Tel +44 20 7408 1613

Oranienburger Strasse 18
Berlin 10178
Germany
Tel +49 30 2888 4030
info@spruethmagers.com
www.spruethmagers.com

7A Grafton Street
London W1S 4EJ
United Kingdom

**Contact**
Monika Sprüth
Philomene Magers
Iris Scheffler

**Artists**
Kenneth Anger
Siegfried Anzinger
Keith Arnatt
Richard Artschwager
John Baldessari
Bernd & Hilla Becher
John Bock
Alighiero Boetti
George Condo
Walter Dahn
Thomas Demand
Philip-Lorca diCorcia
Thea Djordjadze
Marcel van Eeden
Robert Elfgen
Peter Fischli & David Weiss
Sylvie Fleury
Cyprien Gaillard
Andreas Gursky
Jenny Holzer
Gary Hume
Donald Judd
Axel Kasseböhmer
Karen Kilimnik
Astrid Klein
Joseph Kosuth
Kraftwerk
Barbara Kruger
David Lamelas
Louise Lawler
David Maljkovic
Anthony McCall
Robert Morris
Reinhard Mucha
Jean-Luc Mylayne
Michail Pirgelis
Nina Pohl
Richard Prince
Sterling Ruby
Ed Ruscha
Analia Saban
Gerda Scheepers
Thomas Scheibitz
Frances Scholz
Andreas Schulze
Cindy Sherman
Stephen Shore
Alexandre Singh
Robert Therrien
Ryan Trecartin
Rosemarie Trockel
John Waters
Andro Wekua
Andrea Zittel

## Gregor Staiger

**Stand Number H21**
Tel +41 44 491 3900

Limmatstrasse 268
Zurich 8005
Switzerland
Tel +41 44 491 3900
info@gregorstaiger.com
www.gregorstaiger.com

**Contact**
Gregor Staiger

**Artists**
Vittorio Brodmann
Florian Germann
Sonia Kacem
Brian Moran
Shana Moulton
Nicolas Party
Lucy Stein

## Standard (Oslo)

**Stand Number D1**
Tel +47 22 60 13 10

Waldemar Thranes
Gate 86C
Oslo N-0175
Norway
Tel +47 22 60 13 10
info@standardoslo.no
www.standardoslo.no

**Contact**
Eivind Furnesvik
Gilda Axelroud

**Artists**
Tauba Auerbach
Nina Beier
Ian Cheng
Gardar Eide Einarsson
Marius Engh
Matias Faldbakken
Aaron Garber-Maikovska
Goutam Ghosh
Kim Hiorthøy
Ann Cathrin November Høibo
Alex Hubbard
Michaela Meise
Anders Nordby
Chadwick Rantanen
Nick Relph
Torbjørn Rødland
Josh Smith
Oscar Tuazon
Fredrik Værslev
Emily Wardill

## Galeria Stereo

**Stand Number H24**
Tel +48 503 17 89 65

Zelazna 68/4
Warsaw 00-866
Poland
Tel +48 503 17 89 65
galeriastereo@gmail.com
www.galeriastereo.pl

**Contact**
Zuzanna Hadrys
Michal Lasota

**Artists**
Wojciech Bakowski
Piotr Bosacki
Piotr Lakomy
Norman Leto
Gizela Mickiewicz
Mateusz Sadowski
Roman Stanczak
Magdalena Starska

## Stevenson

**Stand Number G10**
Tel +27 21 462 1500

Buchanan Building
160 Sir Lowry Road
Cape Town 7925
South Africa
Tel +27 21 462 1500
info@stevenson.info
www.stevenson.info

PO Box 616
Cape Town 8051
South Africa

**Contact**
Federica Angelucci
Joost Bosland
David Brodie
Andrew da Conceicao
Sophie Perryer

**Artists**
Zander Blom
Dineo Seshee Bopape
Wim Botha
Steven Cohen
Paul Edmunds
Ângela Ferreira
Meschac Gaba
Ian Grose
Simon Gush
Nicholas Hlobo
Pieter Hugo
Mawande Ka Zenzile
Anton Kannemeyer
Michael MacGarry
The Estate of Ernest Mancoba
Sabelo Mlangeni
Nandipha Mntambo
Zanele Muholi
Daniel Naudé
Serge Alain Nitegeka
Odili Donald Odita
Deborah Poynton
Jo Ractliffe
Robin Rhode
Viviane Sassen
Claudette Schreuders
Penny Siopis
Guy Tillim
Barthélémy Toguo
Kemang Wa Lehulere
Portia Zvavahera

## Galeria Luisa Strina

**Stand Number D8**
Tel +55 11 3088 2471

Rua Padre João Manuel 755
São Paulo 01411001
Brazil
Tel +55 11 3088 2471
info@
galerialuisastrina.com.br
www.
galerialuisastrina.com.br

**Contact**
Luisa Malzoni Strina
Marli Matsumoto
Maria Quiroga

**Artists**
Pablo Accinelli
Caetano de Almeida
Leonor Antunes
Juan Araujo
Tonico Lemos Auad
Alessandro Balteo Yazbeck
Eduardo T. Basualdo
Laura Belém
Alexandre da Cunha
Matías Duville
Olafur Eliasson
León Ferrari
Marcius Galan
Carlos Garaicoa
Fernanda Gomes
Brian Griffiths
Federico Herrero
Magdalena Jitrik
Marcellvs L.
Luisa Lambri
Laura Lima
Jarbas Lopes
Mateo López
Renata Lucas
Jorge Macchi
Anna Maria Maiolino
Antonio Manuel
Marepe
Gilberto Mariotti
Cildo Meireles
Pedro Motta
Antoni Muntadas
Bernardo Ortiz
Nicolás Paris
Pedro Reyes
Marina Saleme
Beto Shwafaty
Gabriel Sierra
Edgard de Souza
Adrián Villar Rojas

## Simone Subal Gallery

**Stand Number H15**
Tel +1 917 334 1147

2nd Floor, 131 Bowery
New York NY 10002
United States
Tel +1 917 409 0612
info@simonesubal.com
www.simonesubal.com

**Contact**
Simone Subal
Emily Kohl-Mattingley

**Artists**
Sonia Almeida
Larry Bamburg
Julien Bismuth
Sam Ekwurtzel
Frank Heath
Anna K.E.
The Estate of Kiki Kogelnik
Florian Meisenberg
Brian O'Doherty
Yorgos Sapountzis
Erika Vogt

## Sultana

**Stand Number G25**
Tel +33 1 44 54 08 90

12 rue Ramponeau
Paris 75020
France
Tel +33 1 44 54 08 90
contact@galeriesultana.com
www.galeriesultana.com

**Contact**
Guillaume Sultana

**Artists**
Pia Camil
François Xavier Courrèges
Jacin Giordano
Celia Hempton
Emmanuel Lagarrigue
Arnaud Maguet
Olivier Millagou
Beatriz Monteavaro
Gavin Perry
Walter Pfeiffer
Naufus Ramirez Figueroa
Sally Ross
Bettina Samson
Stefan Sehler

## Supportico Lopez

**Stand Number G21**
Tel +49 30 3198 9387
Kurfürstenstrasse 14B
Berlin 10785
Germany
Tel +49 30 3198 9387
info@supporticolopez.com
www.supporticolopez.com

**Contact**
Gigiotto Del Vecchio
Stefania Palumbo
Marie-Christine Molitor
Von Muehlfeld

**Artists**
Armando Andrade Tudela
Julian Beck
Steve Bishop
Henri Chopin
Danilo Correale
Michael Dean
Maria Adele Del Vecchio
Giulio Delvé
Marius Engh
Jan Peter Hammer
Natalie Häusler
Franziska Lantz
Christina Mackie
Zin Taylor
Niels Trannois
J. Parker Valentine

# Gallery Index

## T293

**Stand Number A21**
Tel +39 347 0836509

Via Giovanni Mario
Crescimbeni 11
Rome 00184
Italy
Tel +39 06 88980475
info@t293.it
www.t293.it

Via Tribunali 293
Naples 80138
Italy

**Contact**
Marco Altavilla
Paola Guadagnino
Alessia Volpe
Vittorio Visciano

**Artists**
James Beckett
Ethan Cook
Simon Denny
Patrizio Di Massimo
Sam Falls
Claire Fontaine
May Hands
John Henderson
Henrik Olai Kaarstein
Sonia Kacem
Wyatt Kahn
David Maljković
Helen Marten
Pennacchio Argentato
Dan Rees
Emanuel Röhss
Martin Soto Climent
Alberto Tadiello
Tris Vonna-Michell

## Take Ninagawa

**Stand Number H8**
Tel +81 90 9870 5594

2-12-4 Higashi Azabu
Minatoku Tokyo 1060044
Japan
Tel +81 3 5571 5844
info@takeninagawa.com
www.takeninagawa.com

**Contact**
Atsuko Ninagawa
Miyako Tan

**Artists**
Ryoko Aoki
Dale Berning
Aki Goto
Taro Izumi
Shinpei Kageshima
Misaki Kawai
Yoriko Kita
Chikara Matsumoto
Yuuki Matsumura
Shinro Ohtake
Ken Okiishi
Aki Sasamoto
Yukiko Suto
Soju Tao
Tsuruko Yamazaki

## Timothy Taylor Gallery

**Stand Number B17**
Tel +44 20 7409 3344

15 Carlos Place
London W1K 2EX
United Kingdom
Tel +44 20 7409 3344
mail@timothytaylor
gallery.com
www.timothytaylor
gallery.com

**Contact**
Timothy Taylor
Tania Doropoulos

**Artists**
Craigie Aitchison
Diane Arbus
Robert Bechtle
Jean-Marc Bustamante
Armen Eloyan
Lee Friedlander
Adam Fuss
Ewan Gibbs
Philip Guston
Simon Hantaï
Hans Hartung
Susan Hiller
Volker Hüller
Jessica Jackson Hutchins
Eemyun Kang
Alex Katz
Jonathan Lasker
Agnes Martin
Eddie Martinez
Josephine Meckseper
Richard Patterson
Mai-Thu Perret
Serge Poliakoff
Fiona Rae
Sean Scully
Kiki Smith
Tony Smith
Pierre Soulages
Antoni Tàpies
Liliane Tomasko
Lucy Williams

## Tempo Rubato

**Stand Number H11**
Tel +972 72 215 0302

Sgula Street 9
Tel Aviv 68116
Israel
Tel +972 72 215 0302
info@temporubato.org
www.temporubato.org

**Contact**
Guillaume Rouchon

**Artists**
Eden Bannet
Joav Barel
Noa Glazer
Raz Gomeh
Lutz Hatzor
Oran Hoffmann
Nadira Husain
Imri Kahn
Lital Lev Cohen
Paul P.
Oren Pinhassi
Xanti Schawinsky
Yariv Spivak
Susanne M. Winterling

## The Third Line

**Stand Number J1**
Tel +971 04 341 1367

Street 6, Al Quoz 3
Dubai 72036
United Arab Emirates
Tel +971 04 341 1367
artfair@thethirdline.com
www.thethirdline.com

**Contact**
Claudia Cellini
Sunny Rahbar
Laura Metzler

**Artists**
Ebtisam Abdulaziz
Arwa Abouon
Abbas Akhavan
Tarek Al-Ghoussein
Shirin Aliabadi
Sophia Al-Maria
Rana Begum
Ala Ebtekar
Fouad Elkoury
Amir H. Fallah
Golnaz Fathi
Lamya Gargash
Babak Golkar
Sherin Guirguis
Joana Hadjithomas & Khalil
Joreige
Hassan Hajjaj
Sahand Hesamiyan
Pouran Jinchi
Hayv Kahraman
Laleh Khorramian
Huda Lutfi
Farhad Moshiri
Youssef Nabil
Sara Naim
Zineb Sedira
Monir Shahroudy
Farmanfarmaian
Slavs and Tatars

## Vermelho

**Stand Number G11**
Tel +55 11 3138 1520

Rua Minas Gerais 350
São Paulo 01244-010
Brazil
Tel +55 11 3138 1520
info@
galeriavermelho.com.br
www.
galeriavermelho.com.br

**Contact**
Eliana Finkelstein
Eduardo Brandao
Akio Aoki

**Artists**
Gabriela Albergaria
Jonathas de Andrade
Claudia Andujar
Ivan Argote
Rafael Assef
Nicolás Bacal
Chiara Banfi
Rodrigo Braga
Leya Mira Brander
Cadu
Henrique César
Lia Chaia
Marcelo Cidade
Marilá Dardot
Detanico & Lain
Dias & Riedweg
Chelpa Ferro
Cia. de Foto
Carmela Gross
Maurício Ianês
Clara Ianni
Enrique Jezik
André Komatsu
Dora Longo Bahia
João Loureiro
Cinthia Marcelle
Odires Mlázsho
Fabio Morais
Gisela Motta & Leandro
Lima
Guilherme Peters
Rosângela Rennó
Nicolás Robbio
Daniel Senise
Ana Maria Tavares
Carla Zaccagnini

## Vilma Gold

**Stand Number F2**
Tel +44 20 7729 9888

6 Minerva Street
London E2 9EH
United Kingdom
Tel +44 20 7729 9888
mail@vilmagold.com
www.vilmagold.com

**Contact**
Rachel Williams
Martin Rasmussen

**Artists**
Charles Atlas
Trisha Baga
KP Brehmer
Nicholas Byrne
William Daniels
Vladimir Dubossarsky &
Alexander Vinogradov
Michaela Eichwald
Felix Gmelin
Brian Griffiths
Sophie von Hellermann
Hobbypopmuseum
Lucas Knipscher
Alan Michael
Marlie Mul
Oliver Osborne
Karthik Pandian
Luther Price
Stephen G. Rhodes
José Rojas
Hannah Sawtell
Markus Selg
Josef Strau
Philipp Timischl
Mark Titchner
Julia Wachtel
Jennifer West

## Vitamin
## Creative Space

**Stand Number F1**
Tel +86 20 8429 6760

Room 301, 29 Hao
Heng Yi Jie, Chi Gang Xi Lu
Guangzhou 510300
China
Tel +86 20 8429 6760
mail@vitamincreative
space.com
www.vitamincreative
space.com

**Contact**
Yan Chuan

**Artists**
Tarek Atoui
Cao Fei
Heman Chong
Chu Yun
Pak Sheung Chuen
Duan Jianyu
Olafur Eliasson
Sou Fujimoto
Firenze Lai
Hao Liang
Lee Kit
Lu Chunsheng
Ming Wong
Koki Tanaka
Danh Võ
Xu Tan
Jun Yang
Yangjiang Group
Zheng Guogu
Zhou Tao

## Wallspace

**Stand Number H4**
Tel +1 212 594 9478

619 West 27th Street
New York NY 10001
United States
Tel +1 212 594 9478
info@wallspacegallery.com
www.wallspacegallery.com

**Contact**
Janine Föller
Jane Hait
Nichole Caruso

**Artists**
Ron Amstutz
Kate Costello
John Divola
Harry Dodge
Shannon Ebner
Paul Elliman
Martha Friedman
Gaylen Gerber
Daniel Gordon
David Korty
Jiří Kovanda
Scott Olson
Laura Riboli
Patricia Treib
Helen Verhoeven
Donelle Woolford

## Michael
## Werner

**Stand Number A7**
Tel +44 20 7495 6855

22 Upper Brook Street
London W1K 7PZ
United Kingdom
Tel +44 20 7495 6855
london@
michaelwerner.com
www.michaelwerner.com

4 East 77th Street
New York NY 10075
United States

**Contact**
Gordon VeneKlasen
Kadee Robbins
Harry Scrymgeour
Birte Kleemann

**Artists**
Hurvin Anderson
Georg Baselitz
Marcel Broodthaers
James Lee Byars
Aaron Curry
Enrico David
Peter Doig
Jörg Immendorff
Per Kirkeby
Eugène Leroy
Markus Lüpertz
Ernst Wilhelm Nay
A.R. Penck
Sigmar Polke
Don Van Vliet
Michael Williams

# Gallery Index

## White Cube

**Stand Number D4**
Tel +44 20 7930 5373

144–152 Bermondsey Street
London SE1 3TQ
United Kingdom
Tel +44 20 7930 5373
enquiries@whitecube.com
www.whitecube.com

25–26 Mason's Yard
London SW1Y 6BU
United Kingdom

50 Connaught Road Central
Hong Kong
China

Rua Agostinho Rodrigues
Filho
550 São Paulo
Brazil

**Contact**
Jay Jopling
Daniela Gareh
Susan May

**Artists**
Franz Ackermann
Darren Almond
Ellen Altfest
Mirosław Bałka
Georg Baselitz
Larry Bell
Ashley Bickerton
Mark Bradford
Candice Breitz
Jake & Dinos Chapman
Chuck Close
Gregory Crewdson
Tracey Emin
Katharina Fritsch
Theaster Gates
Gilbert & George
Antony Gormley
Andreas Gursky
Mona Hatoum
Eberhard Havekost
Damien Hirst
Gary Hume
Robert Irwin
Runa Islam
Sergej Jensen
Anselm Kiefer
Rachel Kneebone
Friedrich Kunath
Elad Lassry
Jac Leirner
Liu Wei
Liza Lou
Christian Marclay
Kris Martin

Josiah McElheny
Julie Mehretu
Harland Miller
Sarah Morris
Gabriel Orozco
Damián Ortega
Virginia Overton
Eddie Peake
Richard Phillips
Magnus Plessen
Marc Quinn
Jessica Rankin
Christian Rosa
Doris Salcedo
Raqib Shaw
Haim Steinbach
Sam Taylor-Johnson
Fred Tomaselli
Jeff Wall
Cerith Wyn Evans
Zhang Huan

## Wien Lukatsch

**Stand Number G7**
Tel +49 173 615 6996

Schöneberger Ufer 65
Berlin 10785
Germany
Tel +49 30 2838 5352
info@barbarawien.de
www.wienlukatsch.de

**Contact**
Barbara Wien
Wilma Lukatsch
Petra Graf

**Artists**
Georges Adéagbo
Nina Canell
Mariana Castillo Deball
Jimmie Durham
Hans-Peter Feldmann
Robert Filliou
Luca Frei
Ludwig Gosewitz
Arthur Köpcke
Dave McKenzie
Elisabeth Neudörfl
Peter Piller
Eva von Platen
Thomas Ravens
Dieter Roth
Tomas Schmit
Shimabuku
Ingrid Wiener
Haegue Yang

## Wilkinson

**Stand Number G1**
Tel +44 20 8980 2662

50–58 Vyner Street
London E2 9DQ
United Kingdom
Tel +44 20 8980 2662
info@wilkinsongallery.com
www.wilkinsongallery.com

**Contact**
Amanda Wilkinson
Anthony Wilkinson
Rhian Smith

**Artists**
Mark Alexander
Dara Birnbaum
Juliette Bonneviot
Matt Calderwood
Heman Chong
Clegg & Guttmann
The Estate of Jimmy
DeSana
A K Dolven
Harm van den Dorpel
Matthew Higgs
The Estate of Derek Jarman
Travis Jeppesen
Joan Jonas
Tillman Kaiser
Ilja Karilampi
Sung Hwan Kim
Thoralf Knobloch
Makiko Kudo
Marcin Maciejowski
Elizabeth Magill
Renzo Martens
Ciprian Muresan
Anna Parkina
Pennacchio Argentato
Barbara Probst
Jewyo Rhii
Silke Schatz
George Shaw
Shimabuku
Laurie Simmons
Phoebe Unwin

## Galerie Jocelyn Wolff

**Stand Number L4**
Tel +33 1 42 03 05 65

78 rue Julien-Lacroix
Paris 75020
France
Tel +33 1 42 03 05 65
info@galeriewolff.com
www.galeriewolff.com

**Contact**
Jocelyn Wolff
Sandrine Djerouet
Nasim Weiler

**Artists**
William Anastasi
Zbynek Baladrán
Diego Bianchi
Katinka Bock
Miriam Cahn
Valérie Favre
Prinz Gholam
Guillaume Leblon
Isa Melsheimer
Frédéric Moser & Philippe
Schwinger
Ulrich Polster
Hans Schabus
Elodie Seguin
Francisco Tropa
Franz Erhard Walther
Christoph Weber
Clemens von Wedemeyer

## Workplace Gallery

**Stand Number H10**
Tel +44 7951 832 671

The Old Post Office
19–21 West Street
Gateshead NE8 1AD
United Kingdom
Tel +44 191 477 2200
info@
workplacegallery.co.uk
www.
workplacegallery.co.uk

**Contact**
Paul Moss
Miles Thurlow
Chris Morgan
Karen Davies

**Artists**
Tanya Axford
Eric Bainbridge
Darren Banks
Sophie Lisa Beresford
Cath Campbell
Hugo Canoilas
Joe Clark
Marcus Coates
Jo Coupe
Jacob Dahlgren
Jennifer Douglas
Peter J. Evans
Laura Lancaster
Rachel Lancaster
Paul Merrick
Mike Pratt
Richard Rigg
Cecilia Stenbom
Matt Stokes
Wolfgang Weileder

## Leo Xu Projects

**Stand Number H19**
Tel +86 21 3461 1245

Lane 49, Building 3
Fuxing Xi Road
Xuhui District
Shanghai 200031
China
Tel +86 21 3461 1245
info@leoxuprojects.com
www.leoxuprojects.com

**Contact**
Leo Xu

**Artists**
aaajiao
Chen Wei
Cheng Ran
Cui Jie
Guo Hongwei
Gabriel Lester
Li Qing
Michael Lin
Liu Chuang

## Zeno X Gallery

**Stand Number E4**
Tel +32 3 216 16 26

Godtsstraat 15
Borgerhout
Antwerp 2140
Belgium
Tel +32 3 216 16 26
info@zeno-x.com
www.zeno-x.com

**Contact**
Frank Demaegd
Jelle Breynaert
Benedicte Goesaert

**Artists**
Michaël Borremans
Dirk Braeckman
Patrick van Caeckenbergh
Anton Corbijn
Marlene Dumas
Kees Goudzwaard
Susan Hartnett
Kim Jones
Johannes Kahrs
Naoto Kawahara
Anne-Mie van Kerckhoven
Raoul de Keyser
John Körmeling
Jan de Maesschalck
Mark Manders
Jockum Nordström
Pietro Roccasalva
Grace Schwindt
Jenny Scobel
Bart Stolle
Mircea Suciu
Luc Tuymans
Jack Whitten
Yun-Fei Ji
Cristof Yvoré

## David Zwirner

**Stand Number B7**
Tel +1 212 727 2070

525 West 19th Street
New York NY 10011
United States
Tel +1 212 727 2070
information@
davidzwirner.com
www.davidzwirner.com

537 West 20th Street
New York NY 10011
United States

24 Grafton Street
London W1S 4EZ
United Kingdom

**Contact**
David Zwirner
Kristine Bell
Angela Choon
Christopher D'Amelio
Justine Durrett
Bellatrix Hubert
Branwen Jones
David Leiber
Greg Lulay
Ales Ortuzar
Hanna Schouwink

**Artists**
Adel Abdessemed
Tomma Abts
Francis Alÿs
Mamma Andersson
Karla Black
Michaël Borremans
Carol Bove
R. Crumb
Philip-Lorca diCorcia
Stan Douglas
Marlene Dumas
Marcel Dzama
Dan Flavin
Suzan Frecon
Isa Genzken
Donald Judd
On Kawara
Raoul de Keyser
Toba Khedoori
Jeff Koons
Yayoi Kusama
Kerry James Marshall
Gordon Matta-Clark
John McCracken
Oscar Murillo
Alice Neel
Jockum Nordström
Chris Ofili
Raymond Pettibon
Neo Rauch
Ad Reinhardt
Jason Rhoades
Michael Riedel
Bridget Riley
Thomas Ruff
Fred Sandback
Richard Serra
Yutaka Sone
Al Taylor
Diana Thater
Wolfgang Tillmans
Luc Tuymans
James Welling
Doug Wheeler
Christopher Williams
Jordan Wolfson
Lisa Yuskavage

# Magazine Index

## Art in America
**Stand M18**
2nd Floor
110 Greene Street
New York NY 10012
United States
Tel +1 212 941 2800
info@brantpub.com
www.artinamerica
magazine.com

## Art Monthly
**Stand M12**
4th Floor
28 Charing Cross Road
London WC2H 0DB
United Kingdom
Tel +44 20 7240 0389
info@artmonthly.co.uk
www.artmonthly.co.uk

## The Art Newspaper
**Stand M19**
70 South Lambeth Road
London SW8 1RL
United Kingdom
Tel +44 20 3416 9000
subscribe@
theartnewspaper.com
www.theartnewspaper.com

## ArtAsiaPacific
**Stand M24**
GPO Box 10084
Hong Kong
Tel +852 2553 5586
info@aapmag.com
www.artasiapacific.com

## Artforum International
**Stand M4**
19th Floor
350 Seventh Avenue
New York NY 10001
United States
Tel +1 212 475 4000
generalinfo@
artforum.com
www.artforum.com

## ArtMag
**Stand M7**
Deutsche Bank AG
CC Art
Frankfurt 60325
Germany
Tel +49 69 9104 3087
mailbox.kunst@db.com
www.db-artmag.com

## ArtReview
**Stand M9**
1 Honduras Street
London EC1Y 0TH
United Kingdom
office@artreview.com
www.artreview.com

## Afterall
**Stand M22**
Central Saint Martins
College of Art and Design
Granary Building
1 Granary Square
London N1C 4AA
United Kingdom
Tel +44 20 7514 7212
contact@afterall.org
www.afterall.org

## Art + Auction
**Stand M21**
88 Laight Street
New York NY 10013
United States
Tel +1 917 767 3279
dgursky@artinfo.com
www.blouinartinfo.com

## Bidoun Projects
**Stand M10**
Suite 501
144 North 7th Street
New York NY 11249
United States
Tel +1 212 475 0123
info@bidoun.org
www.bidoun.org

## Cabinet
**Stand M23**
181 Wyckoff Street
New York NY 11217
United States
Tel +1 718 222 8434
info@cabinetmagazine.org
www.cabinetmagazine.org

## Canvas
**Stand M14**
G-07, Loft 1C
Dubai Media City
PO Box 500487
Dubai
United Arab Emirates
Tel +971 4 367 1693
info@mixed-media.com
www.canvasonline.com

## cura.
**Stand M17**
Via Nicola Ricciotti 4
Rome 00195
Italy
Tel +39 06 960 396 72
info@curamagazine.com
www.curamagazine.com

## esse
**Stand M16**
C.P. 47549
Comptoir Plateau Mont-
Royal
Montreal (Quebec)
H2H 2S8
Canada
Tel +1 514 521 8597
revue@esse.ca
www.esse.ca

## Financial Times

**Stand M6**
1 Southwark Bridge
London SE1 9HL
United Kingdom
Tel +44 20 7873 3000
www.FT.com

## Flash Art International

**Stand M8**
Giancarlo Politi Editore
Via Carlo Farini 68
Milan 20159
Italy
Tel +39 02 688 7341
info@flashartonline.com
www.flashartonline.com

## frieze

**Stand M3**
1 Montclare Street
London E2 7EU
United Kingdom
Tel +44 20 3372 6111
info@frieze.com
www.frieze.com

## frieze d/e

**Stand M3**
Zehdenicker Strasse 28
Berlin 10119
Germany
Tel +49 30 2362 6506
berlin@frieze.de
www.frieze-magazin.de

## Frieze Masters Magazine

**Stand M3**
1 Montclare Street
London E2 7EU
United Kingdom
Tel +44 20 3372 6111
info@frieze.com
www.frieze.com

## International New York Times

**Stand M15**
4 Place des Vosges
CS 10001
92052 Paris La Défense
Cedex
France
Tel +800 4448 7827
inytsubs@nytimes.com
www.inyt.com

## Kaleidoscope

**Stand M11**
Via Macedonio Melloni 33
Milan 20129
Italy
intern@
kaleidoscope-press.com
www.
kaleidoscope-press.com

## Leap

**Stand M20**
5F, Tower 1
China View Building
No. A2 Gongti East Road
Chaoyang District
Beijing 100027
China
Tel +86 10 6561 5550
leap@
modernmedia.com.cn
www.leapleapleap.com

## Modern Painters

**Stand M21**
88 Laight Street
New York NY 10013
United States
Tel +1 917 767 3279
kmurphy@artinfo.com
www.blouinartinfo.com

## Mousse

**Stand M5**
Via De Amicis 53
Milan 20123
Italy
Tel +39 02 835 6631
info@moussemagazine.it
www.moussemagazine.it

## springerin

**Stand M13**
Museumplatz 1
Vienna 1070
Austria
Tel +43 15 229 124
springerin@springerin.at
www.springerin.at

## Texte zur Kunst

**Stand M2**
Strausberger Platz 19
Berlin 10243
Germany
Tel +49 30 301 045 345
verlag@textezurkunst.de
www.textezurkunst.de

# Artist Index

**Armanious, Hany**
Raucci/Santamaria A8
**Armleder, John**
Massimo De Carlo B1
**Arnatt, Keith**
Maureen Paley D13
Sprüth Magers C5
**Arnold, Martin**
Galerie Martin Janda B12
**Arruda, Lucas**
Mendes Wood DM H2
**Arsham, Daniel**
Galerie Perrotin A16
**Art & Language**
Galería Juana de Aizpuru B15
Lisson Gallery B5
Galerie Thaddaeus Ropac A5
**Arte/Ação**
Galeria Jaqueline Martins H22
**Artschwager, Richard**
Gagosian Gallery C3
Georg Kargl Fine Arts B18
Sprüth Magers C5
**Arunanondchai, Korakrit**
Carlos/Ishikawa G26
**Asins, Elena**
Galería Juana de Aizpuru B15
**Askevold, David**
Canada J6
**Assef, Rafael**
Vermelho G11
**assume vivid astro focus**
Peres Projects G2
**Atay, Fikret**
Galerie Chantal Crousel F11
**Atelier**
Cabinet F4
**Atkins, Ed**
Allied Editions J13
Gavin Brown's enterprise F9
Cabinet F4
**Atlas, Charles**
Vilma Gold F2
**The Atlas Group/Walid Raad**
Anthony Reynolds Gallery F10
Sfeir-Semler B8
**Atoui, Tarek**
Galerie Chantal Crousel F11
Vitamin Creative Space F1
**Attia, Kader**
Galerie Krinzinger A6
Lehmann Maupin A18
**Attoe, Dan**
Peres Projects G2
**Auad, Tonico Lemos**
Stephen Friedman Gallery C7
Galeria Luisa Strina D8
**Auder, Michel**
Fonti G19
Office Baroque A13
**Auer, Abel**
Corvi-Mora C13
**Auerbach, Tauba**
Standard (Oslo) D1
**Avedon, Richard**
Gagosian Gallery C3
**Avery, Charles**
Pilar Corrias B19

**Avini, Andisheh**
Marianne Boesky Gallery B14
**Avotins, Janis**
Galerie Rüdiger Schöttle B21
**Avşar, Vahap**
Rampa G8
**Axford, Tanya**
Workplace Gallery H10
**Azorro**
Raster G23
**Bacal, Nicolás**
Vermelho G11
**Bacher, Lutz**
Galerie Buchholz C10
Cabinet F4
Greene Naftali C14
**Bacher, Markus**
Contemporary Fine Arts F6
**Bäckström, Miriam**
Galería Elba Benítez H6
**Bacon, Francis**
Gagosian Gallery C3
**Bader, Darren**
Sadie Coles HQ D2
Andrew Kreps Gallery D11
Galleria Franco Noero D12
**Baechler, Donald**
Galerie Thaddaeus Ropac A5
**Baertling, Olle**
Galerie Nordenhake B11
**Baga, Trisha**
Greene Naftali C14
Gió Marconi B2
Société G15
Vilma Gold F2
**Baghramian, Nairy**
Galerie Buchholz C10
**Bainbridge, Eric**
Workplace Gallery H10
**Bakhshi, Mahmoud**
Galerie Thaddaeus Ropac A5
**Bakowski, Wojciech**
Galeria Stereo H24
**Baladrán, Zbynek**
Galerie Jocelyn Wolff L4
**Baldessari, John**
Marian Goodman Gallery C8
Mai 36 Galerie C4
Galerie Greta Meert B16
Sprüth Magers C5
**Baliga, Mahesh**
Project 88 J4
**de Balincourt, Jules**
Victoria Miro B3
Salon 94 A1
**Bałka, Mirosław**
Galería Juana de Aizpuru B15
Galerie Nordenhake B11
White Cube D4
**Balkenhol, Stephan**
Stephen Friedman Gallery C7
Mai 36 Galerie C4
Galerie Thaddaeus Ropac A5
Galerie Rüdiger Schöttle B21
**Ballester Moreno, Antonio**
Peres Projects G2
**Balteo Yazbeck, Alessandro**
Galerie Martin Janda B12

Galeria Luisa Strina D8
**Baltes, Cornelia**
Limoncello H23
**Balula, Davide**
François Ghebaly Gallery G12
**Bamburg, Larry**
Simone Subal Gallery H15
**Banerjee, Sarnath**
Project 88 J4
**Banfi, Chiara**
Vermelho G11
**Banisadr, Ali**
Galerie Thaddaeus Ropac A5
**BANK**
MOT International G9
**Banks, Darren**
Workplace Gallery H10
**Banner, Fiona**
Frith Street Gallery B4
**Bannet, Eden**
Tempo Rubato H11
**Barba, Rosa**
Gió Marconi B2
Meyer Riegger B2
**Barclay, Claire**
Stephen Friedman Gallery C7
**Barel, Joav**
Tempo Rubato H11
**Barham, Anna**
Arcade J9
Galerie Nordenhake B11
**Barker, Sara**
Mary Mary J3
**Barlow, Phyllida**
Hauser & Wirth D6
**Barman, Rathin**
Experimenter G22
**Barney, Matthew**
Sadie Coles HQ D2
**Barrada, Yto**
Pace A2
Sfeir-Semler B8
**Barrão**
Galeria Fortes Vilaça D5
**Barré, Martin**
Andrew Kreps Gallery D11
**Barriball, Anna**
Frith Street Gallery B4
**Barry, Robert**
Galerie Greta Meert B16
Sfeir-Semler B8
**van Bart, Hannah**
Marianne Boesky Gallery B14
**Bartana, Yael**
Annet Gelink Gallery A20
Sommer Contemporary Art A19
**Barth, Uta**
Tanya Bonakdar Gallery E7
**Bartolini, Massimo**
Massimo De Carlo B1
Frith Street Gallery B4
**Bartuszova, Maria**
Galerie Rüdiger Schöttle B21
**Baruchello, Gianfranco**
Galerie Greta Meert B16
**Bas, Hernan**
Galerie Peter Kilchmann
Lehmann Maupin A18

Victoria Miro B3
Galerie Perrotin A16
**Basbaum, Ricardo**
A Gentil Carioca G6
**Baselitz, Georg**
Contemporary Fine Arts F6
Gagosian Gallery C3
Galerie Thaddaeus Ropac A5
Michael Werner A7
White Cube D4
**Basquiat, Jean-Michel**
Gagosian Gallery C3
**Bass, Math**
Overduin & Co. B20
**Bastard, Pauline**
Barbara Seiler J12
**Basualdo, Eduardo T.**
Galeria Luisa Strina D8
**Batniji, Taysir**
Sfeir-Semler B8
**Batranu, Ioana**
Galeria Plan B H5
**Bauch, Michael**
Galerie Karin Guenther J2
**Baudelaire, Eric**
Galería Juana de Aizpuru B15
Galerie Greta Meert B16
**Bauer, Marc**
Freymond-Guth Fine Arts G18
**Bauer, Michael**
Alison Jacques Gallery C9
Galerie Peter Kilchmann
**Baum, Erica**
Bureau G14
**Baumgarten, Lothar**
Marian Goodman Gallery C8
**Bayles, Dan**
François Ghebaly Gallery G12
**Bayrle, Thomas**
Gavin Brown's enterprise F9
dépendance G17
Galerie Francesca Pia C11
**Beasley, Becky**
Allied Editions J13
Laura Bartlett Gallery H3
**Beasley, Kevin**
Casey Kaplan C16
**Beavers, Gina**
Clifton Benevento J7
**Becher, Bernd & Hilla**
Konrad Fischer Galerie A9
Sprüth Magers C5
**Bechtle, Robert**
Timothy Taylor Gallery B17
**Bechtold, Gottfried**
Galerie Krinzinger A6
**Beck, Julian**
Supportico Lopez G21
**Becker, Julie**
Greene Naftali C14
**Beckett, James**
T293 A21
**Bedwell, Simon**
MOT International G9
**Beer, Oliver**
Galerie Thaddaeus Ropac A5
**de Beer, Sue**
Marianne Boesky Gallery B14

# Artist Index

# Artist Index

# Artist Index

# Artist Index

# Artist Index

# Artist Index

# Artist Index

# Artist Index

# Artist Index

# Artist Index

# Artist Index

# Artist Index

# Contributors

(MA) **Max Andrews** is the co-founder and co-director of Latitudes, Barcelona, and is a regular contributor to *frieze*.

(BD) **Brian Dillon** is a regular contributor to *frieze* and UK editor of *Cabinet*. He teaches critical writing at the Royal College of Art, London.

(CFW) **Chris Fite-Wassilak** is a writer and curator based in London. He is a regular contributor to *frieze, ArtReview, Art Monthly* and *Art Papers*.

(JG) **Jonathan Griffin** is a contributing editor of *frieze*, based in Los Angeles. He writes for various publications, including *ArtReview, Apollo, Art Agenda, Tate etc.* and *The Art Newspaper*.

(MH) **Martin Herbert** writes regularly for *frieze, Artforum* and *Art Monthly*, and is associate editor of *ArtReview*. He is the author of *Mark Wallinger* (Thames & Hudson, 2011) and *The Uncertainty Principle* (Sternberg Press, 2014).

(KMJ) **Kristin M. Jones** is a writer based in New York. She is a regular contributor to *frieze, Film Comment* and *The Wall Street Journal*.

(KK) **Katie Kitamura** is a critic and fiction writer based in New York. Her novels include *The Longshot* (Simon & Schuster, 2009) and *Gone to the Forest* (Clerkenwell Press, 2013).

(PL) **Pablo Larios** is a Berlin-based writer and assistant editor of *frieze d/e*.

(MMcL) **Matthew McLean** is a writer and editor based in London.

(LMcLF) **Laura McLean Ferris** is a writer and curator based in New York. She is a regular contributor to *ArtReview, Artforum, frieze, Kaleidoscope* and *Mousse*.

(TM) **Tom Morton** is a London-based writer and curator, and a contributing editor of *frieze*.

(EN) **Eleanor Nairne** is a regular contributor to *frieze*. Based in London, she is Curator of the Artangel Collection and Public Programmes .

(CP) **Colin Perry** has contributed to *Afterall, Art Monthly, frieze, ArtReview, Art in America*, and is reviews editor of *MIRAJ*. He is based in London and teaches at Central Saint Martins.

(MQ) **Morgan Quaintance** is a London-based writer, musician, broadcaster and curator. He is a regular contributor to *Art Agenda, Art Monthly, ArtReview, frieze* and rhizome.org.

(AS) **Amy Sherlock** is reviews editor at *frieze* and is based in London.

(SNS) **Sarah-Neel Smith** is a writer based in Los Angeles. She writes regularly for *frieze*.

(EDW) **Ellen Mara De Wachter** is a writer and curator based in London. She writes regularly for *frieze*.

Published to coincide with Frieze London 2014
Regent's Park, London, 15–18 October 2014

Published by Frieze
1 Montclare Street
London E2 7EU
United Kingdom
Tel +44 20 3372 6111
Email info@friezeartfair.com
www.friezeartfair.com

Frieze is an imprint of Frieze Events Ltd,
registered in England number 4429032

ISBN 978-0-9572496-6-0

A catalogue record of this book is available from the British Library.

Publisher: Anna Starling
Editor: Tamsin Perrett
Catalogue Co-ordinator: Josephine New
Copy-editors: Matthew Taylor, Rosalind Furness
Advertising Sales: Mareike Dittmer, Melissa Goldberg and Adair Lentini
Advertising Production: Carianne Whitworth

Original Design: Graphic Thought Facility
Art Direction: Studio Frith
Layout: Asuka Sawa
Cover and Divider Page Photography: Amber Rowlands
Printed by: Graphicom, Vicenza, Italy

Distributed outside North America by
Thames & Hudson Distributors Ltd
181a High Holborn
London WC1V 7QX
UK
Tel +44-20-7845-5000
Fax +44-20-7845-5050
Email customerservices@thameshudson.co.uk

Distributed in North America by
DAP
2nd Floor 155 Sixth Avenue
New York NY 10013
USA
Tel +1-212-627-1999
Fax +1-212-627-9484
Email orders@dapinc.com